Sculpture Since 1945

Oxford History of Art

Andrew Causey is Professor of the History of Modern Art at Manchester University. Educated at Cambridge and the Courtauld Institute, he has published and lectured widely on twentieth-century art, especially British. His doctorate was on Paul Nash, and his monograph on the artist was published in 1980. He has written articles on Wyndham Lewis, Stanley Spencer, and Edward Burra as well a for exhibitions at the Tate Gallery, the Hayward Gallery and for 'British Art in the Twentieth Century' shown at the Royal Academy and the Staatsgalerie, Stuttgart, 1986–7, where he was chair of the selection committee. He has been a purchaser of contemporary sculpture for the collection of the Arts Council of Great Britain, and is a trustee of the Henry Moore Foundation and Moore Sculpture Trust.

Oxford History of Art

Sculpture Since 1945

Andrew Causey

Oxford NewYork

OXFORD UNIVERSITY PRESS

1998

Oxford University Press, Great Clarendon Street, Oxford OX2 6DP

Oxford New York

*Athens Auckland Bangkok Bogota Bombay
Buenos Aires Calcutta Cape Town Dar es Salaam
Delhi Florence Hong Kong Istanbul Karachi
Kuala Lumpur Madras Madrid Melbourne
Mexico City Nairobi Paris Singapore
Taipei Tokyo Toronto Warsaw
and associated companies in Berlin Ibadan*

Oxford is a trade mark of Oxford University Press

First Published 1998 by Oxford University Press

*British Library Cataloguing in Publication Data
Data available*

*Library of Congress Cataloging in Publication Data
Data available*

*0–19–284205–6 Pbk
0–19–284255–2 Hb*

10 9 8 7 6 5 4 3 2 1

*Picture Research by Elisabeth Agate
Designed by Esterson Lackersteen
Printed in Hong Kong
on acid-free paper by
C&C Offset Printing Co., Ltd*

Contents

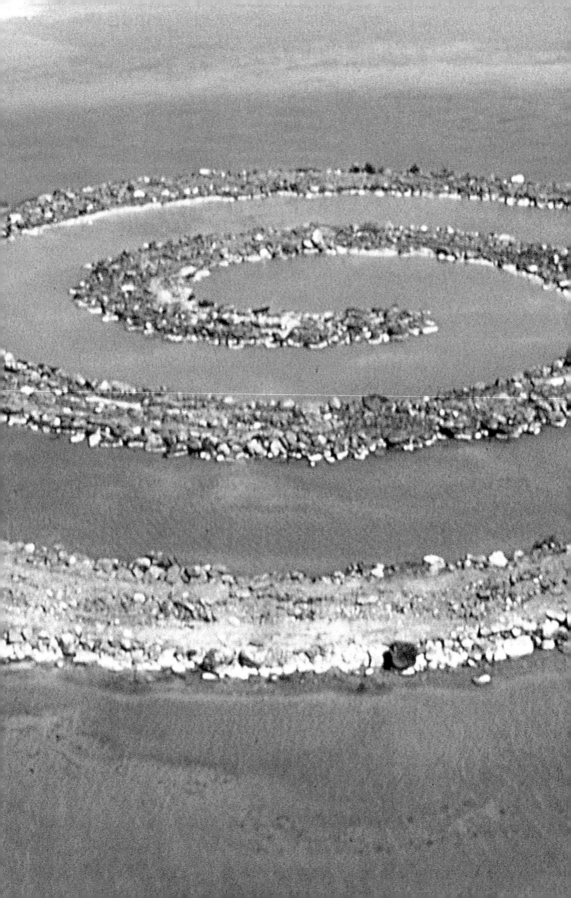

Introduction

In previous centuries sculpture had certain functions—votive, commemorative, didactic, decorative—which it has gradually lost. After the early decades of this century, when avant-garde sculptors abandoned the tradition of Rodin and reconstituted their art from the examples of Cubist painting and relief, twentieth-century sculpture lost touch with the wider public. Though contact between the public at large and experimental sculpture has plainly not been regained in the course of the period covered by this book, redefining the function and purpose of their discipline has always been in sculptors' minds. With the end of the Second World War sculptors were asking themselves what, in an age of abstraction, a commemorative art might be. Was public sculpture possible? Questions of wide public interest have been asked by sculptors all through this period. Sculptors have preferred inscrutability to compliance with the values of a world increasingly influenced by marketing and entertainment. The sheer variety of materials and forms that have been presented as sculpture in this period makes it clear that sculpture has not been regarded as a stable concept with fixed boundaries that have remained untouched by the material facts of post-war history.

With the rapid changes that sculpture has passed through since 1945, there is a particular interest in what other arts, or disciplines outside the arts, sculpture butts up against, what attitude it takes to subjects as diverse as history, memory, landscape, theatre, architecture, the museum, the art market, the manufactured object. Very little of the sculpture discussed here is abstract in the idealist sense of being in flight from the material aspects of the world. Even the resolutely non-figurative forms of 1960s Minimalism evoke in materials and forms other modern manufactured objects. Sculpture in this period borrows its terms of reference from many other areas; its resonances and inflections come from countless sources. It is a peculiarly open discipline.

Chapter 1 looks mainly at the work of sculptors with reputations already established by 1945. It discusses the West's lack of enthusiasm for memorial sculpture after the War and the Holocaust, and asks what other ways existed for sculpture to fulfil a commemorative function. Public spaces were sites for sculpture, sometimes venues for changing

Detail of 89

exhibitions that did not imply a relationship between the work's meaning and a particular place. Certain ideal forms were felt to have permanent significance beyond particular moments in time by some sculptors, who saw the possibility of a new non-figurative public sculpture. That also raised questions about the nature of 'public' space. Public and private bodies both sponsored sculpture in public places, much of which had no real basis in popular acceptance. Chapters 1 and 2 look at the problems created by the separation and distinctive development of the different arts in Modernism. They show the extent to which experimental post-war sculpture was the product of the USA, Britain, and France. Chapter 1 ends with a look at Italy and Germany, showing that developments in those countries in the 1950s that crossed the boundaries between different arts, and were in that sense transgressive according to the consensual Modernism of the USA and Britain, suggested ways forward for the 1960s.

Chapter 2 points to likenesses between America and Britain, and the preoccupation of younger sculptors in both countries with the human figure, treated at different levels of abstraction. The shock of the War, the Holocaust, and the atomic bomb gave rise to sculpture based on the often violent transformations of human, animal, and bird forms in a manner already hinted at in Surrealism. What the critic Clement Greenberg designated in 1949 'The New Sculpture' promised numerous openings and possibilities in both the USA and Britain, but with the rapid expansion of economic prosperity the events that inspired these developments receded in memory. Before the War impulses external to art, such as primitive artefacts and popular culture, had renewed the energies of Surrealism, but in the 1950s sculpture was relatively isolated from outside influence. While meeting with considerable success in the market-place, it became lethargic and academic. The end of the 1950s was a sculptural divide. Few sculptors with reputations made since the War remained internationally significant in the 1960s.

Chapter 3 is concerned with the introduction into sculpture of everyday objects—the blurring of the hitherto tightly guarded boundary between art and life, which had been an essential part of the post-war consensus. The use of the common object is seen as shifting emphasis from art as pure creation, the product of a free, unfettered, creator, towards a three-dimensional art concerned with the difference between objects as things of use and as constituents of works of art. The inflections that objects bring with them from real life gain significance, and there can no longer exist a clear correspondence between the artist's prior intention and final outcome. Presentation became important, with a change of stress from what a thing is to the way it is shown. This contextualization of the object is a starting-point for the issue of critique that was to be important in the late 1960s and

1970s: how does the interaction between an art object and its physical situation cause us to reflect not only on the object but also on the situation?

Images and objects from everyday life had been used in art in pre-1914 collage Cubism, Duchamp's wartime ready-mades, Dada montage, and the 'Surrealist object' of the 1930s. Except in the case of Cubism, in which the representational and 'everyday' character of collage had been played down, these movements had been marginalized in writing on art since 1945. Changes in art around 1960 demanded a revision of twentieth-century art history.

New words now entered the sculptural vocabulary, or represented contingent practices—environment, happening, performance, installation—all of which suggested groups of objects in real space; some also implying the artist's, and possibly the audience's, active participation. The idea that sculpture must be a single object clearly distinguishable from other, non-art objects was challenged. In so far as a performance or happening can be regarded as sculpture, sculpture might now have a short life and, therefore, exist in the same timeframe as the audience. This brought into question sculpture's transcendence and claim to represent values beyond the temporal. Performances and happenings brought 'low' materials into art, the atmosphere of the street, social and political responses.

The distinction between figurative and non-figurative is one way of classifying early 1960s sculpture, and is followed here in chapters 3 and 4. Chapter 4 is, none the less, closely allied to the previous chapter because much of the sculpture in both deals with 'whole things' or 'specific objects', sculptures which—figurative or not—reject 'composition' and the relationship of parts as a basis for sculpture. Even Minimalist abstraction takes a cue from the modern manufactured object. Attention is given throughout the book to the kind of space a sculpture occupies or creates around it, because sculpture's meaning relates to its physical place (museum, private home, landscape), and where it belongs may suggest to whom it belongs. Minimalism is plainly a difficult art in that, by the standards of sculpture at the time, there is little (in the sense of difference between parts, internal relationships, or contrast between core and surface) to get leverage on. An effect of this formal simplicity is to reinforce interest in context, the relationship of the sculpture to its surroundings, to architecture, and to other manufactured objects made of the same materials (plastics, perspex, special metals). In this way a Minimalist work of art is seen not as idealist (Platonic) but as situated and conditional, and has a positive relation to the physical presence of the viewer.

Chapter 5 takes its title, 'Anti-Form', from an article written in 1968 by the sculptor Robert Morris. In general Morris was concerned that, in an urban world of buildings and other manufactured things, form

comes to be regarded as prior to substance. He and others reversed that priority with an array of base materials, such as earth, that are without inherent form and of low value. Anti-Form was about processes of making, temporariness, the provisional, diffusion of material, decentredness of the artwork, and even the absence of a finished work at all. *Arte Povera* in Italy was the closest to a corresponding movement in Europe.

Both these kinds of art were politically charged in a way no other sculpture had been since 1945. The rule of capital that was challenged by the events of 1968 was symbolized for many people by urban structures and manufactured objects that were fixed, permanent, centred, objects of the kind Anti-Form and *Arte Povera* sought to devalue. While at one level the objection made by these artists was to kinds of art that seemed to be identified with the capitalist system of products, there was a second objection, to the idea of any encompassing order. 'Form', and the associated word 'formalism', were part of the language of Modernism, which was seen, both in principle and in the kind of art it produced, as monolithic. The kind of order imposed by Modernism has been identified as male, white, and middle-class. The diffusion and decentredness of Anti-Form can be seen as opposed to a single dominant culture. Anti-Form raised practical questions with implications for the role of the art world itself within capitalism. What happens to the commercial art gallery, the museum, and the private collection if there is no end-product, nothing to sell, nothing to keep, or the materials deteriorate?

Chapter 6 overlaps chapter 5, sharing a concern for materials that are 'low', both in the sense of unprivileged within existing art, inexpensive, and belonging close to, or under, the ground. The period of ten years from the late 1960s was the only time since 1945 when landscape was a major influence on new sculptural ideas. Landscape is seen here not so much as nature, with the overtones of growth and fertility that pervade much previous art, but as the open spaces of deserts and other remote places. Discussion, as in chapter 6, is concerned with decentredness and spread. Much sculpture in the 1960s was located adjacent to non-sculptural subjects that signified the new and the present: modern urban architecture and the manufactured object. Earth Art, in making links with places, their history and the memories they evoke, has as adjacent areas history, geology, and archaeology, all of them disciplines connected with the study of the past and the polar opposite of Minimalism's attachment to the present. Earth Art, like Anti-Form, registers a descent from the 'above-ground' architectural metaphor of Minimalism to 'below-ground' concerns with soil extraction. The opening up in the late 1960s of the closed Minimalist cube can be thought of as a process of lateral spread, along the ground, but equally as having a vertical axis, from architecture to archaeology.

Up to this point much sculpture since 1945 could have been removed from one site to another without loss of meaning. Earth Art developed the idea of the 'site-specific', aligning sculpture with a particular place that was identified either by physical type or by association with specific history or memory. Site-specific sculpture reflects back on the issue of the memorial alluded to in chapter 1. Some sculptures within the genre—like Robert Smithson's *Spiral Jetty* [**89**]—are in a limited sense memorials, in that they encapsulate aspects of the history of the place and retain them for collective memory. Few sculptures at this point are memorials in the more particular sense of keeping in memory an individual event or person rather than the *mélange* of history and myth with which Smithson surrounded *Spiral Jetty*. The recovery in Earth Art of memory and history was to have significant longer-term implications, but it was not until the 1980s that experimental sculpture engaged again with the memorial as a form of public art.

Chapter 7 looks at art from the late 1960s to the 1990s that takes a critical view of its surroundings. This sculpture is site-specific in the sense defined in chapter 6 and, even more than Earth Art, its meaning is completed by its surroundings. At the extreme, there is sculpture here which has little more purpose than to help us read the hidden meanings of the place where it is located. In some cases, therefore, we are looking at work which is not in itself visually interesting, but is more of a site marker or anchor for our attention. It follows from this that the artists discussed are not all much concerned with style and its development within their work; as it is art's context to which they wish to draw attention. In relation to chapter 3 it was pointed out that the introduction into sculpture of objects from the everyday world brought into play problems relating to their existing inflections and the way codings were added to and altered as they took their place in the world of art. The sculptors discussed in chapter 7 acknowledge that all language is coded, and that the artist is no longer an originator in the traditional sense but a manipulator of codes.

The early avant-garde at the time of Cubism saw progress and development in terms of the studio. The post-avant-garde from the late 1960s was politically aware, and examined critically its own situation within institutional structures. Art is no longer simply a creation of the studio, but a product of interaction between the artist and the situations and institutions with which he or she is engaged. The subject of this art may be architecture, buildings of all kinds, museums and public places, and the power or meaning each has in society. Chapter 7, therefore, follows from chapter 5 in showing how the politicization of art in the late 1960s led artists to question the role of museums and public institutions.

The latter part of chapter 7 looks at sculpture in its attitude to history. Two sets of events of the later 1980s are important here: liberaliza-

tion in Eastern Europe and Germany's coming to terms with the Nazi past. In the course of the 1980s a more specific kind of history became a possible subject for sculpture than the generalized references to the past in Earth Art. Far from implying a return to realism of any kind, that is what artists born to Socialist Realism wish to avoid. East European artists working in the West use metaphor and allegory to allude to their pasts. Their work is not transparent in meaning or concerned with closure, and there is an irony related to despair born from their domination by unfavourable political regimes. A way of reflecting on Germany's Nazi past has been the 'counter-monument', a title given to sculpture in public space that comments directly on the past. This is the first post-war monumental sculpture in the West which is experimental in form which may also have wide public appeal. The counter-monument is site-specific but temporary. It is not a memorial because it does not enshrine an ideological position for the future. Indeed, the counter-monument is evidence that the situation of 1945 has not materially changed: the confidence or will to impose present views on the future is absent.

Chapter 8 casts a wide net over sculpture of the 1980s and early 1990s. In the 1980s non-figurative sculpture is notably absent, and there is a wide range of approaches to the common object. British sculpture, which found a shared identity early in the decade, took a mainly critical attitude to consumerism, with an emphasis on decay and waste. American 'commodity sculpture' emerged a few years later, identified with the consumer boom of the Reagan period, and represented a more complicit attitude to consumer culture. In both American and European art the human figure (treated in widely different ways) has provided an exit route for sculpture from the central focus of the object, because it has been able to reflect minority interests, the fertile peripheries against a dominant centre.

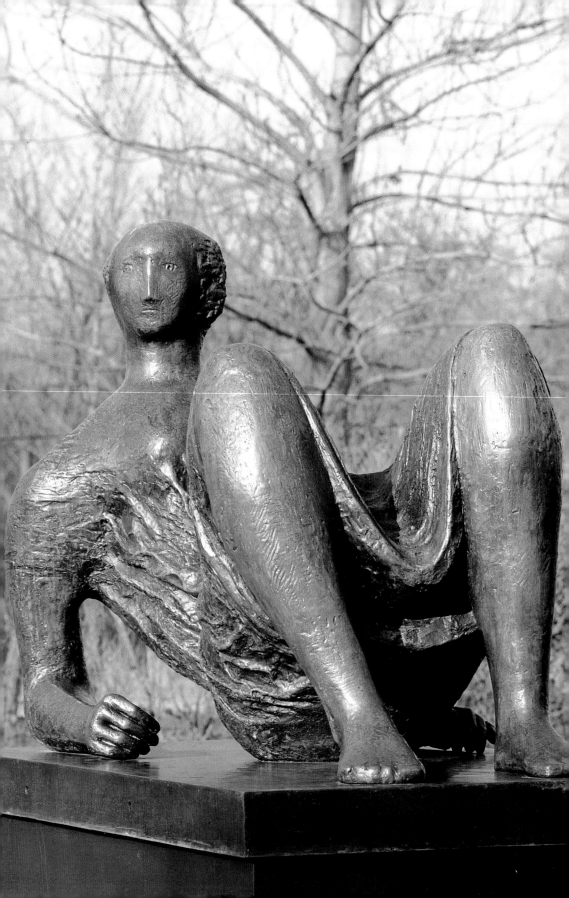

European Sculpture after 1945

1

Popularizing modern sculpture

The end of the Second World War was not like 1918, because there was no comprehensive peace treaty. Europe was divided, and the atomic bomb presented a new kind of threat. There was little sense of the new beginnings that had underpinned Russian Constructivism, the Dutch De Stijl movement, or the Bauhaus in Germany after 1918. The earlier moment's ideals—the unity of art and life, the harnessing of art to industry, and its belief in the evolution of a utopian visual environment for the benefit of all social groups—was a dream that few people held after 1945. The prevailing disillusion with an old order that had failed again to prevent war restricted the possibilities for a commemorative public art, which might have been expected at its conclusion.

This limitation had the effect of paving the way for the advance of modern sculpture. In the fifteen years after 1945 avant-garde sculpture developed from an experimental art form with a tiny audience into a widely recognized genre. Carola Giedion-Welcker's first historical account of modern sculpture in 1937 presented a modest number of names, which had already grown when A. C. Ritchie extended the ground in 1952 to cover the post-war years, and Giedion-Welcker's new edition of 1956 marked a considerable enlargement.

The stages of modern sculpture's expansion are easily pinpointed. The existence of an International Sculpture Prize at the Venice Biennale gave prestige to the practice, and at a time when international exhibitions grew in importance there was strong representation of sculpture both at Venice and in the Documenta exhibitions instituted at Kassel in West Germany from 1955. At Documenta 2, in 1959, on the theme of 'Art since 1945', a special volume was published devoted to sculpture. The 'Monument to the Unknown Political Prisoner' project of 1952–3 was by far the largest sculpture competition ever organized.

Outdoor exhibitions and collections introduced a new audience to modern sculpture by reaching out to those who were intimidated by art galleries. The London County Council's first Battersea Park show in London in 1948 became a three-yearly event, and was the catalyst for initiatives elsewhere in Europe. From 1949 the triennial Sonsbeek exhibition at Arnhem in Holland also offered a parkland setting, and

the Middelheim Sculpture Park in Antwerp started sculpture biennales in 1950. Sculpture was given a significant role in the Festival of Britain (1951) and later, in the mid-1950s, the Italian town of Spoleto became the venue for exhibitions of sculpture throughout its public spaces. The concept of regular sculpture exhibitions associated with the building of a permanent collection was pioneered at Middelheim, while the first of many European public galleries to house its sculpture collection partly in the open was the Kröller-Müller Museum at Otterlo in Holland. The idea that a new town deserved its own permanently sited outdoor sculpture was pioneered at Harlow, a London overspill development, where a large collection of post-war sculpture was sited in 1954. Initiatives of these kinds brought modern sculpture into the public domain with the help of a healthy art market founded on expanding economies in Western Europe and the USA.

But the post-war expansion of modern sculpture did not produce reputations that survived into the 1960s. Many of the large number of sculptors reproduced in early histories of modern sculpture that cover the 1950s, by Eduard Trier, Michel Seuphor, Robert Maillard, and Herbert Read, are now forgotten, while the post-war sculptors whom we still value most highly were largely well established before 1945. It is plain that the moment around 1960 marked a threshold for sculptors that was very difficult to cross. One thing that can be said with some certainty is that the first fifteen post-war years constitute a 'period'.

Public sculpture: remembering the War

The way sculpture had been used by the pre-war dictatorships, followed by the new East–West divide, contributed a political dimension to its development. The War and the need to commemorate human sacrifice required a public art, and one that was by tradition three-dimensional and widely accepted. But, with the decline of social submissiveness and the esteem afforded to heroes of public life, the nineteenth century's enthusiasm for public sculpture had long been diminishing. Even so, the brutal human waste of the First World War was still reflected in a sense of the nobility of sacrifice and the need for memorials to those who had given their lives. Though the breakaway of the avant-garde since the early years of the century raised the question whether there was any longer a single public to which public art could address itself, the tradition of figurative sculpture descended from the nineteenth century nonetheless continued productively after 1918 in the work of Aristide Maillol (1861–1944) [1], Antoine Bourdelle (1861–1929), and Charles Despiau (1874–1946) in France, Gerhard Marcks (1889–1981) and Georg Kolbe (1877–1947) in Germany, and others. Earlier twentieth-century artists, most forcefully Wilhelm Lehmbruck (1881–1919), Käthe Kollwitz (1867–1945), and Ernst Barlach (1870–1938) in Germany, created sculptures displaying grief

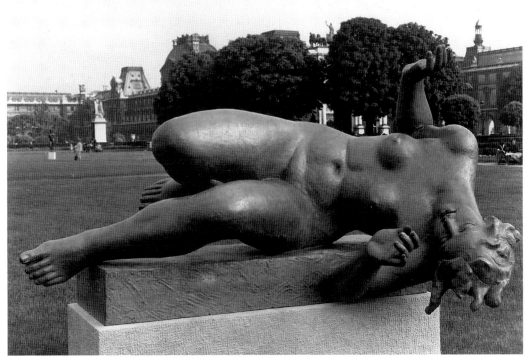

and other intense emotions. At that point the direct representation of the pathos of human sacrifice was possible,

It was only the misuse of the figurative tradition and the false representation of human emotions to support propaganda by the totalitarian powers in the thirties that made the division between avant-garde and academic acute. One of these powers, Stalin's Soviet Union, still existed after 1945, and the official art of its sphere of influence in Eastern Europe was a stylized naturalism with an emphasis on gesture and expression, and a sense that importance could be represented through gigantism.

Public sculpture faced a sceptical public, doubtful whether sculpture could still carry the direct expression of human emotion. It was not just that the earlier German artists' authentic emotion had been overtaken by the kitsch emotion of art under the dictatorships. Disenchantment with direct collective expression of the human condition was deeper and more widespread. The gravitas of *Les Bourgeois de Calais* (1885–95) by Auguste Rodin (1840–1917) is absent from the group of Holocaust survivors by the Dutch sculptor Mari Andriessen (1897–1979) in his memorial for the border city of Enschede [**2**]. Andriessen's group has a generality that expresses the idea of an emotion rather than the emotion itself, a sense of collective responsibility without collective feeling.

The Destroyed City, completed in 1953 [**3**], by Ossip Zadkine (1890–1967), illustrates the dilemma in a different way. *The Destroyed City* was

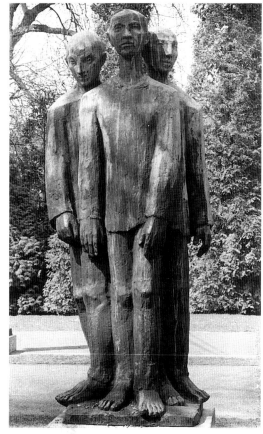

a memorial to the destruction of a large part of Rotterdam in a single
air raid on the night of 14 May 1940, which led within hours to the
surrender of Holland. While sited in Rotterdam, it is a kind of national
war memorial. Zadkine, of Russian Jewish birth, was based in Paris,
and conceived a monument of this kind from seeing the ruins of Le
Havre on his return from America in 1946. He had already, in 1943,
sculpted images of prisoners behind bars which prefigure many of the
submissions to the Unknown Political Prisoner competition. The
possibility of the monument being erected in Rotterdam arose only
during an exhibition of Zadkine's work in Amsterdam in 1948, with the
commission following in 1951. Zadkine failed to discover a representa-
tional mode with the strength to carry the burden of emotion. He at-
tempted, in effect, to satisfy both sides of the East–West political
divide, overlaying forms derived from Cubism with a heavy emotional-
ism more characteristic of the monumental sculpture of Eastern
Europe. The monument was condemned by some critics and art histo-
rians on the grounds that it confused emotion with form and pictorial-
ism with what is essentially sculptural. A notable exception was John
Berger, who regarded it as the 'best modern war monument in Europe'
and Zadkine as one of the few contemporary sculptors capable of

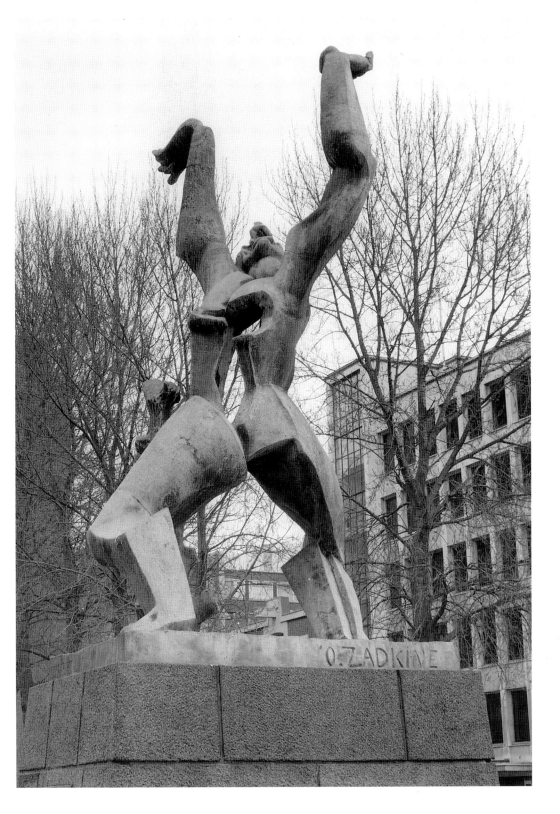

4 Yevgeny Vuchetich,
sculptor, and Yakov Bepolsky,
architect
*Memorial to the Fallen Soviet
Heroes*, 1947–9, Treptow
Park, Berlin
The Treptow Monument is
a sculptural/architectural
ensemble and Russian military
cemetery of massive scale and
ambition. Erected in East
Berlin, it became the paradigm
of the Soviet war memorial for
Western Europe. The sculptor
Yevgeny Vuchetich, winner of
five Stalin prizes, also
designed 'Mother Russia'
above Stalingrad (now
Volgograd), and the
Dzerzhinsky Statue outside
the Lubianka in Moscow
(removed 1991).

addressing the public at large.[1] The dedication of the monument co-incided with the debate over the Unknown Political Prisoner competition and the two events illustrate the problems of making monuments in an age when a knowing and sceptical public was reluctant to countenance the rhetorical devices—evocation of suffering, heroism, hope, glory—that traditionally surrounded war memorials.

The *Memorial to the Fallen Soviet Heroes* designed by the sculptor Yevgeny Vuchetich (1908–74) and the architect Yakov Bepolsky at Treptow in Berlin [4] commemorated the Russians who died in the liberation of the city in 1945. An extensive area was carved from a large park and enclosed with trees. A grieving mother is at one end, while in the centre is a burial ground for Russian soldiers, framed on either side with panels of stone engraved with quotations from Stalin's speeches and positioned like stations of the cross in a huge open parkland cathedral. The culmination is the massive image of a Russian soldier cradling a child. The ensemble is a tribute to the Red Army's sacrifice, and the raising of such a magniloquent monument at Treptow was a reminder to Berliners that the protection of their children and their future had been assured by the Russians. It looked to the West like colonization. The effort that might have been expected in Western Europe after the war to find symbols through which to express collective emotion was inhibited by the absence of feeling for triumphalism and heroics and by the new shape of East–West relations.

It was a problem to which no solution was found. With the Unknown Political Prisoner the issue was faced, but the result was a retreat. The competition was so broadly specified, in terms of what the title meant and how it might be conceptualized, that it seemed to be admitted from the start that the forceful expression of a single idea was impossible. The Cold War formed the political backdrop and the success of abstract sculptors in the competition mirrored the fact that, though it was a world competition, it was an Anglo-American initiative, and in western countries the expression of human emotion in sculpture was regarded as best avoided. It was not that figurative sculpture as such was no longer viable: until the end of the 1950s, up to the time of the 'New Images of Man' exhibition at the Museum of Modern Art, New York, in 1959 (which consisted of painting as well as sculpture), figuration of one sort or another was the dominant mode, at least in sculpture and among younger artists with post-war reputations. But these sculptors tended to draw on myth or created generalized representations of figures that were 'scarred', 'wounded', or 'oppressed'; in either case the appeal was trans-historical rather than to the here and now, and Rodin's extraordinary ability in *Les Bourgeois de Calais* to give the sense that an event hundreds of years ago was real for the present found no contemporary counterpart.

What was public sculpture to be if the traditional idea of the

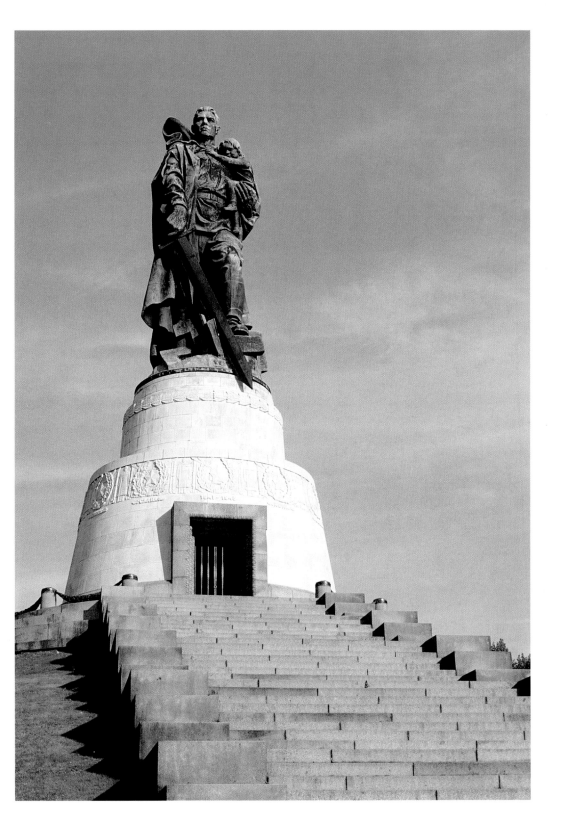

**5 Powell and Moya,
architects, with Felix
Samuely and Frank Newby,
consulting engineers**

The Skylon, Festival of Britain,
1951

More than any conventional
sculpture, the Skylon
represented the forward-
looking technological aesthetic
of the Festival, and its rocket-
like form in modern durable
materials was a precursor of
much sculpture in public
places in America and Europe
until the late 1960s.

memorial was no longer viable? A possible answer lay in one area where social consensus seemed secure. The Skylon [5] was an emblem for the Festival of Britain because its link, through technology, was to the present and the promise of science to deliver a better future. It made no reference to the past, and raised none of the problems of memorials. The competition to design the Skylon—described by the Festival's organizers as a 'vertical feature', neither architecture nor sculpture— was advertised to architects and won by the firm of Powell and Moya, with the engineers Felix Samuely and Frank Newby as consultants. Sculpture shown at the Festival was a cross-section of Royal Academicians' and traditionalists' work, the older generation of Henry Moore (1898–1986) and Barbara Hepworth (1903–75), and younger artists like Eduardo Paolozzi (b. 1924) and Lynn Chadwick (b. 1914). Chadwick's *Stabile (Cypress)*, a thirteen-foot-high vertical open-work sculpture of brass and copper, bears a family resemblance to the Skylon, but was presented so as to make it clearly recognizable as sculpture and associated through its title with a tree form. Generous public commissions were offered for the creation of a variety of sculpture, none of which was as central as the Skylon to the demonstration of Britain's prowess in technology and research. The Skylon's technological analogy, more than any sculpture at the Festival, foreshadowed later aspects of the constructive tradition. While the sculpture exhibits at the Festival of Britain were distributed around the site as embellishments—*Stabile (Cypress)* stood in front of the Regatta Restaurant—the Skylon was the non-functional equivalent of the nearby Dome of Discovery, the educational powerhouse of the Festival where advanced scientific research was shown. The Skylon had its place, while the sculptures were placeless, in the sense that they might be anywhere but happened to be there. As the signifier of science and modernity, the Skylon was an unconscious riposte to Treptow and its many more modest variants. While Treptow, as a Russian monument in Germany, was nationalistic and colonizing, science in all its manifestations was universal and, in theory at least, belonged equally to all. While not itself sculpture, the Skylon was a model for many non-figurative sculptures in public places, especially in America, made of durable modern materials.

One outcome of the placing of sculpture in parks and at the Festival was the association of sculpture with leisure, and the replacement of public sculpture with sculpture in public. The second may occupy the same location as the first, but is different because it occupies a site only temporarily. There is a problem, also, of ownership: public sculpture is work that the public can take collective possession of. Sculpture in public remains the possession, in this sense, of the artist, and before anything else its identity is as the brainchild of the artist. Looked at in this way, the artwork can be seen to exist within a particular economic structure, a stage of capitalism represented by a shift from the social

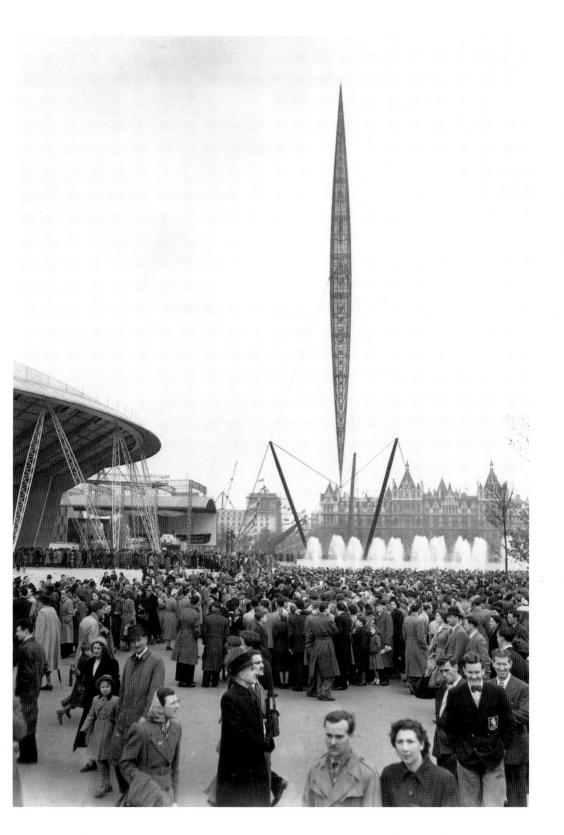

value of a publicly owned object to the exchange value of a privately owned one. This was not a sudden change after 1945, but a trend that had been growing since the turn of the century. What was new was the way this private, movable sculpture was used for exhibitions in public places, as if to fill the gap left by the death of true public sculpture.

A consequence of this was the rapid expansion of taste for modern sculpture. Modernist sculpture in the West after 1945 secured itself against the problems that Treptow and many comparable monuments raised by confining itself to problems within sculpture itself, problems that it had answers to. Only with difficulty, and always with an element of compromise, could it appeal to the mass audience which the memorial had traditionally served.

Manipulation by political forces was not the only problem for public sculpture. Public function is more acute with sculpture than painting because a sculpture is a presence, existing in real space rather than creating, like painting, a fictive space of its own. Sculpture offers itself to scrutiny in a different way from painting: a work of art occupying public space is expected to address itself to the public. However, Modernism had already prioritized artistic individuality over public function. Pablo Picasso's commission to create a monument for the tomb of Apollinaire, a venture which dragged on for many years after the poet's death in 1918 and ended inconclusively, illustrated the incompatibility between the avant-garde and the public. Picasso (1881–1973) offered the project's assessors designs made in a context personal to himself which he thought appropriate to the commission; but they belonged to the sequence of his own ideas before they were a part of the Apollinaire project.

One exception to this incompatibility between Modernism and the memorial were works by Constantin Brancusi (1876–1957) near his birthplace at Tirgu-Jiu, *The Table of Silence* [6], *Gate of the Kiss*, and *Endless Column*, completed in 1938. The group commemorates those who died in a German advance on that part of Romania in 1916. Though it has never been easily accepted by the local population, its forms have links both to Brancusi's earlier work and to aspects of traditional life and spiritual observation in the region. Brancusi was admired after 1945 mainly for his formal purity. But now, after Modernism, Tirgu-Jiu has an additional significance, attributable to Brancusi's sense of sculpture having a place and a specific social function, as against the placelessness and self-referentiality of Modernist art—as well as to the work's relation to life, presenting, as it does, objects of use (a table and stools). While Modernism was concerned with what makes sculpture different from other arts and, particularly, what makes it different from everything that is not art, Brancusi recognized the tenuousness of these boundaries. He illuminates at Tirgu-Jiu the points where sculpture becomes, on the one hand, architecture and, on

6 Constantin Brancusi

The Table of Silence, Tirgu-Jiu, Romania, completed 1938
This First World War memorial in Brancusi's native country was designed as a place for contemplation. Now regarded as one of the century's great sculptural achievements, after 1945 it was behind the Iron Curtain, and it was not a model for Second World War memorials.

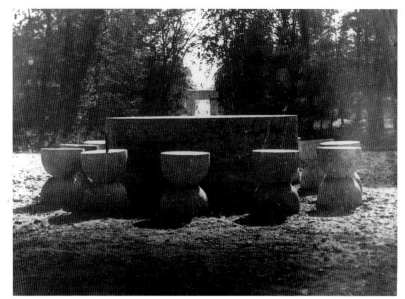

the other, furniture, and the difference between the space of sculpture and the space of everyday life.

Brancusi lived most of his professional life in Paris, but he did not lose touch with the pre-industrial culture of his native country, or see art as separate from life. He understood sculpture's rootedness and meaning in terms of place without the over-insistent rhetoric that falsifies the ensemble in Treptow Park. The years after 1945 gave birth to no new project like Tirgu-Jiu. For other artists sculpture occupies space (a generality) but not place (which is specific). However, if Modernism drove sculpture in on itself, there were nonetheless sculptors within the Modernist canon for whom the memorial function still mattered. To avoid naïve polemic they chose to be allusive in their method.

Henry Moore and the commemorative function

Henry Moore is representative of the sculptor's refusal either to display an uncritical taste for the heroic or to bow to Modernism's rejection of sculpture's commemorative function. A retrospective exhibition at the Museum of Modern Art in New York in 1946, the International Sculpture Prize at the first post-war Venice Biennale in 1948, and a show, alongside Turner, at the Tate Gallery to coincide with the Festival of Britain geared up Moore's already successful career. He was the first twentieth-century British artist to be consciously framed as a national figure. Herbert Read's first volume of the catalogue of Moore's sculpture was published in 1944 to an exceptional standard for a period of wartime restrictions. Zervos's catalogue of Picasso's *œuvre* had started to appear in 1932, and some comparison was surely intended.

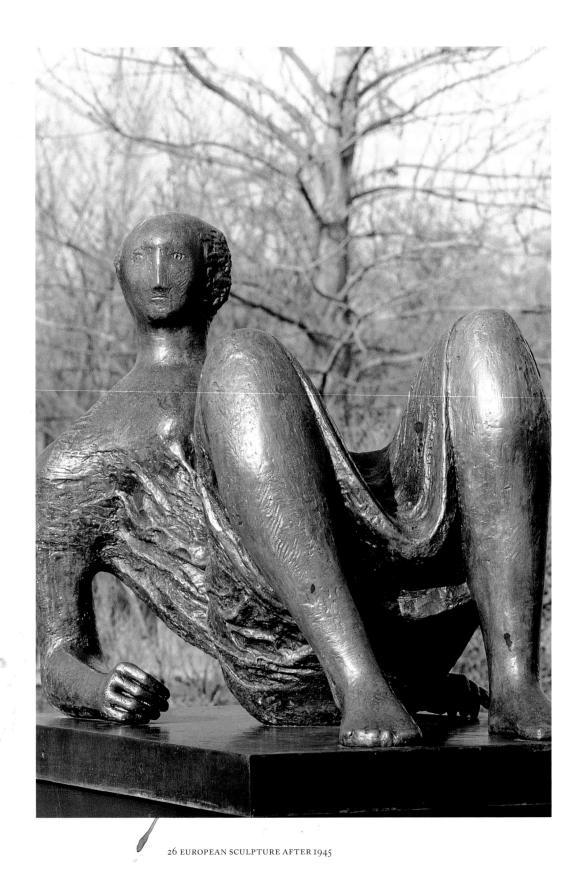

Commissioned for the roof
terrace of the Time-Life
Building, London, this was
Moore's earliest reclining
figure after his first visit to
Greece in 1951, and was one of
several ways, from the 1940s
onwards, in which Moore came
to terms with European
traditions. He used actual
cloth on the plaster maquette
to form the drapery.

The isolation of British art during the War gave rise to introspection and a tendency to turn to tradition for reassurance. Britain's weakness in sculpture since the Gothic had been observed by both Roger Fry and Herbert Read. Both, however, made an exception for British prowess in tomb sculpture, which provided basic inspiration for Moore, alongside a love of the early Italian Renaissance and classical fragments, reflecting his embrace of British culture's long-standing commitment to Italy.

One of Moore's strongest American supporters, the art historian and curator W. R. Valentiner, suggested that people wanted to remember the War not through the usual memorials, making heroes from soldiers, but by dedicating a place, which might be a tumulus or stone structure in extensive space. He had just seen Moore's New York retrospective and drew ideas for war memorials from Moore's drawings, with their deserted locations occupied with the sculptural forms Moore termed 'ideas for sculptures'.

More than any other contemporary sculptor, he expresses our deep longing for a closer connection with the elemental forces of nature as found in primeval deserts, mountains and forests, away from cities, away from the artificial life guided by intellect instead of emotional energies.... Other modern sculptors preceded Moore in creating abstract sculpture out of doors [he mentions Brancusi among others] but their accomplishment depended more upon the inventions of the Machine Age and the highly evolved life of cities than do Moore's, who conjures up the spirit of the wild, uninhabited nature in a manner never to be found in other sculptors of recent times.[2]

Valentiner saw in Moore's reclining figures double meaning, awakening to existence and the acceptance of decay, so that the figures symbolized cycles of life and, appropriately to the moment, Britain's survival [**7**]. A second American writer, Frederick Wight, described Moore's reclining figures as having

a curious air of being aroused to a different sort of life than ours, to be looking about after a revival from a trance. They have a static life more intense than ours, that is devoid of incident. Their clothes... are cerements. They have a Lazarus look.... Moore is particularly concerned with *immovability, permanence* and *eternity*.... Moore... strives to let death pass over his work like a breaking wave. And it must be remembered that his figures, being in stone, are their own monuments. They are born with the bleared surprised look of the mouldering stone sepulchral images in British churches over which time has already passed.[3]

Moore's works are as solid and stable as landscape. 'I would rather have a piece of my sculpture put in a landscape, almost any landscape,' Moore said in 1955, 'than in the most beautiful building I know.'[4] Recalling the 1938 *Reclining Figure* that he had made for the terrace of

the architect Serge Chermayeff's modern house on the South Downs in Sussex, he said: 'My figure looked out across a great sweep of the Downs, and her gaze gathered in the horizon. The sculpture had no specific relationship to the architecture. It had its own identity...[but] I think it became a humanising element; it became a mediator between modern house and ageless land,'[5]

Moore's sculptures are like national emblems, memorials to Britain's resilience as a nation, gathering together in one symbolic maternal figure the suffering and endurance Moore had drawn in wartime in shelters and down mines. If his figures are in a sense Britannia, they are not triumphalist or emblems of conquest, but suggestive of stoicism and survival. Moore's sophistication lies in his allusiveness and ability to condense meaning so that the wider implications of sculpture, and an arguably conservative cultural attitude, are represented without rhetoric.

By 1950 there were historians who saw Moore as the culmination of sculptural development since the Renaissance. Others were more cautious. Clement Greenberg, by then established as the leading American avant-garde critic, associated Moore with a halfway stage between the classical and the new, a stage, he believed, where artists become particularly preoccupied with the archaic and primitive. He acknowledged Moore's talent for threading his way through the complexities of Modernism (the painter Robert Motherwell, in the critical role, was more suspicious of Moore's eclecticism), and observed Moore's traditionalism and a link with Maillol.[6] The Maillol connection brings together two sculptors concerned with the heavy, primitivizing, recumbent female figure.

The middle ground of sculpture
Maillol's widely noted death in 1944, followed by Despiau's in 1946, seemed to bring to an end a tradition of figurative, classically derived sculpture. In Nazi-occupied Paris both were associated with Hitler's favourite sculptor, Arno Breker (1900–91), a former pupil of Despiau. Maillol signed a laudatory introduction to Breker's exhibition at the Orangerie in 1942, and Despiau put his name to a monograph on Breker in 1944.[7] With the end of the War, these associations cast a shadow over the work of Maillol and Despiau and helped to define the moment after which asserting classical-humanist values was seen as regressive. One outcome of this was the definition of a category of sculpture, headed by Moore's, that was not classical or humanist—in the sense of taking man as the measure for sculpture—but was nonetheless based on the human figure and solid three-dimensional form. It was these things, together with the primitivizing instinct Greenberg identified, that led him to locate Moore 'between the old and the new'. This meant, in Greenberg's definition, following

Maillol's preference for volume, as against the newer paradigm which Greenberg saw as linear and pictorial, away from solid volume and closed form.[8]

The work of Marino Marini (1901–80), like that of Moore, belongs to the middle ground. Marini is best known for the horse and rider series begun in the 1930s and continued after the War, when the images became increasingly abbreviated and abstract [**8**]. In the later versions naturalism gives way to images which seem petrified and frozen in muscular tension. As an Italian adopting a classical theme Marini is backward-looking. The horse and rider, however presented, is a difficult theme to reconcile with Modernism in the way Marini would have liked. But he did not want to engage with the humanist tradition, he ignored the usual triumphalism of the subject of the mounted horseman, and his development of the subject, especially after 1945, turns it from a celebratory to a tragic theme. Marini regarded his sculpture as stemming from

the events of my age. With each successive version of my horse its restiveness increases; the rider, his strength waning further and further, has lost his dominion over the animal.... My aim is to render palpable the last stages in the dissolution of a myth, the myth of the heroic and virtuous individual, the humanists' *uomo di virtù*. My effort of the past fourteen years has not been striving for the heroic, it is understood as the tragic.[9]

Marini's sense is of precariousness and of lost harmony between man and the animal world. The stretched and straightened neck of his horses and the impression of strangled cries look back to Picasso's

8 Marino Marini
Rider, 1949
This belongs to a long series of treatments of this theme, starting before the Second World War and becoming increasingly abstract and emotionally direct.

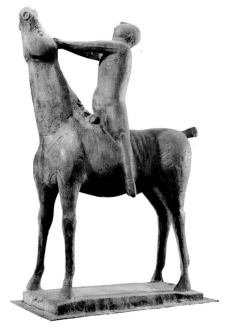

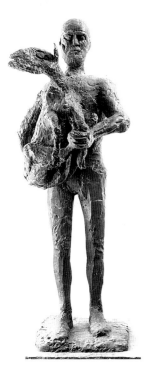

9 Pablo Picasso

Man with a Sheep, 1943

More directly figurative than most of Picasso's sculpture, and larger, *Man with a Sheep* appears to mark the artist's claim of a public role for his art towards the end of the War.

Guernica, where the horse's death represents the loss of man's close companion. After the War Marini became increasingly interested in images of death, especially the incinerated bodies uncovered at Pompeii, which had the same stiffness as his sculpture. Like Alberto Giacometti (1901–66), Marini wanted realism without naturalism (things that would *be* like without necessarily *looking* like) and to get back, as he put it, 'to the source of things'. Born in Tuscany, he witnessed the twentieth century's rediscovery of Etruscan art and it was classicism in its early phases that appealed to him. Archaism was the common character of the best post-war figurative sculpture. This was not new, and Greenberg rightly associated it with the succession to Maillol. For an age where the direction of events denied humanist values, only the pre-humanist stages in artistic cycles, whether of the ancient world or of the Renaissance, seemed relevant.

Moore and Marini did not see themselves as commemorative artists but nonetheless valued the role of sculpture in providing collective symbols of their time. Picasso's intention, however, is less easy to pin down. The Spanish Civil War and the commission to paint *Guernica* for the Spanish pavilion at the Paris World's Fair of 1937 had put Picasso under a public spotlight, but even *Guernica* is a parade of private images that refuses in the end to reveal itself fully as a public statement. The same can be said of Picasso's over-lifesize *Man with a Sheep* (1943) [**9**], which followed a period of ten years when he made virtually nothing in three dimensions. The sculpture's size, its figurative subject, the traditional sculptural material (bronze), and its line of descent from the work of such a figure as Rodin, suggest that Picasso was considering what it meant to be a public sculptor, exhibiting the work for a time in the central square of Vallauris near where he lived. The implications were not followed up, and Picasso's subsequent sculpture is private and experimental, but for a brief moment there is a sense of his contemplating taking a public lead.

Picasso's *Man with a Sheep* is ambivalent. The reference to the good shepherd suggests care and tenderness, yet it is unclear whether the man is holding the sheep protectively or the animal is actually struggling to free itself. The man is muscular and his facial expression stern, and the theme appears to be control as much as freedom. The fact that Picasso's sculpture can neither be reduced to a sequence of developments nor explained analytically reflects the hermetic side of its character. But within Modernist art—and the same could be said of the contemporary work of Moore or Giacometti—an element that is personal and inexplicable is not incompatible with public function. Picasso's long-time friend and former dealer, Daniel-Henry Kahnweiler, writing in 1949 in the introduction to the first major publication on Picasso's sculpture, suggested that the artist's power to concentrate the mind was essentially unceremonious.[10] This absence of

ceremony or rhetoric in the best sculpture of the period created an alliance between artwork and audience that a sculptor like Zadkine was not capable of: an alliance requiring the spectator to bring a high level of intelligence to works that are accessible, but not instantly assimilated; they are suggestive, testing, and ambiguous.

Picasso and Giacometti were the artists who had influenced sculpture most profoundly in the 1930s. Both were concerned with the human figure; both, under the umbrella of Surrealism, went to extremes of distortion, while Picasso, in sharp contradiction, also created, in images of his youthful lover, Marie-Thérèse Walter, portraits of classical beauty. After 1945 Picasso made occasional statements as a sculptor, but his wilful inventiveness, the quick response to the idea of a moment, and the anti-monumental character of most of his later sculpture led him to materials, like bendable metal and cardboard, from which he could create things rapidly, and to ceramics, through which he could express his feeling for colour and his skills as a painter. Picasso had no exhibition of sculpture by itself until 1967, and then, at the moment of Anti-Form in America and *Arte Povera* in Italy, the sheer radicalism of his sculpture struck a chord. Since then his sculpture, like that of his contemporary Joan Miró (1893–1983), has been of recurrent interest to younger artists.

Giacometti and Paris after the Occupation

Alberto Giacometti had been a member of the Surrealist circle until he returned in 1935 to the human figure and a realism of his own definition. He became the key Parisian sculptor of the post-war years and an inspiration throughout the West. After a decade with no one-man show in Paris, the post-war years were his moment of greatest public success, marked by a series of exhibitions in Paris and New York and, in the 1950s, major museum shows.

In the early 1930s Giacometti had composed sculptures of several parts on flat bases, like tableaux. Hans (Jean) Arp (1887–1966) and Moore had made a move in the same direction, setting objects on bases that were part of the sculpture. The space surrounding the objects then became an attribute of the objects' own world rather than part of the space occupied by the viewer. The result was to bring sculpture closer to painting, which always creates its own space. Giacometti's sculpture after 1935 shows little formal variation. Most of the works are of thin figures, standing and full length; women always hold their arms close to their bodies and stand still, while men are sometimes modelled in open stride. There are portrait busts and occasionally detached limbs on their own—an arm, or a face with an extended nose—but the main variation is of arrangement and size, with standing figures varying from a few inches high to life height, and seen singly or in groups.

Giacometti was interested in the act of perception and how we see

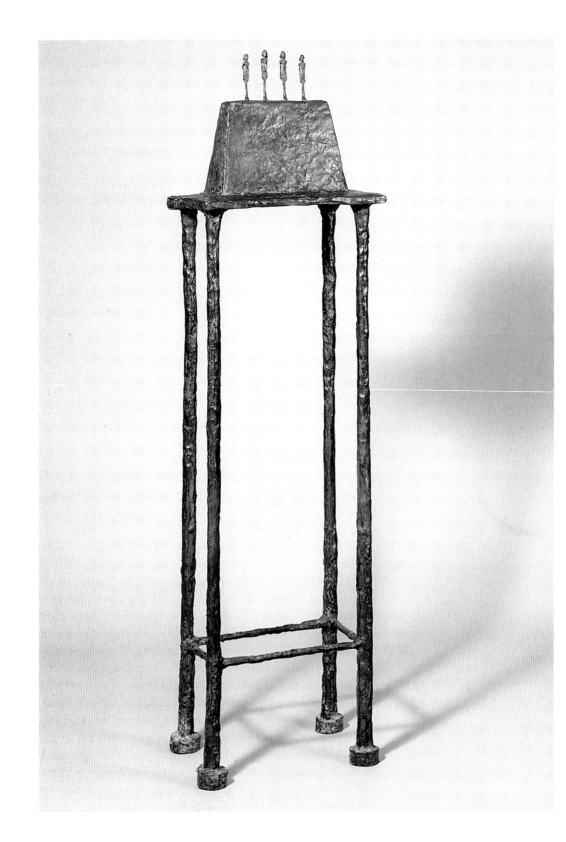

This is concerned with the perceptual problem of how large to make sculpted figures seen from a distance. The figurines were club performers seen across space that the artist described as 'unbridgeable'.

people across space. He was not concerned with close-ups which, he thought, could not represent people in their full reality because they were specific to one person's momentary and partial view. The reality worth recording might be a point in time, the sight of someone across the street, for example, but it was also a matter of space; the gulf between seer and seen represented by the width of the street must be retained. When a moment in time is translated into the permanence of sculpture, the space in which a person is seen must be expressed as well. The reality of a person was thus represented in the existentialist sense of the way that person existed for other people. Jean-Paul Sartre, one of Giacometti's strongest critical supporters, wrote:

Before him men thought they were sculpturing *being*, and this absolute dissolved into an infinite number of appearances. He chose to sculpture *situated* appearance and discovered that this was the path to the absolute. He exposes to us men and women *already seen* but not as already seen by himself alone. ... Each of them [the figures] reveals to us man as he is seen, as he is for other men, as he emerges into interhuman surroundings ... each of them offers proof that man *is* not at first in order to be *seen* afterwards but that he is the being whose essence is his existence for others.[11]

Though Giacometti's figures are tenuously thin, they have distinctive faces and eyes, which engage the viewer in the same way that Giacometti—as the sculptor's sitters have attested—demanded eye contact from them. While in one sense the thinness of the figures mirrors perceptual reality (keeping in mind that they were always figures seen at a distance), in another sense it is as if for Giacometti's penetrating gaze the eye was the gateway to the soul, making elaboration of the body unneccessary. Long after the artist had ceased to be directly influenced by primitive artefacts he gave as his reason for preferring masks from the New Hebrides to the work of the eighteenth-century French sculptor Jean-Antoine Houdon (1741–1828) that the force of the mask was concentrated in the eyes.[12]

Giacometti wanted to escape from the impression of a moment, in favour of an underlying realism. There may appear to be a contradiction when, for example, he points out that the models for the women in *Four Figurines on a Base* [10] were performers at a club whom he saw on stage across a floor that seemed to him unbridgeable. The stock-still figures mounted on a kind of tomb are infinitely remote from us. Their rigid bodies are reminiscent in style of ancient Etruscan figures, connecting them with a culture where sculpture had a strong memorializing function. Paradoxically, Giacometti's sculpture is grounded in the everyday but is also closely allied to tomb sculpture and images of death. The long-legged display stands and the boxes mounted on them create a sense of distance from the viewer—like one's distance from an archaeological object mounted for exhibition in a museum.

A walking man may seem to affirm naturalism and deny the rigidity and finality of death. Kahnweiler's comments on Picasso can elucidate Giacometti's meaning in this respect, in particular his warning against confusing sign with imitation. Kahnweiler was talking of Picasso's sculpture of a free-floating arm, which, he suggested, is not an arm, but represents 'armness'.[13] Giacometti's figures are not walking but demonstrate, as one might say of an early Greek *kouros*, the capacity of man to walk. Giacometti's sculpture transcended, in the words of Simone de Beauvoir, 'the errors both of subjective idealism and false objectivity'.[14] By the first she meant an ideal image built up from the artist's immediate experience; to avoid this hazard Giacometti rejected close-ups and insisted that his models keep a fixed distance from him.

The tension and urgency of Giacometti's figures, who live in the present and feel what it is like to be in the world, are different from the elegiac character of Moore's sculpture. He did not lean, like Moore, to the figure as archetype, nor did he look, like Marini, to the Antique for endorsement of certain subjects. Moore's figures are in their nature trans-historical: they live in the present, but carry their historic references with them to show continuity. Any references that exist in Giacometti's work to the art of the past are not there for this purpose. Giacometti was involved with the isolation of the individual in the crowd and, by contrast to Moore's, his work is urban. Giacometti was concerned with the feeling of being in the world. He was the father of the realism that sees man as the lonely inhabitant of a bleak and thankless world.

Post-war art had a particular attitude to the primitive and to history. The primitive no longer necessarily referred to artefacts from Africa or the South Seas, as it mainly had for the first Modernists, but included the art of children, the untrained, and the insane. It could mean primal, alluding to the beginning of history or the early section of a historical cycle. In his introduction to Giacometti's show at the Pierre Matisse Gallery in New York in 1948, Sartre used metaphors of the beginning and end of history. He was talking not about decline and renewal as embodied in the work of Moore, but discussing a more extreme concept, for an era that knew sudden and violent death on a huge scale. The War, the Holocaust, and the atomic age account for this return to origins, the pre-cultural and the pre-rational; but the concept meant different things in different countries. Britain, under siege but undefeated, produced in Moore a sculptor concerned with endurance and continuity, while France had had to come to terms with the results of life under a foreign conqueror, with the fact of collaboration and a divided society. In Moore's art survival may be threatened but is ultimately assured. In Giacometti's, survival is won against the odds.

Giacometti's pared-down, minimal volumes, apparently on the

verge of disintegration, may be thought to reflect the anxiety of the moment, but the torn bodies of his earlier Surrealist sculpture show that his had always been a bleak vision. Surrealism had already validated the irrational for him. For Giacometti the effect of the war years in France was to turn him in the opposite direction, to make flight from reality into inner worlds impossible—to say, in effect, that in such conditions only the human figure was worthy of art.

By contrast to the figures of Giacometti, who had spent the later war years in his native Switzerland, *Large Tragic Head* [**11**] by Jean Fautrier (1898–1964) was directly inspired by the cries of tortured Nazi victims which the artist had heard from a sanatorium outside Paris where he was living. His images are of singular violence, as when one

11 Jean Fautrier

Large Tragic Head, 1942
Fautrier confronted the atmosphere and actuality of violence in wartime Paris with astonishing directness, making a series of heavily disfigured heads in 1942–4. These led on from 1944 to the formless plaster reliefs known as *Hostages*, which seem to speak of the impossibility at that moment of sculpting an integral or undamaged figure.

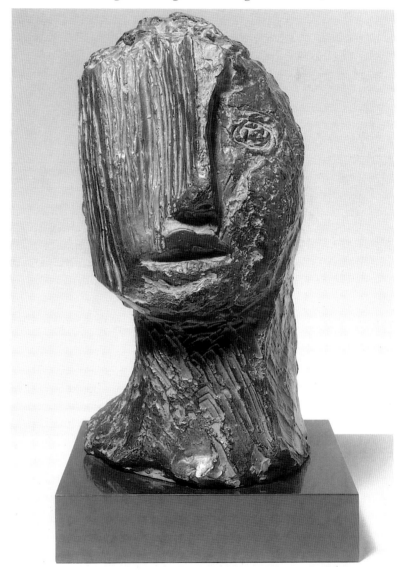

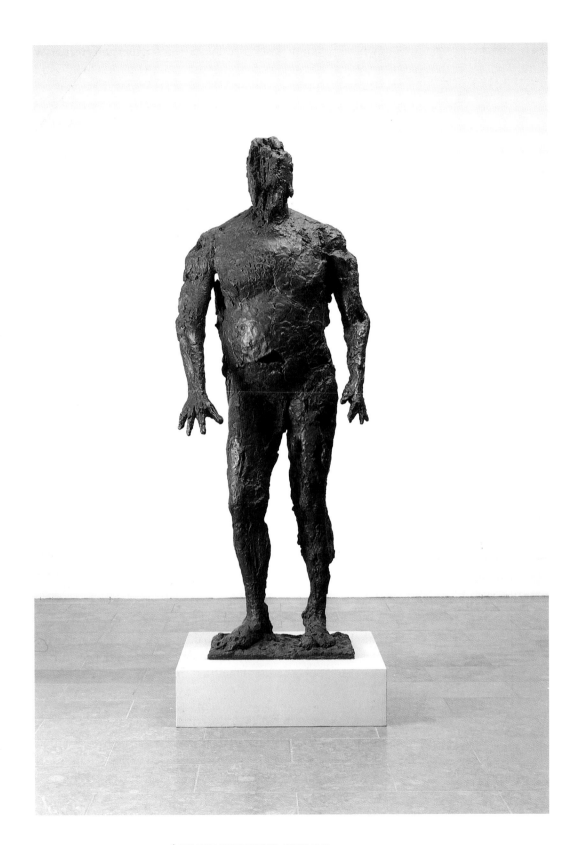

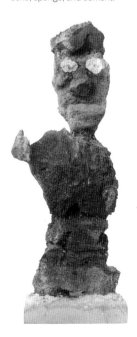

side of a head has been desecrated by vertical scarification created by the artist pulling his fingers down through the wet plaster to leave no facial features, just damaged flesh. The ultimate image of Fautrier is a head in which no recognizable feature remains, only a disturbed surface which can be read—in the knowledge of sculptures that preceded it—as a flayed head. Flaying is a supreme act of violence against a person. In the sense that it removes the outward face it obliterates all masks, it is primal and is a confrontation with a core reality.

The incessant manipulation of material found in both Giacometti and Fautrier occurs differently in the work of Germaine Richier (1904–59). A student of Bourdelle, Richier came from the tradition of figure and portrait sculptors, and the model she used for *Storm Man* [**12**] had sat as a youth for the original, nude version of Rodin's *Balzac* (1897). In Richier's early sculptures there was, as with Marini, a commitment to classicism which had seemed sufficient before 1939 but in response to present conditions now needed to be destabilized. *Storm Man* is a force of nature, a blinded giant who has to feel his way with his outstretched fingers, over-lifesize like Picasso's *Man with a Sheep* but without the latter's firm-footedness.

From 1945 Richier included in her sculpture elements direct from nature—a tree branch, or leaves, for example—and created figures that were partly human, partly tree spirit; with more radical alteration, she shows man, the rational being, allowing himself to be suborned by animal energies and metamorphosing into lower forms of life, insect or bat. Richier, as much as Giacometti, was an influence on younger sculptors in France and the English artists whom in 1952 Herbert Read grouped within the category 'geometry of fear'. Richier's introduction of found material into her sculpture resumes the interest of Surrealism in the found object, the incorporation into art (or as art) of the pre-existent. In contemporary French sculpture the inclusion of bits and pieces from everyday life was part of a wider challenge to 'high' art and contributed to what Dubuffet in 1945 called *Art Brut* and Dubuffet's friend the critic Michel Tapié defined in 1952 as *Un Art autre*. Jean Dubuffet (1901–85) [**13**] was only marginally a sculptor, yet the figures and heads he made from sponge, coal, and cork, sometimes with bits of vegetable matter added, help to define one extreme of three-dimensional art in this period. Dubuffet's friend the Hungarian-born Zoltan Kemény (1907–65) was another artist whose use of unexpected materials was a way of staying outside the boundaries of conventional sculpture. In *Les Bourgeois de toutes les villes* [**14**] Kemény appears to adapt Rodin's title, *Les Bourgeois de Calais*, for a quite different group of disoriented non-heroic figures, formed from iron with scraps of cloth wound round, who stumble about on a bed of earth spread out on a wooden base.

The School of Paris is sometimes thought of as having died with the

14 Zoltan Kemény

Les Bourgeois de toutes les villes, 1950

Kemény had been interested in popular and peasant art in his native Hungary. In the late 1940s in Paris he explored, in parallel with his friend Dubuffet, unusual and lowly materials—such as the iron and old rags, together with the base of raw earth and a piece of old wood, used here.

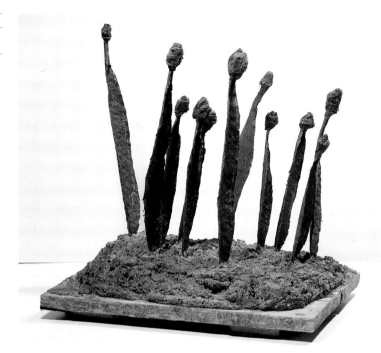

Nazi Occupation and the flight of artists to America at the start of the War. But the transfer of authority to the New World took place more slowly than that, America's confidence was not won quickly or easily, and though there were correspondences between American and European art—both painting and sculpture—in the post-war period, actual contact was modest. The War and its consequences acted as a stimulus to Paris, if an awkward one, and it was only after the mid-1950s, and at first in painting, that American art took hold in Europe and began to make much of what was happening there seem *passé*.

The non-figurative tradition

There was little overlap after 1945 between the advanced figure sculpture of Moore, Marini, and Giacometti and the non-figurative sculpture descended from the post-1918 experiments and utopias. When Russian Constructivism, the De Stijl movement, and the Bauhaus had come under political pressure from changes in Germany and Russia they were given new life in the 1930s in Paris through such groups as *Art Concret* and *Abstraction Création. Art Non-Figuratif*. Sculptor members of these groups were still active in 1945: the Russian-born Naum Gabo (1890–1977) and his brother Antoine Pevsner (1886–1962); László Moholy-Nagy (1895–1946), of Hungarian origin, who had been brought in by the Bauhaus director Walter Gropius in 1922 to re-establish the Foundation Course on modern, industrial lines; the Belgian member of De Stijl Georges Vantongerloo (1886–1965); and the slightly younger Swiss former Bauhaus student Max Bill (1908–94).

Hans Arp, ex-Dadaist and Surrealist, had been a member of *Abstraction Création* and was associated with the pure abstract artists when they re-formed themselves as an exhibiting group, the *Salon des Réalités Nouvelles*, in Paris in 1945. Arp's sculpture, with its bud-like forms, nevertheless had organic references that the work of the others did not. The American Alexander Calder (1898–1976), who divided his time between Paris and the USA, was on the edge of the group, and through his popularization of mobile sculpture was a link with the younger generation of kinetic artists.

The purist movements of the 1920s had been international in influence, strong in Eastern Europe, especially Poland, in the 1930s, and after 1945 the initiative spread to the Madi group in Argentina and thence to other Latin American countries. An international language of art was an exciting prospect, but visual likeness between works of art made at different times does not necessarily imply similar intention or meaning. The use of the word Constructivism has been a particular problem: continuity with Russian art of the early Soviet period has been implied for art that arose from different conditions.

Moholy-Nagy, though he died in 1946, remained influential especially through his writings, and through his rationalism and belief in progress under the banner of science. Moholy-Nagy felt that volume and mass were no longer appropriate to sculpture in an age when energy represented reality better than solid form, and that light and movement were closer to the heart of the modern than the static object. In *The New Vision*, an influential Bauhaus book produced in a revised American edition in 1946, Moholy-Nagy stressed progress, described a sculptural evolution which started with the block and a tactile mode of experience, progressing to the modelled or hollowed-out block, then the perforated block which is bored through, followed by what he called sculpture in equipoise, and finally kinetic sculpture.

The block experienced through touch could be related to Moore, while perforated sculpture related to work like Gabo's that was constructed around space. 'Equipoised' sculpture, Moholy-Nagy thought, had scarcely been explored. It involved reduced contact with the ground, since sculpture with elements held in balance would be compromised if too obviously dominated by gravity in the manner of the traditional monolith. As soon as sculpture is detached from the ground by the narrowing of the base, it no longer faces outwards to the world. It was, therefore, no longer significant *where* a sculpture was in terms of place, but rather *what* it was in itself, and how it worked in terms of its own structure. This theory of 'placelessness' became an important constituent of Modernism. Moholy-Nagy's final stage, the kinetic, was in its infancy, though both he and Gabo had already introduced electricity to sculpture to create movement. As well as actual movement, kinetics could mean virtual movement in the sense of light

15 László Moholy-Nagy

Double Loop, 1946

The Hungarian-born Moholy-Nagy, who died in 1946, left a legacy as artist, teacher, and writer which was to be pivotal among non-figurative, kinetic, and light artists who valued technology and modern materials above personal style.

beams, and Moholy-Nagy prefigures here [**15**] preoccupations with sound and light in sculpture in the 1960s.

Writers on non-figurative sculpture, and sculptors themselves, relied on scientific analogies, drawing on both physics and biology. Herbert Read carried evolutionary theory over from science to art, using, with reference to Gabo, a parallel with nature from the biologist Lancelot Law Whyte's *Aspects of Form*. For Whyte, growth in nature was always seeking more economical forms. In parallel with nature, Read said, the artist finds more and more economical ways of expressing the sense of energy underlying organic forms. Neither Read nor Gabo claimed the precise equivalence of art and science or mathematics; both recognized the intuitive origin of art and its poetic forms, but they did insist on a basic congruence founded on the economical expression of energy.

Carola Giedion-Welcker used the analogy with physics to reject sculpture as mass, arguing that twentieth-century science thought in terms of reality not as mass but as space, time, and motion. Although her book is a balanced account of twentieth-century avant-garde sculpture as it was then understood, her real loyalty is to a core development of modern sculpture from Cubism to non-figuration, and she puts relatively low value on movements like Dada and Surrealism which lacked standardization and objectivity. Giedion-Welcker believed in the driving force of the *Zeitgeist*, which she saw in standardization, industrial materials, and an objective social outlook, replacing what she described as the sensual and sentimental individualism of the nineteenth century. Modern science, industrial techniques, social improvement, these were the things that the earliest artists and theorists of non-figuration after 1918 had wanted to bring together, and Giedion-Welcker's writing is a key link between the 1920s and revived non-figurative sculpture in the 1940s and 1950s. Her stress on the Modernist core descended from Cubism is paralleled in Greenberg's Modernism, but his theory did not share the earlier social idealism.

The social benefits of the new art were no longer an issue as sculpture, in the words of Moholy-Nagy, began to face inwards.

Gabo and Antoine Pevsner had published in Moscow in 1920 the Realistic Manifesto, a key document in the history of three-dimensional art in which they argued that in the modern world sculptural energy was expressed not by mass or closed shapes but by line passing through space. Moore, a friend of Gabo when he lived in England between 1936 and 1946, quoted the older-generation sculptor Henri Gaudier-Brzeska (1891–1915) as saying that 'sculptural energy is the mountain'.[15] Gabo, with an engineering training and a knowledge of modern physics, was saying, on the contrary, that energy and vitality are the product not of mass, for which the mountain might be the acceptable metaphor, but of invisible energy particles passing through space, for which line is the visual analogue. Like Moholy-Nagy and others who used scientific analogies, Gabo saw art, like science, as detached from life because it was governed by its own rules. Unlike the figure sculptors, therefore, they did not see their work as subject to the particular conditions in which they lived. Gabo admitted to Read in the middle of the War that people might find his work irrelevant in the circumstances, but pleaded that it was not lack of concern. 'What can *I* tell *them* about pain and horror that they do not know?'[16] Gabo argued that his art was relevant as an expression of good against evil because in its continuity with the past it reminded people of a world that was different.

Gabo and Constructivism

Gabo's refusal to anchor his art in events of the moment suggests that Constructivism meant for him what he and Pevsner had in 1920 called Realism, which concerned the nature of sculpture itself and not its relation to politics and society. Hard-and-fast distinctions are not possible in relation to Gabo. He produced a complex body of work which, both before and shortly after he left Russia, included designs for such things as a radio station and an airport. These point to the link between sculpture and architecture and the search for models on which to rebuild the relationship of architecture to society that was a feature of early Russian Constructivism. But such interests were not part of Gabo's subsequent thought or work, which is therefore best considered a continuation of his 1920 concept 'Realism'. It was, indeed, the purist character of Realism against the more complex relationship between art and society in Constructivism that had been a cause of Gabo and Pevsner leaving Russia. Read, who wrote the catalogue introduction for Gabo's and Pevsner's joint exhibition at the Museum of Modern Art in 1948, was an early victim of Cold War politics when he said that it was the Russian leadership which had made the brothers' remaining in Moscow impossible; it was rather their fellow artists, the true

Constructivists, with their suspicion of art for art's sake. Gabo used the 1937 publication *Circle* to identify his art with Constructivism, and although earlier authors like Alfred Barr and Giedion-Welcker in 1937, as well as later historians, have recognized that Gabo is not a Constructivist in the same sense as Vladimir Tatlin (1885–1953) or Alexander Rodchenko (1891–1956), for example, only recently has it begun to be recognized how much Gabo's appropriation of the title has distorted the history of Russian art, or how much the shift of meaning relates to wartime and post-war politics.[17]

Gabo's works after he left Russia are not experiments or workshop models in the original meaning of Constructivism, but complete objects. Read was wrong to say that the implications of Gabo's work were the restoration of that lost unity between art and architecture— which was a part of Read's Ruskinian dream for a unity unknown since the Middle Ages.[18] Gabo felt neglected after the War: he felt, in 1953, that he should have won the Unknown Political Prisoner competition, and he wanted to establish his kind of Constructivism as the idiom for post-war public art. But the commissions he successfully gained, from the foyer sculpture for the Esso Building in New York (1949) to the De Bijenkorf project in Rotterdam (1957), are not among his most successful works. Gabo's works were essentially small-scale and hand-made, and it is no surprise that much of his best sculpture was made in England, home of the Arts and Crafts movement, and in the circle of Moore and Hepworth with their stress on truth to materials. The differences between these three sculptors relate not to the value set on craftsmanship but to the fact that Gabo used more modern materials.

Greenberg, in a review of the 1948 exhibition, referred to 'Gabo's objects, small in format and excessively limited by the notion of neatness'.[19] His judgement here is affected by his high valuation of the

16 Naum Gabo
Linear Construction in Space, No. 1, 1942–3
Gabo, who left Britain for America in 1946, was ambitious in the 1950s to project his Constructivist principles in large-scale public art.

more muscular David Smith (1906–65), but he is right that Gabo worked best on a modest scale [**16**], and his sculpture is beautiful in the sense that Burke in the eighteenth century defined beauty, in opposition to the sublime, in terms of smallness, delicacy, and smoothness. Asked by Read in 1944 how he arrived at his forms, Gabo referred to the external world, chiefly landscape ('in the naked stones on hills and roads ... [and] in the bends of waves on the sea'[20]), and it is indeed possible to imagine the Cornish coast around St Ives, where he lived, reflected in his work. It helps, also, despite the different materials they worked with, to explain Gabo's closeness to Hepworth in the 1940s.

Gabo's works, like those of many post-war non-figurative sculptors, have been described as 'constructions', which does justice to his technique, but is not a substitute for the word sculpture. If sculpture is used in the Modernist sense to define a category of object different from any other kind of object and belonging only to art, then sculpture is what Gabo's work is—indeed it is one of the most sensuous and affecting bodies of sculpture this century. David Thompson, reviewing the 1966 exhibition at the Tate Gallery, noted in Gabo's work the 'yielding delicacy, fragility and gracefulness of what Constructivism was supposed not to be about—objets d'art for the connoisseur'.[21]

Although born in 1903 and thirteen years younger than Gabo, Barbara Hepworth was close to him when both were living in

Cornwall during the war. Gabo was concerned with transparency, while Hepworth's sculpture is solid and hard, made of wood and stone. Hepworth was inspired by the Cornish coast and the bright clear light which enters sculptures like *Pelagos* [**17**] as applied paint, in contrast to the hard shiny wood. There is a common ethos to the work of Gabo, Hepworth, and also Calder [**18**], whose sculpture is non-figurative, but lyrical and responsive to sense impressions. Hepworth described in 1952 looking out to sea from her studio window in St Ives with the coast as a pair of arms encircling the bay at the peripheries of her vision, and pointed to the way this idea of enfolding influenced the shape of *Pelagos*.[22] Hepworth wrote and talked about landscape, but she was not a part of the English topographical landscape tradition. She absorbed characteristic landscape properties—shapes that were open, enclosed, round, enfolded—or was guided by a line or contour in nature. Hepworth had been a member of *Abstraction Création* but never fitted closely into the group of artists of similar age, like Max Bill, whose work was more austere and closer to mathematics.

Calder divided his time, from 1927, betwen America and Paris, where he was friendly with many leading artists, such as Léger,

Mondrian, and Miró, and joined *Abstraction Création* in 1932. Calder started making moving sculptures in 1931 by suspending connected rods from a pivot, often giving the effect of the trunk and branches of a tree, with the coloured cut-metal plates at the tips as foliage. Calder's first retrospective at the Museum of Modern Art in 1943 (his second, following quickly in 1951, showed how important for New York Calder's prestige in Europe was) was subtitled 'Sculpture, Constructions, Jewelry, Toys and Drawings'. Calder's early work, with animals, circus performers, and models made from twisted wire, became after 1945 less talked about than work that was more clearly sculpture and confined within the category 'art'. A body of work that had started with experiment and variety gradually narrowed as demand for Calder's work increased, and delicate and elegant creations led on to coarser ones through enlargement to accommodate these essentially modestly scaled works to public, urban locations.

Sculpture, architecture and the monument
Gabo's elder brother and co-author of the *Realistic Manifesto*, Antoine Pevsner, helped to found the *Salon des Réalités Nouvelles* in Paris in 1945. Pevsner had his first one-man exhibition at the age of sixty at the Galerie Drouin, and, allied with the influential writer on abstract art, Michel Seuphor, attempted to rebuild the prestige Paris had had in the early 1930s as a centre for non-figuration. Pevsner welded bronze wires to form planes or surfaces which curved, folded, and reversed on themselves to form abstract constructions with effects of opening and

closing, twisting and crossing, sometimes suggesting plant or bird forms but always leaving a non-figurative reading uppermost. The reflecting ribbed surfaces catch light in different ways, adding to a baroque complexity. Pevsner still talked of 'a synthesis of the plastic arts: painting, sculpture and architecture', and believed that the world was at the beginning of a new era of collective art which would lead to huge monuments in vast open spaces. He retained something of earlier idealism in relation to the role of sculpture and a belief that his own works were models for possible enlargement. Pevsner, as his *Developable Column for Victory* (1946) and his *Peace Column* [19] show, aspired to monumental work.

Unity of the arts occupied the minds of those grounded in the idealist Modernism of the 1920s. Max Bill had entered the Bauhaus as a student in 1927 as one of the first to work and live in the historic Modernist buildings Gropius designed at Dessau. Bill looked to the Bauhaus and to Theo van Doesburg, the former De Stijl leader and a founder member of *Abstraction Création*, for the ideal of an art founded on the denial of nature and reliance on the intuitive creativity of the mind. Bill followed van Doesburg in calling his art 'concrete', because he felt that 'abstract' implied 'abstracted from' and permitted the introduction of nature by another route, while concrete meant generated in the mind.

Bill's contribution to the Unknown Political Prisoner competition of 1952–3 was unlike the others, as the montage shows [20], in being presented as architecture. A structure of three stepped hollow cubes backing onto one another, Bill's design had to be entered, while most of the others were objects to be looked at. Bill planned a monument not to imprisonment but to freedom and personal choice: hence the different entrances to be chosen from, and at the centre the columnar symbol of the free man facing each direction, whom the visitor entering the edifice could identify with. Bill's structure, which he saw as merging architecture, sculpture, and (on account of the use of colour— dark granite on the outside and white marble inside) painting, would have had the character of a shrine.

Bill questioned whether, at a time when sculpture had become closely identified with the object, with something seen rather than experienced as a presence, a sculpture could still constitute a monument. Architecture, because of its relation to the body, as something entered and encompassing, might, he felt, be the best form of monument. Bill specified the inner openings in the cubes as 189 cm, a little more than the height of a tall man. Monumentality in modern times, he thought, had been wrongly identified with gigantism, and his contribution here, perhaps influenced by his admiration for Le Corbusier's studies of human proportion in architecture, was to identify the monumental with human dimensions. Bill's work has a dry and austere character

20 Max Bill

Monument to the Unknown Political Prisoner, 1952–3

The Bauhaus-trained Max Bill was an architect as well as a sculptor, and conceived his contribution to the competition, unlike most other participants, as a place to be entered rather than something to be looked at.

which, by contrast with the more sensuous art of non-figurative sculptors like Calder or Gabo, has contributed to his comparative neglect. Bill was not impressed by the elegance, refinement, and often smallness of scale of much fifties abstract sculpture. In this way he stood clear of Modernist sculpture's commodification, of sculptors' unconscious tendency to make objects the size and character sought by the market.

Paradoxically, perhaps, Bill was a keen collector, and though his art can appear narrow, his intellectual cast was wide. He collected objects from other cultures and continents (Egypt, Mexico, early Greece, and Africa) which he described as 'objects and idols from the origins of culture, from the time when the meaning of an object was not obscured by questionable consumer products, when use and symbol were still closely associated'.[23] Bill saw that the entrenchment of sculpture as a separate category of objects, detached from spritual or social function, exposed it to the risk of becoming a commodity whose *raison d'être* was to be bought and sold. Bill had a clearer insight than his contemporaries into a central problem of Modernist sculpture after 1945, the tendency to adjust to commerce and the market, and he devised strategies for ambushing it.

Bill wanted to recapture forms that evolved before sculpture was debased by possession. He practised as an architect and resisted, as a sculptor-architect might, the isolation of sculpture from human activity and presence. Recognizing the border between the arts as flexible,

Bill was closer than Gabo or Pevsner to true Constructivism and to those sculptor-architects of early Soviet Russia who had kept sculpture in the public domain by designing street kiosks and speaking platforms. Bill also looks forward to the Minimalists of the sixties who rejected what they thought of as Modernism's artful compositions.

Concern like Bill's for the unity of the arts under the umbrella of architecture had been central in the 1920s, but the optimism of that decade no longer existed and the possibility of reconnection was now seen as remote. In *The Art of Sculpture* Herbert Read put forward the idea that sculpture comes into being as a separate mode of expression only when the monument is in decline, because the monument is the typical expression of the indivisibility, now lost, of architecture and sculpture. Read sees Modernism (which in relation to this argument about sculpture and architecture can be taken to mean everything since the Renaissance) as fragmenting in influence, and the unity evidenced by medieval art as irrecoverable. So long as that unity does not exist, he implies, monuments cannot be made. The failure of the Unknown Political Prisoner project—in the sense that no monument was built—may have fed into this aspect of Read's argument.

The architect's invitation to the sculptor to take on the apparently complementary, but in fact subservient, role of making sculptures to adorn buildings was to lead to the debasement of sculpture. The commissions from Jacques Lipchitz (1891–1973) for the Ministry of Education building in Rio de Janeiro (1944), and from Arp, Henri Laurens (1885–1954) and Pevsner for the University of Caracas (1954) were followed by Gabo's De Bijenkorf sculpture in Rotterdam (1957); whether attached to a building, or standing in front of it, these were decorative embellishments, justified by supporters like Giedion-Welcker for the way they would 'give life to' buildings and spaces and forward the interests of sculpture.[24] Moore had experienced the 'complementary' role in his work for the London Passenger Transport Board headquarters as early as 1928, which led him to decline the invitation, in 1938, to design wall sculptures for a similar building, the Senate House of London University. Moore's experience and his sense that sculpture drew from, and contributed to, its physical ambience made him unusually aware of this problem. He too, however, responded to developers' invitations, at the Time-Life building in London (1952–3) and at the Bouwcentrum in Rotterdam (1955), stepping round the problem of the sculptor becoming an adjunct decorator by integrating his sculpture into the form of the architecture. Even so, these are not among Moore's most successful works. If 'Modernism' applied to post-war sculpture means attention to sculptural problems to the exclusion of all others, then 'Functionalism' as applied to post-war architecture has a related meaning. Functionalism refers to architecture's serving as well as possible a narrow definition of human needs,

a definition that left it unable to share territory with sculpture.

This is not to say that the lack of dialogue was the fault only of architects. It was the result of two disciplines enclosing themselves in separate and bounded categories that made dialogue impossible. In the 1960s, from Minimalism onwards, sculpture started to make demands on the viewer by implying that, instead of sculpture existing in no particular spatial relationship to the viewer, it included the viewer in its own ambience, its own physical area of influence. This, more than anything else, was what broke the rigid boundaries between the disciplines, causing sculpture to act in the way that architecture always had, by claiming that sculpture's space and personal space were really one. The detachment of art from life was challenged and, in the longer term, sculpture was able to reflect on, and take up critical positions towards social space.

Herbert Read perhaps had the clearest perception of the problem of the separation of sculpture and architecture, because he was interested in the idea of the monument, and recognized that since the Middle Ages the cultural unity that made it possible had disappeared. But Read was not alone, and attempts to summarize the progress of post-war sculpture—by Giedion-Welcker, Trier, Seuphor—touched on this but shied away. Giedion-Welcker saw the least problem. For her as well as others the opportunities for sculptors to work with architectural commissions in Caracas and Rio de Janeiro were significant because they were seen as forward-looking, rapidly expanding countries, and rather as kinetic art drew some of its sense of modernity from association with countries that were undergoing rapid economic expansion, so there seemed to be a virtue in commissions in Caracas and Rio de Janeiro that were in fact early examples of plaza art—the developer's cultural add-on to functionalist architecture.

Trier's section 'The Problem of Purpose' admitted the separation of architecture and sculpture, and noted that 'the call for synthesis of the two arts has been voiced with growing vigour over the years but, in fact, little progress has been made beyond the stage of makeshift solutions and mutual misunderstandings'.[25] Seuphor's analysis, in his section 'Architecture and Sculpture', went deeper:

The works of art that we admire, for which we sometimes pay very high prices and which we treasure all the more because of this, almost always have an intimate character. They are apartment objects, household goods. We pass before them, we go round them, they do not envelop us. In their attempts at collaboration with architecture, the sculpture and painting of today maintain this strongly autonomous character. There is no joining.[26]

Both Trier and Seuphor reproduced examples of what might be called environmental sculpture. Both illustrated *The Square of the Five Towers* (1957) by the German-born Mathias Goeritz (b.1915) constructed at the

entrance to an overspill town outside Mexico City. It consisted of five solid concrete 'skyscrapers', two of them brightly painted in red and yellow and rising as high as fifty-eight metres. This ambitious scheme, which was, in effect, non-functional architecture presented as sculpture, had parallels with East European sculptural gigantism in which the heroics have been transferred from the human figure to quasi-architecture, used here, as with some kinetic art, as a symbol of the new. Though the public circulates between Goeritz's towers, they express the limitation identified by Seuphor when he said in another context: 'we pass before them, we go round them, they do not envelop us'.[27] Later sculpture, in particular certain examples of American Earth Art, was sometimes monumental in size, but could at the same time be human in scale, in the sense that size still had meaning in relation to the human body. Goeritz's towers do not.

A different aspect of the sculpture–architecture problem, referred to by Trier, was the case of the *Monument for Amsterdam* (1955) by the Dutch artist Constant (b. 1920). Constant had been an original member of the international Cobra group established in Paris in 1948 and concerned, like Dubuffet and *Art Brut*, with popular imagery taken from the colourful life of the street. With post-war reconstruction going on around him, Constant sensed that the artist was being left out of the process because, with the separation of the arts, the artist's task was being interpreted too narrowly. Constant's *Monument for Amsterdam*, which never got beyond the drawing stage, resembled a huge Ferris wheel. In comparison with the rival city of Rotterdam's monuments, this was closer to the technologically based appearance of Gabo's De Bijenkorf project than to Zadkine's *Destroyed City*.

In 1958 Constant joined the Situationist movement founded by Guy Debord in 1957. Debord believed that late capitalism's fear of innovation caused it to force everything into compartments and thus neutralize any overall social critique. The perception that this resulted in passive citizens boxed into their own individual lives and dependent on entertainment was to lead Debord later to write *Society of the Spectacle*. Constant was not political like Debord. His observation of the marginal position of the artist excluded from the process of social and architectural reconstruction, and invited only to decorate the results, was a statement of the ineffectiveness that he felt stemmed from confinement to one kind of workplace, such as a studio. In 1958 Constant evolved his futuristic and anti-naturalist vision, *Urbanisme Unitaire*. He believed that 'integral art', as Debord called it, could only be realized at the level of urbanism. But it could no longer correspond to any of the traditional aesthetic categories. Constant was interested in buzzing city environments, fairgrounds and places which released inhibitions, ideas related to the Situationist concept of psychogeography. Constant's new urbanism turned into a project called New

Babylon, the first drawings for which were exhibited at the Stedelijk Museum, Amsterdam, in 1959. Constant's *New Babylonian Construction* [**21**] bridges sculpture and architecture: on the one hand it continues the tradition of three-dimensional constructivist art, with its use of plastics and modern forms and materials; in this respect Constant's work is, in appearance, quite traditional for its date. On the other hand *New Babylonian Construction*, while it is not the equivalent of any particular architectural space, can be read as a model of the Situationist idea of the *dérive*, the creation of colourful and unfamiliar city spaces which offer free play to sensation and act as stimuli for imaginative release.

Constant is an example of a post-war artist moving from the popular, colourful, primitive world of Cobra to austere forms of model-making in an attempt, against the grain of the 1950s, to establish the visual artist's contribution to the defeat of Modernism's urge to compartmentalize. As a parallel example of the post-war artist reaching out for a role in society beyond the confines of their own practice, the collaboration of the architect Luciano Baldessari (1896–1982) and the painter-sculptor Lucio Fontana (1899–1968) was particularly interesting. Theirs was a well-established alliance dating back to common membership of the austerely non-figurative *Abstraction Création*—which seems anomalous in itself since both also had strong leanings towards Futurism. Giedion-Welcker illustrated in the 1956 edition of her *Contemporary Sculpture* Luciano Baldessari's sculpturesque ribbon of concrete, part of the Breda engineering works section of the Milan Industrial Fair of 1952 [**22**], an example of an architect taking advantage of the temporariness of a structure to give free rein to fantasy. Trade fairs were important in post-war European reconstruction, and the need for the designers of their temporary structures to create

21 Constant
New Babylonian Construction,
1959
This is a sculpture but also reflects Constant's vision of a futuristic and flexible city-centre plan conceived in terms of leisure and spectacle.

immediately engaging effects opened up possible areas of collaboration between architects and artists. The English sculptors Lynn Chadwick and Reg Butler (1913–81), who both had multi-disciplinary experience, worked on trade stands in the forties, and the need felt strongly in England in the years following to identify with a single practice—in their cases sculpture—proved inhibiting.

Fontana saw himself as an explorer of ideas to do with light and space rather than an artist dedicated to a particular medium. Working both figuratively and abstractly in the thirties, he was represented in the 1937 edition of Gieldion-Welcker's book, but was one of the small number of artists dropped from the post-war edition, presumably because in her view he no longer counted as a sculptor. In the 1940s Fontana made small figurative rococo-style ceramics, emphasizing surface movement. He is best known for his slashed canvases of the 1950s opening to a black void behind, and his nature sculptures like huge splitting pods from around 1960.

Fontana's art cannot be pigeonholed, because it is the character of his work that it is not simply painting, sculpture, or design, and his sculpture is not confined to a single material. Italian sculptors since Umberto Boccioni (1882–1916) have been conscious of their country's artistic past as both an honour and a burden, and of Italy playing second fiddle in the twentieth century first to Paris and then New York. Boccioni, whose sculpted figures of his mother incorporated bits of the actual window-frames behind her as she sat for him, initiated in Italian

sculpture the transgressiveness against the past and past convention that is alive in Fontana's refusal to keep separate the realms of high art and everyday life. However much he wanted to revise sculpture's relation to his country's past, Marini represented the trend in post-war Italy that acknowledged that it was a distinction to be Italian. Fausto Melotti (1901–86) [23], on the other hand (another former member of *Abstraction Création*), was like Fontana in crossing boundaries from one form of sculptural material or activity to another, working with astonishing invention and, again like Fontana, undervalued in conventional histories because a consistent *œuvre* does not seem to emerge at the end.

Italian artists like Fontana and Melotti were peripheral to the main focus of post-war Modernism because they would not be restricted by its orthodoxies, in respect of the rigid separation of the arts and of what constituted sculptural materials. Fontana, especially, became something of a cult figure in the 1960s, first with the Zero Group's interest in light as a sculptural medium, and later, at the end of the decade, with the claims of *Arte Povera* to major status outside what was then the mainstream. To be unorthodox required more courage of a sculptor before 1960 than after, and it was often older artists with established reputations, whose experience stretched back to Surrealism and pre-

23 Fausto Melotti

Tightrope Walkers, 1968

Melotti's delicate constructions have a poise and humour, and an empirical approach to materials and construction, which isolates his work from the main trends of post-war sculpture.

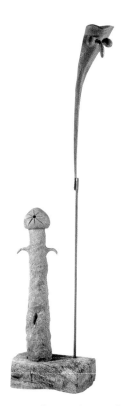

24 Joan Miró
Man and Woman, 1962
Miró's interest in nature and metamorphosis developed out of his pre-war Surrealism, and his free-floating imagination and ambiguous imagery lacked the studied and rather self-conscious seriousness of both abstract and figurative sculpture in the 1950s. Miró, like Picasso, had to wait till the opening up of sculpture in the late 1960s for the quality of his three-dimensional work to be fully appreciated.

war abstraction, who achieved most in this restricted atmosphere. Picasso and Miró [**24**] produced colourful, ad hoc sculpture, loosely related to the human figure and allied to each artist's painting. Their work was quirkily humorous and eccentric by Modernist standards, and made little attempt to put forward a 'public' face. It has been fully accepted only by a later taste that has been less anxious than contemporaries were about what precisely constituted sculpture.

Fontana's *Ceramica Spaziale* [**25**] fits into no sculptural niche or category. Its shiny black, but uneven, light-reflective surface makes the shape of the object hard to pin down. It approximates to the ideal form of a cube, but falls short. Black ceramic is a challenge in terms of sculptural material, and black—by contrast to the light of Fontana's neon artworks [**26**]—is part of his dialectic that needs to pose baseness and indeterminacy of form against the traditional 'high' values of Italian art. If the traditional image of Italian sculpture is that it relates to the human figure, or, like Marini's *Horse and Rider*, is a subject sanctioned by the classical tradition, *Ceramica Spaziale* is a still life and lacks this sanction. At the extreme, it has been compared to a turd.[28]

Three years later Fontana, working alongside Baldessari, designed lighting for the Milan Triennale of 1951. Here again, Fontana was rejecting as old-fashioned any firm distinction between the disciplines—in this case between art and design—in considering neon as a sculptural medium. Light denied mass and was shifting and intangible. Apart

from pendent neon lighting systems and ground-based neon works, Fontana liked to shine light through perforated ceilings to give the effect in a darkened room of the night sky. Fontana admired theatrical lighting effects, and shifting malleable forms of the baroque. The character of post-war sculpture was to identify with the early phases of artistic cycles, primitivizing in order to achieve new beginnings. Fontana's sculptural baroque was opposed to this: it crosses boundaries, abuses rules, and scorns rationalism. Formally his work fits no pattern of development. The twisted neon lighting [**26**], which adapts for tubular glass a form that would be natural in a soft, malleable metal, resists ideas of truth to material. Fontana's excesses run counter to the puritan aesthetic and Anglo-Saxon focus of Modernism, and open up a counter-aesthetic which is theatrical and unruly in its rejection of categories.

Dematerialization

Fontana's conscious unorthodoxy, his refusal to be tied to a single medium or way forward, and his repeated emphasis on art as space (*Concetto Spaziale* is a title that covers several different types of work) represented a desire for change and escape from the limitations of sculptural form as it was then understood. There was a widespread feeling in the late 1950s that art, but sculpture particularly, needed to find new directions, and Fontana was an artist who seemed to point a way forward. As it turned out it was in America, especially, and also England, that the most radical ideas were soon to originate; and they were connected with the object and the relationship of sculptural objects to other types of object in the world. But it was by no means obvious in the late 1950s that this would happen, and sculpture in both

25 Lucio Fontana

Ceramica Spaziale, 1949
Fontana deliberately avoided consistency of materials or approach in his art, which he saw as more to do with representation and evocation of space than as attached to any single medium, whether sculpture, painting, or product design.

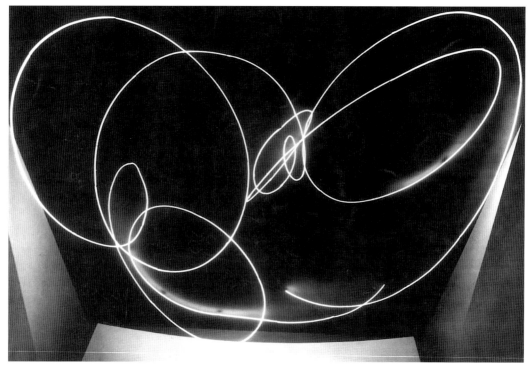

26 Lucio Fontana

Neon structure to hang above the main staircase of the IX Milan Triennale, 1951 (architects: Luciano Baldessari and Marcello Grisotti)

Fontana first exhibited curling neon-light fittings at the Galleria del Naviglio, Milan, in 1949, and refused to distinguish sculpture in this context from design or manufacture.

countries seemed to have reached an impasse.

Stirrings of change in the late 1950s, already hinted at in the work of Fontana, showed themselves through kinetic [**27**] and light sculpture. Motorized moving sculpture, and sculpture that created an environmental effect by the casting of light beams, introduced an element of spectacle or theatre into sculpture. Theatre is a spectator art in a different way from sculpture—as it was understood in the fifties, at least. Kinetic and Light Art take place in time, a process or course of action is experienced, and like theatre it ends and restarts. There is an element not of participation in the sense that the viewer is actively taking part, let alone controlling the process, but of observing a process that seems close to us because it occurs in our time and uses materials that are familiar from everyday life. David Medalla's *Cloud Canyon No. 2* [**28**], for example, pushes a familiar, everyday substance out into our space and gives an aura of mystery to commonplace materials.

Kinetic Art was never just one thing and, like constructive sculpture in the 1930s, was international, with ramifications in Eastern Europe and particularly Latin America. Its relationship to technology gave it a natural 'modernity' in any part of the world. Denise René pulled together existing strands of Kinetic Art in an exhibition *Le Mouvement* at her Paris gallery in 1955, and helped make Paris the initial focus. Kinetic and Light Art stimulated the formation of avant-garde groups in different cities. The Zero Group in Düsseldorf was followed by Gruppo T in Milan, NUL in Holland, and the *Groupe de Recherche*

d'Art Visuel in Paris. The New Tendency became the collective name for the movement, which was, in part, an attempt to reconstitute an avant-garde in resistance to the commodification of sculpture through the creation of modestly sized objects that were by then finding an increasing market. 'Avant-garde' in this sense implies that research, discussion, writing, and making become an indivisible process; it is associated with small, often short-lived, magazines in which artists and chosen spokesmen could explore ideas; and it implies alternative exhibition systems, such as brief studio exhibits and performances, both to serve the demands of unfamiliar media, in the case of light and performance art, and to retain independence from the market. Collectors' thirst for modern art at a time of economic expansion led to dealers devising ways of marketing the avant-garde.

Zero was founded by Otto Piene (b. 1928), Heinz Mack (b. 1931) and Gunther Uecker (b. 1930) in 1957 in Cologne. It moved to Düsseldorf, the leading city for the visual arts in West Germany, where the first number of *Zero* magazine was published in 1958. Much modern German sculpture at that time had an anonymous internationalism, fixing attention on the present and turned its back on pre-1945 German history. Zero drew into its orbit an international group of artists, including Yves Klein (1928–62) and Arman (b. 1928) from Paris and Piero Manzoni (1933–63) from Milan, all of them to become, in 1961, founders of *Nouveau Réalisme*.

Zero wanted to escape from an art of formal relationships, which made Klein's monochrome paintings especially important in this respect. Zero's concern with dematerialization, with light projection, the

27 Vassilakis Takis
Insect, 1956
The Greek artist Takis's early moving sculptures relied for movement on chance currents of air. From 1959 he began to use magnets.

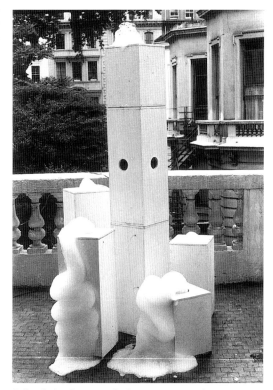

28 David Medalla

Cloud Canyon No. 2, 1964

This work mixed air and water with a chemical agent in plywood boxes, which resulted in slowly expanding mountains of foam which Medalla saw as metaphors for forms of natural growth and decay.

fall of shadow, and the creation of environments rather than objects, stemmed from the artists' conception of art in terms of energy rather than matter. Piene's *Light Ballet* [**29**], which consisted of moving projectors distributing light through stencils, and Mack's *Light Dynamos*, corrugated glass with rotating transparent glass behind, though different in form and impact, were both concerned with energy released, and sensation aroused, through effects of light and shadow. Piene also drew with smoke, placing a candle under a meshed screen with a sheet of paper on top. At first Zero exhibitions were one-evening studio events by invitation, but by 1959 the group was in the public domain, showing at the Hessenhuis, Antwerp, and in 1960 at the Städtische Galerie, Leverkusen. As early as 1959 Piene was exhibiting his *Light Ballet* in the gallery of Alfred Schmela, the Düsseldorf dealer who was at the centre of the 1960s art revival in Germany. In 1964 Zero showed at Documenta, where their collaboration was titled *Homage to Fontana*, recalling the Italian's huge light environments within architectural frameworks. They also saw Fontana's paintings—monochromes with razor slashes—as quasi-environmental objects, with the darkness revealed by the cuts as emotive voids ('behind Fontana's canvas, through and across it, a space opens', Piene wrote in 1962, describing Fontana as 'like a spiritual father').[29]

Zero paid tribute to Moholy-Nagy as pioneer, in the *Light-Space Modulator* (1922–30), of sculpture as the interaction of light and move-

ment. Piene's projection of light beams through rotating stencils was clearly indebted to Moholy-Nagy's invention, which had a light source within two layers of glass and metal which rotated at different speeds, interrupting the light beams from the centre. Moholy-Nagy cast himself in the image, which has been generally endorsed, of a rationalist whose thought was orderly and congruent with modern science. Piene's evocation of sensation through light and shadow makes one look differently at Moholy-Nagy himself, and recognize a romantic side.

Zero and the ambience of the late 1950s avant-garde in general was both for technology and against it, in the same way that Tatlin's pre-occupation with engineering and flight was anchored in technology yet determined to leap ahead of it in acts of faith. Klein's air sculptures were examples: experiments with hollowed-out sponges filled with balloons of hydrogen or helium to counteract the gravitational pull of their weight (patented in 1959). With the Swiss-born future member of *Nouveau Réalisme* Jean Tinguely (b. 1925), Klein explored the levitation of metal tubes, talking about the passing of pressurized air through the tube as if he had some form of jet propulsion in mind. At the instigation of Fontana, who invited him to collaborate on work for the 1960 Milan Triennale, Klein's ideas for environmental sculpture moved towards architecture as he explored possibilities of roofing parts of cities solely with a pressurized curtain of air. The Zero artists and Klein look forward to Joseph Beuys (1921–86) in their concept of the artist as energizer and transformer of elements, their concern with manipulating the elements, and the shamanistic role of the artist that Klein in particular shares with Beuys.

29 Otto Piene
Fire Flower Power, 1967
Piene's first *Light Ballet* involved hand-held lamps shining through stencils positioned in front of them and with jazz accompaniment. In 1960 Piene moved to projectors in fixed positions moving in relation to stencils passed in front of them—the form in which they were seen at the Städtische Galerie, Leverkusen, in 1961. The performance shown here was at the Museum am Ostwall, Dortmund, 1967.

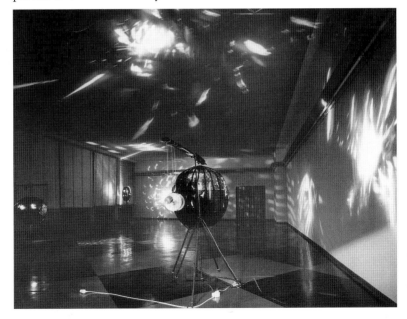

'The New Sculpture'

Clement Greenberg and Herbert Read

In a post-war mood of pessimism and insecurity artists who had lived through the Depression and the Second World War felt distanced from idealizing, non-figurative sculpture. American and European sculptors both looked to the example of Surrealism. Americans had the wartime precedent of New York School painters like Gorky, Pollock, Newman, and Rothko, who had already explored Surrealism's concern for the primitive, towards myth and such subjects as birth and death, good and evil, sexuality and the body. Attachment to myth gave this art trans-historical appeal, and rooted it, like Surrealism, in study of the human psyche. But at the same time preoccupations with themes of aggression and vulnerability related the new sculpture to contemporary issues and meant that an introspective approach was more than a flight from reality into the self.

The characteristic technique and medium of ambitious sculpture between 1945 and 1960, welded iron, has much in common with painting and, especially, drawing. The sculptor joins bars or sheets of iron with welds, creating forms that are planar and linear but not, like cast bronze, volumetric. Welded iron allows the sculptor flexibility in image making, but not as a copyist of three-dimensional objects, for which bronze casting is appropriate. Like painting, welded-iron sculpture has a temporal element, in the sense that decisions can be made as the work progresses. Welding had already enjoyed a brief artistic life in response, initially, to Picasso's need in the late 1920s for a technique to create cage-like structures. These were abstracted but also elaborate and full of detail that could be read as narratives. Picasso was assisted by Julio González (1876–1942), who developed the technique in his own art, but the innovation did not spread, and when González died Picasso did not revert to the practice. It was adopted first in the USA, then independently in Britain, France, and across Europe.

The progress of advanced sculpture in America was closely linked to the advocacy of Clement Greenberg, the mainstay of American critical writing on sculpture in the 1940s and later. Greenberg was already by 1943 a vigorous supporter of David Smith, around whom the renaissance of American sculpture grew.[1] Greenberg described him as early

as 1946, when he was little known outside New York, as a major artist by international standards.[2] In 'The New Sculpture' (1949) Greenberg identified a sculptural renaissance in America with a list of promising sculptors that included Smith, Theodore Roszak (1907–81), Seymour Lipton (1903–86), and Herbert Ferber (1906–91), all using welded metals to create abstracted figure, bird, and animal forms with emphasis on fragmentation, spiky, and skeletal shapes, making reference to archaeology and the remote past.[3] Greenberg mentioned at the same time the Surrealist David Hare (b. 1917), Isamu Noguchi (1904–88), and non-figurative sculptors. It was a short-lived renaissance, certainly, with the weight of new discovery in the 1950s being made, as it turned out, in painting.

In 1946, in the context of the Moore exhibition at the Museum of Modern Art in New York, Greenberg explained for the first time his conviction that the best modern sculpture since Maillol engaged in neither modelling nor carving but was linear, closing itself round empty space, and was not concerned with volume.[4] The new sculpture, he said, drew its strength not from earlier sculpture but from painting, specifically from Cubist collage. Smith's work, he pointed out, was like drawing and the planar presentation in three dimensions of collaged elements. It is clear that welding, a process joining metal bars or sections to create linear or frame-like structures, meets Greenberg's demand for transparency and space enclosure.

In 1949 Greenberg suggested that the new sculpture of the sculptor-constructor could be made from all manner of modern materials from steel and iron to alloys, glass, and plastics. In effect he was drawing the constructive tradition of Gabo, Moholy-Nagy and others into his framework of non-volumetric sculpture and leaving few major figures outside. Moore and Arp remained to continue the legacy of Maillol and what Greenberg called the Graeco-Roman-Renaissance tradition, which he regarded as *passé*. Moholy-Nagy and Gabo had established in their writing the polarity of volume and transparency, presenting their ideas in terms of step-by-step evolution. Greenberg advocated a clean break, with sculpture remaking itself from the example of Cubist collage and painting.[5]

Greenberg later elaborated his theory of the pictorial and began to use the word 'optical' to describe a sculpture that appealed through the eye to the intellect rather than to the touch.[6] Just as a picture is optical, making no physical contact with the viewer, so sculpture could have essentially intellectual appeal through the viewer's perception of it. In taking from the first a non-tactile view of modern sculpture, Greenberg parted company from Herbert Read, the other contemporary critic who attempted a comprehensive rationalization of the medium. The two nevertheless agreed on one thing, that the rise of modern science and the development of capitalism in the industrial age

had led to specialization in the arts, as in everything else, and a need to compartmentalize. 'That the independence of each of the arts is a good thing in itself may not be evident,' writes Read, 'but it is an inevitable condition of the arts within our civilisation'; and later: 'The separation of the arts in our modern industrial civilisation is inevitable, and consequently such arts as sculpture and painting must evolve their own aesthetic.'[7] Greenberg consented to this, if to little else.

Read's *The Art of Sculpture* was dedicated to his three close sculptor friends, Gabo, Hepworth, and Moore, but the text makes it clear that his deepest sympathies lie with Moore; indeed the mutual support Read and Moore offered one another over a long period constitutes a remarkable alliance. 'This is what the sculptor must do,' Read quotes Moore. 'He must strive continually to think of, and use, form in its full spatial completeness. He gets the solid shape, as it were, inside his head—he thinks of it, whatever its size, as if he were holding it completely enclosed in the hollow of his hand. He mentally visualises a complex form from *all round itself*....'[8] Read had published these remarks of Moore, made in 1937, already, in the first volume of the Moore catalogue (1944),[9] and they became a kind of talisman for Read. In *The Art of Sculpture* he also views it as an 'art of palpation', coming back always to the notion of touch as the essential experience.

For the sculptor tactile values are not an illusion to be created on a two-dimensional plane: they constitute a reality to be conveyed directly as existent mass. Sculpture is an art of palpation—an art that gives satisfaction in the touching and handling of objects.... The only way we can have direct sensation of the three-dimensional object is to let our hands move over it, to get the physical sensation of touch and the essential contrasts of shape and texture.[10]

Read's argument extended to a debate over the late-nineteenth-century theorist of sculpture Adolf von Hildebrand (1847–1921), who thought of relief as the ultimate standard for sculpture. Relief, Hildebrand thought, had stability and clarity, and obliged the sculptor to search for the ideal representation of a scene from a single angle. As Read correctly pointed out, 'his real object is to eliminate all sense impressions save those given in visual contemplation from a fixed point of view. Such a result can be achieved only by ignoring the palpability of the sculptural object and by confining the sense within a pictorial framework.'[11] Hildebrand's judgement seems devastating to Read, while representing closely Greenberg's view of what good sculpture should be.

'The New Sculpture' in the USA
David Smith trained as a painter and denied any difference between painting and sculpture, beyond the fact that the latter had a third dimension. He was converted to sculpture by a reproduction of a

welded-iron work by Picasso in *Cahiers d'Art* which he saw in 1933.[12] Unlike most of the Depression generation of American artists, Smith had visited Europe, in 1936, acquiring a broad interest in European (and non-European) art, and subsequently describing himself as 'more Assyrian than Cubist'.[13] Picasso's Cubist constructions, with their denial of volume, are clearly one take-off point for Smith's art. Smith's affirmation that there was something in Assyrian art (cuneiform writing interested him most) that mattered as much or more than this refers to his sense of the mystery of language, his feeling for meaning concealed within a visual emblem, confronting the viewer and asking to be deciphered.

Smith had worked in a car plant, and during the War welded tank frames. He liked sheet iron and a welding torch because their industrial connotations set him on a new track, enabling him to by-pass problems raised by traditional sculptural methods. Smith's experience of industry, and the remote location of his studio at Bolton Landing in upstate New York, can make him seem to have been a loner and non-intellectual, but this would be wrong. Smith was dependent on books and trips to New York to satisfy an intense and catholic curiosity about world art. In 1940 he exhibited the first of his *Medals for Dishonor*, inspired by Greek coins seen in Athens and German First World War propaganda medallions found in the British Museum. Sadism, sexual abuse, and torture are involved in the grotesque and frightening images of these anti-medals, which are parodies—fit for a corrupt soldiery—of the hero's reward. Smith's conjunction of the honorific and ceremonial with the banal and cruel recalls such artists as the French Mannerist engraver Jacques Callot and also Goya, both of whom Alfred Barr had presented in his exhibition 'Fantastic Art, Dada, Surrealism' at the Museum of Modern Art (1936–7) as precursors of Surrealism.

Smith's problem at this stage was refining an art of baroque complexity and maintaining the power of his inspiration without losing himself in a confusion of images. Even more than American painting, American sculpture lacked at this point a twentieth-century history. Smith was the sculptor who got under the classical skin of American sculpture, prising open closed form and exposing a heady assortment of emotions. He did for America what Giacometti had done for Europe in the early 1930s, which was to reframe the purpose and open up new possibilities for sculpture by showing that base as well as noble emotions are fundamental to the creative act. Smith's mid-1940s sculptures mix evocations of war with aggressive sexuality, violating norms of social behaviour and sculptural form. It is as if Smith felt, like Jackson Pollock in his mid-1940s painting, that the unregenerate state of their respective practices could only be revitalized by driving a massive charge of energy through it, meaning not only the technical aspects of their practices but the emotional input as well. Both artists

30 David Smith

Home of the Welder, 1945

This is among the most
formally complex and pictorial
of Smith's sculptures, referring
to house and body, violence
and sexual blossoming.

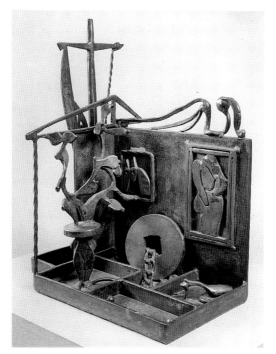

learned from Picasso a manner of risk-taking which demands shame-lessness: you either expose yourself totally or become merely decorative.

To explain the development of sculpture in the 1940s Greenberg adopted from Heinrich Wölfflin (whose death in 1946 he noted in print)[14] the polarities Wölfflin used in order to periodize western art. Greenberg's pleasure in the new American sculpture was at first for its openness and instability. He characterized the present moment as baroque, on the Wölfflinian grounds that it tended to use open rather than closed forms and was 'open to variety and violence of emotion as well as to large and complicated formal rhythms'.[15] Later, when Smith's sculpture had the serenity of closed form [**30**], Greenberg described it in the kind of language Wölfflin used to identify the polar opposite of the baroque, the High Renaissance. The words he used to describe artists in the mid-1940s, which he saw as a time of great energy reflected in unresolved forms, often refer to late phases in the Renaissance and other artistic cycles: thus Pevsner and Lipchitz were 'baroque', Gabo was 'rococo', while Pollock was alternately 'baroque' and 'gothic'.[16]

Home of the Welder represents Smith at his most baroque. It alludes to the artist's house, opened up to give an interior view, exposing a woman's nude body as a picture on the wall alongside a Picasso-like dog's head; on the floor are a millstone and chain and a standing woman's nude torso opening out into a leafy tree form. Extending over this scene is a gibbet-like yard arm or knife, beside flowing shapes

31 David Smith

Blackburn: Song of an Irish Blacksmith, 1949–50

This shows the narrowing of Smith's subject interests since *Home of the Welder* and a move away from pictorializing sculpture into a complex form of 'drawing' with iron bars.

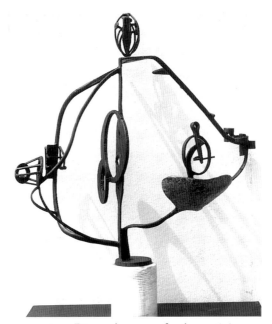

suggesting Picasso's way of schematizing a woman's body. Smith's themes relate to the home as extension of—or metaphor for—the body, and to cruelty and abuse as well as sexual blossoming. He is interested in exposure: literally removing the lid. Taking the roof off the house is like taking the protective skin off the body to expose the inner working and the skeleton. Smith was aware of Giacometti's cage sculptures of the early thirties and Picasso's painting of the *Guernica* period, and seems here to be demanding analysis of himself and self-exposure as a condition of creativity. Smith's 1945 sculptures are among his most frenetic and complex. They are theatrical, in that the cage-house in *Home of the Welder* contains actual space which is not the space of everyday life, but is more like the internal space of a painting or the stage space beyond the proscenium arch.

Blackburn: Song of an Irish Blacksmith [**31**] shows how quickly and how far Smith moved after this 'baroque' work in the direction of clarity, without loss of interest through sacrifice to simplicity. Nexuses of sculptural activity are linked by welded rods, often described metaphorically as drawing in space. *Blackburn* is raised on a pedestal, and is more abstract than the previous work. Unlike *Home of the Welder*, its space is not space that viewers could recognize as their own. The spreading of the forms in space also gives the sculpture a new meaning in time, because without a single focus it is seen as a sequence of parts. More than that, it looks different from different angles—the hollow circle in the centre can be made to disappear when the sculpture is seen edge on. A complete view of the work can be had only by walking round it. Incorporating scrap meant that Smith was able to maintain a sense of surprise: the technique did not have to be lengthily pre-

planned, and he became certain of the outcome only as the [...] veloped. As with Cubist collage, which is in some ways clos[...] Smith was producing in three dimensions, the process was o[...] covery of affinities that constantly renewed itself and avoided the risk of the work becoming academic.

Blackburn was named after the owner of the Terminal Iron Works on the Brooklyn waterfront where Smith had had a studio in the 1930s, and like many of Smith's sculptures it carries human references without being *of* a person. It also refers to the idea of place, with points of activity in the sculpture fixed within the space of the sculpture—as they are on a road or in a landscape. It is of a place in the sense, also, that the Terminal Iron Works was where Smith started to find and weld the kind of scrap from which this sculpture is made. Person, place, and material come together in one image.

Roszak, Ferber, and Lipton all share Smith's restlessness, working with jagged forms and bent planes of metal which allude to primitive birds, wings, beaks, claws, roots; plant forms; and fragmented and tortured human figures. Roszak is the most pictorial of the new sculptors,

32 Seymour Lipton
Imprisoned Figure, 1948
This is an example of the widespread interest expressed in various ways in post-war sculpture in themes connected with body and cage, violence and torment.

deriving his images of predatory creatures from the Surrealist painting of Max Ernst, André Masson and others. Roszak moved away from constructed, non-figurative sculpture in 1946 because, he explained, he could no longer find the harmony between art and society that constructive sculpture implied.[17] Lipton had a background in carving stone and wood but turned to metal in 1945, to create horned, pelvic, and skeletal forms [32] that convey, as with Roszak, his sense of 'the dark inside, the evil of things, the hidden areas of struggle [which] became for me a part of the cyclic story of living things. The inside and outside became one in the struggle of growth, death and rebirth in the cyclic renewal process.'[18] Ferber came from social realism in the 1930s and also switched in the mid-1940s to thorn heads and abstracted plant forms which create the ambience Lipton describes of darkness, threat, and instability. These sculptors traced a pattern similar to some New York School painters, who started from alienated, socially aware figure painting, and turned in the mid-1940s to myth and the primitive. In the case of the painters, but not the sculptors, this led on to non-figuration at the end of the decade.

Greenberg argued in 1951 that the dominant creative tradition in America in the last century and a half, as in England and Germany, had been gothic: transcendental, romantic, and subjective. Industrialism, he said, 'exacerbates and drives us to extreme positions where we write poetry but are unable to calm ourselves and live long enough to fix abiding plastic representations'.[19] His statement of regret fixes on a general problem but most acutely on individuals like David Hare (b. 1917), Isamu Noguchi (1904–88), and Frederick Kiesler (1896–1965), all active in the American Surrealist circles and undervalued in respect of their achievement in sculpture at this point.

Frederick Kiesler, an architect by training, a former member of De Stijl and protégé of Van Doesburg, had been in America since 1927. He designed Peggy Guggenheim's Art of this Century Gallery in New York in 1942 with curved walls, and he constructed the entrance to the 1947 Surrealist exhibition at the Maeght Gallery in Paris to suggest an encounter with rites of passage. Kiesler spent many years perfecting his *Endless House*, an organic living system of linked pods which could be indefinitely extended, and later returned to his first profession and taught architecture at Yale. Kiesler's best-known sculpture, *Galaxy* [33] was shown at the Museum of Modern Art in 1952 as sculpture, and has been treated as such subsequently. But this twelve-feet-high wooden structure was actually designed, in 1948, as a stage set for Cocteau's production of Darius Milhaud's opera *Le Pauvre Matelot*, about a sailor who returns from the sea after fifteen years. With drapes hung over it, the structure represented the sailor's home, its planks shaped like marine skeletons, and the fins equally reminiscent of the sea. 'My sculpture,' Kiesler said, 'is a practical sculpture. It is to be lived with and

within.'[20] Kiesler dealt in much of his work with links across the arts, between architecture, sculpture, and theatre. His range of interests was not fashionable in the 1950s, when the urge was to reinforce distinctions between art forms rather than to cross boundaries. In effect Kiesler was using *Galaxy*'s theatrical origin to make a link, basic to both architecture and theatre, between physical structures and the body.

The Blind Leading the Blind [**34**] by Louise Bourgeois (b. 1911) is like *Galaxy* in having associations with architecture. Wooden stakes, about human height, read as figures in procession, each with arms on the shoulders in front; but equally the sculpture offers an architectural interpretation, as a double row of columns capped with lintels. At the time Bourgeois made this, one of her first sculptures in a long career, she was a painter of canvases showing women with houses for heads or bodies. Her interest already lay in the way people can be thought of as corresponding, psychologically, to the structures they inhabit or the spaces they occupy. Bourgeois's two sculpture exhibitions at the Peridot Gallery, New York, in 1949 and 1950, included individual stick-like personages which could be rearranged from show to show. Building on a Surrealist practice, Bourgeois was making an exhibition into an event. Because of their mobility, her personages are like bodily presences in our space and are not reducible, in Greenberg's terms, to the purely optical or to objects that are understood as self-contained

things in themselves.

Sculpture, which is in Greenberg's definition optical, is understood by sight and intellect and not by bodily presence or the effect on a viewer of sharing space with it. Such an object displaces space on account of its size but does not own the space that surrounds it. The space of theatre, which differs from everyday space because it is reserved for a special kind of performance, was unwelcome in Greenberg's Modernist theory, which envisaged sculpture as not belonging in a particular place or in relation to particular human presences.

Greenberg felt that art could not in the long run perpetuate itself by what he called 'high spirits and the infinite subdivision of sensibility'. The task of the artist—specifically, he felt, the American artist then—was to calm these high spirits and develop them into what he called 'a bland, large, balanced Apollonian art'.[21] Smith alone of contemporary American sculptors met this strict definition, and he became Greenberg's paradigmatic contemporary sculptor.

'Geometry of fear'

Younger British sculptors acquired a collective identity when a group was shown, together with Moore, at the 1952 Venice Biennale. Moore had won the Sculpture Prize in 1948, Hepworth had a show at the Biennale in 1950, and now, in the view of the British commissioner, Herbert Read, and the organizing committee, it was the turn of younger artists. All were under forty, and they included Lynn Chadwick, who was to be awarded the Sculpture Prize at Venice in 1956, Reg Butler, who was to win the Unknown Political Prisoner competition in 1953, and, among the others, Eduardo Paolozzi and William Turnbull (b. 1922).

Read wrote in the catalogue: 'These new images belong to the iconography of despair, or of defiance....Here are images of flight, of ragged claws "scuttling across the floors of silent seas", of excoriated flesh, frustrated sex, the geometry of fear.'[22] The references were to rib and cage forms, crustacean and insect shapes, and imagery that, in Read's view, alluded to aggression and predatoriness, vulnerability and suffering. The forms were presented with a degree of abstraction which Read felt justified the phrase 'geometry of fear', a sobriquet which caught people's imaginations, though it now seems over-emphatic. If Read, who had led the selection committee, was suggesting that Moore was a model for the younger sculptors or that there was direct continuity between them, he was mistaken: Moore's *Double Standing Figure* of 1950, one of the sculptures in question, is itself as close to the narrow attenuated forms of some of the younger artists as it is to much of Moore's earlier work.

The lives of the new generation had been interrupted by war

service, they had played no part in sculpture before the War, and they felt the need for a fresh beginning. Some had had no art education: Butler and Chadwick, for example, came from architectural backgrounds and had experience in designing display stands for trade fairs; Butler had learned welding as a blacksmith. Paolozzi and Turnbull trained as sculptors at the Slade School after the War, but could find nothing to admire in contemporary British practice. These two, unlike the other young Venice exhibitors, had lived in Paris, where they had met leading sculptors of the older generation. Paolozzi especially had become interested in Dada and Surrealism through first-hand knowledge. Neither fitted Read's definition of them as having been influenced by Moore.

As a student at the Slade Paolozzi had already decided that fine art was not an enclosed category limited to the high-art subjects that concerned Brancusi, Arp, or Moore; he believed that it should be involved with a wider spectrum of ideas, from fantasy to the everyday. In his mature work Paolozzi developed a technique of taking small bits of mechanical gadgetry or defunct electrical circuits, making plaster casts from them, filling each cast with wax to make it positive, and applying the wax to a sculptural surface which was then cast in bronze. The subject of the resulting sculpture may be an animal, an insect, a head, or a figure, but the effect of casting the machine or electrical parts in bronze was to integrate into a new whole these clusters of specific detail which had already had a previous life.

Paolozzi was interested in inscriptions on the surface of the body, in tattoos, and the complex ways we use to fix our desires onto our bodies. A figure coated with tiny machine parts can be thought of as carrying the impress of the outside world. But, equally, it can seem that we are seeing the inside, the machinery of the body, exposed on the surface— as Giacometti had exposed it in his transparent Surrealist cage structures in the early thirties. Paolozzi used a commission from the Arts Council to make the most innovative sculpture produced for the Festival of Britain. *Cage* [35] can be read either as a kind of skeleton with scraps of flesh attached to it, or as an enclosure, protective or constraining. At six feet, it is similar in height to the human body; it leaves open the same questions as Bourgeois's *The Blind Leading the Blind*, which can be read as a group of figures but is also conceivable as a structure that encloses or protects them.

Paolozzi's use of the found object, something which has had a previous existence and is renewed in a fresh context, was a legacy of Surrealism. Surrealism's use of the found object in the 1930s, however, had tended to stress incongruity and the differences between things, while Paolozzi, whose work has parallels with Picasso's, is interested in the way things can be made alike, to unite with one another in a new context. Picasso's *Baboon and Young* (1951) joins two toy cars, and adds

35 Eduardo Paolozzi

Cage, 1950–1

Cage illustrates a more abstract approach to the subject of body and cage than Lipton's [**32**]. Visceral forms are attached to the frame or skeleton, suggesting a permeable body without clear distinction between interior and surface elements.

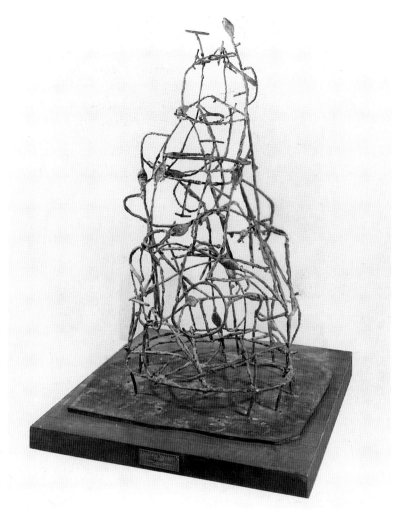

ears to make the baboon's head. Picasso plays on difference and likeness and the way we recognize things, employing his own brand of humour. Picasso used the *objet trouvé* in another way, creating ridged surfaces for still-life objects in sculpture by pressing corrugated cardboard into wet plaster. As an artist who liked to work quickly and wanted the effect of quick decision-making to show in his work, he used this technique to avoid the long process of making by hand, while giving over some of the authorial function to an external 'system'. Paolozzi commented that

it is always difficult for a sculptor to suggest, in his work, the same kind of spontaneity as one appreciates in much of modern [Abstract Expressionist] painting. A sculptor's task is much more slow and laborious than that of a painter. But the use of *objets trouvés* as the raw materials of sculpture makes it possible to suggest a kind of spontaneity that is of the same nature as that of much modern painting, even if, in my case, this spontaneity turns out to be, after all, an illusion.[23]

Paolozzi's point has wide implications. Just as it was to become clear by 1956 to Greenberg that American sculpture—which he had believed in the 1940s to be the medium with the most promising future—had been overtaken by painting, so it was evident by then that some of the sculptors of whom Read had had such high hopes in 1952 were losing their way. The critic Lawrence Alloway, a strong supporter of the British sculptural renaissance, saw in retrospect how 1940s painting (he was referring to America, but a similar argument could be made for Britain) had moved beyond the biomorphic or late Surrealist phase into a new world of Abstract Expressionism, but sculpture had not.[24] On the basis of Paolozzi's argument, this might be because it was hard to find an equivalent expression in sculpture for the spontaneity of painting. David Smith's work through the period used found metal shapes which did not bring with them heavy burdens of meaning. He favoured the shallow curved tops of water tanks, for example, and similar generalized shapes which could be turned into new forms quickly and economically. Smith was in this sense the nearest there was to an Abstract Expressionist sculptor.

Turnbull, like Paolozzi, left the Slade looking for a new start. His earliest sculptures include groups of tiny metal 'sticks' with knobs on top resembling Paul Klee drawings in three dimensions. They are like Giacometti's, with residual human reference but without the identifiably human aspects (the face and gaze that Giacometti wanted). In some sculptures the sticks can be moved from one hole in a base to another, like game scorers, which, even if they are seen as figures, means that they are things that are 'done to'. They have been likened to miniature classical herms, human heads on life-size columns,[25] images both lifelike and abstract which make possible a bridge between the human image and sculpture as abstract object. While Paolozzi's standing figures never gesture or adjust their tenuous balance by stretching their arms, Turnbull goes further in abolishing human expression. The human references that remain in his extremely economical sculptures are signs rather than images, substitutes rather than likenesses. They are austere, anonymous, impersonal, and non-expressionistic.

Some of the most effective metaphors in post-war sculpture were archaeological. With Moore and Marini a sense of disinterment surrounds some of their objects, which gain status as talismans from seeming to be connected with history while actually belonging to the present. The metaphor works differently with those sculptors, from Giacometti to Turnbull, who looked back to early non-naturalistic art, particularly Etruscan. With them there is a feeling, which goes beyond purely formal likenesses, of value attributed to beginnings, to early stages in cultural formations.

Turnbull takes the archaeological metaphor furthest. His *Pegasus*

and *Horse* (both 1954) owe something to classical antiquity, to fragments, perhaps to the Elgin Marbles. The creatures are mounted on bases that are part of the work in the manner of Brancusi, in a mode of presentation suggestive of archaeological exhibits. Because such objects generally come from the remote past, their purpose and meaning have often been lost. Especially when they are fragments, they are denied action or movement. Their interest lies in the way they can be appreciated as physical objects and still present a gateway to the past, even though their full implication or meaning is not understood. Paolozzi and Turnbull made similar heavily scored solid oval forms that are readable as either animate or inert, as heads, small boulders, shelled objects, or chrysalises.

The common character of these forms is that they are unitary, without separate parts, which implies that they are passive, dormant. Unlike contemporary work in welded metal, this kind of sculpture has very little grammar; it is not composed, it is presented. The three parts of Turnbull's *Permutation Sculpture* [36] are not connected, they are placed, and this positioning can occur in several different ways. There are wide implications for this kind of work which is formed, like some of Brancusi's sculptures, by things being placed one on top of another, by a process of addition rather than composition. Turnbull was a precursor in this respect of 1960s Minimalism, in which the directness with which an object confronts us is more important than internal nuances of composition.

The younger generation in Britain were around ten years junior to their counterparts in America—Smith, Roszak, Ferber, and Lipton—and had lost time because of the War. They had not had the benefit of the long education that Moore and Hepworth had enjoyed in the 1920s, nor had they, like the older sculptors, made the time-honoured journey to Italy. They were now in a hurry, and looked for forms of expression consonant with the post-war mood of change. They did not have time to chip away at blocks of wood and stone. In a radio debate with Hepworth, Butler claimed that carving was appropriate to a leisured culture, its pace fitted a pastoral age, and the weathered effects of Moore's and Hepworth's sculpture belonged to an era when time passed more slowly. Butler thought that the fugitive culture of the twentieth century was reflected in such materials as plaster, iron, and wax.[26] But iron, as Smith understood, mirrored an industrial and urban culture as much as a fugitive one, and Butler's point might be recast to enforce a different contrast, between an old-fashioned landscape art and the new art of the city. In reality, though, the situation was more complex.

British culture in the late 1940s was marked by a taste for the picturesque, and landscape was in everybody's mind as Britain recovered from the War. The London County Council parkland sculpture

36 William Turnbull

Permutation Sculpture, 1956
Turnbull had been interested
since the late 1940s in
sculpture, like this, where
there was flexibility in the
arrangement of the parts.

exhibitions, repeated every three years from 1948 for over a decade,
fixed a notion in the public mind (not necessarily with the approval of
the sculptors, it is true) that modern sculpture was complemented by a
picturesque setting. This had an effect on sculpture itself. The tend-
ency to formal complexity and elaboration in Butler's bent and welded
iron figure sculptures demonstrates the picturesque influence. The way
certain iron sculptures of the period carry resonances of old agricultural
tools reflects the joint appeal to landscape and history. There are simil-
arities here with the aesthetic of Moore's and Hepworth's generation,
and though the younger artists were keen to establish their own prior-
ities with the help of new materials and techniques, there is no
straightforward play-off between the old and the new.

 Like Butler, Chadwick was driven by technical experiment; both
were expert welders. Chadwick's earliest works include suspended
mobiles which have an elegance akin to Calder's. But the size and tech-
nical problems presented by Chadwick's *Fisheater* [**37**] mark his in-
creasing ambition, and a shift from the wholly abstract to a play—in
the image of this open-jawed predator—with subject. However, even
the sharpest beaks and claws in the work of Chadwick and the other
Venice exhibitors do not affirm Read's language of torture, death, and
sexuality. Read had come to see the artist as a kind of medium: 'the
more innocent the artist, the more effectively he transmits the collect-
ive guilt', Read wrote in the Venice catalogue.[27] Butler and Chadwick
were interested in process, the way skills acquired from a newly learned
technique could be applied to the creation of complex forms. Subject is
also important but there is no overall message or polemic emerging
from British sculpture at this point.

The Unknown Political Prisoner

There was a determined effort in post-war Britain, recognized by Moore as the advantage of the younger generation over his own, to make sculpture as popular an art form as painting. The LCC park exhibitions were followed by the commissioning of new sculptures for the Festival of Britain (1951). The end of the Festival coincided with the exhibition of sixteen younger sculptors at the Institute of Contemporary Arts in December 1951, and the announcement at the ICA in January 1952 of the international competition for 'A Monument to the Unknown Political Prisoner'. In June 1952 eight younger British artists were shown at Venice, and in September Moore led the sculpture section of an international conference of artists at Venice. He spoke on 'The Sculptor in Modern Society'—a retreat from the original plan for the conference, which had been to 'study the practical conditions required to ensure the freedom of the artist', a more political topic and, like the Unknown Political Prisoner competition, keyed into the Cold War debate. Britain submitted over 500 of the 3500 entries from fifty-seven countries (only Germany submitted more), and came out well when the results were announced in March 1953, with Butler overall winner [38] and Hepworth and Chadwick also taking prizes.

The intention of the competition was stated in the prospectus as being 'to pay tribute to those individuals who, in many countries and in diverse political situations, had dared to offer their liberty and their lives for the cause of human freedom'. The organizers, who—apart from the American project director Anthony Kloman—were all British and connected with avant-garde art, emphasised that 'symbolic or non-representational treatment of the subject would receive the

37 Lynn Chadwick

Fisheater, 1950–1

Fisheater brings together Chadwick's interest in mobile sculpture and in imagery related to predatoriness that was common to many of the sculptors, like Chadwick, who were grouped by Herbert Read in 1952 under the title 'geometry of fear'. *Fisheater* is pivoted at the centre, with balance arrived at empirically by adding a small amount of concrete to the back section of the 'jaws'.

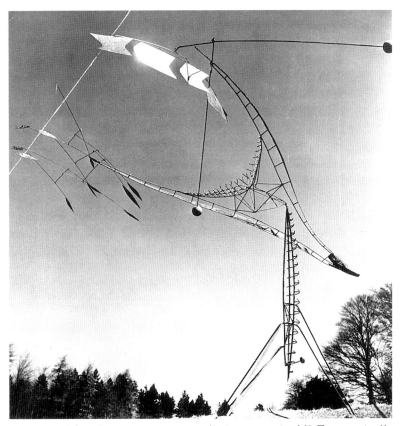

same consideration as more naturalistic expression'.[28] Economically advanced countries submitted advanced art, which took all the prizes, despite the wide cast of the competition rules. 'Advanced' did not mean completely non-figurative. Privately, Read told Gabo that his entry had been thought too abstract, suggesting that the international panel of judges was looking for a middle way between straight figuration and complete abstraction.[29] Butler's winning submission could be taken as evidence for this. The press, however, was not carried along on modern sculpture's victory. A typical informed critical reaction was that of an English critic, William Gaunt, posing the question in an American periodical:

Is abstract sculpture, so much concerned with 'formal values' and so anti-subject, entitled to interpret a subject? Here is the first difficulty, and it must be admitted that some entrants do not submit anything very different from what they have previously produced with no subject at all. They change the title but not the work. It is only the somewhat fortuitous addition of a crossbar that distinguished Barbara Hepworth's 'Prisoner' from her, let's say, 'Three Forms in Relation'. A similar criticism might be made of Antoine Pevsner's entry, or Naum Gabo's.... A second question ... that will disturb many people is whether the results of the competition indicate a new epoch of monumental sculpture—or is it approaching extinction?[30]

The issue pinpointed was similar to that surrounding Picasso's designs for a monument to Apollinaire, except that Picasso's refusal in the 1920s to compromise in favour of the specified subject had been more radical; he added no equivalent of the prisoner's bars, on the basis, presumably, that his art had limited potential for communication but would be understood by Apollinaire's friends anyway.

A more positively critical position than Gaunt's was taken by John Berger, who disputed the possibility of creating a monument on the basis of such a generalized brief, pressing the point that a monument must be in a particular place, because its meaning, and therefore its form, will vary, depending on its location.[31] In this case no site had been chosen—the organizers merely 'hoped that a site of international importance would be available'.[32] A groundless rumour of a plan to erect the winning design on the cliffs of Dover formed a channel for popular opposition. The immediate invitation from the Mayor of West Berlin to erect it at Humboldt Höhe close to the border with the East as a kind of challenge to the Soviet memorial already in place in Treptow Park [4], was a cause of the withdrawal of the Russian from the nine-person jury and an East European boycott of the competition. Both politicians and people at large, these reactions imply, realized that a monument, as an emblem of collective memory, belongs to a specific place, and it was the thought of it in such a place, as much as the thought of the thing in itself, that caused consternation in each

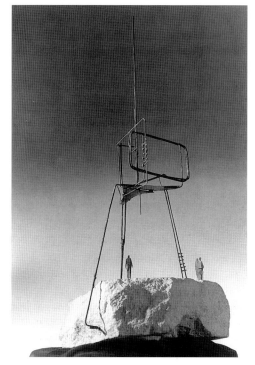

38 Reg Butler
Final maquette for the
*Monument to the Unknown
Political Prisoner*, 1952
Butler had trained as an architect, and his design for the competition, like that of another architect-sculptor Max Bill [**20**] had a clearer sense of monumental scale than many of the submissions.

case. The cliffs of Dover and Humboldt Höhe raised questions of politics and nationalism.

Gaunt, in questioning whether monuments were still possible in an age of what appeared to be placeless or 'portable' sculptures, was in effect asking whether a monument could exist outside politics or nationalism. The competition organizers' answer was that it could, Berger's that it could not. Berger's objections were to the point: the sculptors were working to an anodyne specification and most produced anodyne results. Berger advocated the Dutch sculptor Mari Andriessen's *Concentration Camp Victims* [2], which had been shown at Battersea Park in 1951, as the work of an artist who had struggled with the problems of the specified subject in a way that the abstract contributions did not.[33] Andriessen's sculpture has a certain rather generalized pathos and acknowledges a point Berger had been making for some years, that heroic sculpture is inappropriate in a non-heroic age. Read, in his reply, accused Berger of simply promoting Socialist Realism, and, in effect, showed that traditional realism could not be guaranteed to pinpoint specific meaning any more than international abstraction could.[34] What emerged from the debate was that the issue was not just one of artistic style or mode, but also one of audience. A monument is effective only if it carries its audience with it, which Butler's design did not. Feelings ran high, Butler's maquette was destroyed while on show at the Tate, and another (unconnected) work by him then on public display was daubed with paint.

The 'Unknown' of the title recalls the Tomb of the Unknown Soldier, the most unassuming of monuments in Westminster Abbey, which perhaps suggested to the competition's devisers a precedent for a monument in an unheroic age. But anonymity is different from generalization; the unknown soldier represented definable virtues, the unknown political prisoner possibly quite contrary ones, depending on where the prisoner was thought to be. Appealing to international artists to engage in a competition was inviting contrary forms of representation, with the expectation that if the Russian juror had participated and had been in a minority, he would have been outvoted and Modernism would have won—as it did anyway. The competition was certainly political.

Within the limited possibilities for designing a Modernist monument, Butler's was an impressive solution. Planned to rise to three hundred feet, his design was an open structure suggestive of freedom, with ladders to indicate ascent, and watchers on the ground to engage the spectator by offering something within the sculpture to identify with. The dream of ascent is as old as Jacob's Ladder. Combined with a modern, technological appearance and a perhaps unintentional reference to designs for speaking platforms which are among the most thrusting and optimistic images of Russian Constructivism, Butler

achieved a rich, if somewhat indeterminate, mix of references. Radio and radar buildings which Butler had photographed on the Suffolk coast in 1946–7 were a source of his inspiration. Since the construction of the Eiffel Tower in 1889 radio towers have been adopted as emblems of modernity in art. With Europe in the 1950s still just within the frame of the first industrial age, iron could still be seen as forward-looking in character. Butler and Max Bill, who were arguably the most successful entrants to the competition, were both architects and both approached the problem not by modelling the human figure but by creating an environment with which to frame the figure.

The Unknown Political Prisoner competition came at the height of the early phase of the Cold War and had significant political implications. As much the largest sculpture competition ever held, it can also be seen as a mechanism for popularizing modern sculpture. Apart from the American initiator, Anthony Kloman, the organizing committee —Moore, Read, John Rothenstein (the director of the Tate), the former Surrealist artist and ICA president, Roland Penrose, and the art publisher and patron E. C. Gregory—were all predisposed to modern art, if not in its most radical forms. The competition judges included Read, Alfred Barr (director of collections at the Museum of Modern Art), the German and French critic-historians Will Grohmann and Jean Cassou, all internationally known advocates of Modernism. In this respect one of the functions of the competition was to push modern sculpture forward. The first sculpture prizewinners at the post-war Venice Biennales were widely acknowledged artists, Moore (1948), Zadkine (1950), Calder (1952), and Arp (1954), and—as with the placing of Moore at the head of younger British sculpture at Venice in 1952—this was a way of saying that there was now a history of modern sculpture. Two years after the Unknown Political Prisoner competition the first Documenta exhibition opened at Kassel (1955)—dedicated to the new—and the positive response to it was further confirmation that 'modern art' was becoming increasingly widely accepted.

The 'look' of Modernism

Public recognition that modern art had an existence and history helped to change the nature of the avant-garde itself. In the early phase of Modernism sculptors had looked outside their art to stimulate their expression, to non-European primitive artefacts, to popular culture and the everyday, and—to a limited extent—to technology and modern industry. The years 1945–60 saw less external stimulus of this kind and more internal development within the medium. What Greenberg in 1939 had designated kitsch was art that imitated the effects of a true work of art rather than deriving from the processes the genuine artist had gone through to achieve the effects.[35] Greenberg was partly targeting there the debasement of true academic art under the dictatorships,

but his argument holds good for the academicization of the modern in mid-1950s sculpture. This new mediocrity was a reprise of the aspect of Greenberg's definition of kitsch that related to the copying of effects rather than processes. Post-war histories of modern sculpture illustrate many mediocre works according to this definition, in a way that Giedion-Welcker's 1937 book had not: in the 1930s mediocrity would have been expressed within a traditional, figurative mode; by the late 1950s the mediocre was often modern. The organized popularization of modern sculpture through competition and exhibition was partly responsible for this, but Modernism's turning away from life and inward on itself was the prime cause, because it cut the discipline off from replenishment and inspiration from outside.

Greenberg himself returned to the problem, specifically to sculpture, attacking recent American and British work in the winter 1956–7 issue of *Art in America*, devoted to contemporary American sculpture, in what appears to have been part of a process of boosting American art and 'normalizing' Modernism. Greenberg's article was on Smith and, as always when writing about this artist, he went straight to the point: it was Smith's 'aggressive originality', Greenberg claimed, which enabled him to rationalize the varied and erratic early sculpture, which he designated 'baroque', and arrive at the calmer and more resolved, but no less energetic, sculpture Smith was then making.

To describe much of the remainder of American sculpture— including artists he had held high hopes for in 1949—Greenberg used the word 'artiness'. His intention was to define an urge to make art that is assured above all of looking like art. Greenberg attributed artists' urge to do this to insecurity over aesthetic identity. He described the result as making not art but things. He attacked both biomorphism and Constructivism, pointing out, with reference to the welding torch, that a new technique can advance the means of expression but cannot make an unoriginal artist original.[36] Within this argument is contained a fundamental problem of sculpture in the fifties: at a time when popularization of the modern threatened quality with quantity, the assurance of originality became more important than ever.

In 1949 Greenberg had thought that sculpture, not painting, was the medium through which American art would develop, while his classic 1955 article ' "American Type" Painting' made clear his conviction that the development had actually occurred through painting.[37] In painting the possibility for originality in technique is limited—as painting, unlike sculpture, *is* a technique. With sculpture, technique can offer an alibi, a way of avoiding real change by a change of technique. Fashion hits painting as well as sculpture, and painting too can acquire the 'look' which is really fashion's, rather than art's, definition of change. But sculpture, again, has a way around radicalism that painting does not. Because it is a three-dimensional object, sculpture may have visual

affinities with other designed objects, such as ornaments, which a painting, except in so far as it approximates to a poster, does not. Greenberg's remark that the malign influence of the welding torch among American sculptors had been the arrival of 'a superior kind of garden statuary and a new over-sized kind of objet d'art',[38] conceals behind its throwaway humour an important truth: the rapid expansion of the audience for Modernism, without educational support (that is to say, the understanding of *processes* rather than simply *results*), is likely to diminish its seriousness.

Greenberg reserved his most acute irritation for Constructivism, which he described as the 'terrorising agent' of serious sculpture, 'with its machinery and machine-made *look* [author's italics]'.[39] The shift in the use of the word Constructivism from meaning, in its Bolshevik phase, experiment, to its adoption later to imply little more than 'object sculpture with a machine look' can be seen now as more than a simple misapprehension. It was a shift of meaning used to cloak a change within sculpture from—at the extreme—originality to kitsch. Pop Art and *Nouveau Réalisme*, through which the everyday re-entered art, were seen as threatening to high art, not least by Greenberg. But Pop Art and *Nouveau Réalisme* were not so much the problem as part of the answer.

Sculpture and the Everyday

Myth and reality

By the end of the 1950s the scarred and vulnerable human condition, which underpinned post-war figurative sculpture, no longer seemed relevant. The 'New Images of Man' exhibition at the Museum of Modern Art in 1959 and Documenta 2 at Kassel in the same year still fitted the post-war frame, but they marked the end of a period. The young British sculptor, Phillip King (b.1934), returning from Documenta, described the show as 'dominated by a post-war feeling which seemed very distorted and contorted ... [and] somehow terribly like scratching your own wounds—an international style with every-one showing the same neuroses'.[1] King's comment related to the work of Germaine Richier, a British 'geometry of fear' sculptor, or one of Greenberg's 'new sculptors' in America, and was saying, in effect, that for younger artists the War was a childhood memory which they would not allow to set the terms of their work in a time of economic recovery and the relaxation of social barriers.

Post-war sculpture was traditional in that it focused on the human figure, however abstracted or distorted. Sculpture's history since the Renaissance—much more than painting's—had been geared to the figure; other genres such as landscape and still life had not fed into sculpture. Though Cubism and non-figurative art had started to change this, post-Second World War sculptors were interested in 'important' themes—the condition of man—or non-figurative form, which was 'high' subject matter of a different kind, because it aimed at the ideal. In this way sculpture remained, with a few exceptions, exclusively a high art form.

Lawrence Alloway, the British critic who emigrated to New York in 1960 and was the first to coin the phrase 'Pop Art', saw that the wide-spread appeal of Pop's themes implied the collapse of rigid boundaries between the arts. Alloway argued in 1958 that the distinct categories 'painting' and 'sculpture' were derived from a pre-industrial social order, and had adequately represented the hierarchy of the visual arts in Europe from the Enlightenment to the present. However, the mass arts were the central achievement of industrial society, and with the social change that accompanies industrialism the experimental and

39 Andy Warhol
White Brillo Boxes, 1964
These are near facsimiles of manufacturers' wholesale cardboard boxes, but made from plywood with lettering stencilled on by assistants at Warhol's 'Factory'. The quantity of boxes used and their arrangement from show to show are flexible, and exhibitions of them should be regarded as much as 'installations' as 'sculpture' shows.

flexible values of mass arts reflect culture better than the static, rigid, and self-perpetuating values of high culture. The customary division of the visual arts into painting and sculpture was now a limitation, because the words had high-art connotations, and because commerce had commodified the products of these established categories, painting and sculpture, aligning them with ideas of purchase and ownership.[2] He did not understand in 1958 (as he did later) the extent to which Pop Art and the appropriation of the everyday by high art, on a scale not seen since Cubism and Dada, marked the expansion of bourgeois taste rather than the achievement of a socially unified culture. Pop Art, as opposed to the material on which it drew, had little to do with the masses.

After 1960 the human figure survived in sculpture in Pop Art installations. What disappeared altogether was 'man' as a trans-historical concept, man who was scarred by the elements as well as by war, but heroically survived. 'Man' in this sense had been 'done to'; he was reactive, he suffered and was victimized. In the new works man, if not active, was in the real world [**50, 52**]. Art after 1960, not only Pop Art but much abstracted object sculpture as well, was concerned with what was modern about modern life. 'Important' subjects were exchanged for modern ones. Roland Barthes, in his essays published as *Mythologies* (1957), argued that myth was a language and, as he put it, 'we shall have to assign to this form historical limits, conditions of use, and reintroduce society into it'.[3] The power of myth to give fixed meaning across history was challenged, and a myth becomes more like a reflection of the ideology of a moment. It was not that myths ceased to exist, but that Marilyn Monroe could become one.

Barthes also made contemporary icons out of inanimate objects, recognizing the power of the exemplary manufacture in the contemporary world. Barthes described the new Citroën DS as the superlative, magical object of its time ('cars today are almost the exact equivalent of the Gothic cathedrals...the supreme creation of an era'). Barthes's *déesse* is not about speed, masculinity, or aggressiveness; it is about reflecting surfaces, glass and shiny metal ('the dashboard looks more like the work surface of a modern kitchen than the control room of a factory').[4] It is a showroom experience Barthes draws attention to, in which surfaces are everything and the car might as well not have an engine.

Barthes's DS is a paradigm for modern sculpture, and enforces the point made by Phillip King. Sculpture is no longer concerned with pitted and damaged surfaces but smooth, reflective ones. The meaning of 1960s sculpture is not generally found at the centre, there is not a sense of life force at the centre, or hidden life-giving core. Meaning is on the surface. King's *Rosebud* of 1962 [**57**] flaunts a smooth modern material—fibreglass—and makes new use of colour.

References to the surface of *Rosebud* can also apply to *White Brillo Boxes* [**39**] by Andy Warhol (1928–87) or *Table with Pink Tablecloth* [**40**] by Richard Artschwager (b. 1923). The distinction between Pop and non-figurative sculpture at this moment is less clear than is often suggested. To see claims for the admission of the 'low' into art as in opposition to the preservation of pure abstraction and the unsullied seriousness of 'high' art is too simple a resolution of the 'high–low' debate. Both reject the 1950s, its subjects and its materials, and both reframe the idea of the modern. Pop Art does this through reference to modern life and new methods of marketing and communication, like advertising. Non-figurative art does it through the use of modern materials, from special metals to glass fibre and injection-moulded plastics. The use of colour in abstract sculpture distinguished the new art from the typical materials of sculpture till then, such as bronze and wood. Unbroken surface colour tended to align even non-figurative shapes with manufactured objects.

The likeness of sculpture to ordinary things depended on the disappearance of the base, which left sculpture resting on the floor in the same way other things rest on the floor. The pedestal was the sign of sculpture's privilege, the primary sign of its difference from other things. One effect of its removal was to raise questions about what that difference actually was, a major concern of the sculptural side of Pop Art. What distinguishes Warhol's *White Brillo Boxes* and Artschwager's *Table with Pink Tablecloth* from real-life boxes and tables? Equally, what distinguishes these cubes from other cubes—in, say, the work of Robert Morris (b. 1931) [**66**]—that are art but are not boxes or tables? Sculpture has always been closer to real life than painting, occupying space, as it does, the same way that people and things

40 Richard Artschwager

Table with Pink Tablecloth, 1964

Artschwager was a maker of functional furniture before turning to three-dimensional formica-veneered wooden objects situated as close to the boundary between sculpture and the everyday world as Warhol's *Brillo Boxes*.

do. The space of painting is fictive, an approximation to real space created entirely by the painter. The decline of the sculptural base accentuated this contrast between the new three-dimensional art and a traditional, framed painting, because a pedestal does for sculpture some of what a frame does for painting, isolating it from its surroundings.

The three-dimensional art of the early 1960s, whether it is the pure non-figuration of Minimalism or the new realism of Pop, is constantly involved with cubes and boxes and the way we regard them in relation to manufactured objects. Even painting could approximate to an object. In 1957, for example, the French painter Yves Klein showed at the Galleria del Naviglio, Milan, uniformly painted blue canvases on supports projecting them forward from the wall, so that the painted canvas could be regarded as an object in itself. Klein's work of this kind was later, in 1965, included by the American artist and critic Donald Judd (1928–94) in his definition of 'specific objects'.[5] Specific objects were artworks which Judd saw as forming a new category between painting and sculpture and relating to both, distinguished by having few or no internal parts (no 'composition') but possessing overall distinctiveness as objects. Painters as different as Jackson Pollock and Morris Louis belonged in this category because the 'all-overness' of the painting meant that one was no longer looking at paint on canvas, but at paint and canvas as one thing. The painting was a kind of object. Looking at the problem from the angle of sculpture, the same issues were important: composition is replaced by unity of form, so that the sculptor is no longer admired for compositional skills but for setting up discourse between art and life, or art and the manufactured object.

If the category 'sculpture' seems at this point under pressure—difficult to distinguish, at the extreme, from objects in life and certain kinds of painting—it was not the first time in the twentieth century that this had happened. Much of earlier twentieth-century sculpture, Constructivist art in particular, stemmed from Cubist painting and collage, and from Picasso's extension in 1912 of collage into constructed reliefs, and not from the figurative tradition of Rodin or any tradition that belonged exclusively to sculpture. The transformation of sculpture from solid volume to networks of lines in space, as it occurred in the work of Gabo and others around 1920, could not have happened without the mediating influence of Cubist painting. The precedent of the earlier remaking of sculpture through Cubism is a useful warning against thinking of sculpture at any time as a closed category.

Nouveau Réalisme

Popular realism became a debating point in a number of countries around 1960, with Paris–New York forming the major axis in relation to three-dimensional art. *Nouveau Réalisme* was founded in Paris in

1960 and key members—Yves Klein, Daniel Spoerri (b.1930), Jean Tinguely, and Arman—were initially Paris-based. *Nouveau Réalisme* had an Italian connection through Klein's friend in Milan, Piero Manzoni, and drew support from the Italian of an older generation, Lucio Fontana, whose stature became increasingly apparent as the boundaries between painting and sculpture, and between the fine and applied arts, crumbled. Although centred on Paris, *Nouveau Réalisme* was international, with links to America as well as Italy, and several of its practitioners (Spoerri, Tinguely, for example) were not French by birth.

Although often regarded either as a branch or forerunner of Pop Art, *Nouveau Réalisme* was less concerned with the vividness of modern life than the subsequent Pop Art was to be. *Nouveau Réalisme* introduced objects of everyday life into art, but for the most part without glamour or emphasis on consumption. The focus on consumption within Pop Art was predicated on ideas of abundance and replacement: however many cans of soup are consumed there will always be more. *Nouveau Réalisme*—particularly the work of Arman and Spoerri—was concerned more with retention, as if the basic motivation was fear of loss. The critic Françoise Choay pointed out in 1962 that the present becomes the past so fast that unless in some way preserved it disappears without trace.[6]

The aesthetic shift in much of *Nouveau Réalisme* is away from expressiveness towards a passive, hermetic, and often ironical presentation in which complexity lies in the idea or the process of realizing it, and the end-product may be simple in appearance if not in meaning. Klein's last project was to create a gallery of artist friends by moulding their bodies in plaster, making casts, and painting the casts his patented blue; his own body, as centrepiece, was to be painted in gold. Body-casting—Klein's personal variant on embalming or mummification—was like a challenge to mortality. Klein's planned mausoleum was a reflection on death and loss. Ironically, Klein died at a tragically early age before his project had proceeded beyond the single figure of Arman [**41**].

Piero Manzoni was preoccupied, like Klein, with what their colleague Arman described in 1961 as third-person rather than first-person art. He made work that could be delicate and was often small. It was linked to the person of the artist, in that its point of origin might be a happening presided over by Manzoni. Yet the finished works, like some of those by Klein—who was also a self-dramatist—are paradoxically self-effacing and non-expressive. Mocking the art market's demand for durable art, Manzoni sold his breath in balloons; calling into question what an artist's product was, he sold his faeces in tins. He signed people's bodies and sold them certificates of their authenticity as works of art by him; he cooked eggs for invited friends, which they

41 Yves Klein

Arman, 1962

Arman was the first of a
planned series of frontal
portrait reliefs of the artist and
friends of which this alone had
been cast, in synthetic resin,
at the time of Klein's death in
1962. All were to have been
painted International Klein
Blue against a gold
background, except his self-
portrait, which would have
been gold against blue.

ate, and Manzoni elegantly boxed the shells and sold them marked with his thumbprint as signature. Plinths for non-existent statues bear his own footprint on top, confusing author with subject and parodying the idea of the monumental, and of the heroic status of the artist [**42**]. The conclusive denial of the monument was to inscribe his name on the plinth but position it upside down.

Manzoni was concerned to avoid identifying the artist by means of a conventional artistic gesture or image, conceptualizing it instead as a footprint or thumbprint. In works like these the artist is both there and not there, he speaks in the first person but also conceals himself behind third-person discourse. At one time in the act of creation he is physically closely engaged and the work is a kind of performance, at another Manzoni is distant or concealed, as he speaks through an object that may be ready made, and wrapped, contained, or presented so that there is no outward sign of his hand. There is no apparent authorship in the sense of painterly mark or handworked sculptural surface.

The names of Klein and Manzoni have often been linked, and they have been exhibited together retrospectively. Of the two Klein was closer to the German Joseph Beuys in the sense that he created myths round himself and stayed closer than Manzoni to the traditional image of the creative artist. Manzoni's more intense irony is provocative,

42 Piero Manzoni

Magic Base, 1961

Manzoni's ironical attitude to
the sculptural base was to
leave it empty apart from
footprints where anybody
could, with Manzoni's
approval, stand, and become
a work of art. Manzoni's other
bases included *The Base of
the World*, which is inscribed
with its title upside down
because it is the world
underneath which it upholds.

where Klein's is celebratory. Manzoni, therefore, goes further in opening up to critique the practice of sculpture itself. Within the gestures of Manzoni particularly lies a rejection of any kind of public art, and a refusal to engage conventionally with an art world devoted to art as a commodity. This was a response to the institutionalization of modern art in the 1950s. *Nouveau Réalisme*, with the critic polemicist Pierre Restany as co-ordinator, attempted to re-establish a true avant-garde of a kind that had hardly existed through most of the 1950s. Herbert Read stood for the general idea of an avant-garde as valuable and worthy of support. Restany spoke, as Alloway had in London in the 1950s, for particular interests at a time when the avant-garde had become over-generalized and insufficiently self-critical.

Klein's historic exhibition *Le Vide* at Iris Clert's Paris gallery in 1958 presented the space as an empty container. The windows were painted with Klein's trademark blue, but the gallery was empty. Two years later Arman followed in the same gallery with a complementary exhibition, *Le Plein*, for which he gathered heaps of junk, unwanted clothes, toys, kitchen equipment, gramophone records, and the surplus from everyday life, and literally filled the gallery. Though Arman's crowding the gallery lacks the bleak self-effacement of Klein's emptying, Arman had also withdrawn from the space, which was now physically impenetrable. The implications were considerable because art was being re-identified from object to space. Instead of being something separate from everyday life, this work of art existed in our time and our space until it was disposed of; it was a work of art which could not be taken anywhere else. The art is inseparable from the location. Arman's *Le Plein* was visible from outside through the gallery window, from where the experience of a kind of rubbish tip was given a semblance of order by the architecture which acted as its container. Arman in this way prefigures the device used towards the end of the decade by Walter de Maria (b. 1935) for his Dirt Rooms and Robert Smithson (1938–73) in his Non-Sites, which are also about undifferentiated material, soil and rubble, constrained by rooms or boxes.

Nouveau Réalisme brought art back into contact with everyday life—or, more precisely, the everyday object—in a particular and quite limited manner. This is because *Nouveau Réalisme* was concerned with time. Modernist sculpture, raised on a pedestal and withdrawn from life, can be thought of as ideal and outside time, but objects with everyday reference are less easily seen in that way, least of all Arman's highly styled objects such as door handles [43] or fashion shoes. *Nouveau Réalisme* is ambivalent, however, in that it deals with ordinary objects but withdraws them from use or touch. Arman achieves the low-keyed melancholy of his *Accumulations* by draining everyday objects of the life that is acquired through use and the familiarity gained from touch. They would end up like museum exhibits, publicly visible but pro-

43 Arman

Les Egoistes (Accumulation),
1964

Arman's *Accumulations* in the
early 1960s were mainly used
domestic objects gathered
and displayed in transparent
containers so that there were
enough for the form of the
whole to predominate over
the single example, but not so
many as to make the sense of
quantity completely dominate
over singularity of form.

tected from contact by glass, were it not that the abundance of like objects denies special value. Sculpture is about the way materials are brought together, and had conventionally been about composition. Much 1960s sculpture—*Nouveau Réalisme*, Pop Art, Minimalism—rejected traditional composition in favour of addition, repetition, piling, or Arman's accumulating. Some Americans, such as the Minimalist Donald Judd, saw composition as European and old-fashioned, in its nature a way of creating the hierarchies, formal ones in this instance, that a more democratic art would avoid.

Treatment of time is important to Daniel Spoerri, an assemblage artist who creates works that focus on objects associated with a particular moment, a meal half eaten, a child's play-pen full of toys. Individual elements are stuck firmly down, and objects one would expect to see on a table or floor are encountered on the wall, where the fact that they do not fall off is the measure of the work's unnaturalness, its release from temporality. Spoerri is here like Robert Rauschenberg (b. 1925) with his 1955 *Bed*, shifting a naturally horizontal ensemble of mattress and bedding, with all its evidence of human use, to the vertical, where it hangs like a painting, no longer accessible to touch and certainly not to use. *Nouveau Réalisme* is concerned with preservation, and also with absence: it focuses on real life at the point where the active element, the human presence, has gone.

The Bulgarian-born Christo (b. 1935) and the French-born Jeanne-Claude (b. 1935) have used urban and rural environments. They have often used fabric walls and curtains as ways of forcing different perceptions of space on their audience. They moved into the sphere of public art (in what is, admittedly, not a typical work) by acting on public space. While *Le Plein* and *Le Vide* of Yves Klein became public events because the sensation they created caused a police presence, their

primary meaning relates them to the sphere of art. But *Wall of Oil Barrels–Iron Curtain, rue Visconti, Paris, 27 June 1962* by Christo and Jeanne-Claude [**44**] was different. Rue Visconti is a narrow street with historical associations (Racine, Delacroix, and Balzac all lived there) and Christo and Jeanne-Claude blocked it off for an eight-hour period—without the permission of the Paris *Préfecture*—during the evening of 27 June 1962. The work was a barricade as that word is understood in both the troubled history of Paris as a city and the history of France at that moment, when the Algerian crisis brought it to the brink of civil war. The Berlin Wall had been constructed in August 1961, and political control over the movement of urban populations was topical. But the *Wall of Oil Barrels* was not simply political commentary any more than it was a work of 'pure' sculpture in the Modernist sense. As an alteration to the urban fabric, temporarily inhibiting passage, it highlighted freedoms that are normally assumed, such as walking down a street, and draws attention to the environment and how we use it. What was commonly called 'public sculpture' in 1962 was really private or élite sculpture in a public place. The *Wall of Oil Barrels* takes public issues into genuine account, and looks forward to the situation towards the end of the 1960s when sculpture, spurred partly by the crises of 1968, was to discover a critical role *vis-à-vis* established customs and institutions.

Nouveau Réalisme would no more have taken the form it did than the new American art would have without the presence in both countries of Marcel Duchamp (1887–1968). Duchamp had designated his first ready-mades in America in 1915. His appropriation of manufactured objects as art in the form of ready-mades, laying stress on context (where the object was and how it affected its surroundings) rather than artistic grammar or form, had caused Duchamp to be marginalized by Greenberg's Modernism, and by the 1950s Duchamp's was more or less a lost reputation. Around 1957 his fame began to revive, with an exhibition that year at the Guggenheim Museum in New York. In 1958 a collection of his writings was published, and in 1959 a major monograph with a catalogue of his work in French and English editions was prepared by the French artist and writer Robert Lebel, accompanied by small exhibitions in Paris, New York, and London.

Duchamp's contribution in the ten years before his death was unique and in some respects a repetition of the challenge he had laid down when he abandoned painting in 1912 and turned his attention to objects. He had been a successful Cubist painter, giving it up partly because he feared what he called the 'retinal' in painting—the seductive appeal of paint marks to the eye—and embarked on the ready-mades, designating as art objects of everyday life to which, in some examples, no alteration had been made at all. As with the ready-made after Cubism, Duchamp helped now to draw art away from the painterly

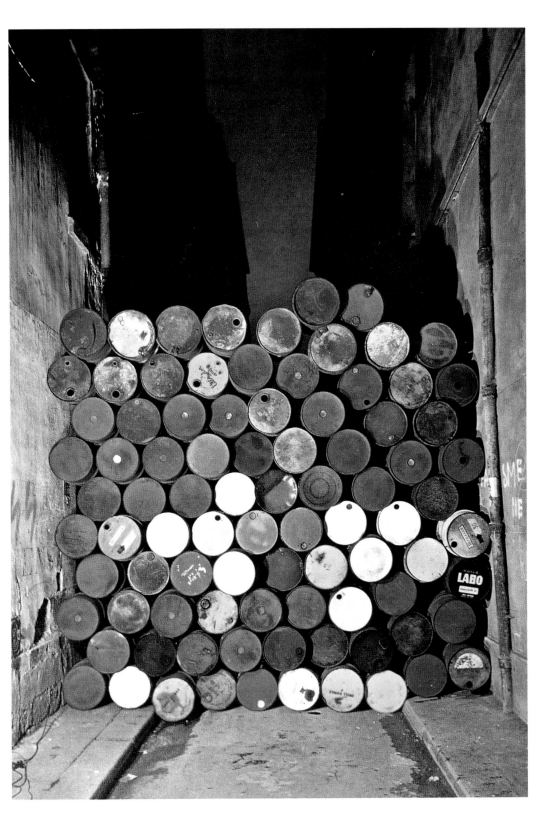

gesture, the first-person mark, to the already known object. The effect was a shift from authorship to discourse and from the object to space.

The *Nouveau Réaliste* interest in enclosure, packages, and boxes reflects Duchamp's packaging of his personal history, first in the *Green Box* (1934), an assembly of personal documents related to his art, and, secondly, in *La Boîte en Valise* (1938), a collection of reproductions of his work. These boxes both existed in editions, and therefore played down uniqueness and opened up what was to be a significant debate within Minimalism concerning the right of artists to remake their work at later points in time without loss of authenticity. Duchamp's willingness to remake lost ready-mades and his decision in 1964 to authorize the Milan art dealer Arturo Schwarz to make limited editions of his earlier ready-mades is another aspect of this.

Johns and Rauschenberg

The three-dimensional work of Jasper Johns (b. 1930) includes flashlights, light bulbs, beer cans, and paint brushes in a coffee tin. They are common objects that have no history in sculpture, and are made in different ways—from bronze, modelling clay, or papier mâché, and incorporating the object itself. Because they are the same size as the small objects they resemble (and may indeed *be* the objects they resemble), they are smaller than sculpture usually is, a size we normally associate, in objects that are not for use, with ornaments or toys. Johns's work has been discussed in terms of its impenetrability. Alan Solomon regards his art as to be looked at and not into,[7] and Leo Steinberg thinks of his works as 'whole systems', remarking on the impossibility of taking them apart.[8] They are passive objects rather than active; Steinberg describes them as 'done to', and in this sense they oppose the active principle of Abstract Expressionism.[9] Such comments—that they are to be looked at rather than into, that they are passive, 'done to', and whole objects—align Johns's work with that sculpture which is identified through surface and not through core, with the Pop Art of Warhol, or with Minimalism. While Johns shared Pop Art's concern with language, how we recognize something as a work of art, or as a thing of the world to which we give a certain name, such as a flashlight; but he was less concerned with what was specifically modern and, unlike Warhol's a few years later, Johns's goods are unbranded. While Warhol refers specifically to Brillo, Johns searched the shops for a flashlight possessing the least distinctive style. In this way he directed attention away from sign value to the more detached issue of a sculptural object's relationship to the same object in the world. Johns was close, in this respect, to Duchamp, and it is remarkable how quickly, after encountering Duchamp and his work in 1958, the influence of the older artist is intensely felt. One reason is Johns's interest in language. His language is ironical, and irony, as a simultaneous combination of affirmation and

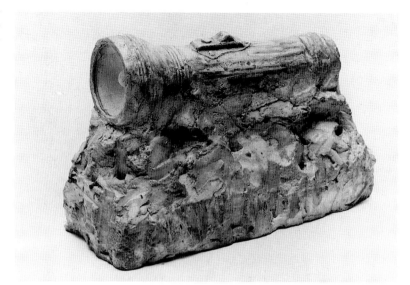

denial, relates to discourse, and not to the still current American interest in the late 1950s in 'expression'. Johns had his first exhibition in Paris in 1958, and there is much in the stillness and silence of *Nouveau Réalisme* which his own art shares. Impassivity was more developed in French art than in American in the late 1950s, and would have drawn Johns to Duchamp in the context of an American art that had done little more than start to react away from Abstract Expressionism.

Duchamp's ready-mades were the only precedent in 1958 for the scarcely mediated appropriation of the everyday object that Johns's sculptures represent. But Johns's sculptures are not ready-mades: even when the actual object is used as a foundation for a sculpture, it may have modelling clay pressed on it; when the object has been cast in bronze, paint is added to the surface. *Flashlight 3* [**45**], is heavily modelled in a manner that recalls the lying nude of Rodin's *Earth*. With Rodin the marks in the clay are records of the artist's work and commitment to modelling. With Johns modelling is an ironical observation on authorship, and in this sculpture the object in itself and the modelling, as traditional coding for sculpture, remain in the end two separate things. Johns's flashlight sculptures exist in a series of dissimilar images concerned not with formal but with presentational issues; he is concerned not with what a flashlight looks like, but with how it affects us under different conditions of display. The flashlight is an exemplary object rather than significant in itself. *Flashlight 1* [**46**], raised from its base on two pins, is presented as an archaeological specimen in a museum, the pins imposing the idea of rarity and characterizing it as something we can scrutinize but not touch.

Different though Johns's work is in most details from *Nouveau Réalisme*, the two share resistance to the active principle of Abstract Expressionism or French *informel*. By insisting on the principle that

his objects are passive and 'done to' Johns ensures that his works, like Arman's, are dead. Motionless and protected from living things by their sculptured bases (or, where the archaeological metaphor fits, by their pins), they appear extracted from time. The elements that constitute the *Flashlights* are their design as objects, the evidence they carry of being worked on as art, and the concerns they show with display. In these three ways they are coded as museum objects, and Johns helped to open up a subject that was to be viewed from many angles in the years following: three-dimensional art as critique of the museum.

Johns and Robert Rauschenberg took part in, or were influenced by, arts not immediately connected with painting or sculpture. The music of John Cage, which was particularly important in this respect, was not conceived in terms of closed compositions. Cage allowed chance and improvisation to play a part so that his music was defined not only by a score but by a time, a place, and a group of people. Performance was thus also an event, belonging to the audience as well as the composer. Rauschenberg and Johns were also associated with the choreographer Merce Cunningham, who worked with Cage and gave a similarly improvisatory character to dance, introducing natural movements and gestures which brought dance, historically closely associated with artifice, nearer to real experience.

Starting with the relatively small *Empire* (1961), and working up to the much larger *Oracle* [**47**], Rauschenberg constructed works from urban wreckage ranging from air-conditioning ducts to car parts. He set up, as a group, five objects which he wired for sound by means of radios with ever-changing wavebands that could be speeded or slowed by the audience. Rauschenberg's technical partner in this project was Billy Klüver, who had also collaborated with Tinguely on *Homage to*

46 Jasper Johns
Flashlight 1, 1958

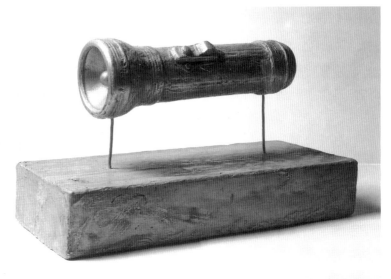

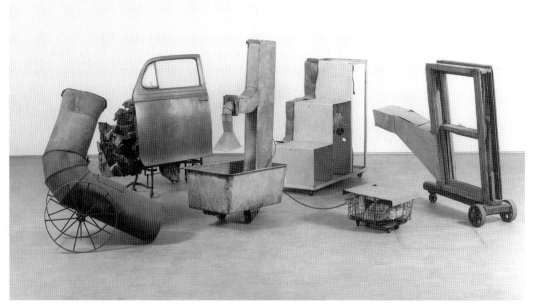

New York [**48**], Tinguely's one-evening orgy of collapsing machinery, in which Rauschenberg himself played a small part. Tinguely had a wild humour which delighted to celebrate the end of the machine age in the city with which it was so closely identified. But Rauschenberg's recovered scrap has a quite different purpose from Tinguely's concern with collapse. Rauschenberg, like Johns, conserves, taking things that have ended their useful life and are due for disposal and making them permanent as art.

Rauschenberg had worked on sets and lighting for Merce Cunningham's dance theatre, and sometimes performed in the dances himself. In 1963 he turned to choreography, devising *Pelican*, loosely based on the the story of the Wright brothers, in which he wore a parachute as landing-gear and roller-skates as aircraft wheels. *Pelican* was figure as machine, while *Oracle* can be read in terms of machine as figures: not literally, but by substitution. The car door is an object that is constantly opened, passed through, and closed, and is thus associated with the human body. Wheels were carried over into *Oracle* from *Pelican*, where tyres had acted as midriff supports to protect the body if it rolled over as the 'body as aircraft' landed. They, also, become identified metonymically with the human body. *Oracle* appears to be an effort, in part, to take performance, an essentially time-based art, and to preserve it beyond time.

The size and scale of Rauschenberg's work and the ambitious way it occupies space is suggestive of a public art; it is clearly not a popular public art, because his work was not for a mass audience. Rauschenberg's *Elgin Tie* of 1964 involved a cow and a barrel on wheels suspended by rope from ceiling. When he organized his friends to pull

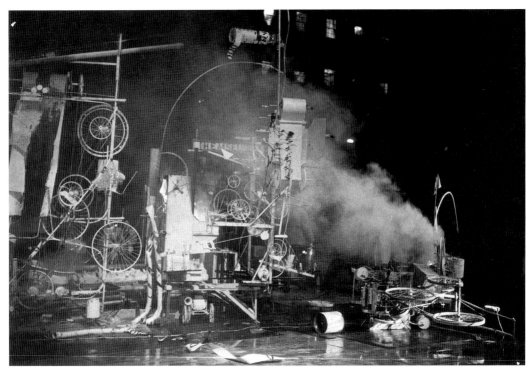

48 Jean Tinguely
Homage to New York, 1960
This was built over three weeks in the garden of the Museum of Modern Art, and, when the motors were started, fell apart in one evening. The junk assemblage included fifty bicycle wheels and a piano. It made various noises and contained a small can of petrol which caused a fire.

his works through the streets on trailers to a gallery for exhibition, the event had a processional character reminiscent of a Renaissance festival or triumph. It was an act of celebration, with an element of public involvement that is natural to performance art, but with undercurrents of parody that questioned the possibility of a celebratory public art in today's world. The range of ambiguity and wit is expressed through forms and structures that parody a public event, whether it is the Wright brothers' plane landing or a triumphal procession.

Pop Art

Between 1958 and 1960 in New York there was rapid expansion of performance art and happenings. The Hansa, Reuben, and Judson galleries were venues for new kinds of art which the protagonist of happenings, Allan Kaprow, regarded as a natural extension of Abstract Expressionism. The Jackson Pollock memorial exhibition at the Museum of Modern Art in 1957 had led many artists, Kaprow among them, to consider how to build on what they saw as Pollock's condensation in paint of the sounds and sensations of urban life. Their answer was to push it out into three dimensions, to bring the city in a more literal sense into art. Following Rauschenberg's inclusion of urban detritus in his 'combine' paintings from the mid-decade, the new three-dimensional art of real space was seen by Kaprow as an extension of painting. Within three years the most interesting artists who followed Kaprow's example, including Claes Oldenburg (b. 1929) and

George Segal (b. 1924), had moved away from performance, from art in which the artist and possibly the audience as well were physically involved, to make objects and installations. Pop Art did not acknowledge the conventional categories of painting and sculpture any more than *Nouveau Réalisme* or the art of Johns or Rauschenberg did. Sculpture is implicitly seen, in the way Alloway described, as belonging to an art, Modernism, that reflected a different social structure. There was not, however, a simple shift from élite to popular: though Pop Art had a larger, and different, audience from Modernist art, 'popular' refers, nonetheless, to the source material not the artwork.

The three-dimensional Pop Art of Oldenburg, Segal, and Edward Kienholz (b. 1927) [**49–52**] shows ordinary people and things or places —café, diner, bedroom—which we can easily recognize and situate ourselves in. Each expresses itself in a puzzling language through use of forms and materials that do not quite make sense in terms of existing conventions. They are strongly pictorial, but are made of real materials and are to scale with the real world. They are tableaux or installations, which are real in the sense that sculpture is real (occupying our space) but also have fictive qualities of make-believe derived from flat art. Understanding their power involves acknowledging the way they cross boundaries between the arts, and especially between the flat arts of painting and advertising and the three-dimensionality of sculpture. They resemble reliefs, which are, in effect, paintings coming out into three dimensions, and even more like theatre. Each of these works has a threshold, equivalent to the proscenium of a theatre, which separates

49 Claes Oldenburg
The Street, 1961
This was installed at the Judson Memorial Church, New York, site of environmental art and dance performances in 1960. It consisted of scattered wall-hung and pendent fabricated junk (made of spray-painted corrugated cardboard), evocative of street life on Manhattan's Lower East Side. The public was invited to add their own detritus. It is seen here reconstructed at the Reuben Gallery, 1961.

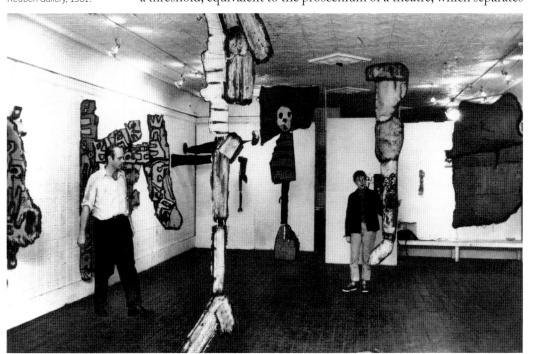

50 George Segal
The Diner, 1964–6
A painter by training, Segal
came to installations through
friendship with the
performance artist Allan
Kaprow. From 1961 Segal
made his figures by encasing
real people with bandages
soaked in plaster, cutting into
the material when it was set
and reassembling it with a
hollow interior.

ordinary space from stage space. With the Kienholz it was originally possible to step from one to the other, to be both part of the audience and on the stage; the Coke machine in Kienholz's café worked. Now that such an installation is valuable in money terms and belongs to a museum, whose function is conservation, it has become solely an object to be looked at, where once they were things to be physically experienced. In introducing theatre to sculpture the Pop Art installation changed the status of the viewer who, in Modernist sculpture, was thought of as a disembodied intellect rather than a physical presence. It was a change that was matched in other sculptural developments in the 1960s and had a profound influence on the medium.

Claes Oldenburg started as a painter and moved on to environments. *The Street* [49] evoked life on New York's Lower East Side with pieces of roughly shaped and painted corrugated cardboard fixed to the gallery walls, rising from the floor and suspended from the ceiling, alluding to figures, buildings, and street rubbish, offering raw and graphic encounters for gallery visitors and evoking life at a basic level. In this respect Oldenburg owed much to Rauschenberg, whose combine paintings have been described as being like places, where disconnected things come together and co-exist side by side. Oldenburg continued in 1961 with *The Store*, a narrow shopfront opening on to East 21st Street where the artist had a 'kitchen' studio at the back—to create painted plaster food which he sold at the front. There is an element of theatre, with the artist as performer and sculptor, using the front of his workshop in lieu of a dealer/gallery through which to sell his own production. Installations such as *The Street* and *The Store* were the work of artists or collaborations of artists with dealers who were willing to stake resources on enterprises with limited profit potential. The rapid turnover of dealers and exhibition spaces between 1958 and 1961 was the result of what was in effect a challenge to the dealer system. Oldenburg and others in their early work were disputing high art not only through their subject-matter but also in the way they presented it. The problem was that the art market had not at that stage developed a way of supporting non-profitable forms of expression, and by 1962 the establishment of Pop Art marked a return to a more conventional object-based art more suited to the market system.

The physicality of Oldenburg's art and the expression of images of basic survival and fundamental appetites as seen in *The Street* and *The Store* were rightly identified as having a particular American quality and an origin in Abstract Expressionism. Performance, as practised by Kaprow, Robert Whitman (b. 1935), George Brecht (b. 1925), and others, was messy and physical, with a sensuality and engagement that is unlike the practice of Johns or even Rauschenberg, but does have one point of origin in Europe. The European influence is of Jean Dubuffet (1901–85), *Art Brut*, and the international Cobra movement which had

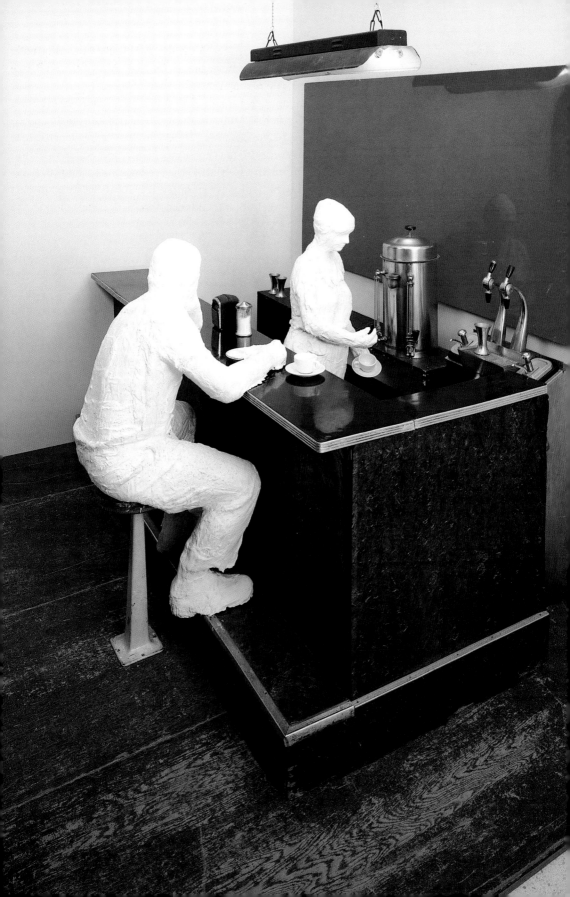

flourished from the late 1940s in Oldenburg's native Scandinavia as well as in Paris. Cobra, a manifestation of north European Expressionism, was involved mainly with painting, assemblage, and relief; it was improvisatory in character and delighted in rich paint and strong colour. The importance of Dubuffet, one of the few Europeans taken seriously by Abstract Expressionists, lay in the interest in street life that haunts his painting, the explicit sexuality of his art, and perhaps most of all in his contribution to the materials of three-dimensional art, his willingness—in the mid-1950s when much European art was enslaved to convention—to use non-art materials such as coke cinders and sponges. Pop Art owes its origin more to painting than to sculpture; indeed sculpture as it was then understood had reached a point of exhaustion by the end of the 1950s. The vitality of Oldenburg's work and its endorsement of sensuality and excess marks the extreme in the art of this moment opposed to the cool irony of Johns.

Oldenburg's environments, for which he coined the phrases 'theatre of the real' and 'theatre of objects', lead directly into installations, which were to be the central contribution of Pop Art to sculpture. 'Installations' differ from 'environments' in that they do not assume the presence of the audience within the work of art: they differ from conventional sculpture in including real space. Oldenburg, George Segal —a friend and early collaborator of Kaprow—Edward Kienholz, and even Tom Wesselmann (b. 1931), who was never part of the happenings or environment movement, were all by 1962–3 making installations or tableaux. These are mainly characterized by having distinct backs and fronts and are extensions of painting and relief rather than conventional sculpture. All the artists used figures of more or less life size; Wesselmann's painted figure backdrops for some of the *Great American Nude* series are larger than life, Kienholz's walk-in installation *Roxy's* (1961–2) has figures two-thirds real life size. In general, these works can be thought of in the same terms as theatre: as being both like life and subject to their own conventions.

Segal makes his figures [**50**] not, like Klein's *Arman*, by casting the body, but by shrouding the model's body in bandages soaked in size, removing these in sections, reassembling them, and painting them white. The result is not smooth like a cast but bumpy and uneven in a way reminiscent of the impastoed painting of Segal's previous practice. The roughness of Segal's figures as well as their whiteness reduces their naturalism. They are often engaged in private activities like bathing or shaving; if they are in a public place they are usually doing things that are not intrinsically interesting, like mounting a bus; even when in company, as in a café, they are uncommunicative. Segal's skill is in the way his figures, though clumsy in shape, seem at one with their environment. He observes how people stand, lean, or bury their heads in their hands, achieving closeness to life without exact imitation.

51 Claes Oldenburg

Bedroom Ensemble, 1963

In this Oldenburg used what he called 'the softest room in the house' to switch from soft objects and bright colours to hard surfaces, sharp corners, and limited colour. 'Nothing "real" or "human".... All styles on the side of death. The bedroom as rational tomb.' (Oldenburg, 1976)

The artists whom Segal's work brings most readily to mind are painters, most of all Edward Hopper, because of the way both artists like to come upon their subjects in the middle of something. Segal's work has fewer sexual overtones than Hopper's but there is an element of voyeurism, nonetheless, because people are unaware that their actions, private or not, are being watched. It is only with three-dimensional art that adopts—as Segal's does—the space of real life, or draws its strength from painting, like Hopper's, which imitates the space of real life, that frissons of the kind Segal evokes can be obtained. Adopting the space of real life implies the need for more or less lifesize figures. This characteristic runs through most three-dimensional Pop Art. In Wesselmann's *Great American Nude* series a naked woman in the bath will typically be painted while the surroundings—a radiator and a towel on a rail—are real. There are things in the ensemble that are taken direct from life, which mean that the whole installation, however much parts of it diverge from reality, will be measured against the real.

Oldenburg's *Bedroom Ensemble* [**51**] had two points of origin in the artist's mind, an actual motel recalled from childhood in which the bedrooms were themed to different animal skins and all the fabric surfaces imitated something else, and an advertisement for bedroom furniture in the *Los Angeles Post* with the room seen in the curious

perspective that Oldenburg adopted. The origin is 'reality' only in the
sense that it is something Oldenburg recalled from 1947 and knew all
the time that his memory was embellishing. Even the perspective,
which is normally thought of as an index of 'truth', the product of the
eye and therefore a sign of actual human presence, was derived from a
graphic designer's fiction. Fantasy and fiction fed into the work, which,
like Barthes's DS, is a part of a modern myth constructed from glamor-
ous surfaces and born of desire rather than use.

Kienholz was an artist on the West Coast, which had its own mani-
festations of Pop Art, derived from the uninhibited expression of Funk
and characterized as a taste for exaggeration and even the grotesque.
The *Portable War Memorial* [**52**] belongs to later Pop Art, when the ini-
tial delights of the new consumerism were viewed through the dark
glass of the Vietnam War. A reproduction in three dimensions of the
famous Second World War photograph of American soldiers planting
the flag on Iwo Jima is posed against a bar, with the table into which
the flag is to be slotted as the element common to both sides. On the
blackboard is a list of all the places that have disappeared from the
world atlas because of conquest, and the clear implication is that con-
sumerism and conquest go hand in hand. The 'portable' of the title,
implying ubiquitous validity, is mirrored in the overall silvery colour-
ing which establishes the object as a single thing. Exactly what kind of
'thing' it is hard to say. Though its size and scale are human and real, its
aura is not. The Iwo Jima photograph was already a museum piece, and
therefore iconic. Significantly, in terms of the work's meaning, the
photograph itself had been posed after the event and to that extent was

not original in the first place. Consciously or not, Kienholz was dealing here, like Oldenburg in *Bedroom Ensemble*, with the problem of appropriation, and the way that objects are converted into signs.

Three-dimensional Pop Art is marked by constant shifts of language and inflection, some of which seem to belong primarily to painting, some to advertising, some to everyday life. Multi-coding is central to its meaning. Distinction must be made, however, between works that are affected by languages belonging to three dimensions and those stemming from advertising and other imagery that belongs to the flat plane and reproduction. Both Oldenburg's *Bedroom Ensemble* and Artschwager's *Table with Pink Tablecloth* are three-dimensional, implying use, even though we know that neither is functional. An 'art' coding points in both cases towards Minimalism and the easily comprehended three-dimensional shape which is wholly within art, while a different code points towards advertising. Both works have the cool 'specimen' character of reproductions in furniture brochures, resembling objects that are not yet in use, that as yet have no human mark on them, functional objects but not attached to function. The plywood that Artschwager's 'furniture' is made of is not the material the objects would be constructed from if they were functional, but a cheaper material appropriate to creating a brochure effect in three dimensions. Play between two dimensions and three, and the codes that refer to each, is central to the sculptural element in Pop Art.

Modernism and Minimalism

4

Greenberg's Modernism

Greenberg's optimism for the future of sculpture in 'The New Sculpture' of 1949, and his conviction that it represented the immediate future for art, was not borne out. In 1956 he condemned contemporary sculpture for its artiness, its need to look 'like' modern sculpture rather than reach its full potential through a process of analysis. The article was written when sculpture, in both America and Europe, was at a low point and a decisive lead had been taken by painting. In 1958, preparing a collection of his essays for the press, Greenberg looked again at 'The New Sculpture', heavily revising it, but almost entirely in a direction that reinforced his earlier thoughts.[1] The tradition of Rodin had led to excellent sculpture in this century (Lehmbruck, Maillol, and others), but was a cul-de-sac; that concept of sculpture was too inherently illusionistic. The sculpted human figure, he might have said, is more like a real human figure than a painted one is because it uses space in the same way. Sculpture, he said, needed to take its lead from collage Cubism, which would liberate it from the monolithic and from tactility, with all their associations with the human body and the real world. David Smith's work remained his paradigm for a constructed sculpture that was non-illusionistic but might be allusive (as Smith's is plainly allusive to the human body without imitating it).

Greenberg's confidence was connected with what he now called the 'concreteness' and 'literalness' of the medium. The very thing that had been a handicap to sculpture when the figurative tradition descended from Rodin had been strong, the likeness of a sculpted figure to a real one, had disappeared with the collapse of the Rodin tradition. Greenberg believed that in a positivist age the actuality of the sculptor's material was an advantage, so long as illusionism introduced by the human figure—or tactility or palpability (the values Read had attributed to good sculpture)—were not there to compromise it. 'The human body is no longer postulated as the agent of space' is the remark that defines the revision in 1958 of the earlier article. Greenberg's form of positivism forbids illusion, but permits allusion in work (such as Smith's) where the fundamental rules of sculpture are observed. These 'rules' are opticality or the essentially intellectual understanding of

forms in space—in contrast to an understanding through touch or the direct association of qualities in a sculpture with the tactile properties of the human body. It may seem contradictory of Greenberg to put a higher value on sculpture, which is made of materials that other things in the world are made of, than on painting, which is a medium exclusive to art, when the 'opticality' that sculpture should observe implies a cerebral and not a physical understanding of form. The revised article introduced a concept, fundamental to an understanding of Greenberg's Modernism at this stage: 'Instead of the illusion of things, we are now offered the illusion of modalities: namely that matter is incorporeal, weightless and exists only optically like a mirage.' The materials of sculpture, he might have said, are actually heavy and subject to gravity, but are not felt as being like this, because sculpture is experienced imaginatively and not as a thing in the world.

Britain's New Generation

After David Smith, Anthony Caro was to be the sculptor who fitted most precisely Greenberg's concept of sculpture. When Caro first visited the United States at the end of 1959 with the encouragement of Greenberg—whom he had met in London—he was modelling figures captured at a moment of animation, such as rolling over or waking up. Caro was concerned directly with the body, and not, like the older 'geometry of fear' sculptors, with the body as metaphor for something else. In America Caro saw Smith's work at first hand, and on his return he started to work with welded steel which he painted a single colour in order to neutralize the 'industrial' effect it would otherwise have had. Caro did not want the kind of associations with heavy industry, the raising and balancing of large weights, and suggestions of instability held in tension, that emerge in the work of a sculptor like the American Mark di Suvero (b. 1933). Di Suvero is closer to the Abstract Expressionist painting of Franz Kline, much of whose work was inspired by the industrial landscapes of Pennsylvania. Di Suvero's sculptures [53] have metaphorical implications in relation to the idea of work and industrial processes, which Caro's do not. Caro is a more abstract artist. He used steel plate with a minimum of bending and twisting, and in order, as he said in 1961, to avoid 'too much personal processing',[2] he treated materials strictly as a medium of expression, not as substances on which to impose his will.

Caro's sculptures work as sequences of statements or gestures following from one another empirically, without prescription or closure. There is a suggestion of time lapse in the development of the forms, so that words like extent and extension, punctuation and grammar, which one could use of Smith's earlier work, are appropriate for Caro too. They are words that derive from literary expression, and Caro's works are structures in the way that sentences are structures. His work is

53 Mark di Suvero

Ladder Piece, 1961–2

Di Suvero's large constructed sculptures use found materials (used iron and splintered wood) in their existing states— unlike the work of David Smith or Anthony Caro, in whose work found materials are less likely to recall former uses.

relational, unlike American Minimalism, and not concerned—in one of the terms by which the sculptor Robert Morris sought to character- ize Minimalism—with 'gestalts', simple and immediately recognizable forms.[3] Morris argued that every internal relationship reduces the pub- lic, external character of the object, and tends to eliminate the viewer to the extent that these details pull him into an intimate relation with the work and out of the space in which the object exists. Caro would see that not as a problem but a virtue.

In 1963 Caro exhibited new work [**54**] at the Whitechapel Art Gallery, London, with an accompanying catalogue written by the critic-historian Michael Fried, who shared many of Greenberg's views. Fried argued that Caro's sculptures were a stage in the development of the language of sculpture since Rodin, a language that was not just one of form; he was emphatic that Caro's work could not be understood only in formal terms. Fried described it as a language of gesture, mean- ing expression that may be pre-linguistic, or for which words do not suffice. He regarded Caro's work as responding to a lack in modern so- ciety. 'We have less and less need', Fried quotes the philosopher Stuart Hampshire saying, 'of poetry, fiction and the visual arts for the explo- ration of social realities, as we have more and more need of them…for indirectly revealing disavowed forms of experience that are in conflict with social roles.' In the face of increasing specialization and the stan- dardization of behaviour imposed by modern civilization, Hampshire says, 'a condition of sanity [is] that the unsocialised levels of the mind should be given some ordered, concrete embodiment and thereby made accessible to intelligence and enjoyment'.[4]

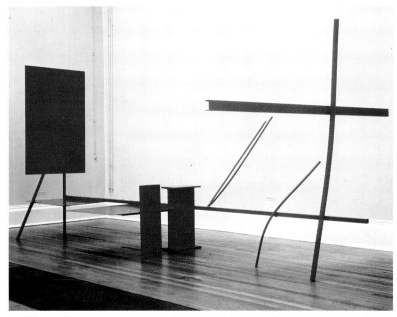

This affirms an avant-garde stance that reaches out to experience beyond the parts of the mind already levelled by standardization, and pleads for the poetic, especially its realization in sculpture, because sculpture can fulfil a function in this respect that painting cannot. Being three-dimensional, sculpture shares the corporeality of the body. Sculpture, therefore, can create figurations and liberate gesture in a way painting cannot. Sculpture's traditional problem, militating against this, had been gravity and the risk always that it was liable to be, not gesture, but object. Caro's answer was to eliminate sculpture's base and, by means of complex forms and lateral extension, to replace gravity with the appearance of weightlessness.

The idea that Caro's sculpture can liberate gesture does not make it like a body in a mimetic sense, but the release of gesture does depend on the relational character of the sculptures. Both Fried and Greenberg, Caro's keenest early champions, stressed the way his sculptures resisted objecthood. This distinguished them from Minimalism and led Greenberg to pick up on and further emphasize Fried's core argument that 'everything that is worth looking at in Caro is in the syntax'. The defence of Modernism against Minimalism, for which, in respect of sculpture, Caro was the key, hinged on the distinction between objecthood and syntax: not, in the Modernist argument, primarily for formal reasons, but because syntax permitted the release of gesture. When Fried wrote about Caro in 1963, Minimalism, or objecthood, was scarcely an issue. But when Fried returned to the argument in 'Art and Objecthood' in 1967[5] it was in defence of his position against the contrary positions taken by Morris, especially, but also Donald Judd and the architect and Minimalist sculptor Tony Smith

(1912–80). Refining the earlier argument, Fried described the way Caro's work could 'defeat, or allay, objecthood by imitating, not gestures exactly, but the efficacy of gestures; like certain music and poetry, they are possessed by the knowledge of the human body and how, in innumerable ways and moods, it makes meaning. It is as though Caro's sculptures essentialize meaning as such.'

Caro's sculptures do not gesture, they are not straightforwardly metaphors for the body, but they show how gestures can be made in sculpture, and it is in that sense that they are what Fried called 'radically abstract'. The importance of their resistance to gravity was that they should do what Greenberg had felt the best Modernist sculpture did: affect the beholder not by touch or presence but cerebrally or optically. The problem with Minimalism, from this point of view, was that it was theatrical, because it existed for an audience, and the experience of a Minimalist work of art was incomplete without the spectator. If that was so, then not only was a presence an active element, but temporality was also, because seeing is something that takes place in time. Greenberg's purpose in using the apparently slightly strange word 'optical' (strange because all sculpture is seen) was to create a sense of something taken in spontaneously, not realized temporally. The word 'cerebral' makes the point more clearly.

Caro's own view of how his sculpture is seen envisages the experience of someone witnessing it from close to as a set of relations, and not seeing it distantly as an object. A difficult question is how any one view of so complex a sculpture can be complete enough by itself to avoid the need for multiple views, involving sequence and reintroducing temporality. Fried's answer is that there is a form of apprehension that can understand as a whole at a single point in time a thing that has already been comprehensively surveyed, without actually seeing it as a whole at that one moment. Such an understanding is also at the centre of Fried's argument when he makes the distinction in 'Art and Objecthood' between 'presence'—the Minimalist object which is looked at across space and in time—and 'presentness'—the sculpture, such as Caro's, which is the subject of instantaneous apprehension. Rosalind Krauss, taking a retrospective view, summarized this issue as being the nature of experience: the effect being to produce the illusion in the viewer that he is not there, an illusion that is set up in reciprocity with the status of the work of art as a mirage. It is not there and he is not there—a reciprocity of absence that she quotes Fried as calling a supreme fiction.[6]

The sculptors who were inspired by Caro's example and gathered from the late 1950s at St Martin's School of Art, where Caro was a teacher, became known as the 'New Generation' when they showed together under that title at Whitechapel in 1965. The following year they exhibited alongside the Minimalists in the 'Primary Structures' show

at the Jewish Museum, New York. The New Generation rejected traditional materials and methods; carving and modelling were replaced by moulding, joining, or constructing. They used materials—plastics, fibreglass, or metals—for what they could do rather than for any association or ideology. While they preferred materials with industrial or manufacturing associations to traditional sculptural materials like bronze, most of the younger artists turned away from Caro's use of steel in favour of fibreglass and plastics. They all abandoned the base, so that their work stood directly on the ground in the same way that a person or an object does. They shared an interest in human scale, which established their sculpture in relation to the non-art objects that surround us in everyday life. New Generation sculptors avoided the monumental.

The New Generation liked strong colour, either as integral to the material or applied as a skin, and their colours often created associations with the world of product design and manufacture. Colour took on something of the role it had hitherto had only in painting, and Matisse's later paper cut-outs acquired special prestige in the 1960s because they fulfilled the exemplary role Greenberg advocated of sculpture as an extension of collage with the strong colours that most

55 David Annesley
Swing Low, 1964
Annesley's sculpture illustrated here, like that of Caro, King, and Tucker, stands directly on the ground in the same way that people and things do.

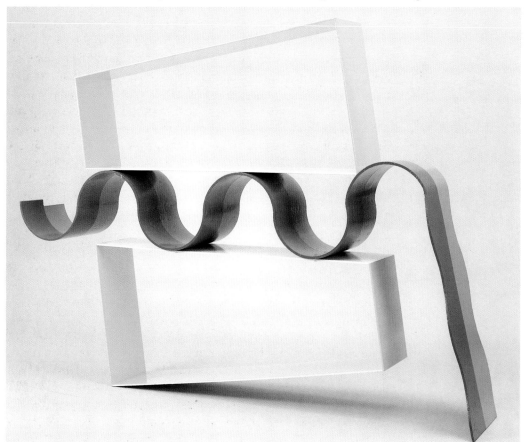

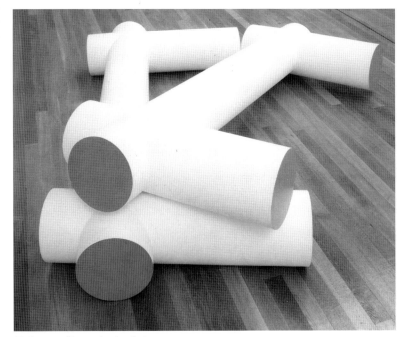

Cubist collages lacked [**55**].

The New Generation looked to Caro, in several cases, as teacher and subsequently colleague at St Martin's School of Art, and as an artist who had raised the professional standards of British sculpture. As a sculptor, however, Caro stood somewhat apart, for the very reasons that the relational, syntactical character of his work appealed to Greenberg and Fried. For the most part New Generation sculpture was more integral, more a single form than a composition of forms. If, like *Series A (Number 1)* (1968–9) by William Tucker (b. 1935) [**56**], it was made of more than one form, its realization was more by assembly, or simply laying things together, than by composition. When the New Generation was shown in the company of American Minimalism at the 'Primary Structures' exhibition in 1966, critics (who were mainly American) preferred the simplicity and directness of Minimalism. Seen in the context of Caro, a work like Tucker's looks Minimalist.

Caro's purposefulness in starting anew in 1960 was matched by Phillip King's decision in the same year to destroy his existing work. King's 1960s work was formally varied, exploring the limits of sculpture, with closed forms followed by open ones, minimal statements followed by formally complex ones, and always the subservience of materials to purpose. He is concerned in *Rosebud* [**57**] with surface as a taut skin with little implication of weight, and with volume as such being less important than the tension of the surface. While Moore, for whom both Caro and King had worked, endorsed the early-twentieth-century sculptor Gaudier-Brzeska's assertion that 'sculptural energy is the mountain',[7] and addressed this idea in his work, King uses a 'moun-

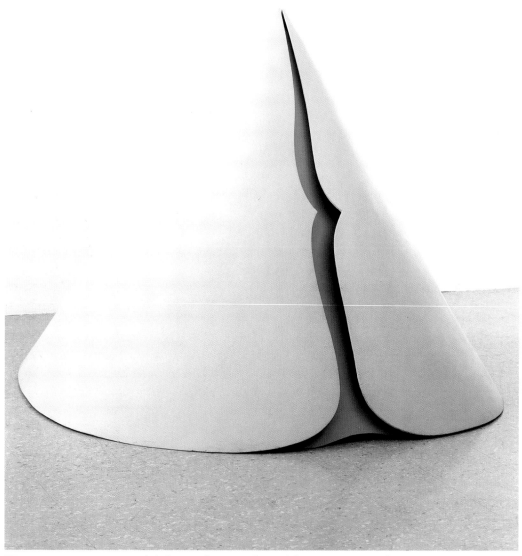

tain' shape, the cone, but without a mountain's massiveness. King has used as sculptural metaphor the least weighty aspect of the body, the lungs, by referring to sculpture as being about breathing in and out. *Rosebud* is like a shape captured at the moment of optimal tension; it is not awkwardly inflated, but it is not loose or slack either.

King's sculptures are described by words like expanding and contracting, propping and leaning, and—with reference to the aperture at the front of *Rosebud*—peeling and opening. But there is a paradox, in that however much such words suggest changes of state, King's sculptures do not imply motion. New Generation sculpture, like

Minimalism, rejects the restlessness of 1950s informal art and the pitted and broken surfaces of the earlier decade's bronzes in favour of calmness, smoothness, and seamlessness of manufacture. New Generation art, despite the strangeness and unfamiliarity of its sculptural forms and colours, was a classical art, not provisional but resolved and complete.

William Tucker expressed the notion of stability in this kind of sculpture through the words of Hannah Arendt, who wrote in *The Human Condition*:

It is … durability which gives the things of the world their relative independence from men who produced and used them, their 'objectivity' which makes them withstand, 'stand against', and endure, at least for a time, the voracious needs and wants of their living makers and users. From this viewpoint the things of the world have the function of stabilizing human life, and their objectivity lies in the fact that—in contradiction to the Heraclitean saying that the same man can never enter the same stream—men, their everchanging nature notwithstanding, can retrieve their sameness, that is their identity, by being related to the same chair and the same table.[8]

New Generation artists were conscious of reacting against the naturalism and contingency of figure sculpture of the 1950s. For this reason they turned to objects which, Tucker argued, were descended generationally and existed in 'families' of their own, in parallel to the human world; the object world depended, of course, on the human world for its continued existence, but its particular significance was in its durability, the fact that in a world of continuous change the object was still there. For Arendt the 'object' meant an object of use—the 'same table', the 'same chair'—while for Tucker it was the 'object sculpture'. The difference was tangential. Without a base to separate it from other objects, and of a broadly similar size to articles of day-to-day use, the object sculpture becomes like an object of everyday life; it was different only because it was unique, it was not useful, and it was art. Tucker shared with Greenberg and Fried the concept of sculpture as a private art with its proper location as the museum, where its audience would be already well disposed, rather than the street or egalitarian space, where it would be matched against a definition of public sculpture. Public sculpture became a renewed issue in the 1960s, but by the end of the decade Tucker was asking in print whether the loss of the sculptural base was beneficial, as it had at least protected what he called the 'internality' of the sculptural object.

New Generation sculpture shared with Minimalism a resistance to tricks: whatever value it had came from the sculpture, from the materials, the way it was made, and the decisions taken by the artist along the way. On the other hand, its forms were much less pre-determined. King, at least, insisted that if the pathway to completion was laid out at

58 David Smith

Cubi XXVII, 1965

This is one of David Smith's last works. Constructed in stainless-steel welded-box forms, and twice human height, it has a monumentality that even the taller of Smith's earlier works do not aspire to.

the start, then it was not worth taking. His specific criticism of Minimalism was that it lacked craft. He did not mean absence of handicraft or of a certain kind of look. He meant, rather, that there must be evidence that the sculpture had been made by an artist as the result of a sequence of interlocking decisions. Minimalist art could be—and often was—specified by an artist and manufactured in an industrial workshop.

Minimalism

David Smith was the established sculptor who most successfully remade an existing reputation in terms of new priorities. Rejecting anything over-elaborated or artful, he seemed aware of the strictures Greenberg had expressed in 1956 (from which he alone had been exempted), and his final series, the Cubis, were impassable, in the sense that to go further with sculpture after Smith's death in 1965 meant to reframe the ambitions of the discipline.

Cubi XXVII (1965) [**58**] has a strength and even severity stemming from its box-element construction—in contrast to the welded rods of *Blackburn*—and a unity from the treatment of the sanded steel. Smith's new work moved some way in what was to be a main sculptural direction of the sixties, from composition to assembly, making use of elements, that is to say, which are simply joined, rather than composed so as to modify one another. Though Smith did not go so far as the Minimalist artists in making his work predictable and self-explanatory from any angle of vision, he was concerned with a frank and uncomplicated relationship with the spectator. His art is accessible in the sense that there is nothing hidden, yet it does not depart from established languages of art to the extent that Minimalism did. At no point did Smith's work disallow psychological readings, nor was his new work a denial of the earlier. His sculpture became increasingly architectural. In *Cubi XXVII* [**58**] we seem to be looking at a threshold or gateway, with raised step and enclosed opening. Smith's preoccupation in the 1950s with metaphors for the standing figure is extended here beyond the figure itself to what might be thought of as a location for the figure (which is a possible description of architecture). To talk about the human figure at all in the presence of such resolutely non-figurative forms may seem paradoxical, but reference to human presence is a major preoccupation of non-figurative sculpture when the sculptural base has been eliminated and sculpture's space is the same as our own.

The key to this change was Minimalism. The word Minimalism was coined only in 1965 of the work of individuals (who were not a group and in some cases objected to the designation), among them Donald Judd, Dan Flavin (b. 1933), Sol LeWitt (b. 1928), Robert Morris, and Carl Andre (b. 1935) [**59–61, 64–5**]. Minimalist art tends to be symmetrical, to rest squarely on the ground without mediation from

59 Donald Judd
Untitled, 1969

Though Judd's 'box' sculptures have been seen as a search through reduction for ideal forms, the artist was anything but an idealist, not looking for an overarching philosophy or metaphysic. His concern was with the perception of physical facts, with what we know, and how this can be presented in a spare and unambiguous way.

a base (it may also be a wall relief). A Minimalist work behaves like any other object and does not resist gravity by being raised on a pedestal. It is either wholly visible to a spectator from one viewpoint or, if not, the invisible parts will be congruent with the visible ones; there are no secrets and no twists in the tail.

Minimalism stresses outsides and surfaces rather than cores or middles, and is likely to made of a 'modern' material such as plastic; if metal, it may be shiny and rustproof, even reflective. (Andre's materials are more varied, and include brick and wood.) With exceptions, Minimalist art has characteristic size and scale. (Size is an absolute, while scale is relative and measures the size of the artwork relative to human size.) Finally, Minimalist art is likely, at its simplest, to be a single symmetrical object, or to be assembled by the repetition of single symmetrical objects; it will not be constructed from elements that are radically different from one another. Minimalism was a non-hierarchical art, not only in its forms and structures, but in its refusal to fetishize the figure of the artist. At the extreme, Andre (influenced by Russian Constructivism) preferred the word 'worker' to 'artist', and several members of the Minimalist circle were involved with the radical Artworkers Coalition in 1969. If the artist was thought of as within the structure of society, rather than poised eccentrically on the edge, and art was regarded as equivalent to other forms of work, it was logical that the artist might, instead of being a pure inventor or creator sealed off from society in the studio, engage with the world. This did not involve making crudely 'social' or 'political' statements; it implied

60 Dan Flavin

'Monument' for V. Tatlin, 1966
Flavin's neon tubes activate
the space of an exhibition
gallery and particularly when
installed in groups call
attention to overall room shape
and architecture. Minimalists
were interested in Russian
Constructivism, and Flavin's
homage is to Tatlin's interest
in non-sculptural materials
and sculpture's relationship
with architecture and the
everyday world.

61 Sol LeWitt
1 2 3, 1978
LeWitt's consistent art is concerned with repetition of units, and sometimes permutation. He described it in 1967 as 'conceptual', meaning that all decisions preceded the execution of the work, but rejected the notion that the 'concept' corresponded to any transcendental idea or feeling. In origin, the work was intuitive.

making work that faced outwards to its surroundings. That was why it was important that Minimalist art implicated the viewer and related to ambient space. It was from this aspect of Minimalism that the idea of art as social critique emerged. Sol LeWitt was particularly adamant that the age of the avant-garde was past and with it the value of personal expression and development. He used almost exclusively cubic forms because they were, he said, the least aggressive of forms and the least emotive. One might add that LeWitt's open cubes have a relationship to architecture, the 'social' art which his own work is contingent to. The permeable character of LeWitt's cubes gives them an undogmatic character; they suggest opening up rather than closure. Later artists, like Gordon Matta Clark, who took sculpture a step closer to architecture, working directly with buildings, profited from the open connected forms of LeWitt's art.

Minimalism was American, specifically East Coast American. The work of some West Coast artists, like Robert Irwin (b. 1928), Larry Bell (b. 1939), and even James Turrell (b. 1943) with his light projections [62] bear close resemblances to Minimalism. But Minimalism was not just a matter of visual similarity: even if there are visual likenesses between different Minimalists' work, Minimalism was never a style, and it is better defined in terms of certain modes of art production allied to particular principles. It was a movement that was closely debated verbally,

with some of the artists themselves taking the lead.

Minimalism arose in part from a feeling of need (articulated in print by Judd) to reject art's European past and the preoccupation since the Renaissance with composition. It had an ambivalent attitude to Abstract Expressionism: on the one hand it rejected gesture and modulation of surface as compromising unity, and Minimalism's coolness is the antithesis of 1950s angst. On the other hand Donald Judd reframed Abstract Expressionism to view it in one particular way as a precursor. As Judd saw it, Minimalism built on and refined his larger category 'specific objects', in which he searched in a wide variety of new two- and three-dimensional art for the principle of oneness or singularity.[9] The painting of Pollock had that oneness if it was seen in its 'all-over' aspect, but not if seen, as Modernists like Greenberg saw it, as developing the relational, compositional aspects of Cubism.

Robert Morris explicitly rejected the relevance of Cubism on the grounds that it was composed and relational. The rejection of Cubism was not peripheral to art theory but a body blow to Modernism and a reminder that, though Modernism was theorized in America, its paradigmatic art was European—Cubist and abstract. Though in retrospect Minimalism fits more comfortably into the continuum of avant-garde art than it seemed to in the sixties, it was nonetheless a declaration of independence.

A parallel argument would say that earlier European art was still

62 James Turrell
Afrum Proto, 1966
Like the Minimalists, Turrell was interested in easily comprehended shapes, but whereas their works were positivist (what you see is all there is), Turrell's work is dematerialized and borders on the mystical. Form is an illusion created by light beams.

relevant in Minimalism but that the history that mattered was different. The Minimalists were indebted, as were the *Nouveaux Réalistes* and Pop artists, to Duchamp—because their four-square unarticulated objects raised the same question as Duchamp's ready-mades [**63**]. By shifting the point of interest in a work of art from its internal grammar to its external context—how it exists in the world—Duchamp had exposed the issue of the artwork which is not isolated by its base. A second strand of Minimalism's revision of history was a new interest in hitherto much misunderstood Russian Constructivism for the way it had started to reform the concept 'art' in relation to life, work, and the manufactured object. A third focus of interest was on Brancusi, who was seen as a sculptor for whom surface mattered more than core or interior, and who was therefore outside Greenberg's definition of a linear non-volumetric sculpture.

The debate around Minimalism was about form or materials but also about context, about where and how a sculpture is encountered and, therefore, with the position of the viewer. In the previous period there was an assumption that sculpture was an enclosed category of things separate from other objects in life, experienced cerebrally, or, in Greenberg's definition, optically, but in any event across a space which was more than simply the distance between the viewer and the object; it was a space that symbolized a change of mode, between the viewer's world and the special world of sculpture. The threshold between the two worlds, when conceived literally, was the base, which both actually and metaphorically isolated sculpture from the everyday world. The disappearance of the base thus affected not only the form of sculpture but its identity. The claim that the fundamental experience of sculpture is optical or cerebral is not invalid simply because of this, but sculpture as physical presence, as something facing and in a sense matching our own presence, must be taken into new account.

At one extreme of Minimalism are Andre's sets of metal tile-like plates that rest on the floor and are to be walked on. We are asked to consider not only the non-exclusiveness of a work of art that we can touch with our feet but also a radical difference in sculpture's relationship with the body. A reflection on the relationship of Minimalism to the human figure is provided by comments of the sculptor-architect Tony Smith. When asked why he had not made his life-height cubical sculpture *Die* (1962) larger, he replied that he was not making a monument. Asked why he had not made it smaller, so that one could see over the top, Smith answered that he was not making an object.[10] Analysing the replies, Robert Morris noted that the character of a monument is the amount of space it needs around it to maintain its difference from us, and that an ornament can be held in the hand and needs no space. The inference to be drawn—in respect of Morris's views, at least—is that somewhere in between, at the point where Minimalism is most ef-

fective, is a space across which a person relates to a presence, because—being neither a monument nor an ornament—it is in some way like, or equivalent to, a human figure. 'In the perception of relative size,' Morris said, 'the human body enters into the total continuum of sizes and establishes itself as a constant on that scale. One knows immediately what is smaller and larger than the self and the two are seen differently because of the different qualities of intimacy in relation to its size.'[11]

Morris's *Two Columns* [**64**] are light grey fibreglass boxes, neutral in character and unrelated to existing non-figurative sculpture. They exhibit a gestalt, a word borrowed by Morris from psychology to describe a naturally comprehensible form that imprints itself easily on the mind because it lacks complexity. It is a term generally applicable to Minimalism. Thus Andre's *Equivalent VIII* [**65**] can be disassembled

64 Robert Morris
Two Columns, 1961
This is a pivotal work in Morris's move from dance works and painting to making three-dimensional art. In 1960, a single column contained the figure of the artist himself, and the columns in this work can still be read anthropomorphically, as figure surrogates.

(the bricks can be removed from the ensemble) but it cannot be broken into parts with gestalts that are either different from one another or from the whole. Morris's interest in the gestalt ran in parallel with his study of 'form-classes'. He made an academic study of Brancusi in 1965–6, influenced by the idea of form-classes expressed in *The Shape of Time* (1962) by George Kubler, who was concerned with the way visual forms recur through history (forms, for example, for which we use the word 'Classical'). Kubler was important in suggesting a theoretical context for the rejection of Greenberg's Modernism because he saw the past in terms of recurrence rather than, like Greenberg, evolution. Minimalism avoids discussion of the contemporary as linear development of the immediate past (the Modernist position). Those who see Minimalism's elementarism, its preoccupation with the gestalt, as a natural step in the development of Greenberg's reductivist theory of art, and therefore a further and, as it turned out, final step in the progress of Modernism, do not take into account the difference between evolution and recurrence. If one is looking for twentieth-century precedents for the extreme simplicity of Minimalism, the primary forms of Rodchenko are more apt than the more complex ones of the earlier David Smith. Greenberg, who condemned Minimalism as 'too much a feat of ideation', was quick to see that Minimalism was not part of his sculptural family.[12]

Morris, like Rauschenberg and Johns, was connected with the new dance movement in America which rejected virtuosity and the balletic in favour of the everyday and the carrying out of specific tasks (like walking a narrow straight line with ritualistic intensity). The extreme abstractness of Minimalist sculpture makes the connection with the human body hard at first sight to comprehend, but Morris's *Two Columns* were conceived as part of a dance performance. At first the

65 Carl Andre
Equivalent VIII, 1966
Like all Minimalist work, *Equivalent VIII* resists complexity, is assembled rather than constructed, and hides nothing from the eye. Andre suggested an affinity with the unit-by-unit system of Brancusi's *Endless Column*; but, in view of what he saw as the over-priapic character of modern sculpture, he preferred the units to be close to the ground.

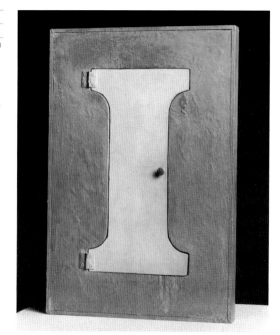

artist occupied one of the columns, which was controlled off stage by a hand-operated wire that pulled and toppled it. Morris was hurt, and subsequently the boxes became figure equivalents, objects that are like a person rather than containing one. Morris's *I-Box* [**66**] can be seen as a development of this: closed it is a gestalt, a pure form with the implication that it might be reduced to a yet purer one hinted at only by the 'I' shape of the hinged door and the door's slightly different colour. In open form it exposes a photograph of the naked Morris, who is thus revealed in the work both as description ('I') and as image. Morris challenges here any notion of Minimalism as an expression of simple reductivism, because we are not simply looking at an abstract form but also at a box.

Boxes were a preoccupation of Morris, as they were in general of sculpture at that time. Morris's *Box with the Sound of its own Making* (1961), was a small wooden cube with, sealed up inside it, a playable tape of the noises involved in the box being constructed. In effect, a measured amount of time was being sealed up in an object with so little individual identity as to make it seem timeless. Morris was, like Duchamp, in his *Three Standard Stoppages* (1913–14), being preoccupied with measurement and anonymity—inventing rules for making a work that were self-imposed and without meaning beyond the particular instance of their use. Manzoni's boxed, thumb-printed eggshells are likewise the record of a personal temporal event made impersonal and a-temporal by the process of boxing.

Minimalism, identified in Morris's language through the idea of the gestalt, in Judd's as 'specific objects', and by others as 'common objects',

is characterized by unitariness, forcing the viewer to find interest outside the work in its physical context. As Morris put it: 'The better new work takes the relationships out of the work and makes them a function of space, light and the viewer's field of vision. The object is but one of the terms in the newer aesthetic. It is in some ways more reflexive because one's awareness of oneself existing in the same space as the work is stronger than in previous work, with its many internal relationships.'[13] In reply to this, Morris's most fervent critic, Michael Fried, summarizes Morris's argument in the idea that 'the awareness of scale... is a function of the comparison made between that constant, one's body size, and the object. Space between the subject and the object is implied in such a comparison.' The larger the object, the more we are forced to keep our distance from it, Fried adds, and 'it is this necessary, greater distance of the object in space from our bodies, in order that it be seen at all, that structures the non-personal or public mode' which Morris advocates.[14]

Fried's problem with Morris was that the effect of distancing the viewer from artwork that Minimalism entailed was theatrical:

The theatricality of Morris's notion of the 'non-personal or public mode' seems obvious: the largeness of the piece, in conjunction with its non-relational unitary character, distances the beholder, not just physically but psychically. It is, one might say, precisely this distancing that makes the beholder a subject and the piece in question ... an object. But it does not follow that the larger the piece the more securely its 'public' character is established; on the contrary, beyond a certain size the object can overwhelm and the gigantic scale becomes the loaded term.[15]

The rejection of Morris and Minimalism was because it was theatrical and theatre implies looking across space, the involvement of time and anthropomorphism within the 'presence' that is the object of vision. Secondly, Fried's view that art was essentially a private experience caused him to resist what he saw as the potential of Minimalism as public art and its implications of monumentality (an implication that, as has already been seen, Morris, at least, rejected).

The Minimalist debate had far-reaching implications because the idea of the theatrical and the greater role permitted to the viewer revealed a way beyond the self-containedness of Modernism and, in the longer term, towards the resuscitation of a public art. It could also—which concerned Fried—be used to validate Pop Art, since the installations of Oldenburg, Segal, Kienholz and others, were clearly theatrical in Fried's definition; they involved an implied continuity of space between viewer's space and space within the artwork.

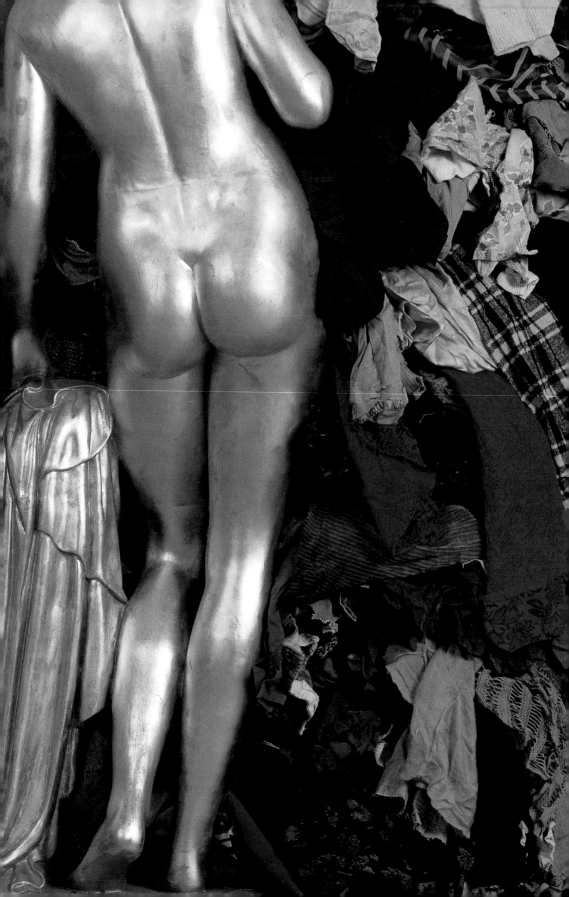

'Anti-Form'

5

The materials of sculpture

With Minimalism or British New Generation sculpture in the mid-1960s it was possible to say what sculpture was, what it looked like and, from the controversy between Donald Judd, Robert Morris, and Michael Fried, to grasp the nature of the major debate around it. The 'New Generation' exhibition at the Whitechapel Art Gallery, London (1965), 'Primary Structures' at the Jewish Museum, New York (1966), and 'American Sculpture of the Sixties' at the Los Angeles County Museum (1967) consisted of objects that were mainly single forms made of one material with a hard finish. Though there was debate about whether certain of these objects were to be called sculpture (Morris said yes, Judd said no), they were 'things' in the traditional way of sculpture.

The austerity of Minimalism is in strange contrast to what followed. At the extreme, late 1960s sculptures could be made from earth and sand, growing plants, live birds and animals, fabric, classical fragments, architectural structures, neon tubes, light beams, and the human body itself. There were hard and soft components; materials like sand, liquids, and air that need containment to give them form; living materials, which relate a sculpture to the time-scales of the organic world, and materials with an array of existing cultural inflections, which opened up new links between the artwork, history, and memory. The consensus that sculpture was generally made from a single material collapsed.

Significance was no longer necessarily vested solely in the finished object; value might be placed on the provisional, and on procedures and processes, so that making might acquire significance at the expense of the finished object. What constituted an individual sculpture might change after initial exhibition: *Four Casb 2'67, Ring 1 1'67, Rope (gr 2sp 60) 6'67* [**77**] by Barry Flanagan (b. 1941) was originally three works which were combined to form what has since by consent been regarded as one sculpture. If some sculptures progressed and survived in new form, others had finite life. This was clearest with Land Art, which was subject to the elements, but was an issue also in work, like Morris's *Continuous Project Altered Daily* [**67**], which was made of low-

grade materials and gained its meaning not from what it looked like at the end (Morris swept it up and disposed of it) but from the nature of the changes it went through and the behaviour of its materials during its existence.

Not all this was new, though where there were precedents, the forms the new work took were original and surprising. The body as sculpture had a history in the work of Klein and Manzoni and in performance art and happenings from around 1958. The leader of New York performance art, Allan Kaprow, was swift to point out in his reply to Morris's definition of the new in his 1968 essay 'Anti-Form'[1] that some of what was happening at the end of the 1960s echoed the situation ten years earlier. Kaprow, like Morris, regarded Pollock's use of unconventional processes as important. Pollock's physical involvement in his work, his use of sticks and punctured paint cans as well as brushes to spread paint on canvas that was laid unstretched on the floor, involved the body, accident, stress on the horizontal, and on art made and deposited on the floor—all features of these new developments.

Minimalism had implied the presence of the viewer and had thereby attributed significance to the space surrounding a work of art, to its spatial context. By doing that, Minimalism had also alluded to temporality. While a work of art can, theoretically, exist outside time, what happens in its ambient space—which, as has been seen, is implicated in Minimalism—cannot be beyond time because that is a part of our world. One of the original justifications for Minimalism and object sculpture in general was the need to counter anthropomorphism, not only in figurative sculpture but in the art of a sculptor such as Caro or even Smith. Soon, however, Minimalism also became implicated in what Fried called 'presence'. If the scale of Minimalism was regarded as between that of the monument and that of an ornament, neither very large nor very small, there was an inference that the 'presence' was human. The urge to avoid anthropomorphism was a motive for further change, particularly with artists who used different, 'low' materials

and, like Morris, drew analogy with landscape. Plainly, though, the human body remained at the centre of sculpture, since body art was a sculptural category of that moment. While Minimalism used the indeterminate word presence, however, body art was involved with situation, context and social space. In a narrow sense body art might imply involvement with one's own body at little more than narcissistic level, but in its wider and ultimately more significant implications, in the work of American artists as varied as Bruce Nauman (b. 1941), Dan Graham (b. 1942), and Vito Acconci (b. 1940), it meant using the body in a way that would give the artist a new critical focus on space and social context and architecture.

The 'vacant all-embracing stare'

At the end of 1968 Robert Morris organized '9 at Leo Castelli' in a warehouse belonging to the dealer on the Upper West Side. Just as the concerns of Castelli and other dealers at the end of the 1950s with how to make something saleable out of performance and happenings had hastened the emergence of Pop, so now Castelli was quick to see that new forms and materials might need different exhibition spaces. Morris did not include himself in the exhibition, but followed it up with a one-man exhibition/performance *Continuous Project Altered Daily* [**67**].

For three weeks in March 1969 Morris went each day to the warehouse, where he engaged with materials that included earth, clay, asbestos, cotton, water, grease, plastic, felt, threadwaste, muslin, electric light, and recorded sound. He worked without predetermined direction, piling, lifting, hanging, sweeping his materials in what he called an 'activity of disorientation and shift, of violent discontinuity and mutability, of the willingness for confusion even in the service of discovering new perceptual modes'.[2] It was not a forming process, nor did it transform low materials into high art. Morris described it in his diary as 'viscera, muscles, primal energies, faeces … a work of the bowels'.[3] The austerity of Minimalism left an unsatisfied need for a direct physical engagement with matter which, since Abstract Expressionism, had been satisfied only in the performance movement. Morris was the Minimalist who had always been involved with performance and dance, and *Continuous Project Altered Daily* has affinities with a performance such as *Meat Joy* (1964) by Carolee Schneeman (b. 1939), in which near-naked figures covered with animal blood and offal rolled against one another.

Morris rationalized the changes in late 1960s sculpture in terms of the contrast of homogeneity with heterogeneity. Minimalism retained the unitariness of historic Modernist sculpture, while a work like *Continuous Project Altered Daily* was characterized as de-centred: describing the Minimalist object as a parallel expression to the human

figure, he meant that, like the human figure, it occupies our field of vision as the dominant object in surrounding space. To describe the new sculpture he quotes the psychological theorist Anton Ehrenzweig: 'Our attempt at focusing must give way to the vacant all-embracing stare.'[4] The new art lacks both focus and boundary. 'In another era,' Morris added, 'one might have said that the difference was between a figurative and landscape mode. Fields of stuff that have no central contained focus and extend into or beyond the peripheral vision offer a kind of "landscape" mode as opposed to a self-contained type of organization offered by the specific object.'[5] The problem with depiction of objects, or, in effect, the Minimalist legacy, he suggested, was that it asserted 'forms as being prior to substances'.[6] In all history, one might reply, sculpture has prioritized the finished object over its material. Morris's argument, however, is rooted in the conditions of present-day urban life, in which our sense of our surroundings comes mainly from manufactured objects. Because we do not witness the manufacture of objects, we have ceased to relate base materials to the conditions of life. Urban construction sites, which he calls 'small theatrical arenas', are the only places where a city dweller sees raw substances and the processes of their transformation. Morris is arguing that we need baseness, a kind of primitiveness, as part of our experience. Morris's reference to 'landscape' does not use the word in the sense of the natural outdoors, though landscape in that sense does now become the subject and location of sculpture in a way that was without precedent. Morris was briefly involved with Earth Art himself.

There is a parallel between the ideas Morris drew from Ehrenzweig and Leo Steinberg's argument in 1972 in relation to the 1950s combine paintings of Robert Rauschenberg. Rauschenberg's combines assemble painted and printed images, including postcards and clippings, to make wall-hung artworks that resemble huge pinboards. Steinberg characterized as a 'scatter' technique the assemblage of bits and pieces on a flat surface. Although the combines are paintings in the sense that they hang vertically on the wall, their mode, he argues, is that of things arranged on a horizontal plane, and he adopted from printmaking the phrase 'flatbed' picture plane to describe it.[7] Rauschenberg's combines differ, according to Steinberg, from traditional paintings in that they do not assume the presence of the upright human viewer. Morris's 'landscape' and Steinberg's 'flatbed' have in common the idea of the de-centred art object, the art object which is based on the principle of heterogeneity and spread, of diffusion rather than centredness.

Richard Serra (b. 1939) came to the problem of de-centredness by a different route. In 1968–9 Serra's sculptures are concerned with propping: the weight of a leaning cylinder of steel pins a flat steel plate to the wall; four square steel plates stand upright by leaning against one another; a freestanding stack of steel slabs begins to tip as it rises

because the individual slabs are not flat enough to form a vertical pile. All these sculptures, which adopt or mimic Minimalist forms, are unstable. Sometimes, as with the wall props, one wonders how the sculpture was erected; at other times, as with the stack, why it doesn't fall. In all these examples, instability gives the sculptures a notional past and future, a 'before' and an 'after'.

For Morris's '9 at Leo Castelli' exhibition Serra made *Splashing* [68], which involved throwing molten lead into the divide between wall and floor. The lead could either be left there, in which case there was a site-specific work: artwork and site are thought of as inextricably and permanently linked. Alternatively the action could be repeated, with each of the L-shaped furrows of lead levered away in turn from wall/floor and lined up along the floor in a process of assembly characteristic of Minimalism. That work was called *Casting*.

'9 at Leo Castelli' altered the relationship between studio and art gallery. Since the Romantic movement the studio had been seen as the unique site of creativity, as the essentially private place where artists work in their own ways and time. The Castelli Warehouse was open to the public, exposing it to art that was unsaleable either, like Morris's, because no end-product existed, or, like Serra's, because it was stuck to the wall. The form that sculpture takes modifies, and is modified by,

68 Richard Serra

Splashing, made in December 1968

Splashing consisted of molten lead thrown into the gap between the wall and floor of a room at the Castelli Warehouse [**67**] in an exhibition curated by Robert Morris.

the institutional structures within which it is made. The end of the 1960s resembled the end of the previous decade, when artist-organized performance and happenings began to supplant object sculpture and encroach on dealers' territory. Within the market system, this was problematic in the longer term for both parties with livings to make, and market forces were one reason for the rapid shift from the body-based art forms of the late 1950s to object-based Pop. The late 1960s saw a more root-and-branch shake-up in art, mirroring more radical social and political developments. The art market had to adjust to this, and Castelli was at the forefront—as he had been around 1960. A new pragmatism emerged not only over the materials of sculpture but over its site, where it was made, and how it was exhibited. Though the traditional order, leading from studio to dealer to patron, has never been supplanted, it has not, since the late 1960s, had exclusive reign. Since then relationships have changed between artists, art dealers, museum and gallery staff, and independent curators working with public and private funds. Within this overall framework, traditional museums have become readier to show site-specific projects made for a particular exhibition and therefore having an element of unpredictability that public institutions were not accustomed to. New kinds of exhibiting spaces have emerged which are neither attached to permanent collections nor run commercially. Attached to these, or working with them, is a different kind of curator who has assumed some of the functions of traditional museums and interpreted artists for an uncertain public.

The most severe test for the art-gallery-going public was not '9 at Leo Castelli', which relatively few people saw and, as a new kind of exhibiting space, had no existing context for people to match this event against. The appearance of the new art in public spaces with existing traditions presented more difficulty. Carl Andre's thirty-six-feet-long sculpture at 'Primary Structures' was testing because it connected two rooms while not filling either. Following '9 at Leo Castelli', the Whitney Museum of American Art organized 'Anti-Illusion, Procedures, Materials'. Michael Asher's contribution was an invisible curtain-wall of hot air. Here was art that generated unease because it confused, as Asher intended, the customary distinction between the artwork—traditionally something visible—and the museum building which might include curtains of hot air. In the same show Bruce Nauman set up a 'corridor' work where the viewer's first encounter was with the wooden battening on the outside that supported the work, whose meaning was contained within and whose fabric demanded to be physically explored. The traditional museum experience of sculpture was of coming face to face with an object whose implications and meaning might be hard to understand, but whose extent and identity as an object were not in doubt. Previously there had been no doubt where, in physical terms, the art experience lay. Usurping this certainty

about what the art object was, where the edge lay between art and not-art, was part of some artists' strategy of disorientation: questioning the public's passive assimilation of art was part of a design to restore sculpture's critical bite. The tactic employed here by Nauman and Asher was to engage the viewer's physical presence. These new materials of art and the new relationships of artworks and spaces are important because strategies were evolving not just for changing what art looked like—the issue was no longer simply one of style development—but for changing the context in which it was seen. One of the effects of that would be to cast light on the institutional frameworks in which art was made, shown, and sold.

Artists have continued to design projects which, like those of Morris and Serra, deny the principles of the market. Art dealers, taking the long-term view and treating artists as investments, have supported numerous projects with no possible financial return. But within the capitalist system there is no way, in the long term, for artists to avoid making artworks which can be sold. The late 1960s and early 1970s was the moment the greatest pressure was brought to bear on the market system, and when sculpture pushed hardest against its traditional boundaries and the idea of objecthood. In 1969, Minimalism could be looked at in two contrary ways: as a re-situating of the viewer in relation to the artwork, with all the implications that had for the recovery of the artwork as a 'thing in the world'; alternatively, the Minimalist artwork could be seen as another machine-made, modern-looking, manufactured object with the same kind of exchange value that attached to non-art commodities—yet another material object in a world that many felt was overfull of objects. The recovery of base materials in the work of Morris and others, and the kind of exhibition project represented by '9 at Leo Castelli', was a critique of this situation.

Eccentric Abstraction

The first New York exhibition to challenge the reigning precepts of Minimalism had been 'Eccentric Abstraction', organized by the critic Lucy Lippard at the Fischbach Gallery in 1966. A landmark exhibition in several ways, it helped to reintroduce the work of Louise Bourgeois who was now, after the death of David Smith in 1965, the only remaining sculptor of the American post-war generation making significant new work. Bourgeois had had her first one-woman show since 1953 at the Stable Gallery the previous year and was working with plaster and semi-soft materials such as latex rubber. She made open-fronted beehive-shaped hanging forms from plaster, called 'lairs', which have contradictory psychological overtones relating to home, nest, and safety, but also to threat and vulnerability. Her work included forms that read as metaphors for parts of the body. 'Eccentric Abstraction'

included Bruce Nauman, a then little-known West Coast artist who also worked with latex rubber, and artists using wood, rubber, leather, and other materials excluded from the Minimalist canon but with different physical properties that lent themselves to a range of metaphor.

The German-born American artist Eva Hesse (1936–70), who showed both in 'Eccentric Abstraction' and in '9 at Leo Castelli', made work from materials such as fibreglass and latex rubber, as well as layers of muslin and cheesecloth soaked in size [**69**], all of which undergo a transformative process, from soft or liquid to hard and solid, in the course of making. Hesse's work is craft-based, involving labour-intensive procedures of binding, threading, and layering that she carried out without assistants. In all this she was unlike the Minimalists, and the kind of clarity she achieved was not the result of industrially manufactured hard materials, but one reached from the revelation of process. Serra, with very different materials, exhibited the transformation of hot liquid into a hard frozen pool of lead, in a manner parallel to the hardening of (albeit more organic) forms in Hesse's work.

Two of Hesse's artist friends, Mel Bochner and Robert Smithson, stressed her concern with order—even if the appearance was of dis-

order—and both stressed the deathliness in her art. Bochner called it 'remote and lifeless'[8] and Smithson used words like 'mummification' and 'funerary' to characterize an art he saw as 'de-temporalised'.[9] Hesse's wrapping and binding have been compared with the activities of Joseph Beuys, whose work interested her when she spent a year in Germany in 1965. Beuys was concerned with the idea of the artist's expiation of the collective wound which Germany had inflicted on itself in war, and used life-sustaining and thermal materials, such as fat and felt, as metaphors for healing. Hesse's layering, wrapping, and binding, on the other hand, is, as Smithson perceived, closer to the process of mummification. It is not life-giving—far from it—it is the acknowledgement of mortality combined with fear of loss and the urge to preserve that led Hesse to counteractive devices like wrapping and the solidification of non-solid forms.

Beuys and Germany

Though Minimalism had equivalents in Europe, most Europeans were reluctant to sacrifice the world of the senses to the same degree. A few, most evidently Beuys in Germany, wanted to retain a sense of history and memory. Beuys was born in 1921 at Kleve in the Lower Rhineland, served with the Luftwaffe in the War, enrolled as a student at the Düsseldorf Academy in 1947, and was Professor of Monumental Sculpture there from 1961 until he was dismissed in 1972. It was only around 1967–8 that Beuys's international reputation was assured. In 1968 Beuys declined Morris's offer to show in '9 at Leo Castelli', and in an interview with Willoughby Sharp the following April stressed the metaphorical content of his art, which he felt distinguished him from American artists. He refused to show in America during the Vietnam War, his transatlantic career was launched only in 1974 and, though it was crowned with a retrospective at the Guggenheim Museum in 1979, Beuys has had a less secure reputation in America than he has enjoyed in Europe. In Beuys's case a biographical outline seems necessary because a mythified version of his life story is appropriated into his art in a way it is not with any American artist. Biography becomes myth as past events, together with Beuys's glosses on them, become the subject of sculpture. Strikingly independent, Beuys evolved a range of artistic ideas through the 1950s, long before there was a substantial audience for his work even in Germany.

Beuys shared with the Zero group, and particularly Klein, the idea of art as a field of energy, and the objects of art as symbols of that energy. The existence and release of energy hidden in individuals was a basic principle for him, and helps to account for the significance of teaching and polemics in his life; releasing energy for social change was an ideal, and led to him adopting the—at first hearing—rather strange designation 'social sculpture' for his deeply subjective work. Beuys

invented a personal myth of rebirth by embellishing a story, which had a basis in truth, of his rescue in 1944 by Crimean Tartars from the wreckage of his Junkers aircraft which had crashed on war service. According to Beuys the Tartars wrapped him in animal fat and felt to conserve his body heat, and these substances became pivotal to his work, as symbols of the gift and conservation of life. Beuys's best-known use of fat is the *Fat Chair* [**70**], an anthropomorphic sculpture in which both the chair and the fat refer to the human body: the first as the piece of furniture which, together with the bed, has fullest contact with the body, and the second because, as Beuys himself pointed out, the parts of the human anatomy closest to the chair are concerned with digestion, excretion, and sexuality, which are well represented by a substance which is nurturing and also undergoes transformations of shape and substance.

70 Joseph Beuys

Fat Chair, 1963

Beuys describes how 'the chair represents a kind of human anatomy' (1979), while the fat has more ambivalent meanings, both as nourisher and sustainer, and as waste.

Beuys's work is about transformation, it is heavily symbolic, and it is central to its character that its symbolism stems directly from him as an individual. Beuys saw himself as teacher and mentor as well as an artist in the narrower sense, and as the agent of change: his position at the Düsseldorf Academy and his astonishing capacity to engage a student audience was as crucial as his other creative successes. In a materialist and socially divided world, in a world which—as he saw it—had lost touch with nature, history, and the wellsprings of its culture, and in a country that was scarred by the evil of National Socialism, Beuys chose to stand for restitution and healing. While for Beuys the results of this might be collective (a culture might ultimately find its lost unity), the method of achievement must be individual. Beuys was a Nietzschean, believing in a quasi-priestly role for the artist who could use his unique position to help others harness their inherent creativity.

Beuys engaged in performances, for which he preferred the word 'action' to describe what were often long periods of physical endurance within an installation or scenario in which he was the only person involved. His chosen materials—fat, felt, and honey—were warming or lifegiving, and he also used appliances like telephones and transmitters, video recorders, and electrical parts, which evoke the passage of energy. Except in his use of gold, which he used in the form of gold paint as the alchemical opposite of base metals, Beuys kept mainly to low-grade materials associated with the first industrial age. At a time when other German sculptors associated being modern, and being, after the War, part of a new and modern country, with high-quality, rust-free materials, Beuys used neither new materials nor mechanized processes. His vitrines, the glass-topped cases in which he showed much of his sculpture, have something of the same psychological effect as the *Merzbau*, the shrine filled with the physical traces of his own life and his friends', that the Dadaist Kurt Schwitters (1887–1948) made out of his Hanover home in the 1920s. The vitrines' contents can be personal, are often nostalgic, and in their fragmented way are mementoes of a world that is past.

Beuys was interested in history and the origins of man and had a sense of a lost unity, the need for reconciliation between north and south, man and his past, and man and nature. He explored the layers and sedimentations of history. One of his earliest works, made in 1952, was based on Grauballe man, a prehistoric figure discovered intact in a Danish peat bog. As a native of Kleve on the low-lying Dutch border of Germany, Beuys identified with the waterlogged lowlands of northern Europe, and their capacity to conserve history intact. His contribution [71] to the 1976 Biennale in Venice, which he saw as like a north European city in being built on water, was to make a deep borehole and to expose as part of the display the substance removed, which included human remains and other historical sediment. He used as the 'above-

ground' part of the work an existing sculpture, *Tramstop*, a cast of military and sculptural remains erected by the seventeenth-century Prince of Nassau in Kleve at the point that happened to be Beuys's local stop as a child. Beuys changed only the figurehead, from a cupid to an open-mouthed suffering man. Beuys, like many German writers and artists since Goethe, saw the need for a northern culture to look south without losing its own identity. The Venice piece made mental and emotional connections between far-apart places marked by Beuys at different times.

Restitution of man's relationship with the animals and the organic world led in practical terms to Beuys's early attachment to the ecology movement, but had a practical as well as a spiritual aspect that aroused an obsessive desire for reconciliation with the animal kingdom. Beuys gave his first 'action' in America a political touch by identifying with the oppressed in American society. For three days he shared a habitat with a coyote, the wolf-like dog which had a special place in the life and myth of Native Americans but has a reputation as deceitful and un-trustworthy in white American society. In *How to Explain Pictures to a Dead Hare*, Beuys wrapped his body in felt, crowned himself in honey and gold paint, and stretched himself out on the floor for a nine-hour period of motionless silence with a dead hare at either end, as if by simulating death himself he could reconstitute a relationship with this mute correspondent from the animal world.

Beuys's appeal to history was to the pre-modern. He paid tribute to the sculptor Wilhelm Lehmbruck (1881–1919), who was one of the last German sculptors for whom direct realization of emotion by means of facial and bodily expression was possible. Beuys believed that 'sculpture begins in thought, and if the thought is not true, the ideas are bad and so is the sculpture. The sculpture's idea and form are identical.'[10] There is an equivalence here of thought—or he might have said feeling—with image, that one of Beuys's strongest critics has called a 'naïve transparency between form and matter and the "idea" '.[11] An example of this 'naïve transparency' might be Beuys's 1961 work *Bathtub*, an old bath with bits of sticking-plaster attached. Beuys informs us that the bath is connected (presumably by association with containment, warmth, and water) with birth, and the sticking-plaster with healing the wound of exposure to the world. Beuys offers a proposition and, in his own response to it, the solution. It is this transparency of image and idea, certified by the artist alone, and detached from critical analysis of his own artistic practice, that has contributed to a relatively hostile critical reception in the United States.

Beuys denied that the bath as a single object appropriated from everyday life, or the other objects he used, were inspired by Duchamp's ready-mades, which were suddenly a discussion point around the time Beuys made this work, in 1960. Beuys was unsympathetic to Duchamp because of the shift in his ready-mades away from meaning given by the artist to meaning arising from their context. The switch from authorship to discourse, a preoccupation of American art and criticism in the 1960s, was alien to Beuys, and from the moment of his 1964 action *The Silence of Marcel Duchamp is Overrated* a lack of compatibility between Beuys and the American avant-garde is implied.

The events of 1968 foregrounded issues of power and authority in ways relevant to art, from education to the museum as institution. Beuys himself was at the centre of a political storm surrounding his activities at the Düsseldorf Academy, which lasted for four years (1968–72) and ended with his dismissal. In 1972 a crisis of a different nature, also involving Beuys, blew up in the context of an exhibition of European art at the Guggenheim Museum in New York in which it was proposed to include Beuys and, among others, the Belgian Marcel Broodthaers (1924–76). Broodthaers was angry with Beuys because he had not protested the previous year against the cancellation by the Guggenheim—on what Broodthaers regarded as unjustified political grounds—of a one-man exhibition of the German-born American Hans Haacke (b. 1936). Broodthaers wrote an open letter to Beuys asking him to consider the conditions of production of his work and these conditions' inseparability from the nature of the institutions where the works were both made and shown. Beuys ignored the letter and Broodthaers withdrew from the exhibition.[12]

Accusations made against Beuys in America have been of excessive projection of self and of a-historicism: that he overvalued independent creative talent outside historical context, and that he used myth—which repels dialogue and, in its traditional sense, at least, is not grounded in the contemporary—as an excuse for not looking critically at the present. More than that, the dominant core of American criticism since Alfred Barr and Meyer Schapiro in the 1930s had been strongly resistant to nationalism, and Greenberg's Modernism had drawn its earliest and strongest impulse from revulsion against the effects of the nationalism of the 1930s dictators. In these terms Beuys's preoccupation with Germany was seen as atavistic. German history since unification in 1871 has been beset by crises involving national identity, reflected in attitudes to art that have shifted radically between focus on nationhood and on the international community.

Arte Povera

Italian *Arte Povera* refused to espouse unconditionally the main line of Modernism, which was seen as American and representing a narrowing of art that ran counter to the richness, variety, and sensuousness of European traditions and kept art apart from everyday life, circumscribed by prohibitions and sealed in its own aesthetic compartment. *Arte Povera* provided an alternative to this and was described by its founder, Germano Celant, in terms of individuals against systems. The individual must find a way 'that refuses dialogue with both the cultural and social systems, and that aspires to present itself as something sudden and unforeseen with respect to conventional expectations: an asystematic way of living in a world where the system is everything'.[13]

'*Arte Povera—Im Spazio*' was the title of an exhibition at La Bertesca Gallery in Genoa in autumn 1967, and shortly afterwards Celant published in the recently founded journal *Flash Art* his manifesto of *Arte Povera*, subtitled 'Notes for a Guerilla War', which surrounded *Arte Povera* with a political aura evocative of a Guevara or Castro.[14] The situation of the late 1960s was for the first time distinctly unlike that which had led to the rise of Modernism: Greenberg's argument in 1939–40 had been that free art, like individual liberty, was threatened by the dictators, and ultimately the role of the culturally aware was, if they could not save the world for freedom, at least to save it for art. The kind of cultural monasticism which, with Europe at war, only America was left to defend, was at the root of what in 1967 Celant called the 'system'. By then German Fascism was long gone and Stalin's Socialist Realism was irrelevant. The problem was the very narrowness of the monastic system, the prescriptiveness of American art as it was perceived in Italy. 'Povera' carried a meaning close to 'popular' or 'demotic', in the sense that neither the materials used nor the ways of assembling them follow established hierarchies. Concerned with the

nomadic, ephemeral, and ad hoc, *Arte Povera* was not racy or style-oriented like Pop. Its materials include earth and steel, coverings for the body from clothing to tent forms, live animals and birds, propane flames, live music, marbles and other touches of glamour from coloured silks to gold leaf, and fragments of classical sculpture.

Picking up a phrase of the Rome-based Greek-born artist Jannis Kounellis, and referring specifically to Kounellis's bridging life with art in surrounding himself with nature as material in the form of coal, cotton, and a live parrot, Celant called for 'concrete knowledge' as opposed to 'conceptual reductions'.[15] Celant was fully aware of what was happening in America—his friend Piero Gilardi published a report from New York in the same issue of *Flash Art* in which *Arte Povera* was announced[16]—and he cannot have been unaware of Fried's 'Art and Objecthood' and part three of Morris's 'Notes on Sculpture', fundamental texts in the debate over Minimalism, which had both just been published in *Artforum*. Celant's writing and *Arte Povera* are to be seen against the backdrop of a powerful and alien American sculptural scene—though it was not until later that Celant responded to Judd's attack in 1966 on European art in general ('I'm totally uninterested in European art and I think it's over with'[17]), Italy, and himself.

Michelangelo Pistoletto (b. 1933), who was the oldest and best-established artist when *Arte Povera* was formed, had made his name with wall-hung sheets of reflective material such as stainless steel, on which images of full-size figures in arrested movement were painted or pasted. The viewer and the room, mirrored on the reflective surface, were seen alongside the painted images, and a complex set of exchanges was set up between the permanent and the contingent, fixed and moving. Pistoletto moved into three-dimensional work in 1965 with what he called *oggetti in meno* (minus objects). In the '*Arte Abitabile*' exhibition at the Sperone Gallery in Turin (1966) he exhibited modern-type furniture which he had made and thought of as particular examples extracted from (hence the 'minus') ideal type-objects. Pistoletto's concern was to make bridges between ideal objects and the everyday world, and his contribution to '*Arte Abitabile*' bears some resemblance to a living-room but looks quite like a Minimalist exhibition as well. Pistoletto and other *Arte Povera* artists were aware of Minimalism, and resisted what they wrongly perceived as its idealizing intentions. They looked back to Fontana and the way his art seemed to bridge painting and sculpture with the world of design and lighting; they wanted their art to be in the world but to view the present against ideal forms.

Golden Venus of Rags [**72**] marks Pistoletto's entry in *Arte Povera* with the contrast between Venus, made of cast concrete covered with mica and gold paint to give the sense of her belonging to a sunlit and ideal world, and heaps of rags which Celant regards as representing

72 Michelangelo Pistoletto
Golden Venus of Rags,
1967–71
This exemplifies a theme
running through twentieth-
century Italian art, the
seduction of Italy's golden
past and the common-or-
garden present.

the confusion and multivalence of marginalized people, the totalities of ran-
dom and disparate communities of social rejects…that is the 'rags of society'.
We are dealing here not with an ideal unity, but with a multiplicity of actors
and persons who, in the madness and desire of continuous redressing, cross-
dressing (again the rags, as a residue of a spectacular disguise), see the realiza-
tion of their own subjectivity.[18]

Pistoletto's *Orchestra of Rags* (1968) shows clothes heaped round an
electric kettle boiling beneath a sheet of glass, on the underside of
which steam condenses. *Orchestra of Rags* suggests—to continue
Celant's metaphors—a primitive camp fire (the 'orchestra' is recorded
bird song playing as a background), but the pristine, designed object in
the form of the kettle and the simple form of the glass exist in contrast.
The lure of the primitive is posed against the austerity of Minimalism.

Celant's position against Minimalism resembled that of the
Futurist Boccioni before the First World War looking, from the van-
tage point of Milan, at Parisian Cubism as an austere, intellectual, and
formally reductive art, and himself proposing a sensuous, inclusive,
impure, and dynamic alternative. Like Boccioni in respect of Paris,
Celant was not able to put America out of his mind, and *Arte Povera*,
from the use of marble blocks by Giovanni Anselmo (b. 1934) and
Luciano Fabro (b. 1936) to the filled-in doorways and windows of
Jannis Kounellis (b. 1936), often points in the direction of perfect form
while stressing the accidental, the contingent, and the hand-made.
The fragment, especially the classical fragment, is key to *Arte Povera*,
directing attention to a different ideal while denying its possibility in
the present. The fragment was for these artists an image of a splintered
and irrecoverable past.

Arte Povera is anti-Modernist in its permissiveness and engagement
with human experience, feelings, and instincts; its unwillingness to
admit a dominant core to art history; and its rejection of the idea of
progress through exclusion. The univocalism of American art was a
point of resistance, together with the belief that Europe was culturally
different, that Italy had its own traditions, and that each artist had a
separate voice. Within contemporary Italian art the focus of discon-
tent was international Modernism represented by the conjunction of
art and technology in *Arte Programmata*, championed by the influen-
tial critic and historian Giulio Carlo Argan. Celant spoke of it as the
death of art, the principle of rebirth being the acceptance of incoher-
ence and the search for a new, unalienated individual relationship
between man and environment. The resistance to Modernism in *Arte
Povera* included a mistrust of the kind of personal artistic development
that resulted in a stylistically coherent oeuvre.

Celant emphasized the anti-idealist basis of *Arte Povera*, and the
need its artists felt for the concrete aspects of the everyday: 'The

difficulty of… taking possession of things is enormous: conditioning prevents us from seeing a pavement, a corner or a daily space'.[19] The problem was taken up by Luciano Fabro, one of whose first *Arte Povera* creations was to make a work from newspapers stuck to the pavement. It was suggested, he said, by paper laid on a newly washed floor, but surely referred to the newspaper as the ultimate image of the present, topical but ephemeral, laid over the pavement, the reality permanently under one's feet and the negative sign of personal presence. Fabro moved from there, in what is, characteristically of *Arte Povera*, an association of ideas and not forms, to his 'Feet' series [**73**]. Different discourses converge, to do with the foot on/as the stone of the pavement, but also to do with expensive coloured fabrics and stones that recall Italy's past. *Arte Povera* is paradoxical in its merger of the everyday with the regal, the ephemeral, and the permanent. In *Untitled (Structure that Eats Salad)* [**74**], Anselmo also reflects on the permanent and the temporary, and high and low value. The precious marbles that Fabro and Anselmo use resonate with history; they signify classicism and Italy. *Arte Povera* was concerned with re-establishing regional values, but was not so much nationalistic as antagonistic to the dominance of Minimalist abstraction. Different discourses were set up in the later 1960s between geometrical block-like forms of the kind used here by Anselmo, and opposing forms and substances that challenge the hegemony of abstract form. Though arising from different interests and circumstances, other contemporary work, such as Medalla's *Cloud*

73 Luciano Fabro

Feet, 1968–72

'Modern sculpture is remade in the shadow of ancient sculpture, even when it is strange and exotic', Fabro wrote in 1981, in relation to his 'Feet' series. Marbles and coloured silks resonate with the glamour of Italy's artistic past, while the foot is literally the image of the 'down to earth'. The installation shown here is at the Venice Biennale, 1972.

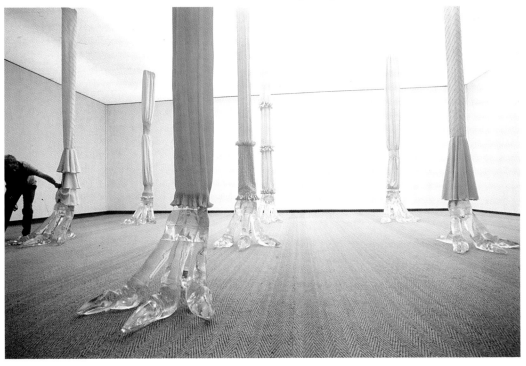

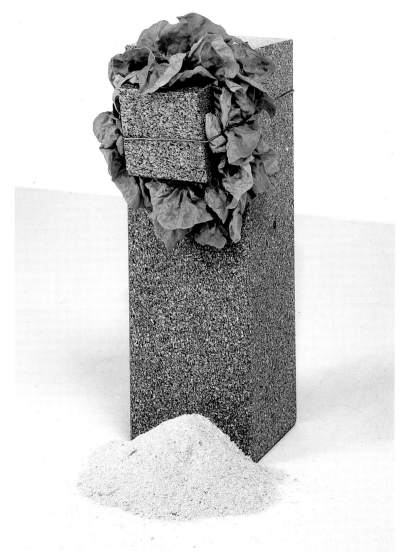

74 Giovanni Anselmo

Untitled (Structure that Eats Salad), 1968

As sculptural materials, fresh lettuce, sawdust, and marble suggest transformation—life, former life, inert material. Anselmo is interested in metamorphosis, and the copper wire binding the assemblage alludes, as with Beuys, to copper as a conductor of energy.

Canyon No. 2 [**28**], spreading soap bubbles in the gallery, and Haacke's *Condensation Cube* [**107**] and *Grass Cubes* (planted on top with turf) can be seen, in the same way as Anselmo's *Untitled*, in terms of Minimalism brought into dispute.

An early *Arte Povera* exhibition was '*Con Temp l'azione*' in three Turin galleries, Sperone, Il Punto, and Christian Stein. Some of the sculptures were 'street' works: a red thread was unwound to physically connect the three; Pistoletto's *Sphere*, a huge ball of newspaper, was rolled from one to the next. 'Art is another form of action,'[20] wrote the organizer Daniela Palazzoli, who suggested that what mattered about such actions was not their relationship to anything preceding but what they gave back.

Celant wanted, as Boccioni had, to create an international movement, and presented *Arte Povera* in 1969 as a book in simultaneous Italian and English editions. No longer conceived as it had been until then as mainly Italian, the book included an international array of artists, many with little real artistic affinity with the movement. 'It is a moment,' Celant says,

which tends towards deculturisation and regression, primitivism and repression, towards the pre-logical and pre-iconographic stage, towards elementary and spontaneous politics, a tendency towards the basic elements in nature (land, sea, snow, minerals, fat, animals) and in life (body, memory, thought), and in behaviour (family, spontaneous action, class struggle, violence, environment).... The artist mixes himself with the environment, camouflages himself, enlarges his threshold of things. What the artist comes in contact with is not re-elaborated; he does not express a judgement on it ... he does not manipulate it.... Among living things he discovers also himself, his body, his memory, his gestures.... He has chosen to live within direct experience, no longer the representation—the source of the Pop artist—he aspires to live, not to see. He immerses himself in individuality because he feels the necessity of leaving intact the value of the existence of things, of plants or animals ... not analysis or the development of an experiment.[21]

It was an ambitious programme and one which, though it had a political slant (spontaneous action, class struggle, violence), was also in part a flight from the urban and rational, paid tribute to Beuys (minerals, fat, animals), and looked for ways to reconnect with nature and make it a part of the artist's resource.

Arte Povera is an art connected with origins, as the work of Mario Merz (b. 1925), especially, testifies. Merz's igloos are primitive space enclosures and, like others of his works made from baskets or stacked brushwood which are hollow-centred, they are human in scale and resemble refuges [**75**]. Brushwood needs little manufacture and signifies a society at craft rather than industrial level. In an early exhibition at L'Attico Gallery in Rome, Merz showed his igloos with the shell of a defunct car (a more specific reference to the short life of the modern machine than Beuys ever adopted), as if to point to the idea of regression raised by Celant. *Arte Povera* returns art to nature and the primitive, not for their own sakes but to point up the polarity of nature and culture. Some igloos are constructed out of shards of smashed plate glass held together with iron clamps which refer to ideas of extemporizing and making life work in an ad hoc way. Yet the shape itself is a geometrical and efficient form of protective cover, and Merz's work, like that of Richard Long (b. 1945) or Robert Smithson (1938–73), reaches out to nature and to materials that are unfamiliar in art, but submits the imperfections and irregularities to a degree of overall geometry.

Merz talks about his pragmatic approach: 'Different materials are

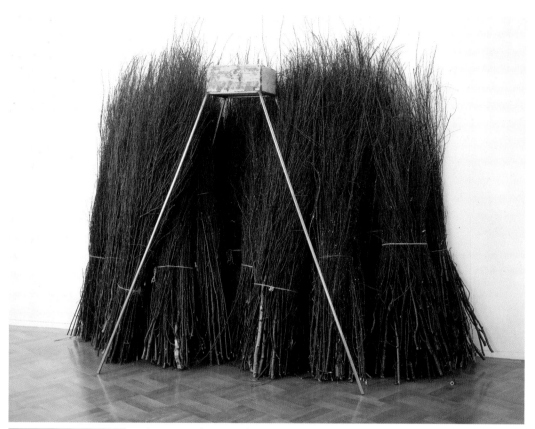

75 Mario Merz

Ingot, 1968

Merz's works often relate to primitive habitations or enclosures. This one is marked out as special because of the block of beeswax which is raised on a metal stand and surrounded by propped brushwood.

chosen each time, determined by chance, place and proximity of other elements, and dictated by the vegetation. The earth's surface must be a body with which these elements can relate intimately. Nothing should be preordained, that is, capitalised. To build is the necessity, hour by hour and day by day—to weld the will onto that which is scattered in life.'[22] Like Long, Merz works for the moment and in a specific place, and by operating in a way that, even within the parameters that the repeated igloo shape imposes, is not pre-determined, Merz joins in Celant's warning to avoid systems, which for both artist and writer associate Minimalism with capitalism. Keeping within the flow of time and respecting the demands of place was seen by Merz as 'opposed to the positive and utopian image of a rigid and monolithic, if not minimal, art. The poverty of language stays in the world of pessimism and disenchantment.' Merz saw the igloo as 'a point of escape, a place of defence and of rest. Its essence is its existence both as sculpture and as habitable structure.'

From 1966 Merz made 'objects passed through by neon', using the bright tube as an energetic flux or spear of light passing through the object and destroying its solidity. Early works, like one consisting of a bottle and an umbrella penetrated by neon, confound perception of form, since the elements are not autonomous but connected and recall

Boccioni's 'lines of force' and the concretization of light as energy in baroque sculpture. Merz was not alone in using neon—the French *Nouveau Réaliste* Martial Raysse (b. 1936) used it, as did the Minimalist Dan Flavin [**60**], and Bruce Nauman came to it in America at the same time as Merz. Most important for Merz, however, was Fontana, a key figure for *Arte Povera* and one of its first supporters (though he died in 1968). Fontana used neon in the gap between sculpture and lighting design as an expression of light as life and energy. Since the 1930s Fontana had been, with Melotti and a few others, exemplary of an Italian reluctance to be bound by conventional distinctions between figurative and abstract. Fontana was an artist, like Kounellis, for whom light and dark had cosmological connotations; when he made his *Concetto Spaziale* series around 1960, he was one of the rare artists to keep direct contact (like Kounellis, again) with nature, growth, and the organic.

From 1970, both for the igloos and other works, Merz used in neon the Fibonacci series, in which the line of numbers mounts exponentially towards infinity through the combination of the previous two figures. He liked the series because its growth was organic rather than additive (Minimalist works, by contrast, were assembled additively), but also because he wanted to impose numbers on an art founded on observation, 'because the art of observation is so subtle and uncommu-

76 Jannis Kounellis
Untitled, 1967
The elaborate juxtapositions and inclusiveness of *Untitled* make it a paradigm of *Arte Povera*'s rejection of the austerity and reductivism of Minimalism. Growing plants, a gas flame (absent from the installation as shown here), and a live parrot stand for life, energy, and growth within frameworks of steel plates that recall an early industrial age.

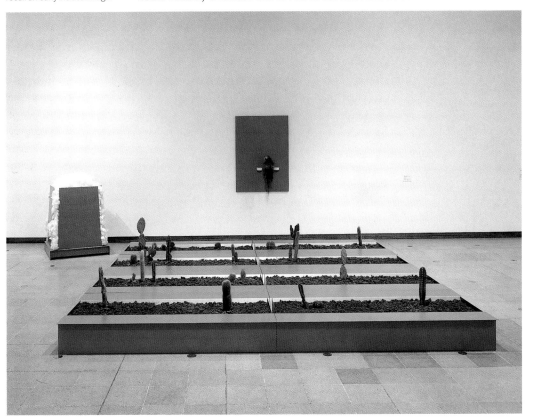

nicative, so profound and hidden, that it needs the art of numbers to reveal it'.

Arte Povera did not have one geographical centre, nor a single direction. The sculpture of the Rome-based Kounellis makes extensive use of iron, with its resonance of the first industrial age, and has affinities with Beuys. For both, early industrialism seems to be relic and memory, but alive and an influence on their work. Kounellis's sculpture [**76**] uses exotic living things, a parrot and cacti, alongside dark, smoky forms, full of mystery and reminiscence of the past, with colours that are redolent of Mark Rothko, utilizing gas flames with their black residual stains evoking the 1961 *Fire Wall* constructions of Klein. Kounellis recalls the pre-scientific world of alchemy, when science and religion had not yet been fully distinguished, and *Arte Povera* as a whole uses the alchemist's contrast of base metals and gold, with fire as an element that gives a sense of charge and metamorphosis, though without the implication of healing or wholeness that might emerge from the alchemist's process.

Arte Povera deals with a jumbled and imperfect world in which we are warned not to look for an easy synthesis. We are asked to accept untidiness, to look for meaning in fragments and to the past for signs—to early industrialism and to Classicism as something past and irrecoverable. Pistoletto's *Golden Venus of Rags* [**72**] is seen from the back as if a thing no longer valued, up against a heap of old clothes. The different Italian pasts exist to be read allegorically, and the present that reads them is the one exhorted to revolt by Celant's 1967 article 'Arte Povera. Notes for a Guerilla War'. Celant described Kounellis's work there as 'a physical memorial testimony, and not an analysis of the successive development of an experiment'. He emphasizes that Kounellis's work, and *Arte Povera* as a whole, is piecemeal rather than structured, extemporized rather than the product of strategy. It does not go as far as Rothko's or Klein's art in the direction of transcendentalism or mysticism, but addresses the complexity of European history, and aims at what Thomas McEvilley has called 'finding a place at the intersection of times, territories and languages'. Its devotion to time, memory, and history was too complex and unspecific for *Arte Povera* to be popular in America and, although it was taken up initially by dealers and public galleries, some critics have seen *Arte Povera*, like Beuys, as romantic, over-detached from the present moment, and insufficiently critical of the institutional framework of the museum. A political artist in America at that time was not Celant's guerrilla, trusting in the power of self and the inspiration of history, but a Broodthaers or Haacke whose present is not so much the pavement underfoot that belongs equally to all, as the museums and their systems and categories which circumscribe an artist's life and activities.

One of the British artists brought into *Arte Povera* at an early stage,

in 1967, was Barry Flanagan, who came to sculpture with little preconceived sense of what the discipline was. It was as if he shared Robert Morris's view that in the urban environment we are so surrounded by made objects that we forget materials, what they are and how they behave. Flanagan filled tall sacks with sand to see how the sacks composed themselves, which depended on how big and how dry the grains were. Materials lie, lean, and prop in different ways. There is a sense of a sculptor not so much using materials to achieve something, in the way Caro, one of Flanagan's mentors, had, but of standing back and seeing how materials conducted themselves: the folded quality of piled Hessian cloth, the poured character of a heap of sand. This questioning side of Flanagan rejects imposed solutions, but there is another side that suggests metaphor and permits interpretation. Like Morris, Flanagan is interested in the scattered character of sculpture, filling a whole room at the Hayward Gallery, London, in 1969 with short lengths of rope—as if the main purpose of the sculpture was simply to fill the room. Morris's point that a landscape reading can emerge from the scatter process applies to Flanagan where the use, occasionally, of part-burnt sticks like an unsuccessful camp fire, or 'bean poles' tied at the top like a Merz living enclosure, permit—but do not insist on—a landscape reading. *Four Casb 2'67, Ring 1 1'67, Rope (gr 2sp 60) 6'67*, [**77**] is like a series of marks or gestures that create and enclose space and suggest primitive or special locations.

The Belgian artist Panamarenko (b. 1940) is best known for his aeroplane variations. His is a low-tech world in which airships and models of pre-First World War biplanes rest lazily on the ground.

77 Barry Flanagan
Four Casb 2'67, Ring 1 1'67, Rope (gr 2sp 60) 6'67, 1967
This pragmatic work juxtaposes simple forms and explores the properties of materials (how dry sand gives shape to hessian sacks), but also creates a distinctive sense that it is a place, bounded by the upright sacks, but overflowing.

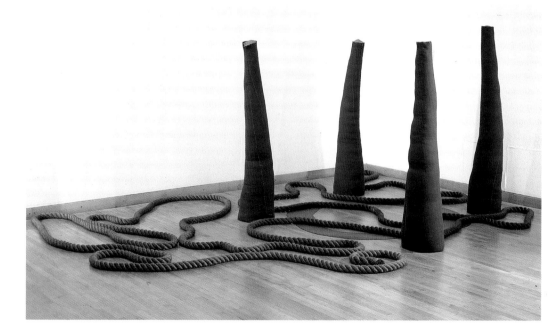

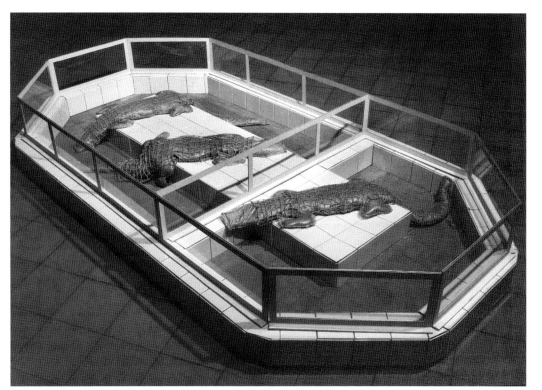

78 Panamarenko
Crocodiles, 1967
Constructed from plastic skins filled with sand, *Crocodiles* reflects the artist's cool humour and desire to protect us from these dangerous reptiles with fishnets thrown over them.

Panamarenko has been positioned critically betwen art and science, though there is something anti-science about the primitiveness even of the aeroplane works. Panamarenko's *Crocodiles* [**78**], formed of sand contained in plastic skins and covered with fishnets, were made in the year *Arte Povera* was launched and have a cool resigned humour, reflecting a lassitude in the face of the modern world that expresses itself through irony (throwing fishnets over these man-eating bags of sand to keep them under control). If it were not that the crocodiles are actually located in the modern pleasure-loving world of the zoo, one would speak of withdrawal to a more primitive world. Panamarenko shares with *Arte Povera* an interest in the old and new together (Merz's igloos emblazoned with neon-lit Fibonacci numbers, for example) with a sense, perhaps, that the old dominates. The year 1967 was when Europe distinguished itself from America in this respect.

The body as sculpture

Since the expansion of Performance Art in the late 1950s, the human body had been involved in an area of the visual arts that was not easily distinguished from theatre. Performance Art at that point, both in America and Europe, was improvisatory and gestural. As Allan Kaprow, polemicist for the movement and its leader in America, pointed out, its origin was partly in Pollock's impulsive and extemporizing art founded on bodily movement. Like Abstract Expressionism,

Performance was an authorial art in which outcomes depended to a considerable extent on actions of the moment. That kind of theatre was closer to painting than sculpture. But the new dance movement in which Morris was engaged, with dancers like Simone Forti, Yvonne Rainer, and Carolee Schneeman, was 'task related'. Movements were made in response to externally imposed rules which did not permit improvisation. As with Minimalism, order is fundamental, and the order imposed is external to the work. The artist is an agent rather than an inventor: the comparison here is with Duchamp in his Dada phase dropping threads on the floor to establish the form of his *Three Standard Stoppages* (1913–14); an accident outside the control of the artist created the measure to which the artwork had to conform. Speaking as choreographer, Yvonne Rainer said in 1968 that she wanted the body to 'be handled like an object, picked up and carried…so that objects and bodies could be interchangeable'.[23] Rainer's remark fits into the context Morris had established in 1961 by equating the Minimalist objects in *Two Columns* [**64**] with the body in the sense of actually occupying one of them. It is a notion of dance intimately linked to Minimalism because of its stress on the body as surface, as something governed by outside forces, that is 'done to', rather than being active and creating its direction from within. A historical parallel would be with the *Triadic Ballet* of the Bauhaus painter-sculptor-choreographer Oskar Schlemmer (1888–1943), in which the performers' individual appearances are masked and their movements ritualized so that they become more machines than humans. The change in the 1960s in performance/dance, and Rainer's equation of body and object, brought the practice closer to sculpture, especially in the work of artists like Gilbert & George's *The Singing Sculpture* [**81**], where movement is ritualized and common style of dress reduces the separateness of the two artists' identities.

Even so, Body Art at the end of the 1960s did not move in a single direction, and there are other distinctions that need to be made: one is between the ritualized body and the body as used in much of Earth Art (by Richard Long, for example), in which the artist's journeys make connections with nature while the Minimalist-influenced gallery installations carry the cultural resonances. Long's ambitions, in this respect, parallel those of *Arte Povera*: he wants to reconnect art with the world and the everyday and yet achieve—as Merz does with his igloos—the sense that sculpture is a cultural fabrication. A second distinction, which carries the argument beyond what is usually accepted as Body Art, distinguishes crucially between the body of the artist used as art and what the artist does to the bodies of the viewers. Minimalism had implicated the viewer in the space of sculpture, Post-Minimalism can be thought of as specifying further what that contextualization implied.

The American Bruce Nauman used the body in widely different ways, and proves the difficulty of looking at Body Art as one thing. Nauman's language was post-Duchampian in the sense that, though the artist's body may be the subject of his art, the distance between himself and the art object is maintained as if they were two different things—or at least, like Rainer's body and object, two interchangeable things. Nauman made casts of body parts, such as *From Hand to Mouth* (1967)—an arm that includes the hand at one end and a corner of Nauman's face incorporating chin and mouth at the other—and presents it like a measured object or anatomical specimen, as the quintessence of armness. The part face permits the pun of the title, and opens up the language games, quick switches between word and image, that are part of the versatile humour of Nauman's work. But the hand and mouth are there also to establish armness, not just as measure but also as image; an arm is a thing of certain length but it is also something that has a hand at one end and a face at the other. *Neon Templates of the Left Half of My Body Taken at Ten-Inch Intervals* [**79**] offers a reading of Nauman's body, not, as with the fleshy *From Hand to Mouth*, in terms of representations, but, in the form of a skeletal rib-cage, as a kind of diagram or map. Nauman's work veers between presence and absence: the arm is there, the figure, as will be seen, can be present in his art. But, like Jasper Johns's *Targets*, with their casts of fragments of the human body encased in wooden boxes, Nauman is interested in relics, fragments that are isolated and removed from time.

Nauman is also close to Manzoni in his interest in trace. The equivalent for Nauman of the point in Manzoni where even the relic no longer existed and only the trace remained—the thumbprint on an eggshell, the footprint replacing the absent figure on the plinth of a statue [**42**]—was the negative cast. Nauman made sculptures of the gap between things—the space under a chair, the space between his hand and a table. He also made imprints, in the form, for example, of the cavities left by a row of five artists' feet in a soft substance. It is as if by contrast with the arm, which is very much there, he wanted to consolidate absence, to make small private memorials—private because most are hard to recognize for what they are without the clue of the title.

In the short period of the later 1960s Nauman's work moved a long way and through several media, from objects to installations and video. Correspondingly, the irony of suggestion and denial, presence and absence that characterizes the early objects and connects Nauman to Duchamp and Johns changes tempo as he moves into installation and video.

Nauman's corridor installations share with the absent objects a reversal that seems, at first encounter, to put the weight of meaning in the wrong place. Just as with the absent objects what we see is contin-

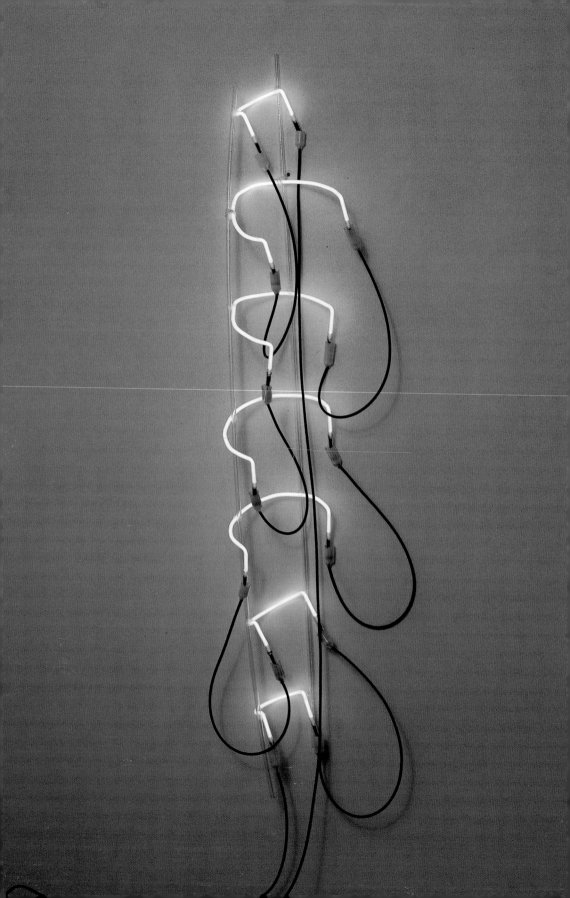

79 Bruce Nauman
*Neon Templates of the Left
Half of My Body Taken at
Ten-Inch Intervals,* 1966
Nauman is interested in
measurement and the body
as skeleton in the way an
anatomist looks at it, but uses
neon, as Merz did at the same
time in Italy, but in a different
context, to represent energy
or life blood flowing through.

gent space represented as solid, so the installation corridors are disconcerting because we see the outsides of their structures first, the battening that holds up the walls, and only later experience the full bodily sensation of being enclosed, claustrophobically, in a narrow space. *Green Light Corridor* [80] is open at both ends and invites us to pass along a twelve-inch space for a distance of forty feet under the glare of bright green lights.

From ironical detachment Nauman has turned to an art of intense physical sensation. He retains the forms of Minimalism, but reverses the process which in Minimalism limited meaning to the surface of objects. You walk on Andre's metal plates, but there is no Minimalist work which you get inside in the way you must enter Nauman's corridors to experience them. In locating the audience at the centre of the work instead of outside it, Nauman was releasing the power of sculpture to stimulate sensation and taking it beyond Minimalism into areas that were also the concern of Earth Art.

The kind of space that Nauman was creating was described by the critic Carter Ratcliff, in respect of the work of Nauman, Michael Asher, and Richard Serra at the 1972 Documenta, as 'adversary spaces'.[24] Asher's room space disconcerted the viewer-participant because the dim light left the contours of the space uncertain, while Serra's sculpture, by contrast, was a projection of steel walls into room space, leaving the audience threatened by the scale of the work and disorientated because of the difficulty of getting a clear view of the whole piece from any position. Adversary spaces were attempts to disorient the viewer and heighten sensation from within an installation space that was itself contained inside, but was different from, the normal space of an art gallery.

Nauman's contribution to Documenta in 1972 consisted of two corridors entered through a door between the two. In whichever direction the viewer then moved, the corridor narrowed to an opening which looked back out to the exhibition hall but was too slim to pass through. In effect, instead of being a person looking at a work of art in an exhibition, the person within Nauman's work of art becomes a spectator of the other spectators and the rest of the exhibition. Nauman was evolving a critical position, not only in respect of existing art, but in respect of the exhibition space as a whole. Within the larger Documenta exhibition area, his space compelled participants to look not just at art, but at people looking at art, and in that way his work became a critique of the exhibition as a whole. Nauman is using the audience, but positively rejected audience participation, if participation implied freedom to choose one course or another. The adversarial character of this space is in its narrowness and refusal to offer its occupant any option. Nauman's corridors are an example of 'situation aesthetics', which particularized the non-specific viewer–artwork relation of Minimalism, and clarified

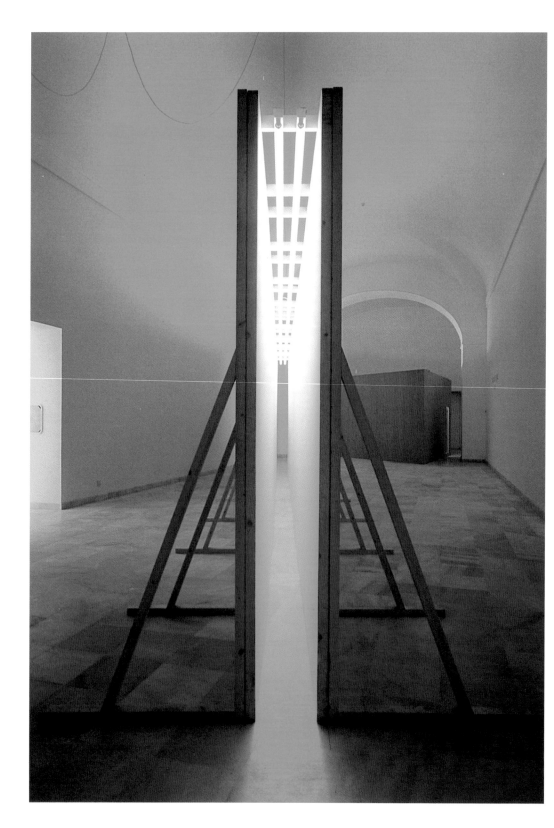

160 'ANTI-FORM'

80 Bruce Nauman

Green Light Corridor, 1970

This is one of a number of corridors and passageways designed by Nauman, which heighten the participant's sense of self-awareness—to the point of claustrophobia. In some examples, closed-circuit delayed action video allows participants to witness their own reactions.

the meaning and implications of the different spaces viewers might find themselves in.

Nauman's corridors are also connected with Body Art to the extent that they induce self-awareness and reflection, and often claustrophobia as well. There was a move at the time to subject the body to extremes of physical sensation and even danger. Chris Burden had himself locked in an unlit cupboard measuring two by two by three feet for five days with nothing but a supply of water, and on another occasion had himself shot at and injured in the arm. Dennis Oppenheim stood for an hour beneath a building from which stones were dropped that nearly hit him.

The London artists Gilbert & George established themselves in 1969 as *The Singing Sculpture* [**81**], with ritualized re-enactions of Flanagan and Allen's music-hall song 'Underneath the Arches'. Standing on a table (having established themselves as sculptors, they needed a podium) in Edwardian-style suits and equipped only with a walking-stick and a glove as props, they mimed the music to a tape-recorder, stepping down alternately every few minutes to reset the tape. What is presented is neither, on the one hand, the recreation of a music-hall turn, nor is it parody. Gilbert & George call up a part of the British vernacular tradition of musical performance from the vantage

81 Gilbert & George

The Singing Sculpture, 1970

In this work Gilbert & George appropriate for sculpture the human figure's role in theatre and performance, parodying, in the process, traditional, formal, public sculpture.

82 Vito Acconci

Seedbed, 1972

Acconi's performance—
masturbating beneath a
specially constructed platform
in the Sonnabend Gallery—
comments on the relationship
of artwork to audience, issues
of public and private, and
the possibilities for art that
can be heard (with the help
of amplification in this case)
but not seen.

point of high art. In 1969 they were still students at St Martin's School of Art, London, where the ethos of Caro and the New Generation was by then also being contested by Barry Flanagan and Richard Long. This was a rebellion, but evoking the music hall does not in itself constitute a descent from 'high' to 'low'. Slow ritualistic movement repeated time after time is a cumulative formation, the same kind of formation pursued by Minimalism.

Minimalism, of course, used mainly industrially produced products and the human body was, admittedly, its least likely subject or material. Gilbert & George countered that by using different devices to negate their humanity. They painted their faces red or gold—to acquire the anonymity of icons—or stood stock-still for five hours on the stairway of the Stedelijk Museum in Amsterdam, to enforce the image that they are not people but sculptures, not private but public. The effort of endless repetition, not just replaying the tape in *The Singing Sculpture* over and over, but almost never creating a work that does not consist of, or contain an image of themselves, has turned them into familiar objects. Like statues we see in parks and streets, which are part of the urban scene but may also be unknown relics of vanished history, Gilbert & George are private individuals inhabiting the public domain. Like Marilyn Monroe, repeatedly re-presented through media images in the art of Warhol and others, we known them as simulacra while the real Gilbert & George remain hidden. Their work comments on the accessibility of reality and the real individual in a world saturated by the media with secondary imagery.

The American artist Vito Acconci, who also around 1970 identified

his art with his body, had a clear perception that he wanted to make his work in the art gallery; not to make work *for* the gallery but *in* it. Acconci's *Seedbed* [**82**] installation at the Sonnabend Gallery, New York, consisted of a raised area of the floor in one corner of the gallery beneath which Acconci lay in darkness and masturbated. Acconci's domain and the gallery were connected by a personal speaker system which amplified his fantasizing. There are manifold implications, connected with ideas of above and below, shadowed areas and light, and the spreading of seed. The pivotal idea, however, is connected with connection and separation, the distance between the private and public spheres. Acconci was interested in the nature of an art gallery, traditionally a place where art, made in the studio, was brought to be exhibited to the public. The late 1960s and the early 1970s, even more than the initial phase of Performance and non-gallery art ten years earlier, was the period when the location of art was most open. It might be in a conventional gallery, in a warehouse, in a public urban space, or in a remote rural or desert location. The space of Acconci's *Seedbed* was the same space—the Sonnabend Gallery in New York—where a year earlier Gilbert & George had performed as the *Singing Sculpture*. This was not a simple 'return to the gallery', the prodigal artist returning home. Once new spaces for art had been opened up, to revert to the conventional one was an act of choice. Acconci was interested at the time in public space. A recent work had been a photographic record of himself stalking an unknown person so long as the person remained in public space. The measure of the work of art was the extent of another person's existence in the public domain.

Returning to the art gallery, which is notionally a public space, but actually belongs to the particular community identifiable as 'gallery-goers'—and is to that extent private—Acconci is playing with ideas of public and private. His action is one generally regarded as private and he is himself hidden from view; yet the gallery-goer who picks up the headphones shares his private musings and acquires a complicity that may cause anxiety, awkwardness, or pleasure. At least, it makes gallery-goers active because, short of switching off, they are necessarily engaged. In a sense this is another of Carter Ratcliff's 'adversary spaces', where members of the audience are put under the pressure of awareness of their own presence and situation.

In an interview in 1972 Acconci used the phrase 'performance areas' for the way we all necessarily conduct person-to-person encounters. In all encounters behaviour is governed by a 'line' which reflects not simply thoughts of the moment but our perceptions of ourselves and our audience. In short, conversation or any other kind of communication is not natural but coded. The soundtrack of *Seedbed* plays upon the moment of sexual intimacy when we feel ourselves both servants of nature and intimate with another person. In Acconci's example, however, neither of these things is true. The situation is wholly artificial, the supposed intimacies meaningless in respect of any recipient, and the point being made is that we inhabit an environment which is socially regulated, in which we are the agents of convention. Acconci's action is further devalued, as a personal action, by regular repetition, in parallel to the robotic circularity of Gilbert & George's stepping down to rewind the tape.

Gilbert & George's miming of 'Underneath the Arches' and Acconci's wasted words of sexual endearment are both external orders of expression determined by convention and not by the person who utters the words. In this sense they belong within the field of Minimalism, in that their logic is an order that is not invented by the artist. An achievement of Minimalism had been to re-establish a physical, spatial relationship between viewer and object. In so far as post-Minimalism is a useful phrase, it is because post-Minimal artists started to identify how this space, left unspecific by Minimalism, could be particularized.

The work of Rebecca Horn (b. 1944) maps the human body and locates it in relation to the world. The mapping mainly occurs in later works like *Rising Full Moon* and *Missing Full Moon*, complex sculptures involving tubes and pipes carrying bodily liquids, from blood to semen and amniotic fluids. Horn's work in this sense is a mapping of the body onto surrounding spaces. Horn's early work involved body extensions, prostheses in medical terminology, leather and stuffed fabric extensions which project the body into external space. These can be thought of as expressions of power, in that they enlarge the body physically and magnify its area of authority. But some of the prostheses

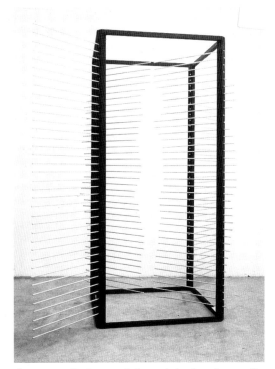

Measure Box was one of several devices Rebecca Horn improvised both for empowering the body by extending its range through physical extensions and, as here, for stressing its vulnerability to forces outside it.

were so hard to wear, and went so far beyond the original orthopaedic functions of this kind of physical attachment, that they succeeded in making the body vulnerable by creating instability and hindering movement. One of Horn's themes is nudity, either of the body whose functions are exposed metaphorically, or the body which would be actually naked but for the extensions. These extensions may also be coverings, in the sense that Horn will half conceal a naked body with a cloak of bird's feathers. Feathers are a product of nature but of a particularly hardy kind; like fur, which Horn has also used, feathers survive the death of the body, and are protective in being waterproof as well as durable. Horn refers both to sexuality, in the sense that she is interested in exchange of body fluids, and exchange of sexual characteristics, the single erect forms (projecting from head and hands and not belly) that allude to maleness. She is also an erotic artist in her early work in that the outermost coverings, such as feathers, are positioned directly against a naked body.

Horn's bodies resist self-containment: they have prosthetic projections which push them out into surrounding space, and equally, surrounding spaces press in on them. *Measure Box* [**83**] is a container which takes on the image of its human occupant even when its occupant is not there. At first sight it belongs to the same pattern of thought as Nauman's corridors, and enforced claustrophobia is certainly an element in Horn's work. But her work is different from Nauman's in that it is a two-way box, in which the bars move inwards and outwards;

in the same way that Horn's prosthetic pieces demonstrate both power and vulnerability, *Measure Box* can be thought of as illustrating both enclosure and release. Horn made a related work, *The Chinese Fiancée* (1976), a multi-entranced box, the doors of which closed automatically when the threshold was crossed, leaving the participant for one minute in a small space in total darkness. A further surprise, however, was the gratification (assuming the participant was male) of the soft whispers of endearment of the voice of a Chinese woman. Horn's work is about pleasure and pain, power and vulnerability, inside and outside. With the course of time, and with experience as a film-maker, Horn developed command of narrative, and her later works are site-specific, reflecting on the history of the places where the works are sited.

Horn's contribution to the Münster Sculpture Project (1987) was the discovery of a small defensive tower in the city's medieval walls which had been bricked up since the Second World War because it was the site of Nazi atrocities. Horn had it opened up and, using the contrast of dungeon and open sky, dripping water, candles, and even a snake, opened up a language with bodily connotations, which contrasted high and low, the sky and the chthonic, and also had alchemical overtones suggesting completion or making good. The theme of the body as vulnerable is extended in Horn's later work to an expression of collective vulnerability which must be exposed and healed. The idea of healing, particularly in relation to Germany's historic wounds, was a preoccupation of Beuys, and in this respect Horn was a successor.

Greenberg's Modernism was focused on the exclusion of the body as a physical object from the space of art, and the end of Modernism is appropriately symbolized by the physical consumption of Greenberg's *Art and Culture*. John Latham (b. 1921) was a teacher at St Martin's

School of Art who invited a group of students to join him in each chewing a page of the copy of Greenberg's book belonging to the school's library. Latham used hydrochloric acid to stabilize the remains, which were bottled and neatly packaged together with visual and verbal records of the event, in a suitcase. Latham's *Art & Culture* [84] is an apt tribute to Duchamp's *Green Box*—in the sense that Duchamp was the twentieth-century hero who was excluded from Greenberg's canon, and whose reputation, when recovered in the 1960s, signalled Greenberg's downfall. Greenberg's literary remains were subsequently acquired from Latham by the Museum of Modern Art, New York, the institution which mirrored most precisely in its collecting and exhibitions policy Greenberg's theory of a canonical history of modern art. Rather than taking the Museum's acquisition as straight irony, one should be aware of the power of institutions to reinvent themselves by subsuming history.

Natural Materials

6

Minimalism to landscape

The essentially urban culture of the 1960s had little time for nature and landscape. The 1970s were different, with landscape a source of materials and a site for sculpture. Landscape has traditionally been where an artist might experience a heightened sense of origin, of spiritual belonging, and the primitive, or of new beginnings away from the city. There were elements of this in the 1970s, but Earth Art and most of sculptors' new encounters with landscape were city dwellers' assimilations of the non-urban. They amplified and re-directed urban culture, but represented neither a flight from commerce and the 'gallery system', nor—for the most part—a withdrawal from the city into nomadism or rural settlement.

In some respects the impulse for involvement with landscape came from art that had no direct link with landscape itself. In relation to *Continuous Project Altered Daily* [**67**], Morris had pointed out that work concerned with change, spread, lack of centre, and unfocused boundaries could be thought of as like landscape: but he did not imply that it represented landscape. Leo Steinberg, writing in 1972—a time when landscape art had fully re-established itself—provided what may also be thought of as a validation of the genre. Describing Rauschenberg's 1950s combine paintings in terms of the 'flatbed picture plane', Steinberg opposed a humanist, perceptual view of art to a non-humanist view based on heterogeneity or scatter.[1] Nothing Steinberg said actually related to landscape. But, taken together, these ideas show how the way was being opened up for its reinstatement, on technical rather than spiritual or emotional grounds. Shifts in sculptural technique, not themselves connected with landscape—from composing to assembling, from upright to horizontal, and from interest in centre to concern for periphery—coincided with artists' new interest in nature. The 'nature' that artists became interested in was, in any case, not that of most traditional art. As Robert Smithson pointed out: 'The desert is less "nature" than a concept, a place that swallows up boundaries.'[2] This is another way of saying that making works of Earth Art in the desert was less a tribute to spiritual inspiration of place than a parallel to what Morris was doing in *Continuous Project Altered Daily*.

Detail of 93

Tony Smith, architect turned Minimalist sculptor, described in 1967 his unhappiness with art that was small and portable ('paintings like postage stamps'); he wanted an art that was extensive and public, preferring over easel painting the mural art of Mexicans like José Clemente Orozco, because it was big and its content 'holds onto a surface in the same way a state does on a map'. Topology—surfaces and the way they are mapped and events are inscribed on them—was part of Smith's interest, extending from big painting to physical involvement with landscape. Smith described a moment several years before, when he had broken onto the unfinished New Jersey Turnpike in his car at night:

there were no lights or shoulder markers, lines, railings, or anything at all except the dark pavement moving through the landscape of the flats, rimmed by hills in the distance, but punctuated by stacks, towers, fumes, and coloured lights. This drive was a revealing experience. The road and much of the landscape was artificial, and yet it couldn't be called a work of art. On the other hand, it did something for me that art had never done. At first, I didn't know what it was, but its effect was to liberate me from many of the views I had had about art. It seemed to me that there had been a reality there that had not had any expression in art.

The experience on the road was something mapped out but not socially recognized. I thought to myself, it ought to be pretty clear that's the end of art. Most painting looks pretty pictorial after that. There is no way you can frame it, you just have to experience it.[3]

Smith's reference to 'the end of art' was to art that had fixed edges, in which the boundary between art and not-art was certain and stable. The new art Smith was searching for was one the audience, as physical presences, are at the centre of, while the peripheries are uncertain. Earth Art picked up on and developed these ideas. Smith's arguments were among those that Fried in 'Art and Objecthood' was keenest to rebut because—in a more radical form than Minimalism—Smith was advocating the theatricality that Fried resisted, the invasion of the stage by the audience, the actual occupation by the viewer of a quasi-artwork, the turnpike and its surrounding landscape. Some examples of Earth Art, as of Body Art, grew from this inversion of the traditional relationship between the viewer of art and the thing seen. Instead of looking in from the outside, the viewer is at the heart of the work looking out.

Carl Andre provided an experience of landscape complementary to Smith's. Unlike other Minimalists, Andre used natural materials and located work out of doors. He was attracted to landscape in 1954 on a visit to England, which he saw, in contrast to America, as a fabricated landscape, formed by generations of farmers. He became interested in Stonehenge and places surrounded by an aura. The rootedness of monuments mattered more to him than their age or purpose, and when

he came to know Brancusi's sculpture towards the end of the decade, he saw the *Endless Column* as rooted in the same way. It was not that the *Endless Column* went deep into the actual earth, which it does not; it was its function as a bridge that appealed to him, not human in measure but connecting the lowest conceivable place with the highest. Andre called the *Endless Column* 'the great link into the earth....[It] drives down into the earth with a kind of verticality which is not terminal. Before that verticality was always terminal: the top of the head and the bottom of the feet were the limits of sculpture.'[4]

Andre prioritized the concerns of recent sculpture as, first, an interest in form, followed by interest in the structure that lies behind the form and, third, concern with location—how sculpture constitutes its environment as a place. In the 1966 'Primary Structures' exhibition he devised a thirty-four-foot-long line of bricks leading from one room to another and therefore not visible as a whole from any one position. He considered certain of his sculptures as like causeways or roads which, if laid over a sufficient extent of outdoor ground, might appear and disappear without offering a single fixed-point vista. Following such a work was a form of travel rather than simple viewing; the experience is temporal. But Andre has emphasized that he is 'not a person of the countryside. I am a person of the town.'[5] Although interested, like Robert Morris and Richard Serra, in the way places can contribute to the meaning of sculpture, Andre, like them, has seen the problems of contemporary art as needing to be solved within the social and economic context of the city.

The restoration of history

Much outdoor sculpture in the 1960s had anchored itself resolutely to the present, with Constructivist forms made from materials, like stainless steel, that weathered well and maintained a modern look. Such sculpture might be kinetic, with motorization alluding—almost always in a low-tech way—to the technological values on which the optimism of the post-war period was founded. Memorial sculpture, or any work that was tied into, and represented, a place or neighbourhood, its people and history, or suggested social or political values, was invalidated by this sense that sculpture should live in the present. It might be 'forward looking', because technology was progressive, and 'socially unifying', because technology was regarded as value-free and for the benefit of all. This had been the situation with the Skylon at the Festival of Britain in 1951, which pointed Britain away from the war and immediate past in the direction of an idealized future. The enlarged abstract designs that adorned corporate plazas and lobbies, masquerading as public art, were, similarly, a way of asserting capitalism's social neutrality (the art alluded to nothing outside art and threatened nobody) and its aesthetic benevolence. While not actually invading

public space in the way that advertising did, 'plaza' art had the effect of draining meaning away from it, of creating a kind of outdoor space poised between public and private: accessible to all, but devoid of history and association, and therefore belonging to nobody.

Site-specific art suggested an alternative by linking art with place and history, and the sudden collapse of interest in kinetic art at the end of the 1960s should be seen in parallel with the equally rapid expansion of interest in Earth Art. Earth Art opened the way for history, occasionally through direct allusion, more often through the disciplines that sculpture was now contingent to and drew strength from, such as geology, anthropology, and archaeology. Unlike technology, which pointed into the future, these were disciplines that valued the past.

Earth Art was not one thing; it did not define a group, and neither this name nor alternatives, such as Land Art, were welcomed by all the artists included within them. 'Earth Art' was, however, the title of a group exhibition at the Dwan Gallery, New York, in 1968, and in the next year a related title, 'Earthworks', was adopted for an international show at the Andrew Dickson White Museum, Cornell University. Within the explosion of new ideas towards the end of the 1960s Earth Art made its presence felt rapidly. Narrowly interpreted, Earth Art was short-lived, with most of the best-known examples completed by the time of Robert Smithson's death in 1973. More broadly interpreted, the connection between sculpture and natural materials lasted through the 1970s.

Earth Art can imply several different things. It can mean an architectural type of construction made in landscape, which may be a remote western desert if the artist is American. It can mean a removal from the landscape, or some kind of burial. But the work of art does not need to be in the landscape at all, and can consist of the transfer of stone or other substance from the landscape and its installation in an art gallery. Most Americans involved with Earth Art had been connected with Minimalism, and Earth Art never severed its links completely with that movement. It was dialectical, counterposing the white-walled gallery as box-like container and organizing device against undifferentiated base material, earth or rock. The discourse was between rural and urban, open and closed, scattered and centred. The significance of much Earth Art lies on a line between these polarities, within the process of change, removal, and re-forming. The finished object is important, but the process by which it is arrived at also has meaning. In relation to Earth Art, travelling, surveying, mapping, researching, and writing can all be constituents of works of art.

By adding to the art gallery alternative locations for displaying art, Earth Art did not circumvent the capitalist structures of the art world. Art of the size that Smithson or Michael Heizer (b. 1944) created in the desert required entrepreneurial talent and financial support for the

85 Walter de Maria
New York Earth Room, 1977

purchase of land and hire of equipment. Photographs of works being surveyed and under construction show artists travelling in light aircraft and working with massive diggers and low-loaders. Virginia Dwan of the Dwan Gallery and the collector Robert C. Scull were among sponsors and purchasers, operating within a system of art finance that was unique in detail but within a familiar capitalist frame. European artists were different: whether working at home, or abroad in places as remote as Americans adopted, they did not want to become site managers, preferring a lighter touch, and working more spontaneously on the surface of the earth with available materials.

The American artist Walter de Maria's one-man exhibition at the Heiner Friedrich Gallery, Munich, in 1968 consisted of an even depth of earth spread through the three rooms of the gallery. A second *Earth Room* [**85**] was made in New York in 1977. In 1968 Richard Long's first one-man show, at the Konrad Fischer Gallery, Düsseldorf, consisted of parallel lines of twigs laid on the floor, a physically modest ensemble by comparison with de Maria's denser material and logistically more complex operation, but occupying the whole room space in the same way. De Maria's *Earth Room* is an extreme work of art, violating

traditional boundaries by exposure within such a culturally differentiated space as an art gallery of the most primitive of materials. Earth, in conjunction with sun and rain, is the vehicle for life and growth, but exposed on its own in this way it has a pre-organic deadness. When we speak of art as 'low', as opposed to 'high', we generally use it as a measure of popularity and proximity to everyday urban life. But low has a more literal meaning relating to what is underneath and, as opposed to the architecture of urban culture above it, exists in a primitive and undifferentiated state. Earth Art was concerned not with one or the other of these separately, but with the relationship between the two.

In 1970 de Maria proposed a project in connection with the 1972 Olympic Games to be held in Munich. On the edge of the city was an artificial hill formed from the rubble of wartime bombing and subsequent clearance. He projected [**86**] a narrow hole to be bored down to the bottom of the artificial hill, and continued for an equal distance further down into the natural sedimentations below the rubble. The sole visible emblem of de Maria's literal digging into history would have been a capping plate, some five metres in diameter at the top of the bore hole. De Maria's proposal was for an invisible line through history, man-made history and natural history in equal degrees. In effect, he was proposing a new kind of war memorial, a minimal memorial for an unheroic age. The project failed, for political as well as economic reasons, but the reawakened interest in the past re-opened the possibilities for memorial art—if of a somewhat esoteric and not, in the traditional sense, 'public' kind.

Michael Heizer's excavations and burials relate to pre-history. His *Displaced/Replaced Mass*, Silver Springs, Nevada [**87**], consisted of three granite boulders, dynamited nine thousand feet up in the Sierra mountains and brought sixty miles on low-loaders four thousand feet down into the Great Desert Basin Plain, where they were tipped into

87 Michael Heizer

Displaced/Replaced Mass, 1969

In this work Heizer achieved a historical restoration, replacing granite boulders in the position they had occupied in an earlier formation of the earth's crust.

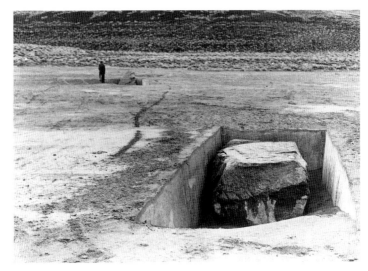

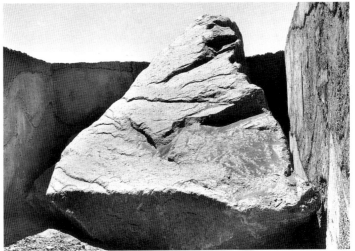

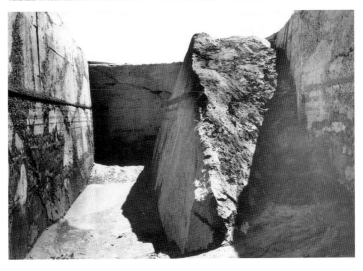

prepared cement-lined holes. The granite blocks, the clay bed of the plain, and the cement linings of the holes were all the same colour, so the action seemed in this respect natural. The Sierras had a volcanic fault which had caused the granite to be thrown up to nine thousand feet millennia previously, so Heizer's actions were not only visually rational but historically concordant, as he reversed the physical processes and returned the boulders to their original location.

Heizer's *Double Negative* [88] is without historical associations. It is purely an art of reduction, nothing is added, and meaning derives from the space that is left and its situation in the wider landscape. *Double Negative* consists of two deep trenches cut into a desert escarpment, almost parallel to the cliff face, at a point where a high desert plateau falls away steeply into a wide river valley. It is possible to see from one trench to the other across the gap where the cliff has fallen away, but not to pass between them. Though in a different type of location, Heizer is working here in parallel with Nauman, the trenches being corridors, in effect, on a vast scale. They are shadowed and cool within, and their high walls are protective against the heat and sunlight of the desert. Heizer evokes sensuous response, using not only the high walls of the cuts but the precipitous ambience of the whole piece to create a kind of landscape sublime.

The experience of Smithson's *Spiral Jetty* [89], which also has a primal position between a deserted landscape and an open expanse of water, is one, like *Double Negative*, of something vastly larger than one-self, whose scale is difficult to grasp. As a type of art that is rarely seen at first hand, Earth Art constructions are understood more than most sculpture through the way they are photographed. Because sculpture is three-dimensional, photographs of sculpture are always interpretative in a way that photography of painting is not. The photography of sculpture was important in the sixties as record at a time when process vied with end-result for importance. The photographic record of Morris's *Continuous Project Altered Daily* tells us what otherwise we could not know. Earth Art introduced a new experience of the artwork through the adoption from archaeological practice of aerial photo-graphy. Overflying proposed sites was a part of the surveying process, and Smithson lost his life in an aircraft accident while surveying the site of his last work, *Amarillo Ramp* (1973). The aerial view might be part of the artist's imagination from the point of the work's inception. Smithson was careful over visual records, and the film of *Spiral Jetty* by Gianfranco Gorgoni is even-handed in mixing aerial and ground views. Earth Art is to be seen but also to be felt; it is a phenomenological art of direct experience and not just a perceptual one. Aerial photography is useful for mapping sites but can never give a full understanding. But since then aerial views have predominated in books, and what, in Morris's Minimalist terms, would be called the gestalt view has

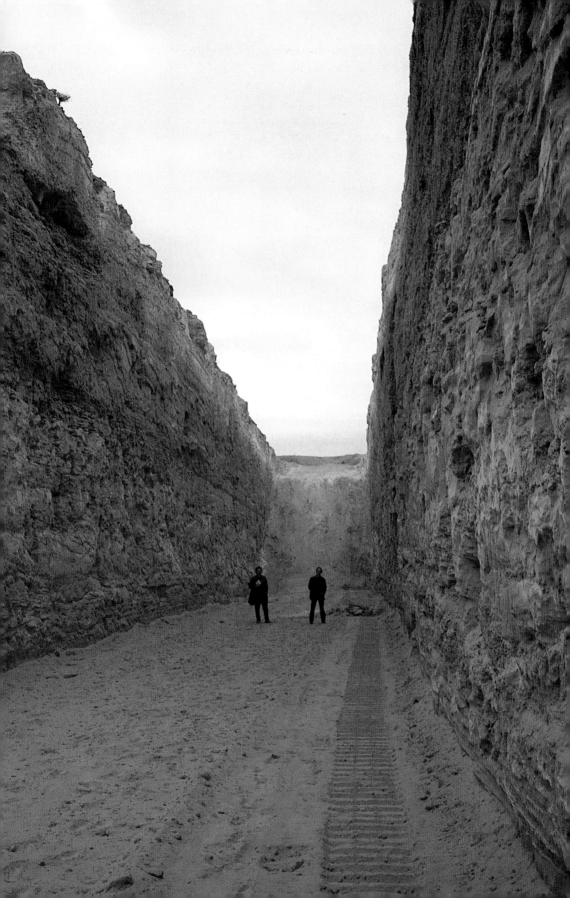

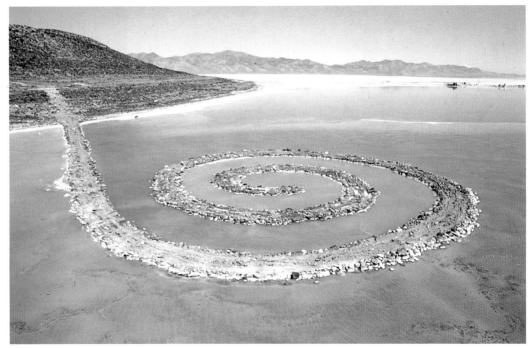

predominated over the phenomenological one, the pivotal experience of walking the spiral, of actually being there, is too rarely evoked.

Smithson and entropy

Spiral Jetty has uniquely caught the public imagination and, with *Double Negative*, become emblematic of Earth Art as a whole. In his description of *Spiral Jetty*, Smithson drew attention to the history and myths surrounding the place: the existence of defunct oil wells nearby, the memorial some distance away to the first trans-continental rail link, closed long before, but marked by two rusting locomotives face to face in the desert. The legend that at the bottom of the Great Salt Lake a drain connects the lake to the distant Pacific Ocean, allegedly creating disturbances to the water surface in the form of vortexes, determines the spiral form of the jetty. Smithson used a mixture of history and fantasy to point up truths about the frailty of human endeavour and the inevitability with which human achievements turn to ruin and are sucked back into the ground.

Smithson's *Six Stops on a Section* [**90**] consists of a row of metal bins containing stones, a row of photographs of the sites from which the stones were taken, and a sectional map of Smithson's six-day journey from New York to Dingman's Ferry on the Delaware River. Each night he removed stones from the stopping place, and in the final work identified each day's journey by coordinating the profile of the lip of each bin with the contour line on the section of the map relating to the day's walk. The bins of stones, removed from their original location,

connect 'site' with 'non-site'—Smithson's words to define, on the one hand, the place of personal experience and the source of his material in its raw form, and, on the other, the point of display, the art gallery. A site will be defined in an exhibition by a photograph, while a non-site will be a container holding material from the site. The words 'site' and 'siteless' would have been familiar to Smithson from the current debate over the shift from the 'placelessness' of sculpture within Modernism to its 'locatedness', its existence somewhere, which was the way Earth Art, following Minimalism, released itself from the restrictions of Modernism.

In terms of space, Smithson described the site and the non-site dialectically and pointed out how the opposite poles converged. Thus, a site has open limits and a non-site closed ones; a site is a series of points, a non-site an array of matter; a site has scattered information, a non-site contained information; a site is 'some place (physical)', a non-site is 'no place (abstract)', and so on. Plainly Smithson's thinking went down some of the same tracks that led Morris to view the course of his own work as it moved from the containment and centredness of Minimalism towards the diffuseness of his floor-pieces made of arrays of cotton shoddy or his *Continuous Project Altered Daily*. De-centredness, and interest in undifferentiated base material, are focal interests of sculpture after Minimalism.

Temporality emerges in Earth Art in different ways: if planning and making is thought of as integral to the work, the time involved in construction is the first relevant aspect, while the second is the time a

90 Robert Smithson
Six Stops on a Section, 1968
This is a record or diary of a six-day journey across New Jersey which includes a sectional map and photographs on the wall with stones in the bins removed from each night's stopping-place. Smithson is concerned with how to record as sculpture a sequence of events and places that are diffused in time and space.

work lasts. Just as the time taken to make something had previously been taken for granted and not regarded as part of a work's identity, so its life span had been thought of till now as infinite. But Heizer's *Displaced/Replaced Mass*, for example, was short-lived, because the desert winds blew sand into the excavations and covered the boulders. Works of art with finite lives (which included, at this point, much more than just Earth Art) question the centrality of the museum in the understanding of art. Conservation, a principal function of the museum, assumes that all works of art have a finished state that should be maintained in perpetuity.

A third aspect of time is associational, a work of art's relationship to history. Smithson was unhappy with the present day's understanding of time: a technologically based society, he thought, appreciated only the present, because it had no sense of time. Sculpture made of an indestructible steel, which never altered in appearance, and seemed somehow 'timeless', represented false values. It was against this static perfection that Smithson called to his aid the theory of entropy. In science entropy refers to the conclusion of the second law of thermo-dynamics that energy, though it can never be destroyed, can be so scat-tered across the earth's surface as to become useless.[6] Against ideas of 'art as perfection', Smithson foregrounded the inevitability of decline and the need (quoting Vladimir Nabokov) for the artist to think of the past as the future in reverse. Smithson's involvement with archaeology and geology was not based on scientific antiquarianism (though there was an element of this in his mental constitution); it was driven rather by the knowledge that we ourselves and the present day itself are the archaeology of the future. Technology, he felt, tried to conceal this fact by always presenting itself as progressive.

Smithson summed up his sense of entropy in the remark that the fundamental property of iron is rust. 'In the technological mind rust evokes a fear of disuse, inactivity, entropy and ruin. Why steel is valued over rust is a technological value, not an artistic one.' Once artists were released from the thrall of technology, the conviction that the future would be better than the past would begin to fall away, he quoted Nabokov as saying, and primitive states of the world would come into their own. A Pennsylvania quarry which he visited in the summer of 1968 became the place where 'all boundaries and distinctions lost their meaning in this ocean of slate and collapsed all notions of gestalt unity. The present fell forward and backward into a tumult of "de-differenti-ation", to use Anton Ehrenzweig's word for entropy.'[7] The quarry was one of Smithson's sites and, framed in geometric boxes, its stone was exhibited at the Dwan Gallery as a non-site. Smithson was not just revelling in primitive chaos; he was interested in chaos, because he saw it as a fundamental state of the world which we ignore at our peril, but he liked to see it parcelled into compartments, as his article on the con-

struction of New York's Central Park, illustrated with nineteenth-century photographs of neat picket fences dividing up a sea of mud, shows.[8] He was preoccupied with the dialectic of form and formlessness, focusing attention on what he called 'geologic time' as the contrasting pole to present time. Smithson questioned the high value placed on the physical sciences, which underpinned material progress, at the expense of the natural and earth sciences. He was interested in geology and natural history, and in the way sciences involved with growth and decay endorsed a cyclical view of time rather than a linear one.

Smithson's polarity between site and non-site is not to be seen as one-directional, with the non-site being seen as virtuous to the exclusion of the site because of the way it imposes a measure of control over the chaos of the site. He was excited by the appearance of chaos and wrote of the way bulldozers and steam shovels 'seem to turn the terrain into unfinished cities of organized wreckage.... These processes of heavy construction have a devastating kind of primordial grandeur and are in many ways more astonishing than the finished project—be it a road or a building.'[9] In the end what interested Smithson most was the sense of working between what, following Ehrenzweig's study of human personality, he called the 'oceanic' and 'strong determinants'; he was interested in the process of change and felt that present art was a form of intervention as much as it was a thing.

Critics, by focusing on the 'art object' deprive the artist of any existence in the world of both mind and matter. The mental process of the artist, which takes *place* in time is disowned, so that a commodity value can be maintained by a system independent of the artist. Art, in this sense, is considered 'timeless', or a product of 'no time at all'; this becomes a convenient way to exploit the artist out of his rightful claim to his temporal processes.[10]

Artworks regarded as separate 'things', 'forms', 'objects', 'shapes', with beginnings and endings were, Smithson thought, no more than convenient fictions. The existence of the artist in time is worth as much as the finished product.

Earth Art and Europe
Though Richard Long exhibited at the 1968 earthworks show at Cornell, his art is unlike American work. His links are with continental Europe: following his first one-man show in Düsseldorf, he showed the same year with *Arte Povera* in Amalfi. Long touched his surroundings more lightly than American artists, disturbing the land-scape very little and leaving minimal evidence of his presence. He has not made constructions far above the ground and has not dug deep below. His work relates to Minimalism in its connection with geometry and in being assembled rather than composed. As with the bricks in Andre's *Equivalent VIII* [65], Long's works can be simply

91 Richard Long
Stone Line, 1980

91 Richard Long

Stone Line, 1980

Long's austere work of assembled slate stones relates to Minimalism's respect for directness and absence of formal complexity. Long does not suppress the singularity of his materials, opening up thought about their origin and discovery and the activities of quarrying and stonecutting.

taken apart by reversing the process which put them together. This is not a sign that the artists are tentative or unconfident, but of their reluctance to add, permanently, new things to a world already full of things. It also highlights the importance of ideas and process alongside end results. That Long's arrangement of stones [**91**] and twigs can easily be removed does not mean that his work is not 'grounded', any more than Brancusi's work lacked grounding in Andre's perception of it. Andre and Long would both say that you do not have to excavate or dig deep to prove the groundedness of your work, and that to leave the surface of the land undamaged is a mark of respect. Andre is the Minimalist with whom Long has an affinity, because Andre's sculptures are closest to the ground and may be made from natural materials and located out of doors.

Long lays pieces of wood or stone in a gallery installation next to one another in a way that is fitting to the material and the space, and is distinct from the casual filling of Smithson's bins, where the material contained is exemplary—it could have been any stones from that site, it happened to be those. Long's arrangements are Minimalist, with the stones not piled but laid out, easily comprehensible and without illusion. On the other hand Long's stones are not identical in the way Andre's bricks are, any more than they are exemplary, like Smithson's. His sculptures have a deliberateness and often a gravity which gives them a monumental character. They are not monuments *to* something, and in so far as his work has a public face it is not because it instructs or admonishes. What it does do is to represent a personal experience of landscape in a way that brings back into an art gallery something of landscape's commonality, of its meaning for other people as well as for Long himself.

Long's work is sometimes described as private, either because works

he has made in remote places are unlikely to be seen except in photographs, or because the changes he makes in the landscape can be very slight. It is private in the sense that it is discreet and does not declare itself loudly, but it is not exclusive in attaching to one kind of place or person. Long has worked in different parts of the world (whereas American Earth Artists have worked predominantly in America), suggesting, not that Long's work is international in the sense of searching for a style that is above nationality and speaks equally to people everywhere, but that it is available to people anywhere who think as he does. It is a direct art that does not re-order things and is not metaphorical—a stone is always a stone—and Long's art is always about natural things. It is simple, if it is accepted that simple forms can contain complex ideas, a characteristic that links Long not only with Minimalism but with artists as different as Daniel Buren (b. 1938) or Sol LeWitt—artists for whom a simple statement in paint, in words, or as a three-dimensional grid can have wide ramifications of thought and meaning. Long avoids expressiveness or any implication of simple transparency betwen idea and object.

Nature and artifice

Some of the same things said of Richard Long could be applied equally to Ulrich Rückriem (b. 1938) [**92**], who was a stonemason working on Cologne Cathedral before becoming a sculptor. Like Minimalists he has confined himself to a narrow formal morphology, and he, similarly, creates works in which the process of assembly and dis-assembly work in an obvious way (obvious, but not, in Rückriem's case, easy, because splitting stone is difficult and liable to go wrong). Rückriem's work is post-Minimal because it exhibits process, in the marks of the wedges driven into the stone to split it. But it is hand-made and craft-based in

92 Ulrich Rückriem

Double Piece, 1982

This shows the marks of the stonemason, the chiselling and splitting of the stone. The marks of mason and sculptor tell the story of human contact with the material.

a way that Minimal art is unlikely to be. Rückriem characterizes a direction of the 1970s which held on to the simple forms of Minimalism while drawing out meaning from a wider range of sources—associations with quarrying, craft, and the historical associations of stone as a building material. There is a conscious play in the work of Rückriem and others between nature and artifice: stone that seems natural and slots 'naturally' together while forming sculpture that is urbane in its apparent simplicity.

Many sculptors in the 1970s worked in the gap between sculpture and furniture, from the Minimalist Donald Judd to Scott Burton (1939–89), who made right-angled cuts into blocks of raw stone to create benches for public spaces. There was no one idiom for the new interest in sculpture as furniture, but in general it represented sculpture's reaching out towards life after Minimalism, and building on the greater understanding of earlier twentieth-century movements established in the 1960s—Constructivism, the Bauhaus, De Stijl—in which art and design had lived in closer relation and the possible roles of art within the functioning of society had been explored.

In England, as in America, the later 1970s saw increased interest in natural materials not only in Earth Art but in object-based sculpture. At the root of the work of David Nash (b.1945) [**93**] is the response to feeling 'very removed from nature by the culture I'm living in…a cul-

ture that looks at nature through windows—mainly out of *car* windows.... To me nature and reality are synonymous.'[11] For Nash natural materials, principally wood, were the starting-point, and his concern is making wood (a difficult material because it dries over a long period and cracks and splits) effective sculpturally. Nash pushes sculpture back in the direction of craft after Minimalism had moved it towards mass production. Craft implied for him not a quick learning process but an understanding of organic materials and how to use them as a way of getting inside the processes of nature. Nash is as close to nature as Long, but in a different way. His work does not involve travel or getting to know different places, nor is it concerned with trace or imprint; it is object-based, and often related to objects of use such as chairs and tables [**93**]. Nash positions himself as a 'natural' artist, but his work is full of ironic comment on the nature-culture divide. Does a table become a tree, or does a tree become a table. Is nature turning into cultural artefact, or is the process the other way round?

Some of the same things can be said of Andy Goldsworthy (b. 1956), who also works entirely with natural materials, but rarely within the studio or with object-based works in his sights. Working with stone and ice, sticks, leaves and flowers, he makes works (many of those using the colours of flowers being closer to painting than to sculpture) which make us look at nature with more intensity and enthusiasm. His works do not imitate nature. A Leafwork [**94**] that resembles, say, a bees' nest, is a brilliantly crafted object bearing a likeness to a quite different kind of object. It is not only that one is an artwork and the other a lair; it is also that the craft involved is quite different. Goldsworthy's art is about nature without being natural. It is, on the contrary, a highly artificial art that points us in the direction of the natural and organic. Like other artists working in nature, he follows the demands of traditional agriculture, and country practices in general, by returning the labour content to art, after Minimalism had asserted art's urban base by affecting the methods of industrial production. To imitate a process in this way—even if not consciously—presupposes a cultural sophistication which is not natural. Goldsworthy is an artist, like Nash, who has left the city and immersed himself in nature. The return to nature that was so marked a character of later 1970s art was not—could not have been—a return to the pre-industrial. The place returned to is never the same as the point of initial departure.

Ian Hamilton Finlay (b. 1925) is a Scottish artist with varied modes of expressions: poetry, garden design, sculpture, lettering. Even though he works with landscape, and connects landscape with sculpture, he has little in common with other British landscape artists because his work is equally grounded in literature and politics. The link between his different practices is classicism, which he alludes to as style while sharing with the ancient world a combination of interests that is

rare today: beauty and warfare. The garden he has made in the Scottish Lowlands—the name of which has been changed, significantly, from Stonypath to Little Sparta—is pastoral in the eighteenth-century Palladian mode, but populated with miniature stone battleships and aircraft-carriers as well as the *Nuclear Sail* [**95**]. Even when an aircraft-carrier doubles as a bird-table, it threatens the harmony of the garden. Little Sparta is a garden for contemplation and thought, into which the elegant abstract form of *Nuclear Sail* fits without difficulty, but without bringing comfort either. Hamilton Finlay has a clearer under-standing than the majority today who look back to the eighteenth-century garden nostalgically of the covert political readings that garden design and its contextual poetry and literature in the eighteenth cen-tury offered. If *Nuclear Sail* resembles a Hepworth sculpture, it can only be intended to point to the difference between the two artists. For Hamilton Finlay abstraction is an emptiness waiting to be filled. *Nuclear Sail's* title points up its likeness to the conning towers of the nuclear submarines stationed at Holy Loch some fifty miles away beyond Glasgow. And though the reference to sail alludes to a safer and more traditional form of marine transport, Hamilton Finlay's demure irony does not allow the force of his statement to become neutralized. The gentle surfaces of Hamilton Finlay's work are cara-paces, the outer covers that conceal a graver sensibility.

Sculpture and architecture
Non-functional architectural models and constructions, often located in landscape settings, form a type of 1970s art that overlaps Earth Art but is nonetheless distinct. It is American and connected with the names, among others, of Alice Aycock (b. 1946), and Mary Miss (b. 1944). Their works are generally environmental in scale and can be entered. Built of wood, their works often seem to refer to Russian Constructivism, and particularly—with constant changes of level and non-functional abstraction mixed in with steps, ladders, and platforms —to the Russian Constructivist stage. They can resemble fire-towers, follies, bridges, ladders, refuges, shelters, and enclosures of different kinds, as well as tunnels, if the construction is all or part below the ground. These constructions are difficult to categorize. They are sus-pended as much between sculpture and building as between sculpture and architecture, because, even if ambiguity surrounds their possible uses, they seem to express function rather than style. Many of them seem protective, to be refuges. The impulse to tie them in with archi-tecture and building stems from their being locations for people, and it is the sense that they are places, and can even be habitations of a kind, that distinguishes them from Earth Art. There is often play between above- and below-ground, and an appeal to primal instincts in the sense that underground lairs and burrows as well as overground watch-

NUCLEAR SAIL

**95 Ian Hamilton Finlay
(with John Andrew)**

Nuclear Sail, 1974

Hamilton Finlay is a sculptor
and landscape architect
concerned, like the designers
of sculpture and pavilions in
eighteenth-century English
gardens, with language in a
very broad sense—both verbal
and visual. With Hamilton
Finlay allusions to the past
never conceal the relevance
of his apparently serene
creations to the here and now.

towers signify protective feelings. Defensive or homing mechanisms
are often evoked.

Aycock's *Studies for a Town* [**96**], designed for an exhibition of her
work at the Museum of Modern Art in 1977, is part of an oeuvre that
includes 'impossible' house-like structures, and maze-like construc-
tions that exist almost entirely underground. Some of her work puts
the body under physical pressure in the sense that it is difficult to nego-
tiate and can put a participant at actual risk of falling; most of her work
subjects the body to psychological pressure, nowhere more than when
she is inviting her audience to squeeze through underground tunnels
with sparse openings to the ground to offer light and reassurance.
Studies for a Town creates the impression of a traditional town: it is
walled and protective, its entrances are tight, narrow spaces with
changes of level, and the town might be a Mediterranean hill town de-
signed for self-defence round the idea of community. Aycock's works
include *A Simple Network of Underground Wells and Tunnels* (1975)
which requires one to crawl through narrow unlit spaces that give rise
to claustrophobia. In the artist's mind these were ways of forcing hos-
tile experiences on herself and thereby exorcising panic. Works like this
arouse contrary emotions: secret underground places allude to warmth,
home, and refuge, but also to entrapment, and have catacomb-like
remembrances of mortality.

96 Alice Aycock

Studies for a Town, 1977

This illustrates the closeness
of Aycock's sculpture to
architecture. Models and
structures alluding to
enclosure and constriction
correspond in her mind
to psychological states.

There are towers and cabins in the work of Aycock and Miss which seem to allude to pursuits such as hunting and foresting, and coverts and fire-towers which refer to watching. But psychological explanations can often be turned round on themselves: fire-towers designed to watch and protect can become prison-camp towers from which one is oneself watched. Building types alluded to tend to be ones that are in themselves strange and ambiguous, and there is often a look of dereliction to Aycock's works that combine wooden wheels and scaffolding forms, hinting at early industrial machines collapsing back into nature.

Unlike Earth Art, this architectural sculpture was made not in the open expanses of the deserts but in more intimate wooded countryside, usually in the eastern states of America. In more complex constructions, like Miss's *Perimeters/Pavilions/Decoys* [97], site was important in the sense of providing natural boundaries, such as trees and changes of level and sight lines. This was an art connected with seeing the meaning and impact of human presence. It is concerned with feelings that correspond to personal and group situations like gathering, watching, seeing, being seen, refuge, enclosure, and escape.

The Dane Per Kirkeby (b. 1938) is better known as a painter than sculptor, and his canvases have landscape as one source of inspiration. As a sculptor, Kirkeby works in brick, and though he is interested in local craft and especially bricklaying traditions, his is not a rural practice. Kirkeby was touched by Minimalism in the 1960s, and his concern has been that of many artists in the following decade, to retain a certain austerity gained from the example of Minimalism, but to loosen up its severe reductivism to permit a wider range of meanings and implications. His work has grown in size since 1980, from low-lying brick sculptures, with something of the character of anonymous 'monuments', to a kind of non-functional brick architecture [98]. To call Kirkeby's work 'monumental' would mis-describe it, by alluding to its

97 Mary Miss

Perimeters/Pavilions/ Decoys, 1977–8

This is made up of several built forms ranged through the landscape and divorced from specific function, but suggestive of primal instincts—searching, seeking refuge, watching, being watched. (View from inside pit, opposite.)

size, while not taking account of the fact that it makes no reference to particular external events. Influenced by eighteenth-century Neo-classicism and respectful of Malevich's attention to the symbolic importance of the square, Kirkeby creates forms that relate to human measure and scale (though not necessarily to human size), while maintaining a mystery that is beyond explanation. His brick sculptures have been made over a long period, and while brick belongs to the 1970s attraction to natural materials, his anonymous architectural forms have the character of models, while not seeming to be models for anything particular. That was a preoccupation of sculptors, particularly in Germany, in the early 1980s.

Siah Armajani (b. 1939) bridges the gap between sculpture and architecture in a different way: he claims the title 'public artist' and is interested in the social functions of building where Aycock and Miss are concerned with psychological implications. Armajani has received

public commissions since 1978, working around a range of building types, from bridges to reading-rooms [**99**], which have in common that they are places where people converge (they are socially intense) but are not domestic. The position of his work between architecture and sculpture means that it may be found in a museum but not, according to sculptural convention, in a gallery. He has created a staff recreation room for the Hirshhorn Museum in Washington and the public reading-room for the Museum of Modern Art in Frankfurt. As a sculptor, Armajani does not impose preconceived architectural form on a space, but starts from the consideration of people and use, and designs what are in effect sequences of small usable locations which, instead of connecting up into a single coherent space, retain an almost perverse distinctiveness and individuality. In the mid-1970s Armajani made a series of life-size architectural-type models of part rooms—a stairwell joined to a wall, or a wall to windows—which he called his 'Dictionary for Building'. While not an anthology of forms directly for use, it was a way of making himself think in terms of buildings as relationships

98 Per Kirkeby

Untitled, 1982

This belongs to a long line of brick sculptures deriving from Kirkeby's interest in the Neo-Classical architectural tradition, and the historic relationship of sculpture to the proportions (if not in this case the scale) of the human figure.

between functions rather than individual immutable elements (stair-well, wall, window). The way elements were combined followed from the way people would want to use the building. He might start a design with elements close to personal use, like seating, and move from there to walls and roof. His designs are socially led and not idealistic.

Born in Persia and living in Minneapolis, Armajani is interested in roots, seeing the origins of a more austere and democratic American culture, visually in Shaker buildings, and ideologically in America's early fathers, such as Thomas Paine and Thomas Jefferson. Armajani believes that America accepted European architectural Modernism too uncritically, implying that the Bauhaus or Miesian model has no popular legitimation in America and that, however functional in a social sense Modernist architecture was in its European origins, in America it had been used as a style. His sharp sense of the varied channels down which early Modernist principles had flowed in countries other than America led him to study Russian Constructivism. He is interested in the Constructivist idea (not unique to any one art) of 'laboratory' work: the distinction, in effect, between the evolution of models for doing something and making (possibly at a much later date) the thing itself. His concern is in keeping research and models close to need to avoid the danger of fixed architectural forms. Armajani admires Russian Constructivism for wanting to bring laboratory models into production. Like the Constructivists Armajani treads a difficult path, faced with the risk of experiment ossifying into style.

Public Spaces

7

Sites for sculpture

In the aftermath of the upheavals of 1968, in the knowledge that the authority of governing institutions had been challenged though not actually dislodged, artists looked critically at the systems that controlled daily life and their expression in the urban fabric. In this way architecture and buildings became a focus of attention. As artists became interested in the institutional framework of their own profession, the spotlight fell on the art gallery and museum. Although public museums were the main subject of attention, the private gallery also figured in the debate. Alternative venues like the Castelli Warehouse emerged, sculpture got outside the gallery, and the gallery itself was the object of analysis, taking on a new role—in the work of Acconci, for example—when its space and audience became part of the artist's discourse [102]. The word 'intervention' was increasingly used to describe artists' activity in public places, signifying not necessarily the creation of a new, free-standing work of art, but rather some kind of commentary, the insertion of the artist's reflections on a place or situation which is as likely, as in the case of Gordon Matta Clark (1948–78), to be marked by removal or disappearance as by addition. The artists' ambition is not to expand their practice in terms of style. Artists with these concerns rejected style from the beginning, by always using the same visual appearance (Daniel Buren), the same expressive mode (Broodthaers), or the same sculptural material (Serra). Discourse in art of this kind is conveyed not by constant variation in the artwork but by its physical situation. The art is critical not inspirational.

Reflecting human presence

Dan Graham's *Two Adjacent Pavilions* [100] are made of different kinds of glass (darkened, mirrored, etc.) used in the same proportions but in different sections of each pavilion. There is play on sameness and difference as, on entering, the participant becomes subject to different impressions of light and space, landscape, and sky. Mirrored glass played no part in Modernist sculpture, because an image thrown back onto the viewer would have compromised the principle of the work's self-containedness. Mirrored surfaces entered sculpture with

100 Dan Graham
Two Adjacent Pavilions,
1978–81
Graham's pavilions, sited in
a wooded landscape, play
on ideas of urban and rural,
nature and culture, and refer,
through the idiom of urban
architecture set incongruously
in the wild, to the artifice of
the rococo trianon and to
garden *tempiettos*.

Minimalism, in Morris's *Untitled* (1965), four mirror-surfaced cubes reflecting the viewer, the gallery floor, and the containing space. In 1968 Robert Smithson published an article in *Artforum*, 'Incidents of Mirror-Travel in the Yucatan', the record of a car journey through this Mexican province, punctuated with photographs of clusters of twelve-inch-square mirrors temporally embedded in different locations. Smithson pointed out that 'the mirror itself is not subject to duration, because it is an ongoing abstraction that is always available and timeless. The reflections, on the other hand, are fleeting instances that evade measure. Space is the remains, or corpse, of time, it has dimensions.'[1] Smithson removed the mirrors after photographing each location and kept them in his New York apartment. He was thus able to separate in his mind the mirrors as objects from the images reflected on them. The reflections became for him, through the photographs, arrests of time translated into space.

Visually, Graham's pavilions are like Morris's cubes, but, being situated in landscape, they are actually closer to Smithson's mirrors. We may experience them personally, but most people will see them as photographs, fixed with the imprint of the single moment when they were photographed. *Two Adjacent Pavilions* [**100**] was first set up at Documenta in 1982 in the grounds of the eighteenth-century summer palace, where they fitted into the tradition of the *tempietto*, the folly, and the trianon. The work was moved to the park of the Kröller-Müller Museum, itself of Modernist design with lavish plate glass and

surrounded by woodland. But trees and other sculpture, reflected in the pavilions' surface, are problematic: first, because wildness, when mirrored onto a flat picture-like surface in this way, and held in time as a photograph, ceases to be wild and becomes the image of wildness. Nature's situation as cultural construction is emphasized. Secondly, the removal of the pavilions from Kassel meant that they reflected different trees. Do these pavilions—or any objects faced with mirrors—become different objects when moved to another place? Can they be the same pavilions in two different places when the reflections on them affect their identity so strongly?

Two Adjacent Pavilions touches on the Enlightenment's concern for the civilized against the primitive and on the trianon type of building, which locates high culture in an organized parkland landscape and sets nature and artifice against one another. With the Modern Movement, architects played on the trianon effect by setting paradigmatically urban houses in untouched nature (Mies van der Rohe's Farnsworth House near Chicago and Philip Johnson's own house in Connecticut). By juxtaposing in his pavilions plain glass, mirror glass, and two-way mirrors (which are both transparent and reflect at the same time), Graham complicates the Miesian juxtaposition by enabling us to see through, back on ourselves, and a mixture of both. There is no simple dialectic between urban forms and rural environment, or even between inside and outside. By entering the pavilions and absorbing the different sensations each gives, we are made to look at the circumstances of our own perceptions, and the ways in which our knowledge of the world is gained. The outside world, seen directly and as mirrored image at the same time, loses the sense of seamless continuity that landscape normally presents to us, becomes estranged, and impresses itself, like the pavilions, as another cultural construction.

Urban interventions

Deserts and the remote sites of Earth Art lacked the social resonance of urban locations. Earth Art's absence of engagement with social critique limited its appeal to Morris and Serra, who explored it briefly and withdrew to the city environment. Gordon Matta Clark, an artist who had assisted Smithson at the Cornell 'Earthworks' show, and pursued certain of Smithson's interests after his death in 1973, was another who felt it was in the city that art must state its claims to social relevance. Matta Clark's *Office Baroque* [**101**] consists of excisions from the floors of an office building in Antwerp, removed and shown in the gallery alongside photographs of the site. It shares Smithson's interest in layering and in the exposure of what is little valued and usually unseen—in Smithson's case quarried stone and in Matta Clark's floorboards and joists, and the space between the floors of a building.

There is a parallel here with Smithson's site and non-site, and his

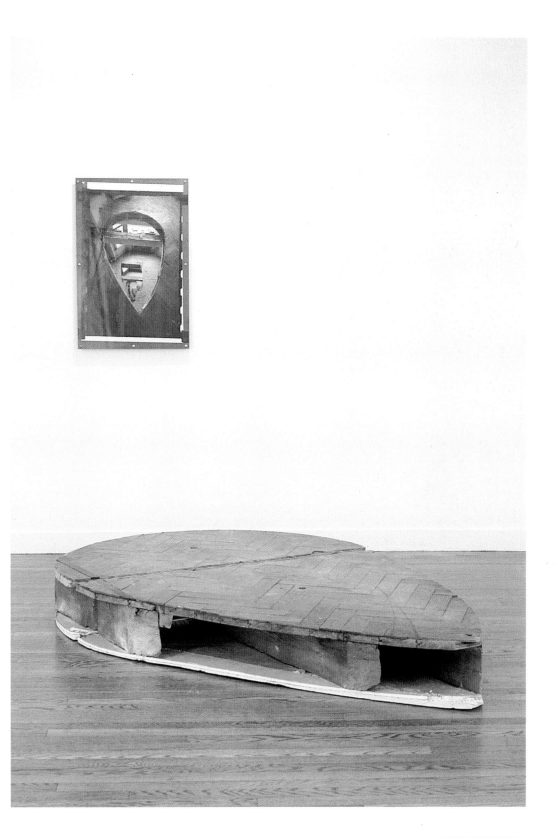

interest in formless matter and low-lying sediments and in the geometry of modern art and the art gallery. For Matta Clark 'above' meant buildings reaching towards the sky, revealed by sequences of holes cut from the fabric of the architecture from top to bottom. Typically, a viewer standing on the pavement might see such a building not as a solid form but as a passage, or sequence of spaces, registering not the separateness of individual interior room spaces but interconnectedness, with implications of social exchange. 'Below' meant basement, sewers, foundations, tunnels, and the subway, the dark and often unseen fabric of urban New York. It also meant garbage, from which, in 1970, Matta Clark built a wall that he then allowed to crumble, illustrating the principle that construction and waste are not irreconcilable opposites but states within a sequence of organic transformations. 'Above' related in Matta Clark's mind to urban architecture's link to capitalist economic structures, and correspondence between the enclosed room and systems of control. But 'below' also had a social meaning, referring to the urban underclass. Matta Clark saw Modernist architecture's preoccupation with geometry as equivalent to capitalism's desire to pigeonhole individuals and classes of people within closed compartments. The excisions that form visual passageways through buildings are metaphors for social movement and fluidity. Matta Clark shared common ground with Dan Graham, who saw the repetitiveness of the terraced or single detached house as reflecting, similarly, the forms of confinement underpinning market capitalism. 'By undoing a building,' Matta Clark said, 'I open a state of enclosure which had been preconditioned not only by physical necessity but by the industry that [proliferates] suburban and urban boxes as a context for ensuring a passive isolated consumer.'[2] Modernist architecture has become here the analogue for Minimalism's repetition of like units. Matta Clark's ambivalence towards the three-dimensional work of Sol LeWitt ('one of the artists I truly admire'[3]) is informative: his admiration is for the older artist's perfection, elegance, and wit, but he bridles against LeWitt's refusal to go beyond, to break out of the cube or unit [61] and to set up a flow between spaces that would establish, he implies, social critique.

Matta Clark's cuts on the outsides of buildings are violations of private space, offering outsiders 'a view in'. Entering a room other than through the socially and physically established threshold of the door is a form of aggression, and Matta Clark can be aggresive in this respect. In a different instance Matta Clark borrowed a shotgun and blasted the windows out of a building belonging to an architectural group with whom he was exhibiting, violating both the building as structure and architecture as a profession. Graham compared him with the Situationsists on the Paris streets in 1968, using physical interventions to create a crowd psychology for change.

This exhibition at the Paula Cooper Gallery, New York, 1975, shows miniature abstract/representational forms (as small as 3.6 cm in length) on the wide floor spaces of the gallery.

Joel Shapiro made tiny sculptures of chairs and houses, bridges and ladders which he would place singly on the art gallery floor [102] or on a shelf extending from the wall, in such a way that objects that 'belong' to the human body, like a chair, or enclose and protect, like a house, are pushed out into public space where their vulnerability is manifest. The younger age group of artists, to which Shapiro belonged, worked at a remove from the literalism of the Minimalists, in such a way that stored memories and experiences feed into the meaning of the forms. When he puts a chair into a gallery space, Shapiro has explained, he is insisting on an intimate experience in a public situation. The strangeness of a tiny thing in near empty surroundings points to a shift of the private into the public sphere, and with it the question of how the individual relates to the public or communal. Shapiro is interested in metaphor not description, in how one thinks about something or conceives the meaning of a word like 'house' in one's mind.

The museum as institution

Matta Clark was interested in how we remember the past. Three of his major projects were in buildings adjacent to—or about to become—museums. *Office Baroque* was close to the Maritime Museum in Antwerp, and the boat-shaped extraction [101] is an allusion to it. Matta Clark's attitude to the museum was ambiguous: his treatment of two seventeenth-century Paris town houses prior to their demolition in order to open up space around the adjacent Pompidou Centre revealed the history of the buildings but also provided, by means of the tunnel which he cut through the building, a visual link with other

elements in Paris's architectural history, including the Eiffel Tower. In linking visually locations representing different points in the city's history, Matta Clark drew attention to the city's organic growth. As inhabitants, we assemble a city's fragmented architecture variously in our minds according to our day-to-day experience of it. Matta Clark is, in effect, saying that this is a better way of understanding history than the definitive view of the history of—in this case—art imposed by the Pompidou Centre.

Coming from different angles, Graham and Matta Clark were both uneasy with Modernist architecture and grid planning for its isolating effects. Graham, a critic of art, architecture, and popular music, sympathized with the Italian architectural critic, Manfredo Tafuri, who theorized Modernist grid planning as a principle of isolation and a capitalist device for retaining maximum flexibility on any one site while ensuring that change on that site did not threaten the structure of the city as a whole.[4] The theory works against collective possession, prioritizes private over public, and justifies 'plaza' sculpture, which is an adjunct of capitalist planning, and not the product of organic or popular response or demand, serving no public need, but a sign of corporate business's public image of itself and, from the public viewpoint, pure spectacle. Artists like Graham and Matta Clark were not evolving an alternative public art, which was no part of their intention. Their urge was to expose the codes and meanings of governing systems. It was a critical standpoint.

Also working from the Pompidou Centre, the French artist Daniel Buren made a statement in *Les Couleurs: Sculptures*, which is similarly about de-centring, dispersal, and connections that he presses us to make between the Pompidou Centre and other Paris buildings. By raising flags with identical stripes—the stripes are present and identical in size in all Buren's work—on buildings across Paris, Buren made connections between the Pompidou Centre, churches, government buildings, museums, and department stores. Telescopes were provided at the Pompidou Centre for viewing the work, which brings the Centre as a focus for the exhibition and study of art into association with commerce and the state. As a phrase in normal French exchange, '*Les Couleurs*' resonates with national pride. As used by Buren, it makes us—the viewer and activator (via the telescopes) of the work—consider in a new way the relationships between the Pompidou Centre and other French institutions that affect people's lives.

A range of artists from the end of the 1960s used architecture to put the viewer into a different relationship with the artwork. Nauman's corridors heightened self-awareness but others, from Matta Clark, Buren, and Asher to Graham saw architecture as a social construct, and by altering it, cutting holes or raising flags, they drew attention to its ideological underpinnings.

Against the museum

The early 1970s witnessed various disputes between artists and museums: Robert Morris's argument with the Tate Gallery (1971) was about audience safety in relation to one of his works; Hans Haacke's quarrel with the Guggenheim Museum in 1971 concerned the rights of an artist to criticize the trustees of the museum where he was exhibiting. Haacke, most emphatically of his generation, has seen art as a political weapon and his career has been combative as a result. The dispute between the Belgian artist Marcel Broodthaers and the Guggenheim in 1972 concerned Joseph Beuys's unwillingness to react to the Haacke issue the previous year. The pursuit of the French artist Daniel Buren by five other artists included in the 1971 Guggenheim International was an argument between artists not directly involving the museum. The Guggenheim was particularly vulnerable, not least because it took on an ambitious pro-European programme when other New York museums did not. European artists experienced comparable incidents. Buren, again, was sued for setting up a counter-exhibition to 'When Attitudes Become Form' at Berne in 1969.

The crises were symptoms of a critical attitude to museums as institutions, exemplified both in art itself and the writing of history. In 1973–4 the leading New York art magazine, *Artforum*, published articles by William Hauptman, Max Kozloff, and Eva Cockcroft, exposing the role of art museums, mainly the Museum of Modern Art, in helping to frame and implement official American art policy during the Cold War, with support from governmental institutions such as the CIA.[5] The articles showed how New York School painters were projected in Europe as representative of the freedom of the American artist to do what he liked in contrast to the official Socialist Realist policy in the East. The material cited was historical but touched on recent events, such as the need felt in the USA to win for the first time the major prize at the Venice Biennale, achieved by Rauschenberg in 1964. This research has become embedded in art historical writing on the Cold War period, but its significance in relation to the art of the 1970s needs emphasis.

In 1975, the year following Cockcroft's article, Max Kozloff, as executive editor of *Artforum*, came further into the open with an editorial statement, saying that 'there is no escape from ideology, either in the creating or interpreting of art',[6] a statement which seems unremarkable now, but was startling at the time, and drew a stinging response in the *New York Times* from Hilton Kramer, a prominent critic and fervent supporter of Modernism.[7] Modernism offered no critique of art's institutions. The sudden instability in relations between vanguard artists and museums around 1970 is a key part of the Post-Modern situation. In 1976 Hans Haacke picked up on the debate by warmly supporting the argument put forward in a recent lecture at the Museum of

Modern Art by Edward Fry, a distinguished historian-curator dismissed by the Guggenheim for publicly supporting Haacke in 1971. Fry's point, as reported by Haacke, was that if a theory of art—in this case 'Greenbergian formalism'—does not open itself up to ' "extra-artistic" sources', then once the battles (against kitsch and false academicism), around which Modernism grew, were won, and the appeal of the avant-garde on that account had worn off, all that would be left was bureaucratic maintenance of the status quo—and that corresponded to Stalinism.[8]

The museum had appropriated certain functions which were increasingly failing to fulfil the needs of artists. Buren reflected on these in an article in 1973, 'The Function of the Museum'.[9] He discussed museum collecting in terms of choosing, endorsing, adding economic value, attributing mystique, isolating, and providing a frame and a refuge, using alternatively such words as 'asylum' and 'shelter' for art. Buren's own work has always consisted of stripes on paper (flags, in the case of *Les Couleurs: Sculptures*, or any other flat surface), always the same width and varying only in colour. Buren believes that outside reality, 'life', is real, that most art is an illusion, and that the achievement of most artists is to take something that is real and create an illusion.

Because works of art in a museum are all different, it is on them, naturally, that viewers' attention focuses. Meanwhile, Buren would say, the museum itself, and its function in society, remains concealed, because museum rooms are—give or take a few details—all the same, with their white walls acting as neutral background. Buren turned this round, so that all the art was the same (coloured stripes), but its situation within the museums' spaces was made to reveal previously unseen ideologies. It was a problem that had been opened up in *Nouveau Réalisme*, with Klein and Arman's revision of the relation between artwork and space in *Le Vide* and *Le Plein*, but it had dropped out of sight. Klein had been worried about the appropriation of art by the market, as if art were equivalent to any commodity, and, prefiguring Buren, had seen that by making his art always look the same (monochrome canvases in his patented 'International Klein Blue') he shifted attention from the artwork to its context. Klein had stressed his point with an exhibition in which all the pictures were the same but all the prices were different.

Buren sees his art as site-specific—what he does depends on where it is—and he regards it as temporary. He has issued stringent contracts with his works that specify how long they shall last. In a number of examples he has used museum buildings, but not necessarily the galleries themselves, to draw attention to the museum as an institution. An example was his contribution to the exhibition 'European Art in the Seventies' at the Art Institute of Chicago (1977), significant in

being the first major retrospective exhibition of European art after Modernism held in America two years before the Beuys retrospective at the Guggenheim. By papering the risers of the main staircase with his signature stripes [103], Buren was issuing a reminder that we are on the threshold of a distinguished art gallery, that we are entering an institution which, like all institutions, functions on assumptions that affect all the spaces in the building and not only the exhibition galleries. The traditional categories and ordering of artworks mean that the visitor can expect to see paintings and sculpture, drawings and prints of many different periods laid out within a design historically approved for an institution of this range and quality.

Buren wanted to make people ask questions. In revolutionary Paris in 1968 he had pasted his stripes on public billboards. He had not sloganized, urging people to do this or that, because that would have encouraged them to become involved in a corrupt system. Creating an art out of stripes alone put Buren beyond the reach of art market mechanisms, in particular the requirement for stylistic development. Buren takes what he believes to be the revolutionary stand, the refusal to imitate, and to escape from the material circumstances of life by creating personal and national myths in what he and others saw as the artistic cul-de-sac represented by Beuys.

The following year, 1979, the Art Institute of Chicago commissioned Michael Asher to create what emerged as a comparable intervention in, and comment on, the art institution. Buren had been an artist of public spaces in the sense that he had worked in the street, using billboards, and was in 1980 to paper round the podiums of all the public sculpture in Lyons, in an effort to recover for view what had become part of the unseen background of the city's history. Asher, on the other hand, had always worked in the museum, literally reshaping museum spaces, making familiar spaces unfamiliar, to surprise people and compel recognition that museums are determined spaces and we as audience are conditioned by that.

Asher's Chicago project was part of the museum's 73rd American Exhibition, 1979. He took a statue of George Washington, a bronze cast from an original marble by Jean-Antoine Houdon (1741–1828), moving it from the top of the steps to the centre of the room in the gallery where French works of Houdon's generation were shown. The Houdon statue as seen at the top of the steps was a monument to the founding father. As one of an edition of twenty bronze copies of the marble original, it was itself hardly 'original' as other works in the gallery were. It had been cast in 1917, the year America entered the First World War, when national identity had been a particular issue. Transferred to the French eighteenth-century room in the gallery, the Houdon bronze looked out of place [104] because it was weathered and plainly an 'outdoor' piece, which read now as sculpture rather than as a

103 Daniel Buren

*Up and Down, In and Out,
Step by Step A Sculpture,*
1977

This installation at the Art
Institute of Chicago 1977
involved papering the risers
of the stairs and drew attention
to the public non-art space
of the museum, with the
message that a museum is a
single whole and its ideology
is manifest in all its spaces,
not only in those where art
is displayed.

statue. Seen in the galleries, rather than at the museum entrance, it was
in the wrong place for a monument. But, in a different sense, the
statue/sculpture was now in the right place, because it is only life-
height—small for a monument—and the marble original from which
it was made, now in the State Capitol at Richmond, Virginia, was
never intended to be shown outside.

The sum of this transfer was to heighten awareness of the identity
we attribute to things on the basis of where we see them—a monument
in one place is a sculpture in another. More than that, as Asher pointed
out, we tend to expect works of any period to observe the style codes of
that period. Modern art is no less entrenched in its own codes than
eighteenth-century art, yet here an exhibition by Asher is projected
as being modern but presented in eighteenth-century style codes.
Preoccupation at the time with Post-Modern eclecticism—the appro-
priation by artists, and especially architects, of period features—gave
currency to the issue. Asher regards the practice as merely the
objectification of history (creating out of a historical style a thing to be
incorporated into the present). In his own work it is not a thing that is

being appropriated, but a sculpture with historical associations, and meaning is being re-situated.

Asher worked on a parallel project at Chicago's Museum of Contemporary Art, where he removed aluminium cladding panels from the exterior of the building and displayed them on the corresponding interior walls. Like Houdon's statue, the things exhibited were not changed, merely moved. But the move involved a change of identity. The panels became non-functional: hanging in a gallery, they were re-identified as artworks, and recognized as such without difficulty because they bore visual resemblance to Minimalist reliefs. What constitutes a Minimalist work of art? Why should an aluminium panel not be a building material on the outside of a building and a sculptural relief inside? The answer is that art institutions, in relation to artists, the market, and the public at large, work to a conventionalized system which orders the way works of art are made, acquired, and displayed. Any suggestion that this system can be circumvented by removing a panel from the outside and refiguring it as art inside threatens the system.

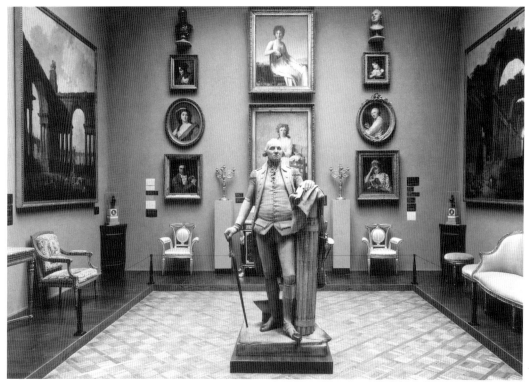

Marcel Broodthaers parallels Asher's use of period material, which is more central to his art than to Asher's. The Belgian poet, writer, and bookseller turned to making visual art in 1964, interested in *Nouveau Réalisme*, in how we preserve things as they pass from the present into history. Arman's *Accumulations*, with their period look, feed into Broodthaers's work, and Manzoni seems relevant for his treasuring of objects, from eggshells to bread rolls, which have passed from the stage of use to that of relic. Manzoni and Broodthaers both collected empty eggshells and packaged them in boxes or vitrines. As outsides left over when the living core has been consumed, eggshells are a paradigm of deadness, and draw ironic attention to the museum's duty to conserve, because as objects they appear to be so little worth preserving.

The studio as museum

In 1968 Broodthaers took part in the student- and artist-led occupation of the Palais des Beaux Arts in Brussels, stimulated by the events of that year to consider the position of the museum as an institution of social control. Acting in the way many artists did after 1968—from Acconci and Gilbert & George to the Earth Artists, Asher and Buren—Broodthaers reviewed the possible meanings of the locations of art—studio, exhibiting space, museum—questioning in projects that followed the continued relevance of the studio as a site of creative production. In September 1968 Broodthaers opened his Brussels

studio/home as the Musée d'Art Moderne, Département de XIXe Siècle. He exhibited packing-cases on the floor and postcards of nineteenth-century art on the wall, and imitated a real museum opening with an official-looking invitation card. A real and distinguished avant-garde museum director, Dr Johannes Cladders, of the Städtisches Museum, Mönchengladbach, performed the opening ceremony. It was the first of several museums Broodthaers opened, at home, in dealers' galleries, and in other exhibition spaces between 1968 and Documenta in 1972. In conflating the studio (as place of making) with the commercial gallery (as point of sale) and the museum (as the site of timeless preservation), Broodthaers opened up a range of discourses around art as processes of exchange, valuation, and institutionalization. His references were repeatedly to the nineteenth century as, presumably, the century in which the role of the museum shifted from its original Enlightenment function as the place where the precise codification of knowledge takes place, to the site of increasingly frenetic and often haphazard acquisition. In choosing the Eagle as one of his categories (the Musée d'Art Moderne acquired a Département des Aigles in 1969) he showed how arbitrary categories can be and that collecting, when removed from the course of actual history, can turn almost anything into a category.

In 1975 Broodthaers designed *Décor: A Conquest by Marcel Broodthaers* [105] for the Institute of Contemporary Arts in London. His theme was the relationship of war to comfort. Napoleonic cannons stood alongside emblems of class distinction and domestic relaxation —period furniture, a candelabrum, and Broodthaers's hallmark palms, which help to establish the soothing atmosphere of his always well groomed exhibitions by evoking the 'palm courts' of grand hotels. Laid out at the ICA on individual rectangles of green grass-substitute matting placed on top of red institutional carpet, the location was ambiguously coded as both indoors and out of doors. The second room had patio furniture, a jigsaw puzzle of the Battle of Waterloo, and rifles in working condition, an ensemble which could be taken to refer to the way society has been lulled into neglect of reality.

Society is presented as seduced by leisure, implying that the museum, in losing its true historical base, becomes a site not of education in history but of entertainment. *Décor: a Conquest by Marcel Broodthaers* was a site-specific work which took into account the location of the ICA adjacent to government offices and close to Buckingham Palace. Broodthaers's film made round the exhibition included in its soundtrack tapes of the annual military pageant of Trooping the Colour on the nearby parade-ground. The work was recreated posthumously at Documenta in 1982 as a tribute to the artist, who had died in 1976. While at the ICA and supervised by Broodthaers, it was shown in two contrasting rooms with audience circulation between the exhibits. At

Documenta it occupied a single space and was cordoned off. In changing from a physical experience to a spectator object, Broodthaers's work was forced to share in the very descent from reality to the virtual that the work itself was concerned with. The 1970s can be seen as the decade of a losing battle to retain the aesthetic advances of the later 1960s, one that can be defined as between Documenta 1972 with its 'adversary spaces' and Documenta 1982 which marked the consolidation of Neo-Expressionism and the resurgence of painting.

The sculpture of Lothar Baumgarten (b. 1944), an admirer of Broodthaers to whom he dedicated a work in 1973, was also concerned with institutions and their power structures. Baumgarten resembles the Belgian artist also in his use of language, both in the sense of description and of linguistic codes. A student of Beuys in Düsseldorf, Baumgarten, like Beuys, was preoccupied with the healing of social wounds. But Baumgarten was a Beuys student who, as he gained maturity and independence, stood back from his own work in a way Beuys was reluctant to, so that play with ideological discourse takes over from polemic. While Beuys focused on Germany, Baumgarten's concern was the legacy of colonialism among the Indian peoples of south America. As artist-anthropologist he faced the issue of voyeurism: how to avoid patronizing the 'other'? Site-specific art around 1970 was often involved with kinds of mapping and the relationship of synthesized, tabulated, and other forms of mapped information to material reality. Mapping is characteristic of Earth Art, in the work of Long and Smithson, and, differently, in the urban cartography of Haacke, which analyses slum landlordism in New York through photographs as well as words and figures. When Baumgarten 'maps' a section of the upper Amazon in *Terra Incognita* [**106**], his technique resembles that of

Long, retrieving elements of the site for the work. He uses torn sections of presil, the highly valued wood that gave its name to Brazil, as an emblem of despoliation, lamps that are suggestive of the burning lights used to ward off insects as well as the electricity that aids the work of deforestation, and porcelain plates indicative of both gold panning and imported European civilization and manners. Baumgarten uses photographs sparingly, only as locator or index, and not for analytical purposes. This avoids the danger of voyeurism, because viewers of the work do not look at the people who are the subject of study and could be presented as 'natives'. We look, instead, at conditions, a landscape spoiled by gold panning and logging, a situation in which we inevitably feel complicit.

Sculpture as political weapon

In 1982 Hans Haacke, whom Broodthaers had supported in 1971 by withdrawing from the Guggenheim exhibition, dedicated to Broodthaers what was to be one of his best-known works, an oil-painted portrait of President Reagan facing across a red-carpeted room a blown-up photograph of protesters against the installation of American Cruise missiles in West Germany. The event occurred within a few days of the opening of Documenta where Haacke's *Ölgemälde, Hommage à Marcel Broodthaers* was shown. Haacke's and Broodthaers's work do not have much in common visually, any more than Buren's and Broodthaers's do—though the two were also mutually supportive, and Buren was a guest at the opening of the Musée d'Art Moderne in September 1968. These artists had moved beyond the realm of style. A hallmark of individuality and authorship, symptomatic of the desire for constant progress and development within the

discipline, style was rejected. Each artist arrived at a different solution: Buren, with stripes that are superficially related to Minimalism, transcended style by always doing the same thing; by contrast, Haacke used whatever medium and mode suited his purpose, and Broodthaers concealed his critical stance ironically behind period attributes.

German by birth, Haacke had been in contact at an early stage with the Zero artists, with whom he shared an interest in natural forces as sources of energy. He made wind sculptures which were like huge airport windsocks anchored to the ground; growing sculptures, in which turf was laid in the trenched top of a plastic cube; and Condensation Cubes [107], which reflected location and temperature through the state of the water in the sealed interiors. Haacke's sculptures were closed systems, which he described to Jack Burnham in 1966 as 'positivist scientism'. Though the cube is a typical Minimalist form, Haacke detached himself from the Minimalists on the grounds that they were concerned with inertness, he with process and change. Haacke's early works are contemplative and poetic, in keeping with Zero aesthetics and some kinetic art. He moved to the United States in 1965 and in 1969 started, first in commercial galleries, and then at the Museum of Modern Art's 'Information' exhibition (1970), incorporating statistics related to gallery-going, sales and purchases of works of art, poll information about responses to works of art, and—in respect of the abortive Guggenheim project in 1971—information about the property-holdings of one of the Guggenheim Museum's trustees.

From that point Haacke used documentary evidence as critique of

institutions. Unlike Asher, Buren, and Broodthaers, who all exposed power structures inferentially, Haacke acted directly. He described himself as 'job oriented', and the connection between his cubes and later work is the scientific approach: while the cubes observe natural processes, the later art approaches social systems as scientific constructs. Both are in their own ways objective, but statistics which showed that a trustee of the major museum where Haacke had been invited to show was New York's biggest slum landlord were likely to be seen—however much their presentation resembled that of social science—as polemic.

In 1983 Haacke responded to 'Artists' Call against US Intervention in Grenada' for a contribution to an exhibition at the Graduate Center of New York University. Haacke's *Isolation Box* [**108**] was a copy of isolation chambers in which American troops incarcerated prisoners at Point Salines Airport Prison Camp in Grenada. The boxes, which had four small windows too high to see out of and few ventilation holes, were effectively a form of torture. The isolation chambers, as cubes, carried for an artist such as Haacke resonances of Minimalism and his own Condensation Cubes. Robert Morris's early Minimalist work, *Two Columns* [**64**], had enclosed himself; his *I-Box* [**66**] was a person-container in a different sense. The performance artist Chris Burden had enclosed himself for long periods in box-like spaces as a behaviourist experiment to test his power of endurance. In that sense Haacke was saying that there exists, formally, a context in which the *Isolation Box* can be regarded as art. It was possible for *Isolation Box* to express a formal affinity with Minimalism without endangering its function as a

107 Hans Haacke
Condensation Cube, 1963–5
This was no more than a superficial engagement with Minimalism, since his interest was in change rather than stability, as the system of interior divisions caused water to condense. Haacke was concerned with closed systems, which after 1968 turned from the scientific to the criticism of social and political systems.

fierce political statement because viewers would have been aware of Haacke's reputation. They knew from his work in the 1970s that stylistic and formal consistency did not matter to him, and that the exhibition in which *Isolation Box* was shown had a particular polemical purpose. In respect of Minimalism, however, *Isolation Box* restores the direct relation of the artwork to a contemporary context. Benjamin Buchloh has described the way that, within Minimalism,

consumer objects are stripped of all referentiality, of all allusions or connections to the social context from which they are initially drawn. Indeed, an object only takes on aesthetic meaning precisely when its referentiality has been abolished, when it no longer reminds us of the labour invested in its production, of the exchange value extracted from its circulation and of the sign value imposed in its consumption. For within that tradition, elimination of referentiality is in fact the quintessential condition for aesthetic pleasure.[10]

The challenge of public space

In 1970 Richard Serra turned to sculpture out of doors. Just over a year after making *Splashing* for '9 at Leo Castelli', Serra laid a circle of steel, *To Encircle Base Plate Hexagram, Right Angles Inverted*, into the street in a deprived area of the Bronx. The steel ring, resembling a disused turntable—something no longer functional and abandoned—was hardly distinguishable from the road. Serra's intention was not to make public sculpture, but to make sculpture that was not visible until you were very close to it, ensuring that the experience of sculpture was direct and physical and it was not something to be looked at from a distance. There was in fact a position where the public could see *To*

108 Hans Haacke

Isolation Box, 1983–4

This is a near facsimile of the eight-foot wooden cubes used to incarcerate prisoners during the American invasion of Grenada. The cube also makes reference to sculpture, to Haacke's brush with Minimalism [**63**] and to Warhol's wooden Brillo box facsimiles with their stencilled sides [**39**].

Encircle from almost directly above, thus defeating the artist's objective. Serra had recently visited Smithson in Utah during the construction of *Spiral Jetty*, which was finished in the same year, and, coincidentally, *To Encircle* introduced a similar problem of understanding. Seen from above, both works display Minimalism's clear gestalt, and *To Encircle* showed, like *Spiral Jetty*, how distance and loss of close contact reduces the artwork to a perceptual unity, a whole object, rather than a discovery made physically within the course of time. Still photography presented an incontrovertible problem for Post-Minimal sculpture because it imposes a single authoritative viewpoint that takes the artwork outside time. From among all art forms, Roland Barthes distinguished photography for its association with death for this reason. Within Modernism this had not mattered because Modernist sculpture was, theoretically, outside time anyway. When the physical proximity of viewer to artwork was significant, and the work was intended to be experienced as well as seen, photography presented a problem.

In 1977 Serra was commissioned by the German city of Bochum to create a sculpture on a site where trams turned outside the railway station. Serra's solution, *Terminal*, consisted of tall abstract intersecting planes of cor-ten steel, blunt in shape, and without the special processes and additives that would have made it shiny and stainless and therefore within the limits of what might be acceptable as abstract public sculpture. *Terminal* caused further anxiety because it leaned alarmingly over the tracks, leaving narrow clearance for trams. Apparent instability and a certain edginess has characterized Serra's sculpture generally, as a strategy for resisting the static permanence of the conventional monument. Opponents of *Terminal* argued that it did not lend dignity to the city, while Serra replied that the cor-ten steel from which it was made (in a local Thyssen steel mill) reflected the industrial tradition of Bochum and the sculpture was a tribute to the skills of the labour force which had made the Ruhr region great.

The text that the debate opened up concerned a local population's being asked by Serra to take possession of its city and traditions rather than being resigned to existence as an alienated workforce. Those who would have preferred a traditional monument—a statue, in effect— would have liked to memorialize ownership, while Serra spoke for labour. More than the other artists concerned with art in public space, Serra is involved here with the problem of the monument as public sculpture. The difference is one of site. While Graham, Asher, and Buren were materialists in valuing art in terms of its historical circumstances, their presentations were arcane to the point, at the extreme, of being hardly visible, and in places, museums especially, that are public but of relatively narrow social appeal. Their analysis of institutional

power often took place within the confines of the institutions themselves. Serra's was in the fullest sense in the public domain.

Serra also shows his work in art galleries, but its material (industrial steel) does not vary, and his sculptures differ from one another relatively little in size or form. This is in itself a critique of the gallery system, which is predicated on the notion of progress and development. Dealers and the public expect of an artist enough consistency to ensure a continuing, recognizable identity, together with sufficient innovation from year to year to reassure clients that they are acquiring something unique. Serra has questioned that.

Serra's most notorious encounter with hostile authority was over *Tilted Arc* [**109**], a national commission for Federal Plaza, New York. *Tilted Arc*, a long, leaning twelve-foot-high steel wall, was widely condemned for disrupting sight-lines, obstructing video cameras, causing people to walk further than they need, creating cover for drug-dealers, and (on account of the quasi-enclosure caused by the tilt) causing additional risk of disaster from a possible bomb explosion. Serra argued, essentially, that people cannot take personal or collective possession of a featureless space, and that *Tilted Arc* helped to shape the plaza by creating a sculptural form for people to measure themselves against. Extensive public hearings were held before *Tilted Arc* was removed in 1985.

Strangely for a work whose palpability is beyond question, *Tilted Arc* raises in a new way the difficult question in relation to Post-Minimal art of what actually constitutes sculpture. Process Art, Body Art, and Earth Art introduced problems of temporariness and finish, time of making and time of duration, the role of photography, the part played by literature and publications, and the balance between work on site and art in the gallery. Sculpture was no longer necessarily an object at all, indeed in 1981 there would no longer have been any virtue in Serra's proposing a hefty section of sheet steel as sculpture, if its value as art had rested in the material. Plainly, value actually rested in context, in its effect on Federal Plaza.

However, if that effect is properly measured, it extends to the whole of the debate and the sculpture's ultimate removal. If the artist's intention affects, is a part of, the work's identity, *Tilted Arc* should be considered in terms of the battle for art as a weapon for public awareness, a battle which Serra believed had to be fought out in public. In this sense the identity of *Tilted Arc* extends beyond its weighty presence, and the judicial hearings which led to the adverse judgement, the removal, and the subsequent book, *The Destruction of Tilted Arc: Documents* (1991), should be thought of as integral. *Tilted Arc* was another stage in the de-centring of sculpture, that disappearance of the middle or fixed point which had previously established the identity of a sculpture, towards the edges where, in this case, argument and legal process took over.

109 Richard Serra
Tilted Arc, 1981
This sculptural intervention in New York's Federal Plaza turned a sculpture commission into a public controversy. The issue went beyond sculpture as form and style, to public space— who occupied it and had rights over it.

Serra was a skilful adversary with articulate supporters. He measured his provocation carefully, and must have had a sense that such a massive wall of steel, looking by that date old-fashioned to anybody as sculpture, would engender resistance. The removal of *Tilted Arc* is generally thought to indicate failure, but how does the loss of this provocative object compare with what was revealed in court: that Federal Plaza was under surveillance because the authorities feared bomb-throwers and drug-dealers?

The return of the monument?

The challenge of Modernism after 1945 and the appropriation of the traditional figurative forms of public art by Eastern Europe were described at the beginning as helping to make monumental art difficult, if not impossible, in the West. The failure of the Unknown Political Prisoner competition was a clear example. Edward Kienholz's *Portable War Memorial* of 1968 [**52**] was a sophisticated parody of the real thing; Oldenburg has made many public artworks parodying plaza art. Even artists like Gilbert & George, when they affected to be statues [**81**], were ironically raising themselves to the position of public sculpture. Does the end of Modernism and the gradual recovery of public space for art herald the return of monumental and, in particular, memorial art? The end of Modernism is not, of course, the end of vanguard art, and none of the projects discussed here which have taken artists out of

the studio could be described as popular, or were planned to win over a popular audience.

If monumental sculpture implies substantial public backing, it is no more likely to be renewed now than it was in 1945, because art is not more of a socially binding force now than it was then. Scepticism towards the heroic is more universal than it was in 1945, and Oldenburg's jokey send-ups using gigantic models of popular objects seem less modern today than sparer expressions that are more in keeping with our lack of commitment: Manzoni's plinth with only a footprint on top, or de Maria's Munich project, which would have left nothing to public view but an engraved plate. The direction of sculpture at the end of the sixties was to the horizontal, to ground level, and to resist the heroic wherever that implied elevation. Joseph Beuys was rare among major figures of his generation to have a sense of the monumental, and his proposal at Documenta 7 in 1982 to involve the public in planting seven thousand oak trees empathized with the mood to express collective feelings through ecology. Robert Smithson's transplanting trees upside down, so that their roots stuck out of the ground, feels like a nihilistic counter-gesture in the manner of Manzoni. The monument and the memorial are the ways in which a society not only wants to make itself known, to express itself in and for the present. It is also a legacy for the future, the way in which it would like to be remembered. In this way it is comparable with a museum, which also guards the past and present for the future. Memorials should be regarded as official institutions the same way that museums are. The achievement of artists like Buren, Asher, Broodthaers, and Baumgarten has been to demythologize institutions, to return them from the world of myth to history and the present. Artists like these cannot be expected to put their own work in reverse through a form of art, the monumental, that is essentially a way of mythologizing history.

The counter-monument

The 1980s' solution to the desire to remember and alleviate the burden of the past without re-mythologizing it has led to what James E. Young, following the artists Jochen (b. 1944) and Esther (b. 1948) Gerz, has called the 'counter-monument'.[11] The counter-monument is largely a German manifestation, because it was in that country, as Beuys recognized, that time would not by itself clear the collective conscience and the past must be brought into the open and debated. Against the permanence of the monument, the counter-monument is about absence, disappearance, and trace. In terms of art, the German problem, pressed on public consciousness by Beuys, became inescapable with the first exhibition exclusively of Nazi art at the Frankfurt Kunstverein in 1974. After that, whether Nazi art was to remain taboo (as most museums in Germany and around the world pre-

ferred) or become an equal part of German art history, was an unavoidable question. The German industrialist millionaire, Peter Ludwig, trained as an art historian and the biggest private art patron in Europe, commissioned Arno Breker to make a portrait bust of himself and his wife, specifying that it should be in the style in which Breker had sculpted Nazi leaders. Ludwig argued that the writing of National Socialist art out of German history was no different from the Nazis banning Expressionism as degenerate.

The counter-monument rises, implicitly, to Ludwig's challenge, acknowledging that there is a debate that must be engaged with. While Breker's sculpture was designed within the canon of classical art's claim to permanent value and might thus be thought appropriate for a Reich that was supposed to last a thousand years, the counter-monument was generally short term: it was designed not as a memorial (to keep events in memory) but as contemporary discourse, as a way of debating history in the present. It was often intended to be ephemeral, it was sometimes participatory—requiring personal engagement. If made from durable materials, it might be a gesture, like *Tilted Arc*, which was unlikely to survive in the long term.

The massive black presence of Sol LeWitt's contribution to the 1987 Münster Sculpture Project *Black Form (Dedicated to the Missing Jews)*, prominently located in front of the baroque palace that is now Münster University, was a provocation of this kind and was removed on the grounds that it obstructed turning traffic. As James E. Young put it, 'an absent people would now be commemorated by an absent monument'.[12] Jochen and Esther Gerz's *Harburg Monument against Fascism* [110] in a Hamburg suburb, consisted of a lead-covered hollow aluminium pillar with graphite pencils attached to encourage comments and graffiti. Like *Black Form*, the obelisk of the Harburg monument is neither descriptive nor symbolic as a form. Counter-monuments may have inscriptions and details that identify them, but they are Post-Minimal and within the framework of Asher's or Buren's work, in that formal simplicity denies that meaning resides within the object, insisting that it is contained in the context. At Harburg the context is the viewer because it is we who, by filling the blank faces of the obelisk with our messages, cause it to be lowered into the ground to provide more writing space, and thus ultimately to disappear. This form of engagement derives from Post-Minimalist sculpture and not from the history of monuments. While the impulse to compel debate, and to involve people at large, was Beuysian, the Gerzs' standing back from the project, allowing the public to take it over, was a denial of personality. It reflected the desire for debate and opening up, rather than a claim to personal sculptural expression, which would have been a form of closure.

Also in 1987 the sculptor Ulrich Rückriem was invited to make an

Harburg Monument against Fascism, 1986

In the Hamburg suburb of Harburg, this monument was an obelisk that sank into the ground as the public engaged with its surface with messages and graffiti.

anti-Nazi memorial for his native city of Düren. The proposal was for ten sites in the city which had been connected with Nazi activities, and in front of each Rückriem was to erect a plain granite stone monument in a shape easily recognizable as his. His strategy is not like that of the Gerzs, to create a temporary participatory device, but is closer to that of Buren, to use as a site-marker a stone which says nothing in itself but if repeated ten times round the town will make people realize that these are significant and connected places.

The following year Hans Haacke, the most openly political of artists, responded to a commission from the Austrian city of Graz to contribute to the exhibition 'Points of Reference 38/88', commemorating the half centenary of the *Anschluss*. The organizer Werner Fenz described the project as aiming 'to challenge artists to confront history, politics and society, and thus to regain intellectual territory that has been surrendered to everyday indifference in a tactical retreat, a retreat that has been continual, unconscious and manipulated'.[13] He wanted neither spectacle nor artistic decoration, not a museum without walls, but 'an intellectual space of action'. The prominent *Column of the Virgin Mary* had been draped for a major Nazi parade in 1938, and inscribed '*Und ihr habt doch gesiegt*' ('And you were victorious after all') [111], referring to the Nazi victory in 1938 following an abortive coup four years earlier. Haacke remade the memorial with the same epigram

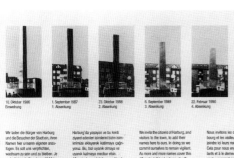

| 10. Oktober 1986 Einweihung | 1. September 1987 1. Absenkung | 23. Oktober 1988 2. Absenkung | 6. September 1989 3. Absenkung | 22. Februar 1990 4. Absenkung | 4. Dezember 1990 5. Absenkung | 27. September 1991 6. Absenkung | 27. November 1992 7. Absenkung | 10. November 1993 letzte Absenkung |

Wir laden die Bürger von Harburg und die Besucher der Stadt ein, ihren Namen hier unseren eigenen anzufügen. Es soll uns verpflichten, wachsam zu sein und zu bleiben. Je mehr Unterschriften der zwölf Meter hohe Stab aus Blei trägt, um so mehr von ihm wird in den Boden eingelassen. Solange, bis er nach unbestimmter Zeit restlos versenkt und die Stelle des Harburger Mahnmals gegen Faschismus leer sein wird.
Denn nichts kann auf Dauer an unserer Stelle sich gegen das Unrecht erheben.

Harburg'da yaşayan ve bu kenti ziyaret edenleri isimlerini bizim isimlerimize ekleyerek katılmaya çağırıyoruz. Bu, bizi uyanık olmaya ve uyanık kalmaya mecbur etsin. 12 metre boyundaki kurşun sütunda imza ne kadar çoğaldıkça o kadar yere gömülecektir. Günün birinde sütun tamamen yere gömülerek kayboluncaya ve faşizme karşı uyarı anıtının yeri boş kalıncaya kadar bu devam edecektir.
Çünkü, bizden başka hiçbir şey haksızlığa karşı kalıcı olarak direnemez.

We invite the citizens of Harburg, and visitors to the town, to add their names here to ours. In doing so we commit ourselves to remain vigilant. As more and more names cover this 12 metre tall lead column, it will gradually be lowered into the ground. One day it will have disappeared completely, and the site of the Harburg monument against fascism will be empty.
In the end it is only we ourselves who can rise up against injustice.

Nous invitons les citoyens de Harbourg et les visiteurs de cette ville à joindre ici leurs noms aux nôtres. Cela pour nous engager à être vigilants et à le demeurer. Plus les signatures seront nombreuses sur cette barre de plomb haute de douze mètres, plus elle s'enfoncera dans le sol. Et un jour, elle disparaîtra entièrement et la place de ce monument contre le fascisme sera vide.
Car à la longue, nul ne pourra s'élever à notre place contre l'injustice.

אנו מזמינים את תושבי הרבורג
ומבקרי העיר להוסיף שמם
לשמנו. בעשותנו זאת אנו
מתחייבים להשאר על המשמר.
כמה יותר שמות יכסו את
עמוד העופרת בן גובה שתים־
עשרה מטר לאורך האדמה,
יום אחד הוא יעלם לחלוטין
וריחבת האזכרה נגד פשיזם
תהיה ריקה.
שהרי רק אנו עצמנו יכולים לקום
נגד אי־צדק.

Мы приглашаем жителей и гостей города Гарбурга присоединить свои имена к нашим. Это обяжет нас всех быть бдительными и оставаться таковыми и впредь. Чем больше подписей будет набираться на свинцовом столбе 12-метровой высоты, тем глубже он будет опускаться в землю, пока однажды полностью не исчезнет, оставив место Гарбургского монумента против фашизма пустым.
Ибо только мы сами можем противостоять несправедливости.

إننا ندعو سكان مدينة هاربورغ وزوارها إلى تسجيل أسمائهم على هذا النصب التذكاري. يُلزِمُنا هذا العمل بالحذر من الفاشية. كلما سُجِّل المزيد من الأسماء على هذا النصب التذكاري ازداد انغراسه في الأرض، حتى يختفي تماماً ويصبح مكان النصب التذكاري ضد الفاشية فارغاً.
لأنه لا يمكن لأحد أن يحل محلنا في مناهضة الظلم.

Harburgs Mahnmal gegen Faschismus, Krieg, Gewalt – für Frieden und Menschenrechte wurde nach einstimmigem Beschluß der Bezirksversammlung Harburg im Auftrag der Kulturbehörde Hamburg nach dem Konzept von Esther und Jochen Gerz realisiert.

and, in a sense, the same meaning: fifty years after the *Anschluss*, who had been successful? Was the Austrian conscience clear? This was the time of the exposure of the contemporary Austrian Chancellor Kurt Waldheim as a former Nazi sympathizer. On 2 November 1988, within a week of the fiftieth anniversary of the bombing of all Jewish synagogues in Graz, Haacke's monument was destroyed by a neo-Nazi firebomb.

The counter-monument is in the public domain and may invite public participation, but resists monumentality because it does not put itself outside time. Temporality is at the core of this issue. A monument is transcendent, claiming for a society that its ideals and achievements have value for following generations. There are elements of this in the counter-monument, which reaches beyond what is purely of today, but does so in a form that keeps today as well as the past in mind. The Harburg monument makes its appeal against fascism in an inscription in seven languages, including Turkish. This implies an enduring message—that today's violence against Turks is equivalent to the Nazis' against Jews.

The sculpture of the 1970s and 1980s used a battery of weapons, from irony to allegory, to infiltrate meanings into the public domain, and made no claim to encompassing truth. Fenz's phrase 'intellectual space of action' helps to define a period that does not have a coherent myth and is more interested in substituting powers of thought for transparency of meaning, and maintaining pressure towards critical, collective awareness of our situation in the world, and the ways in which ideologies govern our lives. An art emerges from this which is discursive as much as didactic.

The Other Vietnam War Memorial [**112**] by Chris Burden (b. 1946) was a late response to the official *Vietnam Veterans War Memorial* (1982), designed by a Yale architectural student Maya Lin on the

111 Hans Haacke

Und ihr habt doch gesiegt
(And you were victorious
after all)

This was commissioned for
'Points of Reference 38/88',
held in Graz to remember the
fiftieth anniversary of Hitler's
Anschluss with Austria. It was
a close facsimile of a Nazi
monument (facing page,
below) erected in 1938 for a
Nazi parade celebrating the
union. Both the 1938 and
1988 monuments were
constructed around a statue of
the Virgin Mary at the centre of
this largely Catholic city (facing
page, above).

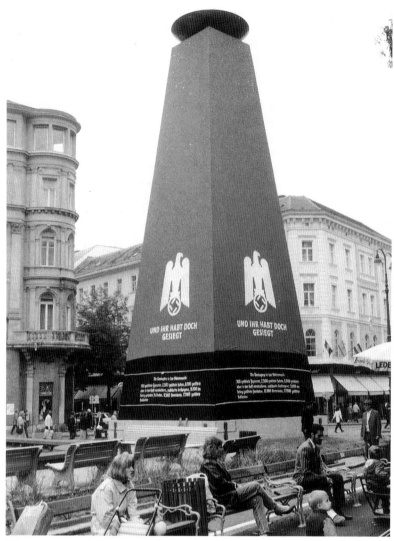

Washington Mall, the ground which, more than any other, represents
American history. The official memorial consists of two black marble
walls engraved with the names of all the Americans who died in
Vietnam. The walls are set at an angle and partly below ground level
with one arm pointing in the direction of the Washington Monument
and the other towards the Lincoln Memorial. Burden's *The Other
Vietnam Memorial*, exhibited in 1991 in the Museum of Modern Art's
'Dislocations' show, is like a book with swinging pages, steel framed
with copper pages. The names of the Vietnamese dead, so far as they
are known, are engraved on the pages.

Debates with history

Sculpture's gradual recovery, from the late 1960s, of a sense of history
showed itself in different ways, and not all the artists who looked back

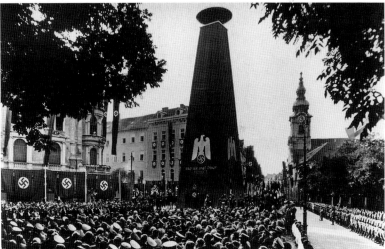

to Nazism, racial brutality, and the displacements of European populations, wished to do so with the historical precision of the countermonument. The problem with public and political statements in sculpture was that they suggested that historical narratives were certain and fixed and could be translated directly into sculpture. By the 1980s many people believed that the artist no longer had command over truth and authenticity in that way, but had a critical role, exposing the dominant texts or threads of current discourse. Traditional certainties became impossible and irony was the much-used means for leaving meaning open and ambiguous. In the debate with history, the art of Christian Boltanski illustrates this problem.

Boltanski, born in Paris in 1944 in an intellectually oriented French Jewish family, is an artist whose work engages with the racial upheavals of twentieth-century Europe, the Holocaust, residual possessions, and

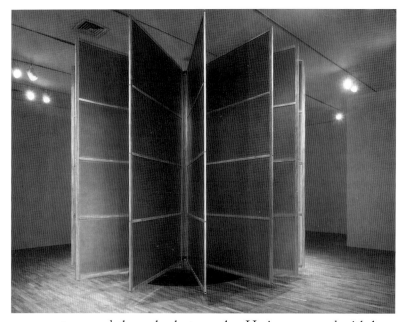

memory treasured through photographs. He is concerned with loss. But he says at the same time that we cannot know historical reality, that photographs often lie, or—at least—that we draw the wrong inferences from them. Boltanski's work teases with misinformation but enlightens because it compels consideration of how we recognize and know the past. Boltanski composes biographies from photographs, documents, and personal possessions. He is Beuysian in his gathering of private residues, but arranges them with the tidiness of an archaeological display, imposing order on unordered material like an archivist. *Les Monuments*, started in 1984, are darkened rooms with small photographs in tin frames or banks of rusting biscuit-boxes of personal effects reminiscent of the reliquary boxes found in Catholic cemeteries. There is a seductive Byzantine gloom which adds to the feeling of reverence and sincerity. He then turned to more shameful aspects of the German past, arranging, at Documenta 8 in 1987, banks of photographs interspersed with wire mesh to suggest links with internment camps. In 1988 Boltanski made his first arrangement of used clothes, adopting the title *Reserve Canada* [**113**] from a Nazi euphemism for the death camps. The effect of the clothes is of human presence, because they belong to someone, and absence, because nobody takes possession of them.

Boltanski's 'archives' are not authentic: his register of Holocaust victims includes people who had appeared already as constituents of families he had purportedly known, and examination of the clothes of 'Holocaust victims' exposes modern design labels. Boltanski warns us against naïve trust in photographs, which we believe cannot lie, but, he would say, are only bits of paper that are not in themselves evidence of

anything except that someone somewhere once existed.

Magdalena Jetelova (b. 1946), who left her native Poland in 1985 before the easing of East–West relations, makes sculpture of massive pieces of furniture—chairs, tables, staircases—tipped on their sides, slanted, or raised so high from the ground as to be unusable. Metaphors for the clumsy monumentality of East European art, or simply for the wrecks that the East European regimes then were, Jetelova's work demystifies monumentality through parody of its faults that is close to ridicule. Chairs and tables were common in West European sculpture in the 1970s, as artists drew Minimalist forms back into the ambience of human activity, and in almost all cases sculptured furniture kept close to function (Shapiro is the clearest exception, at the opposite end of the spectrum of size and scale from Jetelova). After the 1968 Prague Spring, a possible way forward for an ambitious sculptor was through the tradition of Constructivism, which had been successful in Czechoslovakia before Communism. Though not officially approved by the political regime, Constructivism was, in the anodyne form it had developed as 'public art' in Western Europe, relatively

113 Christian Boltanski
Reserve Canada, 1988
Canada was a Nazi euphemism for the death camps. Boltanski's characteristic method is to allude to a subject (the victims' clothes), but leave false trails (modern designer labels) which suggest that the truth of the past is ultimately unknowable.

unthreatening. Jetelova's preference for minimally worked rough-hewn oak [**114**] was a form of resistance to this easy way out. More than that, her ambition to confront the issue of monumentality by facing up to history required her to avoid sculptural generalization and create work that would be specific without—and here her work diverges from that of both Boltanski and the Russian Ilya Kabakov—relating to specific individuals or groups. In this way she runs less risk than they do of indulging nostalgia. Her subjects are things everybody uses which, when presented without distortion, belong to the flow of every-day life. Jetelova works in between everyday temporality and the time-lessness of the monument. That, to her, is what a monument is: not a different kind of image from things in life, but the same kind treated in a different way.

When Kabakov (b. 1933) settled in New York in 1992, he had been a member of the dissident Moscow Sotsart group for many years. His art reflects on the history of Russia since 1917, and the many 'Russianisms' in a work like *The Red Wagon* [**115**] are not so much influences as meas-ured reflections by an artist who has spent many years studying the styles of Russian art against their institutional frameworks. *The Red Wagon* is a three-part work of a kind that Kabakov calls 'total installa-tion' because it envelops the viewer who is made a participant in a time-based and theatrical work of sculpture. The entrance end consists of a network of ladders in the Constructivist style leading into the sky where flags and banners are hung in celebratory fashion. The wagon

114 Magdalena Jetelova
Untitled, 1991

115 Ilya Kabakov

The Red Wagon, 1989

This is an allegory of the Soviet system from early promise to abject failure by a dissident and *émigré* whose art has expressed, through often complex installations, the hardness and deprivation of Soviet peoples' lives.

itself is decorated with paintings in Socialist Realist style. It seems to be modelled on Agit Trains, the mobile propaganda vehicles of the early Soviet period decorated by avant-garde artists. There are benches down the left side of the interior and, on the right, a painted backdrop for a performance that never happens. After a period of frustrated expectation, the audience leaves through the further door down a ramp leading to a tangled heap of detritus.

Kabakov has offered clues towards meanings for the work. The Constructivist end echoes early ideals, the idea of the sky as the limit, while the wagon is like an Agit Train that is stalled (it has no wheels) and reflects the Stalinist period of failed ambitions. The rubbish tip at the end is the Brezhnev period, which marked, as Kabakov confirmed, the failure of Soviet ambitions, from ideology to political and economic policies. 1985 was the year Kabakov perceived that the Soviet system was beyond repair and felt the need to make, there and then, a work with 1917 and 1985 as its defining moments. He felt like someone sitting on a ruin, the sterile and disfunctional Soviet state symbolized in this mysterious presence, *The Red Wagon*. Kabakov is not advocating Constructivism or condemning Socialist Realism but using them as reference points: *The Red Wagon* is allegorical, reverting to obsolete modes but endowing them with new meaning.

Objects and Figures

Spirit and matter

In 1980, for the first time since the 1950s, painting seemed more dynamic than sculpture. With Anselm Kiefer (b. 1945) and Georg Baselitz (b. 1938) as Germany's representatives at the 1980 Venice Biennale, the Royal Academy's 'A New Spirit in Painting' exhibition (1981), the strong representation of painting at the 1982 Documenta, and the 'Zeitgeist' exhibition in Berlin in the same year, Neo-Expressionist painting was the focus of attention. In its regional variations (the German Neuen Wilden, the School of London, the Italian transavanguardia) it had a strong following through the decade. But in the consumerist 1980s Neo-Expressionism's concerns with the condition of man, power of myth, relation to history, had far from universal appeal. Like Neo-Expressionism, 1980s sculpture looked over its shoulder—to Minimalism, Pop, and *Arte Povera*, as well as to older traditions that touched on religion, spiritual values, and cultural origins—but it did so pragmatically, without the sense that it was placing itself in history, without posturing or self-importance.

Sculptors turned away from the previous decade's interest in landscape and natural materials to confront issues connected with the city, consumption, and the manufactured object. Pop Art's debate with material culture was resumed, most fervently in America. American 'commodity sculpture' narrowed the gap, not only between art and the everyday object, but also between their respective methods of distribution and exchange, to the point where the existence of any difference at all was open to question. The problem of criticality became acute in the mid-decade in the assessment of work by sculptors such as Jeff Koons (b. 1955) and Haim Steinbach (b. 1944), whose apparently uncompromising celebration of the consumer object, and the less tangible but even more compelling commodity sign, have been read as a surrender to the political and social mechanisms of late capitalism. In other countries the manufactured object was put to different uses. In Britain social criticism was reflected in the use of discarded consumer goods, quite different from the practice in America. In Germany an artist like Katharina Fritsch (b. 1956) shared the widespread interest in the banal commercial object that is the product of endless simulation, but unlike

Detail of 118

American artists she chose images [**124**] which can never be entirely drained of original meaning and power to affect.

Sculpture since 1980 has acknowledged theatre: questions of theatricality had been at the core of the 1960s debate that admitted the viewer into the space of sculpture or—to put it the other way round—brought sculpture into the real space of the world. By the 1980s sculpture's existence in real space was no longer a debating issue. Sculpture has benefited from theatre's being like real life and at the same time not like it: of dealing with human problems on a stage occupied by people as actors, but at the same time having free run of convention and metaphor. In the work of several artists, figure types and figure parts are used (from the Virgin Mary to a dwarf, a flayed man to a detached leg), all of which can be thought of as expressions of difference from a norm; or, perhaps, as expressions of difference which imply that a norm does not exist. Sculpture of the 1980s is crowded with models and miniatures, with surprising changes of scale, and with 'staged' environments.

The 1980s saw a new interest in the figure in sculpture. This was not a return to an earlier concept of the figure, nor a revival of interest in the 1950s, the last decade in which the figure (outside Pop) had been seriously at issue in sculpture. Certain early post-war French sculptures—Fautrier's traumatized heads [**11**] for example—can be thought of as prefiguring the concern with abjection in the work of Kiki Smith (b. 1954) and others. But early post-war figure sculpture, however rickety and battered the figures were, generally implied divergence from a norm of wholeness and harmony. Some sculptors—Antony Gormley (b. 1950), Stephan Balkenhol (b. 1957)—have worked with the figure by itself, while many more have seen the figure as part of often complex assemblages. Some sculpture recalls Surrealism, with its interest in marionettes and dolls, in toys and kitsch objects. Art of the 1980s is concerned with figures that approximate to life but are not life-like, and may be not whole, or are in some way abnormal. Narratives are often implied (Juan Muñoz (b. 1953), Robert Gober (b. 1954)) which work like theatre with figures of different kinds and sizes located in real space. Towards 1990 theatre becomes particularly important, as a medium of art which tells stories of human significance, but, following its own conventions, can do so in a non-human, or partly human, way.

Scale has increasingly since the 1970s become an issue in sculpture, which has moved a long way from the 'neither too big nor too small' of Tony Smith's *Die*.[1] Scale was a theme inherited not only from the much-larger-than-human size of Heizer's *Double Negative* [**88**] or Smithson's *Spiral Jetty* [**89**], but also from the minuteness of elements in Joel Shapiro's installation at Paula Cooper in 1975 [**102**]. Shapiro's work denied the scale of Minimalism: if sculpture was about memory, then the scale that Minimalism had adopted for a positivist art related

to the size of manufactured objects (not monuments, not ornaments) was no longer adequate. Shapiro was not alone in being concerned with the implications of divergence from expected size in subjects like architecture and furniture. The gigantism of Jetelova's furniture [**115**] is at an extreme from Shapiro, while Kirkeby made brick structures in many different sizes [**98**], as if alluding to the role of size in helping to define how we see something—as architecture or as sculpture.

Scale remains important in later sculpture, especially in relation to models. From the earlier 1980s in Germany, the architectural model is presented as sculpture by artists, including Schütte, wishing to comment on ambiguity in relation to human presence and use. Buildings and houses associate themselves with the body and everyday life, but the model can have an object-like detachment that can positively reject human reference. *Imagine You Are Driving. Sculpture 2* [**120**] by Julian Opie (b. 1958) has neither the associations of a toy with play nor those of an architectural maquette with future use, but has a disturbing, a-topic character that seems to block readings connected with use.

'Objects and Sculpture'

The 'Objects and Sculpture' exhibition (1981) at the Institute of Contemporary Arts, London, and the Arnolfini Gallery, Bristol, brought together, among others, Tony Cragg (b. 1949), Bill Woodrow (b. 1948), Richard Deacon (b. 1949), Antony Gormley, and Anish Kapoor (b. 1954), artists who were to pull British sculpture back from the 1970s preoccupation with landscape, and re-position it in terms of 1980s urban culture. Most had the backing of the same dealer, the Lisson Gallery in London, and shared a career pattern—involving rapid expansion into Europe—that Richard Long, Barry Flanagan, and Gilbert & George had enjoyed in the late 1960s.

The artists were less of a group than the New Generation around Caro had been. Cragg and Woodrow used found objects or fragments, whose existing identity contributed to the meaning of the work. Contrary to Caro, for whom material was neutral, the materials used by Cragg and Woodrow, Gormley and Kapoor, were part of the nature and meaning of the work. Deacon sometimes uses materials (linoleum, galvanized metal and patterned carpet) associated with the cheap or the popular, but in other respects chooses materials with no existing non-art inflection, which gather meaning from the way he uses them. Cragg and Woodrow work within the discourse of production and consumption, surplus and waste. Deacon's work is more abstract and concerned with language and poetry. Kapoor and Gormley are concerned with cultural origins and spiritual expression, both being interested—from different starting-points—in the contrasts of West and East. In Britain—as opposed to America—the return to common objects had nothing to do with Pop. Brand labelling was not enshrined

as a subject for British art, as it was, on account of Warhol particularly, in America. What had been seen in Britain as the American passion for consumption, as pictured by Richard Hamilton and others in the 1950s and 1960s with a wry humour, never embedded itself in British art.

Cragg started working in 1978 with found objects, fragments of coloured plastic that express the rapid turn-around of production, use, and discard that marks today's world. This was not a reprise of Oldenburg's recovery of the crude energy of the streets, but a cooler and more distanced expression. The minimal form of *New Stones, Newton's Tones* [116] reads as a grid imposed on the fragments recovered in Cragg's exercise in contemporary archaeology, and is concerned with the relationship of part to whole. There is a parallel with Richard Long (with Cragg's plastic equivalent to Long's stones [91]). Cragg's fragments are not old, but the archaeological metaphor defines his objectivity towards his material. It avoids the value judgement that would surround such a word as 'rubbish', which pinpoints the otherness of the discard in relation to what is valued. Cragg is a *bricoleur*, but his art is not messily inclusive, like Rauschenberg's, possessing, on the contrary, a tidiness stemming from his imposition of order through the grading of colour. The relationship of fragment to whole acquires a definite purpose as he goes on to 'draw' huge figures with plastic fragments on wall and floor. Images of policemen, soldiers, and flags construct an iconography of authority and nationality. Cragg's first exhibition in a public space, at the Whitechapel Art Gallery in 1981, included a wooden model of a Polaris nuclear submarine alongside other openly political images. Cragg's new work was contemporary with the reinforcement of Gilbert & George's reputation, coinciding in the late 1970s with the start of the Thatcher era. Gilbert & George focused on street imagery including race, nationalism, authority, and violence, and expanded into larger, more colourful works, overtly public in intent.

Cragg's materials were commonplace, low in value, and overlooked, and even if his art occupied a space no more public than the museum, it was nonetheless a new view of the world from street level, as close to a public art as was possible at that moment. His work showed that a threshold had been crossed which made many of the debates defining the 1960s obsolete. Modernism's fear of the theatrical is not an issue, and Minimalism's determination to maintain human scale while avoiding anthropomorphic overtones has been reversed, so that scale becomes monumental and the work openly figurative. This gives Cragg's work the character of a public statement.

Woodrow, like Cragg, uses found objects, from domestic appliances to furniture, that have been well used and are close to everyday life [117]. While retaining the idea of things found in his own locality

(never bought), Woodrow specifically rejected his 1970s beginnings within Long's field of activity, retrieving material from the countryside. The shift of emphasis from country to city is particularly marked in British art. While Cragg assembles fragments, Woodrow constructs, cutting into existing manufactured articles and making a new object from the material displaced, which always remain attached to the 'mother' body. Contrary to Pop, Woodrow's objects are never new and shiny, never a source of domestic pride and, if they are domestic, do not have the sense in the English artist Richard Hamilton's work of the late 1950s of belonging to, or being projected through, women. Their point of origin is not the home but the tip. Like Cragg's, Woodrow's work is street-based. *Arte Povera* is the mediating force standing between these artists and a direct view of the earlier 1960s.

Woodrow's work resists consumerist interpretations because these are not objects that are proud of their brand names—we are not, as with commodity sculpture in America a few years later, looking at an art in which the commodity sign (which in Woodrow's case might be Hoover) has overtaken its referent (vacuum cleaner). Woodrow is a modern-day rag-picker, and his art is about consumerism in a different way, relating to recycling as rebirth (the 'umbilical' cord of cut metal

that attaches the old object to the new). His work is a metaphor for the
activity at the bottom of society of patching up and making do, but car-
ried out with a wit which ensures that it does not become heavy-
handed or dogmatic.

Anish Kapoor was in Britain for seven years from 1972, revisiting his
native India for the first time in 1979. On his return to England,
Kapoor started to make moulded shapes which he coated with bril-
liantly coloured chalk dust he had seen being sold in Indian markets,
possessing specific meanings in Indian culture. The 'mountains', the
breast-like body shapes, and even the yellow boat-shaped object in *As if
to Celebrate, I Discovered a Mountain Blooming with Red Flowers* [**118**],
can be related to Indian symbolism. Kapoor is not trying simply to be
an Indian artist in London, but to bring to bear, on ideas drawn from
his native culture, procedures current in European art. Low-lyingness
was an aspect of British art manifested through Richard Long, and

Kapoor's art develops Long's in the sense that by clustering forms across space, he is creating places—reflections in a physical location of the wider field of imagination. While Long observes a kind of truth to materials (stone belongs in the ground and is therefore appropriate to a sculpture that values closeness to the earth), Kapoor moves in the opposite direction, giving his grounded forms the most artificial of colours. Kapoor's is a sensuous art, without Cragg's and Woodrow's allusions to the used and worn. His surfaces are tactile, yet the fragility of the sculptures is such that even the lightest touch will damage them. His work is metaphorical, and though some of the associations evoked are with the body and others with landscape, his forms, spread across the space of the floor, have a wider implication and are like sculptural models for the origins of culture itself.

Richard Deacon's sculpture is also metaphorical, but is different from Cragg's and Woodrow's in that it starts from materials and their possibilities in the abstract and works towards images. Deacon's materials are varied—galvanized metal, laminated wood, leather, linoleum, carpet, and stitched fabric—and are used in a direct way with evident craftsmanship. Deacon avoids solid materials, like stone, because he is concerned with skin and surface and not mass, and his works draw attention to the presence of the artist as craftsman because of the multiplicity of rivets and screws and the surplus glue bulging out from between the laminations. Deacon's forms are open, or possess openings, even when the centre is not visible, and the suggestion of parallels with the orifices of the body—ear, mouth, vagina, eye socket—is confirmed in titles. These works are not so much metaphors for the body itself as suggestions for a language of communication between bodies. The arguments that Michael Fried made in 1964 in relation to Caro— that there is a kind of sculpture which relates to the body but is nonetheless radically abstract, because it alludes not to the body as physical entity but to the idea of gesture—could also be applied to Deacon [119].[2] In Deacon's case, gesture is thought of in terms of speech (or singing, as Deacon has since 1978 connected his work with Orpheus). Compared with others in this group, Deacon is more traditionally sculptural, and the sculptor in the group who most obviously connects the 1980s with the 1960s.

In the 1980s the issue of figurative against non-figurative, so much debated in the 1950s and 1960s, no longer seemed important. None of the sculptors discussed in this chapter is concerned with abstract form alone. Richard Deacon comes closest, and his sculpture has a historical grounding in non-figuration. But not only is it allusive to parts of the body connected with communication, but it is also concerned with the sculptural expression of communication itself. Deacon's work helps to show that when all sculpture is permeated by problems of language, the polarity figurative–non-figurative is no longer a useful starting-point.

Julian Opie (b. 1958) is sometimes included in the 'Objects and Sculpture' group of sculptors, but he is younger than the other artists and emerged two years later, having only just graduated from being a student, in the much larger 'Sculpture Show' at the Serpentine and Hayward Galleries in London. While the older sculptors were concerned with manufactured objects at the end of their life, Opie was, like the contemporary commodity sculptors in America, drawn to the clean image of things not yet brought into use. But unlike the Americans', Opie's sculpture is not involved with domestically purchasable manufactured objects or with branded goods as sculpture. His art is closer to developments in Germany concerned with the gap between sculpture and architecture, and the relationship of models to reality, than to most work in England. His sculpture simulates such factory-made objects as cubicles, booths, small buildings, and wall-mounted ventilators—always in an uncompromisingly modern, show-room style, and with art codings that usually refer back to early Modern movements such De Stijl and the Bauhaus.

The objects in life that Opie alludes to are often things that could be physically entered if they were real, but, as they are not, can only be looked at, and their interior spaces mentally conceived but not experienced. The pavilion type of building had been introduced to the architecture/sculpture debate by Dan Graham [100], who belonged to the

group of sculptors that emerged in the late 1960s (Nauman and Asher were others) and were concerned with the actual physical experience of a fabricated environment. Opie offers a purely optical or intellectual experience, that of 'looking at' but not 'being in'. The same applies, in a slightly different way, to *Imagine you are Driving. Sculpture 2* [**120**], which resembles the model of a self-contained motorway network like an enlarged child's toy in cast concrete. As with much of Opie's sculpture, we are guided from sculpture to model to toy, with excursions into art-historical areas—like De Stijl—where fine art, design, and architecture have momentarily coalesced. In these circular movements, for which *Imagine you are Driving* seems like a general metaphor as well as providing a particular example, we do not decisively touch ground in the real world, and cannot settle on a temporal framework for the artwork that will connect or collectively represent the different signs that it registers.

The work of Rachel Whiteread (b. 1963), who belongs to a younger age group of British Sculptors, is also cool, isolated, and singular, but has different human resonances, which are evoked economically and without nostalgia. Her work has a classical directness which gathers in history, subsuming it with extraordinary intensity for work of such minimalist appearance. Since the late 1980s Whiteread has made casts of things so close to everyday life that they seem to stand in for the human figure: furniture—beds, chairs, and wardrobes—and household fittings, such as basins and baths. Whiteread has emphasized the importance of human association:

I always use second-hand things because there is a history to them....I once got a load of second-hand bedding from the Salvation Army and it was sweat and urine stained. All things I was trying to use....The smell of people, just everyday living....With the bath pieces...I wanted the rust to leave a trace on the plaster—like scum left in the bath; creating a sense of something having been in there.[3]

The allusion to humanity can be equally precise in a different way, with the sculpture a direct metaphor for the figure. Whiteread, for example, bent the wax cast of a mattress while it was still soft, so that its form rested against both wall and floor. The suggestion is of a slumped human figure, which Whiteread, in effect, confirms in speaking of the tragedy of London's homeless.[4]

Whiteread's best-known work, *House* (1993), was the cast of an entire house, the last remaining from an otherwise already demolished east London terrace. The white block-like form of *House* had none of the 'used' look or human character of a familiar brick structure, and stood like a cenotaph in a newly made green space, drawing into its monumental form the memories and associations of a lost social enclave. Though *House* was initially intended to be temporary, three months of public debate about its possible retention preceded demolition. The debate covered an array of issues, relating to ownership, habitation, neighbourhood social structures, and local authority planning. These intersecting threads were examined in a book published after the demolition,[5] which asked how we want to remember the past, whether, for example, the fact that demolition of the area started with wartime bombing would have made *House* an appropriate war memorial fifty years on.

Revisiting the site of *House* now one searches for the marks on the grass, the repair in the now seamless pavement railings, which signify disappearance. Whiteread herself has described as disconcerting the elimination of all traces of the Berlin Wall,[6] and the removal of *House* is a similar erasure, leaving a featureless open space that has no marks of

time on it and therefore ascribes value and significance only to the present. If the history and memories that *House* absorbed are part of its meaning, then the posthumously published book bears the same relation to it as the book of documents surrounding the demolition of *Tilted Arc* did to Serra's sculpture:[7] in this kind of art the sculptural object cannot be stood apart from its own history.

Whiteread's *Ghost* [121] is like *House* but cast from a single room. However, the conceptual problems it raises are different, because the original site was not identified and it cannot have the manifold social resonances of *House*, it is movable (with difficulty, and in pieces), an indoor work, and is in a private collection. Public memorials exist at different distances from the location of the event they commemorate: in nearby churches, or more distantly, like the Cenotaph in Whitehall. But memorials of this kind cannot be in private collections because they are in the public domain and cannot, like privately owned art, be bought and sold. *Ghost* is not in this sense a memorial but it does evoke common memory. It is generalized and minimal, but with enough domestic traces, like a fireplace, to enable each of us to connect it and its hidden inner space with our own experience.

Germany after Beuys

Beuys remained influential until his death in 1986, and German sculptors, such as Baumgarten and Horn, reshaped his concern for sculpture's public engagement to give it a more critical edge. But by 1980 there was a perception that Beuys did not reflect what was modern about the world. Young Düsseldorf sculptors around 1980 (Thomas Schütte [122] (b. 1954), Ludger Gerdes (b. 1952), Reinhard Mucha (b. 1950), Hubert Kiecol (b. 1950) and others) started making models and assemblages which simulated architecture, but generally operated closer to the scale of sculpture, and often had the presence of theatre. Sculptors' models and appropriations from architecture were different from those of architects making prototypes of buildings actually to be erected. These sculptors were forming what the critic Martin Hentschel, in relation to Schütte, has called 'repertoires',[8] promoting the notion of 'series' above that of 'original', and thus attributing to these models the character of dictionaries in the way that Armajani— in some ways an independent precursor of this idea—used the phrase 'dictionary of building' for his own models in the mid-1970s. Marin Kasimir (b. 1957), another young Düsseldorf sculptor, made seating for public places in which the cross-coding between sculpture and street furniture was difficult to unravel and the furniture so hard to use that the public tended to avoid it. Like Armajani's work, Kasimir's straddles the public and private, although Kasimir does not share the concern of Armajani, who has always seen himself as a constructor and public artist, restoring the connection between sculpture and use, albeit with-

out making a direct equation with functionality. Sculptors like Schütte and Gerdes, by contrast, are interested in the hitherto unfashionable subjects of the decorative and ornamental for their own sakes; they accept the alienated condition of the post-industrial world and enjoy it—in all its fragmentariness and contingency—as theatre.

In reaction against the site-neutrality of international Modernist architecture, some architects turned to the pragmatics of ad-hocism, advocating the virtue of using what was available rather than establishing transcendent standards: making buildings from used bottles was not a way of saying that bottles were an ideal building material, but was, rather, a contribution to localism, ecology, and the value of individual human resource. Reinhard Mucha's assemblages [**123**] fit with the ideas of the other Düsseldorf artists in being quasi-architectural, but are distinct in other respects. Using immediately available materials—tables, chairs, and ladders belonging to the institution in which he is working—Mucha has built huge three-dimensional collages of objects, with some resemblance to fairground objects in form and presence, and something of the awesomeness of specialized industrial machines. Mucha is closer to Beuys and *Arte Povera* in his use of avail-

able resources and in the drama of his presentations (like Merz he uses neon to signify energy and drama). Mucha's use of actual tables and chairs sustains the human reference and again distinguishes him from colleagues whose work was further removed from physical reality. His work has been compared with that of Bruce Nauman, who has already been seen using the chair, as an allusion to the body, and who around 1980 also moved on to a larger scale with 'machine' sculptures including suspended chairs. Mucha ascribes to his assemblages the drama of monuments, but they may be temporary, and are anti-heroic because constituted of things that are part of our own everyday lives.

Katharina Fritsch is interested in the circulation of popular images, and her work bears comparison with that of those American artists like Jeff Koons and Haim Steinbach who appropriate consumer objects directly into art. Fritsch differs, however, in that a statue of the Virgin Mary is special, and if it is located, as it was at the 1987 Münster Sculpture Project, in a busy street in a largely Catholic city [**124**], it acquires through its physical situation a different meaning than when it is sited in a shopping-centre in Toronto. Fritsch's concern is with the way in which images travel and how their implications change in different situations. The garishly painted plastic object on a plaster base had appeared before, in the miniature mass-produced form in which it was

122 Thomas Schütte

Eis, installed at Documenta # 8, Kassel, 1987

Schütte's work takes many different directions and cannot be simply pinned down. One concern is with the problem of what 'public' sculpture is. In a number of works, such as this, he has explored 'usability as a key to success', by creating an ice-cream parlour on the lawn in front of the Orangerie at Kassel.

fabricated for tourists, as part of the ensemble *Merchandise Rack with Madonna* (1984). This was a Nativity scene, with a toy car and trailer standing in for the Magi and a white cube for Christ. There is in the 1984 work interest in the relative values of kitsch and high art, while the *Madonna of Lourdes* offers a set of critical observations on the way that valued, enduring, and highly conventionalized objects, like the kitsch Madonna, are received within different surroundings. When transformed by the artist into near-life-size objects they approximate to the human in the real world, while as miniatures they occupy a knife-edge position coded both as a manifestation of traditional religious observation—the Christmas crib—and as a lightly satirical mantelpiece ornament.

Commodity sculpture

Commodity sculpture was one name among others (Simulationism, Neo-Geo) given to American art in the 1980s that represented branded goods and other everyday objects as art. Commodity sculpture made a powerful impact in exhibitions in America and Europe in 1986. British sculpture, as has been seen, picked up on the found object, but the

emphasis was on 'found' and the material would be old, while the equivalent word in respect of American art might be 'purchased' and the object would be new. More than that, British artists engaged in a transforming process to make sculpture out of everyday things; the things were not, at least in the state they were found, the works of art.

This difference existed already in Pop Art, especially that of Andy Warhol, which had no parallel in Britain or continental Europe. Warhol's multiple images of Campbell's soup cans do not simply fetishize consumption, they fetishize—in the language of the French sociologist-philosopher Jean Baudrillard, writing in *The Language of Objects* (1968)—the sign. As artists reflected on the world of marketing and consumption, it became obvious that what was being bought was—to continue the example of Warhol—not soup but Campbell's, and that the world of consumption was geared to marginal differences between labels. The issue was particularly relevant to art because, by the mid-1980s, the New York art market was frenetically active, new marketing-directed galleries grew up promoting art that used these ready-made 'commodities', and—like purchasers of domestic goods—new collectors were often buying quantities of work at one time.

The question to be asked of commodity sculpture is this: if a vacuum cleaner by Koons, or any similar manufactured object is presented (shelved, packaged, or cased) as art, for example [**125**]—and if its process of exchange and distribution in this fast-moving art market was equivalent to the system of exchange and distribution of the same manufacture when it was simply a vacuum cleaner—in these circumstances what distinguishes a vacuum cleaner from a work of art? In

124 Katharina Fritsch

Madonna of Lourdes, 1987
Based on the enlargement of a small pilgrim's effigy, *Madonna of Lourdes* explores the public reception of an image that is recognized and still widely respected, even though it has long circulated as kitsch, and has survived as a sign despite declining belief in the original. Fritsch reproduces it, greatly enlarged, in plastic, painted a garish yellow, and locates it far from its expected setting.

Two Ball 50/50 Tank, 1985
Koons conserves pristine and
desirable consumer objects
behind perspex, where the
possibility of their use is
remote and their value relates
to their status as signs.

answer, one might revert to the argument made in the 1960s, in respect of both Pop Art and Minimalism, that the use—following Duchamp—of the ready-made to shift significance from the object to its context is equally valid with commodity sculpture and that it is the object in a particular situation rather than the generic object that is under consideration. There is a difference, however, in that Duchamp, in the 1910s, was not living in a world of hectic consumption or the commodity sign: a bottle rack was just a bottle rack, while Koons's vacuum cleaner is a Shelton. Precise correspondence between sculpture and manufactured object, and parallel correspondence in their means of exchange and distribution, results in at least the partial loss of the artwork's aura, or cachet, because it is now so marginally distinguished from the object of everyday life which never had aura in the first place.

Nonetheless, if the artwork is to be considered as different from the same object in real life, the difference must be connected either with real, if marginal, differences of identity or with specific meaning that stems from its display. Fritsch worked with both these ideas: she used objects—from the *Madonna of Lourdes* to life-sized stuffed elephants—in which colour, particularly, is used as a distinguishing feature between art object and original, but placement in public, private, or museum space also affects how the object is perceived and valued. Fritsch allows partial loss of aura, partial coalescence between object and sculpture: it is from the partialness of the merger, and the part retention of difference, that meaning emerges. The same is true of at least some work by commodity sculptors. Koons includes a perspex display case as part of the sculpture, or codes his small ornamental works as art by casting them in expensive materials—in both cases keeping 'real life' at bay. Similarly, Steinbach makes shelves which are as much part of the artwork as the objects resting on them [126], and the subject, therefore, is not simply the object but the display. Gudrun Inbogen has aptly described as 'a second skin'[9] the fine surfaces of Koons's sculpture, the expensive materials from which some are cast and which distinguish them from ordinary objects, and, specifically, to describe the perspex case in which the basketballs of *Two Ball 50/50 Tank* [125] are suspended.

This second skin is familiar from earlier post-war realism, Arman's 'accumulations' [43], and other objects that are put out of reach by enclosure in boxes, cases, or vitrines. The impulse behind the earlier works was often protection against loss and the vitrines seemed, on that account, to be associated with the museum as site of preservation—even if the superfluity of like objects that Arman preserved implied an ironical view of the museum. But Koons's are objects of desire, and the second skin is a metaphor not for the museum display case but for the shop window. Both artists approach objects from the point of view not of need or use but of spectacle and the urge to collect. Both also

mimic mantelpiece ornamentation, and Steinbach's shelves, like Koons's perspex windows, refer to sight not touch.

Steinbach is as concerned with display as Koons is. The incongruous objects he displays include 'collectibles' as well as mass-produced objects, and there can be a disconcerting disparity between the objects which suggests that Steinbach's intention is in part a critique of the promiscuity of contemporary collecting. Groups of unlike objects appear alongside each other in his work, forming random accumulations rather than coherent series. Koons is more concerned with isolation: with a basketball, like a stored trophy, unavailable for human use. The viewer's implied distance is that of the voyeur (whose source of pleasure is sight not touch), and it is not surprising that—by extension—some of Koons's work is overtly pornographic.

One point of origin of commodity sculpture was in the appropriation of imagery practised by the 'Pictures' group of artists, named after an exhibition of their work organized by Douglas Crimp in New York in 1977.[10] The Pictures group was concerned with flat art, photography as much as painting, and the purpose behind the re-use of existing imagery was to question the concept of authorship and the degree to which originality was, in any case, possible. As Steinbach, who was conscious of his position in relation to the Pictures group, put it:

The discourse this [Pictures] art has been engaged in questions the position of the subject in relation to the image/object. There has been a growing awareness of the way the media have been turning us into tourists and voyeurs outside our own experience. The Pictures artists have been involved in questioning their own position as producers of art in relation to the mythic baggage of subjectivity and individuality, of which they have become acutely self-conscious. There has been a shift in the activities of the new group of artists [commodity sculptors] in that there is a renewed interest in locating one's desire, by which I mean one's taking pleasure in objects and commodities, which includes what we call works of art. There is a stronger sense of being complicit with the production of desire, what we traditionally call beautiful seductive objects, than being positioned somewhere outside of it. In this sense the idea of criticality in art is also changing.[11]

Steinbach answers the question of commodity sculpture's status relative to Pictures art, opposing their criticality in respect of the commodity with his own complicity. Though nobody would deny that a difference exists, Steinbach's selection of objects, their juxtaposition and display, suggests that, as with Fritsch (but unlike Koons), the answer lies in between criticism and complicity.

The work of Ashley Bickerton (b. 1959) differs from Koons's and Steinbach's in that Bickerton does not appropriate manufactured objects, but creates embellished minimalist forms which mimic specialist technical equipment, with expensive materials and elaborate craftsmanship signifying high value. Surfaces are studded with name-

plates and painted signs referring to corporate businesses, including art galleries, and to the artist himself. The invasion of the surfaces by signs implies that his works, apart from being art objects, are sites like busy urban locations. Bickerton's referencing is complex, with openings towards traditional genres of art—there are allusions to portraiture and still life—and different moments of earlier history—Pop Art and, in its symmetry and modern materials, Minimalism [**127**]. Discussing commodity sculpture in general, Bickerton asserted: 'After years of pulling the object off the wall, smearing it across the fields in the Utah desert, and playing it out with our bodily secretions, the artwork has not awkwardly but aggressively asserted itself back into the context: the space of art—but this with an aggressive discomfort and a complicit defiance.'[12]

For Bickerton defiance means the opposite of what it had meant in the previous twenty years. Then, it meant the elimination of boundaries, now it means remaking them; then it meant a critical attitude to the art gallery, now it means relocating there. Bickerton builds into his artworks such things as handles and moving instructions (inscribed on the back) to emphasize that he is re-establishing his sculpture, after Earth Art and Body Art, in terms of what sculpture used to be: mobile and exchangeable, available for hanging, display, and transport—the properties that identify an artwork as a commodity within the general category of saleable things. In contrast to what he saw as the didacticism of the Pictures artists, Bickerton's appeal was to the poetry evoked by the collision of signs in his own art:

I feel the Pictures group was after a particular deconstruction or breakdown of the process of the corruption of truth, whereas at this point I feel that we are utilizing that process of corruption as a poetic form. … Much of the work produced by the Pictures group was essentially deconstructive and task-oriented in its spectacular didacticism. It was a cool approach to hot culture, whereas this new work of which we speak has more to do with information in general, specifically the schism that exists between information and assumed mean-

127 Ashley Bickerton
Biofragment No. 2, 1990
This is part of a series with viewing windows that reveal displays of geological fragments. The sculptures are primarily concerned, nonetheless, with the glamour and desirability of expensive consumer products, rather than with any function they may have.

ings, particularly how the formal elaboration of information necessarily affects its possible meanings. This work has a somewhat less utopian bent than its predecessor.[13]

Allan McCollum (b. 1944) is sometimes included within commodity sculpture, because works like Fifty Perfect Vehicles [128] are barely mediated appropriations of a non-art object. They are plaster reproductions of a typical Chinese ginger jar, varying sometimes in size and painted different colours. The reductiveness was intended, in the way opened up by Minimalism's contact with the ready-made, to shift the emphasis from object to context: 'If one wants to understand art, it seems to me, one should begin with the terms of the situation in which one actually encounters it.'[14] McCollum wanted to escape from the inflections and associations with desire and possession that Koons's and Steinbach's multiplicity of objects have, and contemplated making only one work of art altogether and using it again and again. He discarded the idea because he wished his art to comment on the nature of the market, which would have been difficult with a single object, not only because there would had been nothing to exchange, but because McCollum saw continuous marginal variation of a single unit of production as reflecting the nature of the market in late capitalism, creating an illusion of choice where none really exists.

Within computer-aided mass production, minor variations to the production-line norm are easily introduced without varying the basic design. McCollum's changes of colour-way and size parody this process. What consumer society wants, Craig Owens points out in relation to McCollum, 'is the object not in its materiality but in its difference—the object as sign. This difference itself becomes an object of consumption, and the agenda of serial production becomes apparent: to carefully engineer and control the production of difference in our society.'[15]

The subjects of commodity sculpture are advertising's language of signs, desire, purchase, and making collections. It is a clean and shiny art because it is protected from touch and use and available only to sight. Belonging to the world of ownership and exchange, commodity sculpture does not touch ground, and therefore excludes issues of time (it lives in an eternal present) and place (it is siteless)—questions that are taken up by David Hammons (b. 1943), an Afro-Caribbean artist working from Harlem. Hammons works with the everyday, taking possession of places, their associations and histories, their racial, community, and musical traditions. He creates an art that is impure, literally made of waste in the case of elephant dung rescued from a passing circus, but waste that is wrapped in metal foil (the poor man's equivalent of Koons's stainless steel) to signal that it is valued (and can be fetishized) [129]. The big dung balls are matched against tiny ele-

Fifty Perfect Vehicles, 1985–9
These are solid cement casts
based on a typical Chinese
ginger jar. A large number
were made in different colours,
and slightly varying in size,
as a form of commentary
on repetition, permutation,
and marginal difference.

phants to direct attention to the high value of waste. Hammons's work is often ad hoc: it can have the festive air of what is important for the moment but not expected to last. 'I spend eighty-five per cent of my time on the streets as opposed to in the studio,' Hammons says. 'So, when I go to the studio I expect to regurgitate these experiences of the street.'[16] In Hammons's work *Arte Povera*, with its grounding in the real, the demotic, and the used, is regrounded in an art that belongs to the pavement and not to the world of advertising. Hammons alludes to the idea of an alternative culture and is concerned with ethnic difference, but is also oppositional in taking a critical stance towards New York art in general (as *Arte Povera* had towards the context of Minimalism). Hammons's work sets itself against commodity sculpture, expresses difference: it is dirty instead of clean; is street-based and site-specific as well as located in the gallery; and is present in time, and, when expressed in terms of street performance, physically engaged rather than the object of sight.

Reference to *Arte Povera* in relation either to Woodrow in Britain or Hammons in New York is a statement less of influence than evidence of the embeddedness in the 1980s of an untidy, ad hoc kind of art associated with the everyday, which had not been universally welcomed even in Europe, let alone America, in the 1970s. In the new decade it stood, against commodity sculpture, for the non-commercial, the unprivileged, the art of the street. As the Spanish sculptor Juan Muñoz, like many others, felt, it represented inclusiveness, allusion, association, the freedoms that sculptors working in the shadow of Minimalism had denied themselves.

The human figure

With the exception of some Pop and hyper-realist artists (such as George Segal, John DeAndrea (b. 1941), Duane Hanson (b. 1925)), the human image had played little part in sculpture since the 1950s. Although figure sculpture now became possible again, there was no identifiable group, it was not a 'revival'. As important now as earlier histories of the figure in sculpture is the treatment in the 1960s and 1970s of the artist's own person as, or in relation to, sculpture—in the form of Performance, Body Art, and some of Earth Art. The interlocking of the figure subject and sculpture over the period from 1960 has many ramifications. It gained currency in the 1980s partly because of increasing interest in using public space, which was capitalized on in works of the English sculptor Antony Gormley and the German Stephan Balkenhol, partly as a consequence of the collapse of sculptors' resistance to theatre and narrative, which made possible the work of Juan Muñoz or Robert Gober. As Muñoz has said in relation to the end of Minimalism and his own respect for *Arte Povera*: 'We have become aware of the millions of stories we did not allow ourselves

129 David Hammons

Elephant Dung Sculpture,
1986

This picks up on *Arte Povera's*
valuing of the undervalued and
search for reality in the street.
Hammons's art was a point
of resistance to American
'commodity sculpture' in
the mid-1980s.

to tell over the last ten years because of our suspicion of the conditions of expression. Now we know we can express without being expressionistic.'[17]

The resemblance of Antony Gormley's figures to a quasi-classical idealized figure type betrays their real nature as plaster casts of the artist's body overlaid with sheets of lead, with individual features levelled off to reduce individuality. Though Gormley is not concerned with implied movement, there is a parallel with ritualized dance movements in the work of Yvonne Rainer and others, and Rainer's desire to make the body as much as possible like an object. Gormley's sculptures are similarly both himself and objects. He has spoken of becoming passive while being wrapped in clingfilm and plastered over, and the need to have the right pressure in his lungs as the plaster dries, to give the body interior space. The aim is not personal expressiveness but the right relationship of space within and the outside the body ('my work is to make bodies into vessels that both contain and occupy space').[18] Although the metal casing encloses him like a suit of armour, his sculptures have a distinctive relationship with the outside world. The joins of the lead casing can be read abstractly as grids, emphasizing the remoteness of the figures, or (if the figure is standing) in terms of vertical and horizontal, figure and landscape. Seen out of doors, as the works often are, the horizontal join is equivalent of the horizon. The figures do not just occupy ambient space, but relate to space in its fullest extension.

Gormley also makes reverse body images which are solid concrete blocks with wide openings corresponding to the limbs and narrow holes representing the body orifices. These pick up the thread of the

negative monument from Manzoni (though Gormley's work has a sombreness that is unlike Manzoni's) or Nauman's taking impressions of artists' knees. *Home* [**130**] shows a lying figure with a terracotta house over his head, so that—allowing for drastic change of scale—the house is equivalent to the head. 'The house is the form of vulnerability,' Gormley says,[19] referring, perhaps, to the surroundings of the body—walls, room, house—that can be regarded as both maternal and protective, but also to the exposure of the body to the world, to social surroundings. A comparison might be made with Rebecca Horn, who encased the body and put pressure on it, but also empowered it with outward extensions that gave it command of room space and allowed her to equate the felt space of the body with the external space the body inhabited [**83**].

Stephan Balkenhol came to represent figure sculpture in Germany almost with the singularity that Gormley did in England. Balkenhol is distinct from painters—such as Georg Baselitz and Jorg Immendorf, who have made figurative sculptures out of wood, because his images have an everyday character against the painter-sculptors' emotional expressiveness. Balkenhol's figures are positioned between the generalized (there is still a residual relationship to Minimalism) and the specific, in that they are ordinary clothed or part-clothed people [**131**]. Balkenhol admires Egyptian sculpture because he finds in it both transcendence and individuality.[20] His figures are not defined by physical posture and few engage in any kind of activity. They have a separate-

130 Antony Gormley

Home, 1984

Gormley's concern with enclosure of the cast human figure in metal casing is extended here to the covering of the head by a house—the form of habitation that encloses the body in life.

ness from the world that gives them a certain kind of distinction but none of the superiority of a traditional statue. Even when positioned out of doors, in public space (on the end wall of a house for the Münster Sculpture Project, 1987, or in the middle of the Thames in London by Waterloo Bridge, as part of the Hayward Gallery's 'Double-take' exhibition of 1992), the works remained themselves and still refused the self-conscious look of much public sculpture. The reason is partly that they are made of roughly carved wood, a material which, though it has an important role in historic German sculpture, has none of the traditional public resonance of stone or bronze. Balkenhol was a student of Rückriem, who had a similar role in retrieving sculpture for the world of nature and the senses after Minimalism.

While Gormley's is a spiritual art, edging towards the mystical, Balkenhol's is more quotidian, and reintroduces, without specific intention, the problem of representing the ordinary person. Socialist Realism had played the major part in all but closing off the figure as a possibility for Western European art, and the figure could be revived only by avoiding Socialist Realism's faults. As opposed to rhetoric and the picturesque, what Balkenhol offers is authentic lifelikeness and the individuality of the independent person irrespective of class.

131 Stephan Balkenhol
Man with Black Trousers,
1987
This illustrates the artist's interest in creating images that endow the common person with distinction without crossing the threshold of traditional public art's concern with the heroic.

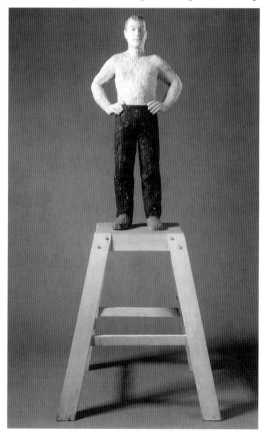

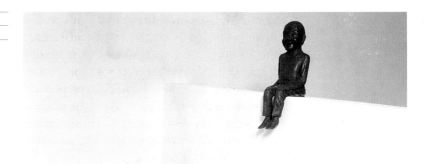

While Balkenhol's serene figures are on pedestals and in niches but have no environment, those of the Spanish artist Juan Muñoz occupy places that are described or alluded to by means of balconies, handrails, and elaborately patterned floors which separate viewer from sculpted figure. Muñoz's figures are either not quite human or, if they are, lack some essential character of their human type. Ballerinas lack feet, a ventriloquist's dummy has no voice except his master's. Distance is important, with figures located on shelves and balconies across floors that seem as much like bumpy seas as 'bridges' between them and us. At first sight there seems to be an element of voyeurism, with ourselves as normal people looking at the not quite normal. Muñoz has spoken of contacting an actual dwarf by phone to propose making a cast for sculpture, and the dwarf, in agreeing a meeting, asking how he was to recognize the artist. Muñoz saw that the dwarf had turned the tables on him, and that he, the artist, would have to make himself physically

133 Robert Gober

Untitled, detail from an
installation at the Jeu de
Paume, Paris, 1991

The lower halves of male
bodies were shown imprinted
or implanted with sheet music,
sink drains, and candles,
'which seemed to present a
trinity of possibilities from
pleasure to disaster to
resuscitation' (Gober, 1993).

distinc̣ e to effect the meeting.[21] Muñoz's work is about seeing and being seen [132], not the limited experience of empowered viewers looking at the vulnerable. Another series, on the subject of hunters, shows dark silhouetted armed figures attached to a system of hinges that raises and lowers them like targets. Here the reversal reveals the apparently empowered subjects of the sculpture made vulnerable to the imagined gunfire of the viewer.

Robert Gober's early work bears superficial resemblance to the sculpture of Steinbach and Koons. It is pristine and appropriates imagery from life. But Gober's choice of subject is not random, nor is it distanced from us—encased or shelved—as theirs is. Like Whiteread's, Gober's objects suggest intimate use: basins, urinals, beds, and children's cots relate, like hers, to the body and its functions. They may be relocated to give special, and perhaps contrary, inflection: the upright splashbacks of two sinks, half buried in a quiet corner of a garden, resemble tombstones. Urinals are without plumbing and dis-functional, but have a pristine cleanliness suggesting inhibition of bod-ily functions, while the cot changes from a straight simulation to a distorted rhomboid that seems resentful of infancy. There is implica-tion of individual and family space being merged, and privacy compro-mised, with doors taken off their hinges and propped against the wall. In contrast with Robert Rauschenberg's messy, well-used *Bed* (1955), which similarly challenged conventional ideas of the natural by being mounted upright on the wall, Gober's beds are tidy and made up but unused—interpretable as images of absence and loss in their still, silent spotlessness. Gober attacks the sentimental belief in the innocence of childhood, the cleanliness of bodily functions, and the virtues of home and family. Matthew Weinstein rightly points out that Gober stirs 'murkier, more psychologically provocative waters [than his con-temporaries]…transforming his roster of everyday objects into an iconography of fundamental human experience'.[22] Gober is gay and his art reflects and comments on gay identity in the early years of AIDS. More than that, it takes a critical view of the complacency of modern life, the family and family values, and the importance placed on the appearance of cleanliness.

In 1990, Gober departed from object-based art into a series of dis-turbing installations involving the body. The figure first appears as wallpaper design showing, in repeat, a white boy in bed alongside a black man lynched and hanging from a tree. We do not know if the black man is in the white boy's dream, is of no interest to him, or is even an object of his sexual desire. Gober does not attempt to answer such a question, alluding to wallpaper's customary function simply as decora-tion and leaving it at that, as if no more need be said. Gober introduces wax models of men's lower halves [133], which may be unclothed ex-cept for underpants, and project into walls which are painted as wood-

land. The legs have implanted hair and either metal sink drains or candles embedded in them. Part-nudity and emblems of death, body drainage and the background forest, elaborate a play between culture and nature that suggests resolution awkwardly and only through death, the subsuming of the body, wedged as it is into the wall, back into the earth. 'For me,' Gober says, 'death has temporarily overtaken life in New York City. And most of the artists I know are fumbling for ways to express it.'[23] Although the imagery of this art—woodland, candlelight—has parallels with the nineteenth-century fin-de-siècle, Gober's is not—as the earlier work often was—a resigned art, a surrender to the mysteries of life and death, but a critique of the institutions of family and home that create the need to identify the gay as other.

Kiki Smith shares with Gober a concern for the lower half of the body, that which is not the head or thinking part. Most of Smith's work to 1988 dealt with the inside exposed, organs extracted, grouped for display, sometimes cast in bronze. Much of her subsequent sculpture has dealt with the exterior body, often stained with its own fluids (semen, lactation), so that one looks at a conflation of inner and outer. Smith's earlier work not surprisingly encountered shock and even disgust from viewers, and there is surprise of a different kind in the later works in which she shows the body whole (in an image which could loosely be called 'classical'), but then upsets a reading of that kind by exposing leaking fluids. The ideal is contrasted with the real body, an issue touched on earlier by Gormley in a statuesque figure which one

134 Kiki Smith
Man, 1988
The dismembered and suspended body of *Man* represents one of several directions in which the artist has developed the issue of abjection.

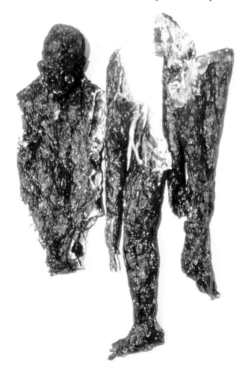

could call 'ideal', who looks down at his erect penis, contemplating, as it were, the nature and origin of being.

Smith's *Man* [**134**] is a flayed and dismembered body with the head hanging limply next to arms and legs. While Smith had first studied the human form from Gray's *Anatomy*, this is plainly not a corpse prepared for medical students' study. It is torn apart rather than dissected. In 1985 Smith had worked with New York's Emergency Medical Service, where she had gained a view of the traumatized body, and her image becomes one of the body that cannot be mapped, as if by an anatomist, and as if the body were essentially one thing, an object.

In the 1980s Smith's was more or less an underground reputation, and her first one-person exhibition occurred only in 1988, when she had practised as an artist for some ten years. Commodity sculpture was a gallery art structured around certain ideas of marketing and collecting which were essentially traditional and constituted a system. In different ways, the work of Gober and Smith uses transgressive strategies— whether of material or subject, estrangement and use of part objects, methods of display, problems of permanence and collectibility—to disestablish boundaries between what is conventionally accepted as art and what is not, and within the art world system itself. Smith's *Man* lacks the very element that in traditional figure art marks the boundary between self and other—the skin, the outside of a person, the boundary of an object. Smith's work fits the definition of the 'abject' in art in its connection with the baseness of the body, its fluids, vomit, excrement. Julia Kristeva, theorist of the abject, has generalized the concept in terms of 'what disturbs identity, system, order, what does not respect borders, positions, rules. The in-between, the ambiguous, the composite.'[24] These are the properties and the problems—whether or not to observe the borders between aesthetic categories—which, back to the 1960s, were the debating points of art. One of the changes that enabled the debate to get under way was the virtual elimination of the worn-out subject of the human figure as a subject for sculpture. As the figure re-emerges as a subject in the 1980s, it does so as a dynamic category, full of possibilities.

Chapter 1. European Sculpture after 1945

1. John Berger, 'Ossip Zadkine', in *Permanent Red: Essays in Seeing* (London, 1960), 120.
2. W. R. Valentiner, *The Origins of Modern Sculpture* (New York, 1946), 140.
3. Frederick S. Wight, 'Henry Moore: The Reclining Figure', *Journal of Aesthetics and Art Criticism*, December 1947.
4. Henry Moore, 'Sculpture in the Open Air', ed. by Robert Melville for the British Council, partly published in Philip James, *Henry Moore on Sculpture* (London, 1966), 97–109.
5. Ibid.
6. Robert Motherwell, review of *Henry Moore Sculpture and Drawings*, with an introduction by Herbert Read, *New Republic*, 22 October 1945. Greenberg's remarks on Moore and Maillol are contained in 'Review of Exhibitions of Gaston Lachaise and Henry Moore', *The Nation*, 8 February 1947, repr. in Clement Greenberg, *The Collected Essays and Criticism, vol. 2, Arrogant Purpose 1945–1949*, by John O'Brian (ed.) (Chicago, 1986), 125–8.
7. Charles Despiau, *Arno Breker* (Paris, 1942). Despiau had known Breker since around 1928 when Breker had been his student in Paris.
8. See, especially, 'The New Sculpture', *Partisan Review*, June 1949, reprinted in Greenberg, *Arrogant Purpose*, 313–19. A much revised version of this article was published as 'Sculpture in our Time', *Arts*, June 1958. Repr. in Clement Greenberg, *The Collected Essays and Criticism, vol. 4, Modernism with a Vengeance 1957–1969*, by John O'Brian (ed.) (Chicago, 1993), 55–61.
9. Marini quoted by Sam Hunter in *Marino Marini* (New York, 1993), 16.
10. Daniel-Henry Kahnweiler, *The Sculptures of Picasso* (London, 1949).
11. Jean-Paul Sartre, 'The Quest for the Absolute', in *Essays in Esthetics*, sel. and trans. by Wade Baskin (London, 1964), 101. First published in *Les Temps Modernes*, January 1948.
12. Georges Charbonnier, 'Entretien avec Alberto Giacometti, 1951', in *Lettres Nouvelles*, April 1959, quoted by Reinhold Hohl, *Alberto Giacometti* (London, 1972), 280.
13. Kahnweiler, *Sculptures of Picasso*.
14. Simone de Beauvoir in *La Force de l'age* (Paris, 1960), quoted in Hohl, 275.
15. Henry Moore in the *Architectural Association Journal*, May 1930, 408–13, quoted by Evelyn Silber in *Gaudier-Brzeska. Life and Work* (London, 1996), 139. Moore's remark was adapted from a statement of Gaudier-Brzeska published in Wyndham Lewis (ed.), *Blast*, 1 (1914).
16. Naum Gabo, in 'An Exchange of Letters between Naum Gabo and Herbert Read', *Horizon*, July 1944.
17. See Benjamin H. D. Buchloh, 'Cold War Constructivism', in Serge Guilbaut (ed.), *Reconstructing Modernism: Art in New York, Paris, and Montreal 1945–1964* (Cambridge, Mass., 1990), and the same author's 'Construire (l'histoire de) la sculpture', in Margit Rowell (ed.), *Qu'est-ce la sculpture moderne?* (Paris, Centre Georges Pompidou, 1986).
18. Herbert Read, *The Art of Sculpture* (London, 1956). See ch. 1, 'The Monument and the Amulet', especially p. 14.
19. Clement Greenberg, 'Review of a Joint Exhibition by Antoine Pevsner and Naum Gabo', *Partisan Review*, April 1948, reprinted in *Arrogant Purpose*, 226.
20. 'An Exchange of Letters', 61.
21. David Thompson, 'Outlines for a Public Art', *Studio International*, April 1966.
22. Hepworth, in *Barbara Hepworth: Carvings and Drawings*, ed. by Herbert Read (London, 1952), section 4, 1939–46.
23. Max Bill quoted in Eduard Hüttinger, *Max Bill* (Zurich, 1978), 11.
24. Carola Giedion-Welcker, *Contemporary Sculpture: An Evolution in Volume and Space* (London, 1956), p. xxiii.
25. Eduard Trier, *Form and Space: The*

Sculpture of the Twentieth Century, Section 3, 'The Problem of Purpose' (London, 1961), 253.

26. Michel Seuphor, *The Sculpture of this Century*, Section 21, 'Sculpture and Architecture' (London, 1959), 208.

27. Ibid.

28. Yve-Alain Bois, in the section 'bas matérialisme', in *L'informe: Mode d'emploi* (Paris, Centre Georges Pompidou, 1996), 54.

29. Piene at the opening of the Fontana exhibition at the Städtische Galerie, Leverkusen, 1962, as quoted by Lawrence Alloway in intro. to *Zero 1–3* (Cambridge, Mass., 1974), p. xii. And Piene in 'The Development of Group Zero', *The Times Literary Supplement*, 3 September 1964, reprinted in *Zero 1–3*.

Chapter 2. 'The New Sculpture'

1. See Greenberg's review of 'American Sculpture of Our Times' at the Buchholz and Willard Galleries, New York, in *The Nation*, 16 January, 1943. Greenberg wrote substantially of Smith for the first time: '[his] work puts in the shade almost everything else [in the exhibition]. … Of the better work none comes close enough to great art. None except David Smith's *Interior*.' Reprinted in Clement Greenberg, *Collected Essays and Criticism, vol. 1, Perceptions and Judgments 1939–1944* (Chicago, 1986), 139.

2. Greenberg in 'The Present Prospects of American Painting and Sculpture', *Horizon* (October 1947), reprinted in *Arrogant Purpose*, 167.

3. Greenberg, 'The New Sculpture'.

4. See Greenberg, 'Review of Exhibitions of Gaston Lachaise and Henry Moore'.

5. Greenberg, 'The New Sculpture'.

6. 'Opticality' was implicit in Greenberg's writing since the 1940s but was clearly spelled out in 'Sculpture in Our Time', *Arts*, June 1958. A re-thinking of the 1949 'The New Sculpture', it takes into account Greenberg's recognition in his 1955 article 'American-Type Painting' (*Partisan Review*, spring 1955, repr. in Clement Greenberg, *The Collected Essays and Criticism, vol. 3. Affirmations and Refusals 1950–1956*, ed. by John O'Brian (Chicago, 1993), 217–36) that painting had outstripped sculpture as a radical practice in America.

7. Read, *The Art of Sculpture*, pp. x–xi.

8. Ibid., pp. ix–x.

9. Henry Moore, 'Notes on Sculpture', first published as 'The Sculptor Speaks' in *The Listener*, 18 August 1937, reprinted in *Henry Moore: Sculpture and Drawings, vol 1, 1921–1944* (London, 1944), pp. xxxiii–xxxv.

1̷ ̷ ̷ *Art of Sculpture*, 49.

11.

12. ̷ ̷ *Project for a Sculpture*, 1928–9, repr̷ ̷ ̷ n *Cahiers d'Art*, 4 (1929).

13. 'Progress Report on Guggenheim Fellowship 1950–5̷', in Garnett McCoy (ed.), *David Smith* (London, 1973), 68.

14. In *The Nation*, 26 January, 1946, reprinted in *Arrogant Purpose*, 51.

15. Ibid.

16. The reference to Smith is in Greenberg, 'The Present Prospects of American Painting and Sculpture', as is the reference to Pollock as 'gothic'. 'Baroque' is used of Pollock in 'Review of exhibitions of Adolph Gottlieb, Jackson Pollock, and Josef Albers', *The Nation*, 19 February 1949, reprinted in *Arrogant Purpose*, 285–6. Gabo is referred to as 'rococo' and Pevsner as 'Jacobean baroque' in 'Review of a Joint Exhibition of Naum Gabo and Antoine Pevsner', *The Nation*, 17 April 1948; *Arrogant Purpose*, 227. Lipchitz is 'baroque' in 'Review of Exhibitions of the American Abstract Artists, Jacques Lipchitz and Jackson Pollock', *The Nation*, 13 April 1946; *Arrogant Purpose*, 73.

17. Theodore Roszak in H. H. Arnason, *Theodore Roszak* (Minneapolis, Walker Art Center, and New York, Whitney Museum of American Art, 1956–7). Similar points were first made in 'Theodore Roszak: Some Problems of Modern Sculpture', *Magazine of Art* (February 1949).

18. Seymour Lipton quoted by Sam Hunter in *American Art of the Twentieth Century* (New York, 1974), 247. Contemporary texts by Lipton with a similar message are 'Some Notes on my Work', *Magazine of Art* (November 1947), and 'Experience and Sculptural Form', *College Art Journal* (autumn 1949).

19. Greenberg, 'The Present Prospects of American Painting and Sculpture'.

20. Frederick Kiesler, 'Correalism', in *Fifteen Americans* (New York, Museum of Modern Art, 1952), 8.

21. Greenberg, 'The Present Prospects of American Painting and Sculpture'.

22. Read, 'New Aspects of British Sculpture', in *XXVI Venice Biennale, The British Pavilion* (London, 1952).

23. Eduard Roditi, interview with Paolozzi in *Dialogues on Art* (London, 1960), 167.

24. Lawrence Alloway, 'Sculpture as Cliché', *Artforum* (March 1963).

25. Lawrence Alloway, 'The Sculpture and Painting of William Turnbull', *Art International* (February 1961).

26. Referred to by Lawrence Alloway in 'Britain's New Iron Age', *Art News*

(summer 1953).

27. Read, 'New Aspects of British Sculpture'.
28. The prospectus was much quoted from in contemporary journals. A copy exists in the library of the Museum of Modern Art, New York.
29. Letter from Read to Gabo, 19 March 1953, quoted by Joan Pachner in 'Zadkine and Gabo in Rotterdam', *Art Journal* (winter 1994). The Read-Gabo correspondence (Beinecke Library, Yale) has also been quoted by Steven Nash in *Naum Gabo: Sixty Years of Constructivism* (Dallas, 1985), and by Robert Burstow in 'Butler's Competition Project for a Monument to the Unknown Political Prisoner', *Art History* (December 1989). Gabo was very ambitious to win the Unknown Political Prisoner Competition, and wrote to Read, 4 January 1953: 'This work is the height of my striving towards an image which would combine sculpture and architecture in one entity.' Several sources make it plain that Gabo thought the logical evolution of Constructivism, as he conceived it, was towards a new public sculpture. Read argued in an essay on Gabo in *The Tenth Muse* (London, 1957) that the Bijenkorf sculpture had the 'aspirational' character of a gothic cathedral, and that 'in age of confusion, of distraction, and despair [he] has remained faithful to a vision of transcendental order.' Read would certainly have liked Gabo to win the competition. Moore, the sculptor to whom Read was closest, remained outside the competition, and it is doubtful whether Read would have regarded him as an equal candidate to Gabo for a major public urban work.
30. William Gaunt, *Art Digest* (1 April 1953).
31. John Berger, 'The Unknown Political Prisoner', *New Statesman* (21 March 1953).
32. From the prospectus (see above, n. 28).
33. Berger, 'Unknown Political Prisoner'.
34. Read, 'Tragic Art', *New Statesman* (28 March 1953).
35. Clement Greenberg, 'Avant-Garde and Kitsch', *Partisan Review* (fall 1939), repr. in *Perceptions and Judgments*, 5–22.
36. Greenberg, 'David Smith', *Art in America* (winter 1956–7), repr. in Clement Greenberg, *The Collected Essays and Criticism, vol. 3 Affirmations and Refusals 1950–1956*, ed. by John O'Brian (Chicago, 1993), 175–9.
37. Greenberg, '"American-Type" Painting', *Partisan Review* (spring 1955), repr. in *Affirmations and Refusals 1950–1956*, 217–36.
38. Greenberg, 'David Smith'.
39. Ibid.

Chapter 3. Sculpture and the Everyday

1. Phillip King, 'British Artists at Venice. 2: Phillip King Talks about his Sculpture', *Studio International* (June 1968).
2. Lawrence Alloway, 'The Arts and the Mass Media', *Architectural Design* (February 1958), repr. in C. Harrison and P. Wood (eds), *Art in Theory 1900–1990* (Oxford, 1992), 700–2.
3. Roland Barthes, 'Myth Today', in Annette Lavers (ed.), *Mythologies* (London, [1957] 1971), 109.
4. Barthes, 'The New Citroën', in *Mythologies*, 88–90.
5. 'Donald Judd, Specific Objects', *Arts Yearbook*, no. 8, 1965, repr. in Donald Judd. *Complete Writings 1959–75* (Halifax, Nova Scotia, and New York, 1975), 181–9.
6. Françoise Choay, reviewing the Venice Biennale, *Art International* (September 1962).
7. See Alan Solomon, introduction to *Jasper Johns* (New York, Jewish Museum, and London, Whitechapel Art Gallery), passim.
8. Leo Steinberg, 'Jasper Johns: The First Seven Years of his Art' [1962], in *Other Criteria* (Oxford 1972), 35ff.

Chapter 4. Modernism and Minimalism

1. Clement Greenberg, 'The New Sculpture' (1949); rev. 1958, *Art and Culture* (Boston, 1961), 139–45. For other publication details of these articles, see above, ch. 1 n. 8 and ch. 2 n. 6.
2. Lawrence Alloway, interview with Anthony Caro, *Gazette*, 1 (London, 1961), 1.
3. Robert Morris in 'Notes on Sculpture, Part 4: Beyond Objects', *Artforum*, April 1969, repr. in Morris, *Continuous Project Altered Daily* (Cambridge, Mass., 1993), 51.
4. Michael Fried, 'Anthony Caro' introduction to the artist's exhibition at the Whitechapel Art Gallery, London, 1963.
5. In *Artforum* (June 1967), reprinted in Gregory Battcock, ed, *Minimal Art: A Critical Anthology* (New York, 1968).
6. Rosalind Krauss, in *Theories of Art after Minimalism and Pop*, Dia Art Foundation Discussions in Contemporary Art, no. 1, Hal Foster (ed.) (Seattle, 1987), 61.
7. See ch. 1, n. 16.
8. William Tucker, 'An Essay on Sculpture', *Studio International* (January 1969).
9. Judd, 'Specific Objects'.
10. Tony Smith quoted by Robert Morris in 'Notes on Sculpture: Part 2', *Artforum* (October 1966), repr. in Morris, *Continuous Project Altered Daily*, 11.
11. Ibid.
12. Clement Greenberg, 'Recentness of

Sculpture', in *American Sculpture of the Sixties* (Los Angeles County Museum, 1967), repr. in Clement Greenberg, *Collected Essays and Criticism, vol. 4: Modernism with a Vengeance 1957–1969* ed. by J. O'Brian (Chicago, 1993), 250–6.

13. Morris, 'Notes on Sculpture: Part 2'.

14. Fried, 'Art and Objecthood'.

15. Ibid.

Chapter 5. 'Anti-Form'

1. Robert Morris, 'Anti Form', *Artforum* (April 1968), repr. in *Continuous Project Altered Daily*, 41–6.

2. Morris, 'Notes on Sculpture. Part 4: Beyond Objects'.

3. Morris, unpublished diary, quoted by Kimberley Paice in *Robert Morris: The Mind/Body Problem* (New York, Guggenheim Museum, 1995), 235.

4. Morris, 'Notes on Sculpture. Part 4: Beyond Objects'.

5. Ibid.

6. Ibid.

7. Steinberg, *Other Criteria*, 82ff.

8. Mel Bochner in *Arts* (November 1966), quoted by Lucy Lippard in *Eva Hesse* (New York, 1976), 83.

9. Robert Smithson quoted by Lippard, *Eva Hesse*, 83 and 185.

10. Bernard Lamarche-Vadel, interview with Beuys, *Canal* (winter 1984–5), quoted by Eric Michaud, 'The End of Art according to Beuys', *October* (summer 1988).

11. Eric Michaud, *October* (summer 1988).

12. The incident was extensively reported in contemporary New York art journals (and by *Studio International* in London) and is analysed by Stefan Germer in 'Haacke, Broodthaers, Beuys', *October* (summer 1988).

13. Germano Celant, 'Arte Povera, Notes for a Guerilla War', *Flash Art* (November–December 1967). English translation in *Flash Art: Two Decades of History. XXI Years*, ed. by Giancarlo Politi and Helen Kontova (Cambridge, Mass., 1990), 189–91

14. Ibid.

15. Ibid.

16. *Flash Art* (November–December 1967). Gilardi's report is also translated into English in *Flash Art: Two Decades of History: XXI Years*, 189.

17. Donald Judd in Bruce Glaser, 'Questions to Stella and Judd', *Art News* (September 1966). Repr. in Battcock (ed.), *Minimalist Art, A Critical Anthology*, 148–64: see p. 154. Celant's reply is from *Arte Povera: Histories and Protagonists* (Milan, Electa, 1985).

18. Germano Celant, 'Michelangelo Pistoletto: Gli Stracci' (Berkeley, 1980), and quoted in Celant, *Michelangelo Pistoletto* (New York, 1988), 26.

19. Celant, 'Arte Povera, Notes for a Guerilla War', 191.

20. Daniela Palazzoli quoted in Germano Celant, *Precronistoria, 1966–69* (Florence, 1976), 44.

21. Germano Celant (ed.), *Arte Povera: Conceptual, Actual or Impossible Art?* (London, 1969), 225–30.

22. Mario Merz quoted by Germano Celant in 'Mario Merz: The Artist as Nomad', *Artforum* (December 1979).

23. Quoted in RoseLee Goldberg, *Performance Art from Futurism to the Present* (London, [1979] 1988), 143.

24. Carter Ratcliff, 'Adversary Spaces', *Artforum* (October 1972).

Chapter 6. Natural Materials

1. Steinberg, *Other Criteria*, 82ff.

2. Robert Smithson, 'A Sedimentation of the Mind: Earth Projects', *Artforum* (September 1968), repr. in Nancy Holt (ed.), *The Writings of Robert Smithson* (New York, 1979), 89.

3. Samuel Wagstaff jr, 'Talking to Tony Smith', *Artforum* (December 1966), repr. in Battcock, *Minimalist Art: A Critical Anthology*, 385–6.

4. See Willoughby Sharp, 'Carl Andre', *Avalanche*, 1 (fall 1970).

5. Achille Bonito Oliva, 'Interview with Carl Andre', *Domus* (October 1972).

6. Robert Smithson, 'Entropy and the New Monuments,' *Artforum* (June 1966), repr. in *The Writings of Robert Smithson*, ed. Holt, 9.

7. Smithson, 'A Sedimentation of the Mind: Earth Projects'.

8. 'Frederick Law Olmsted and the Dialectical Landscape', *Artforum* (February 1973), repr. in *The Writings of Robert Smithson*, ed. Holt, 117.

9. Smithson, 'A Sedimentation of the Mind'.

10. Ibid.

11. David Nash, *Aspects* (spring 1980), quoted in Lynne Cooke, 'Between Image and Object: the "New British Sculpture" ', in *A Quiet Revolution: British Sculpture since 1965* (Chicago and London, 1987), 40.

Chapter 7. Public Spaces

1. 'Incidents of Mirror-Travel in the Yucatan', *Artforum* (September 1968), in *The Writings of Robert Smithson*, ed. Holt, 96.

2. Gordon Matta Clark quoted by Donald Wall in 'Gordon Matta Clark's Building

Dissections', *Arts* (March 1976).

3. Quoted by Judith Kirshner from her interview with the artist in 1978, in 'Non-Uments', in *Gordon Matta Clark* (IVAM, Valencia, 1993), 366.

4. See Dan Graham, 'The City as Museum', in *Rock My Religion: Writings and Art Projects, 1965–1990*, 244ff; first published in *Artforum* (December 1981).

5. Max Kozloff, 'American Painting during the Cold War', *Artforum* (May 1973); William Hauptman, 'The Suppression of Art in the McCarthy Decade', *Artforum* (October 1973); Eva Cockcroft, 'Abstract Expressionism, Weapon of the Cold War', *Artforum* (June 1974).

6. Editorial, *Artforum* (December 1975).

7. Hilton Kramer, 'Muddled Marxism Replaces Criticism at *Artforum*', *New York Times* (21 December 1975), quoted in Hans Haacke, interview by Margaret Sheffield, *Studio International* (March–April 1976).

8. Hans Haacke, interview by Margaret Sheffield.

9. Daniel Buren, *Artforum* (September 1973).

10. Benjamin H. D. Buchloh, 'Hans Haacke: Memory and Instrumental Reason', *Art in America* (February 1988).

11. See James E. Young, 'The Counter-Monument: Memory against Itself in Germany Today', in W. J. T. Mitchell, *Art and the Public Sphere* (Chicago, 1990), 49–78.

12. Ibid. 50.

13. Werner Fenz, 'The Monument is Invisible, the Sign Visible', *October* (spring 1989).

Chapter 8. Objects and Figures

1. Smith's *Die* (1962) was the Minimalist steel cube around which Robert Morris constructed his argument in 'Notes on Sculpture: Part 2', that 'the size range of useless three-dimensional things is a continuum between the monument and the ornament'. See above p. 124. *Die* is reproduced in Morris, *Continuous Project Altered Daily*, 21.

2. See above p. 113.

3. 'Rachel Whiteread in Conversation with Iwona Blazwick', in the catalogue of Whiteread's exhibition at the Van Abbemuseum, Eindhoven, 1992, 13.

4. Ibid., 14.

5. Rachel Whiteread, *House*, James Lingwood (ed.) (London, 1995).

6. Ibid.

7. Clara Weyergraf Serra and Martha Buskir (eds), *The Destruction of Tilted Arc*, intro. Richard Serra (Cambridge, Mass., 1991).

8. Martin Hentschel, 'Schütte's Worlds', in *Thomas Schütte: Sieben Felder* (Kunsthalle, Bern, 1989), 35.

9. Gudrun Inbogen, 'Ecstasy and Banality', in *Jeff Koons* (Stedelijk Museum, Amsterdam, and elsewhere, 1992), 39ff.

10. Artists Space, New York, 1977. See also Douglas Crimp, 'Pictures', *October* (spring 1979), repr. in Brian Wallis (ed.), *Art after Modernism: Rethinking Representation* (Cambridge, Mass., 1984), 175ff.

11. In Peter Nagy, moderator, 'From Criticism to Complicity', *Flash Art* (summer 1986).

12. Ibid.

13. Ibid.

14. Allan McCollum quoted by Gray Watson in 'Allan McCollum interviewed by Gray Watson', *Artscribe* (December 1985–January 1986).

15. Craig Owens, 'Allan McCollum. Repetition and Difference', *Art in America*, September 1983, repr. in *Beyond Recognition: Representation, Power and Culture* (Berkeley, 1992), 119.

16. David Hammons interviewed by Maurice Berger, *Art in America* (September 1990), quoted by Tom Finkelpearl, 'The Ideology of Dirt', in *David Hammons: Rousing the Rubble* (Cambridge, Mass., 1991), 79.

17. Iwona Blazwick, James Lingwood, and Andrea Schlieker, 'Interview with Juan Muñoz', in *Possible Worlds. Sculpture from Europe* (London, ICA and Serpentine Gallery, 1990), 61.

18. In *Antony Gormley: Five Works* (London, Serpentine Gallery, 1987), repr. in John Hutchinson and others, *Antony Gormley* (London, 1995), 118.

19. Ibid.

20. *Possible Worlds: Sculpture from Europe*, 27.

21. Ibid., 59.

22. Matthew Weinstein, 'The House of Fiction', *Artforum* (February 1990).

23. Robert Gober, 'Cumulus from America', *Parkett* 19 (1989), 169.

24. Quoted in the exhibition catalogue, *Repulsion and Desire in American Art* (New York, Whitney Museum of American Art, 1993), 7.

List of Illustrations

The publisher would like to thank the following individuals and institutions who have kindly given permission to reproduce the illustrations listed below.

1. Aristide Maillol: *The River*, 1938–43. Bronze. 124 × 230 × 163 cm. Collection Musée Maillol, Paris. Courtesy Fondation Dina Vierny-Musée Maillol © ADAGP, Paris and DACS, London, 1998.

2. Mari Andriessen: *Concentration Camp Victims*, 1946–9. Bronze. H. 164 cm. Courtesy of the Mari Andriessen Stichting, Amsterdam/photo Louk Tilanus, Leiden.

3. Ossip Zadkine: *The Destroyed City. Monument to the Destruction of Rotterdam*, 1947–53. Bronze. H. 614 cm. Photo Conway Library, Courtauld Institute of Art, University of London. © ADAGP, Paris and DACS, London 1998.

4. Yevgeny Vuchetich, sculptor, and Yakov Bepolsky, architect: *Memorial to the Fallen Soviet Heroes*, 1947–9, Treptow Park, Berlin. Detail, showing climax of the ensemble. Photo Axel Lapp, Manchester.

5. Powell and Moya, architects, with Felix Samuely and Frank Newby, consulting engineers: The Skylon, Festival of Britain, 1951. Steel frame and louvered aluminium panels. H. 88.4 m. Hulton Getty Picture Collection, London.

6. Constantin Brancusi: *Table of Silence*, Tirgu-Jiu, Romania, completed 1938. Stone. Table, 800 × 214.6 cm; stools, each, 54.6 × 45 cm. Photothèque des Collections du Musée National d'Art Moderne, Paris. © ADAGP, Paris and DACS, London 1998.

7. Henry Moore: *Draped Reclining Figure*, 1952–3. Bronze. L. 157 cm. Henry Moore Foundation, Much Hadham.

8. Marino Marini: *Rider*, 1949. Bronze. H. 188 cm. Museo Marini, Florence/Fondazione Marino Marini, Pistoia © 1998 DACS.

9. Pablo Picasso: *Man with a Sheep*, 1943. Bronze. H. 222.5 cm. Musée Picasso, Paris/photo Réunion des Musées Nationaux. © Succession Picasso/DACS 1998.

10. Alberto Giacometti: *Four Figurines on a Base*, 1950–65. Bronze. H. 156.2 cm. Tate Gallery, London. © ADAGP, Paris and DACS, London 1998.

11. Jean Fautrier: *Large Tragic Head*, 1942. Bronze. H. 38.5 cm. Tate Gallery, London. © ADAGP, Paris and DACS, London 1998.

12. Germaine Richier: *Storm Man*, 1947–8. Bronze. 189 × 72 × 58 cm. Louisiana Museum of Modern Art, Humlebaek. © ADAGP, Paris and DACS, London 1998.

13. Jean Dubuffet: *Madame j'ordonne*, 1954. Cinder. H. 52 cm. Fondation Jean Dubuffet, Paris/ © DACS, London 1998.

14. Zoltan Kemény: *Les bourgeois de toutes les villes*, 1950. Iron and rags on a base of wood and earth. 38 × 39.5 × 26 cm. Musée National d' Art Moderne, Centre Georges Pompidou, Paris. © DACS 1998.

15. Lázló Moholy-Nagy: *Double Loop*, 1946. Plexiglass. 41 × 56.5 × 44.5 cm. Museum of Modern Art, New York. Purchase. Photo © Museum of Modern Art, New York. © DACS 1998.

16. Naum Gabo: *Linear Construction in Space, No. 1*, 1942–3. Perspex with nylon monofilament. 55.7 × 45.1 × 8.1 cm. Solomon R. Guggenheim Museum, New York/photo Robert E. Mates © The Solomon R. Guggenheim Foundation, New York (FN 47.1101). The works of Naum Gabo © Nina Williams.

17. Barbara Hepworth: *Pelagos*, 1946. Wood, partly painted, and strings. 36.8 × 38.7 × 33 cm. Tate Gallery, London. © Alan Bowness, Hepworth Estate.

18. Alexander Calder: *Red Polygons*, c.1949–50. Metal and wire. 86.3 × 154.9 cm. The Phillips Collection, Washington DC. © ADAGP, Paris and DACS, London 1998.

19. Antoine Pevsner: *Peace Column*, 1954. Bronze. 127.2 × 85.2 × 47.4 cm. Musée d' Art Moderne CCI, Centre Georges Pompidou,

Paris. © ADAGP, Paris and DACS, London 1998.

20. Max Bill, design for *The Monument to the Unknown Political Prisoner*, 1952–3. Montage. Planned for dark and light marbles, with each opening 400 × 400 cm on the outside and 189 × 189 cm on the inside. Courtesy the Max Bill Foundation, Adligenswil. © DACS 1998.

21. Constant: *New Babylonian Construction*, 1959. Metal, wood, and perspex. 51.5 × 65 × 47 cm. Rijksmuseum Kröller-Müller, Otterlo, The Netherlands. © DACS 1998.

22. Luciano Baldessari: Architectural Construction for the Entrance to the Breda works at the Milan Industrial Fair, 1952. Concrete. Courtesy the Archivio Mosca Baldessari, Milan.

23. Fausto Melotti: *Tightrope Walkers*, 1968. Brass. 160 × 48 × 25 cm. Courtesy of Signora Beatrice Tartarone Melotti/Archivio Melotti, Milan.

24. Joan Miró: *Man and Woman*, 1962. Ceramic. H. 250.2 cm. Acquavella Contemporary Art, Inc., New York. © ADAGP, Paris and DACS, London 1998.

25. Lucio Fontana: *Ceramica Spaziale*, 1949. Ceramic. 60 × 60 × 60 cm. Courtesy the Fondazione Lucio Fontana, Milan.

26. Lucio Fontana: Neon Structure to hang above the main staircase of the IX Milan Triennale, 1951. 100 m of neon-lit 18 mm tube. Courtesy the Fondazione Lucio Fontana, Milan.

27. Vassilakis Takis: *Insect*, 1956. Steel plate and rods, wire and iron. H. 119.8 cm. The Menil Collection, Houston/photo F. W. Seiders, Houston. Courtesy the artist.

28. David Medalla: *Cloud Canyon No. 2*, 1954. Boxes with water and chemical additive and electric motor. H. 173.2 cm. Courtesy of the artist and Guy Brett/photo Clay Perry, London.

29. Otto Piene: *Fire Flower Power*, 1967, at the Museum am Ostwall, Dortmund. Light projection with moving filters. Courtesy of the artist and Kunstmuseum, Düsseldorf/photo Hein Engelskirchen.

30. David Smith: *Home of the Welder*, 1945. Steel. 53 × 44 × 34.5 cm. Photo Conway Library, Courtauld Institute of Art, University of London. © DACS, London/VAGA, New York, 1998.

31. David Smith: *Blackburn. Song of an Irish Blacksmith*, 1949–50. Iron and bronze. 111 × 97.8 × 57.6 cm. Wilhelm Lehmbruck Museum, Duisburg. © DACS, London/ VAGA, New York 1998.

32. Seymour Lipton: *Imprisoned Figure*, 1948. Wood and sheet lead. 215.2 × 78.3 × 59.9 cm.

Museum of Modern Art, New York. Gift of the artist. Photo © 1997 Museum of Modern Art, New York. Courtesy the Estate of Seymour Lipton (Maxwell Davidson Gallery, New York).

33. Frederick Kiesler: *Galaxy*, 1947–8. Wood and rope. 363.2 × 421.6 × 434.3 cm. Museum of Modern Art, New York. Nelson Rockefeller. Photo © 1997 Museum of Modern Art, New York. Courtesy Lillian Kiesler..

34. Louise Bourgeois: *The Blind Leading the Blind*, c.1947–9. Painted wood. 170 × 164.2 × 41.5 cm. Becon Collection Ltd/photo Peter Moore. Courtesy Robert Miller Gallery, New York. © Louise Bourgeois, DACS, London/ VAGA, New York 1998.

35. Eduardo Paolozzi: *Cage*, 1950–1. Bronze. 148 × 75 × 75 cm. Arts Council Collection, South Bank Centre, London © Eduardo Paolozzi 1998. All rights reserved DACS.

36. William Turnbull: *Permutation Sculpture*, 1956. Bronze. Longest element 124.5 cm. Ossorio Collection, New York/ photo courtesy the artist and Waddington Galleries, London. © William Turnbull 1998. All rights reserved DACS.

37. Lynn Chadwick: *Fisheater*, 1950–1. Iron and copper. 228 × 460.8 cm. Courtesy the artist, Lypiatt Studio Ltd.

38. Reg Butler: Final maquette for *The Monument to the Unknown Political Prisoner*, 1952. Bronze sheet and wire on stone. H. 45.7 cm. Photo courtesy of Rosemary Butler.

39. Andy Warhol: *White Brillo Boxes*, 1964. Serigraph on cardboard. Each box, 43 × 43 × 35 cm. Courtesy The Sonnabend Collection, New York/The Warhol Foundation, Pittsburgh, PA. © ARS, New York and DACS, London 1998.

40. Richard Artschwager: *Table with Pink Tablecloth*, 1964. Formica on wood. 65 × 112 × 112 cm. Art Institute of Chicago. Gift of the Lannan Foundation (1997.133)/photo Susan Einstein. © ARS, New York and DACS, London 1998.

41. Yves Klein: *Arman*, 1962. Pigment in synthetic resin on bronze. 176 × 94 × 26 cm. Musée National d' Art Moderne, Centre Georges Pompidou, Paris. Courtesy Yves Klein Archives. © ADAGP, Paris and DACS, London 1998.

42. Piero Manzoni: *Magic Base*, 1961. Wood. 80 × 80 × 60 cm. Courtesy the Archivio Opera Piero Manzoni, Milan. © DACS 1998.

43. Arman: *Les Egoistes (Accumulations)*, 1964. Painted and welded metal. 19.7 × 31.8 × 28 cm. Hirshhorn Museum and Sculpture Garden, Smithsonian Institution, Washington. Gift of Joseph Hirshhorn 1996/photo Lee Stalsworth.

© ARS, New York and DACS, London 1998.

44. Christo and Jeanne Claude: *Wall of Oil Barrels—Iron Curtain, rue Visconti, Paris, 27 June 1962*. 240 oil barrels. 430 × 380 × 170 cm. Courtesy the artists. Copyright Christo 1962/photo Jean Dominique Lajoux.

45. Jasper Johns: *Flashlight 1*, 1958. Sculpmetal over flashlight and wood. 12.9 × 22.8 × 9.52 cm. Courtesy the Leo Castelli Gallery, New York. © DACS, London/VAGA, New York 1998.

46. Jasper Johns: *Flashlight 3*, 1958. Plaster and glass. 13.3 × 20.9 × 9.52 cm. Courtesy the Leo Castelli Gallery, New York. © DACS, London/VAGA, New York 1998.

47. Robert Rauschenberg: *Oracle*, 1965. Five elements of galvanized metal. Overall size subject to arrangement: Bath/shower element, 178 × 115 × 60 cm. Musée d'Art Moderne, Centre Georges Pompidou, Paris. © DACS, London/VAGA, New York 1998.

48. Jean Tinguely: *Homage to New York*, self-destructing installation, Museum of Modern Art, 1960. Photo David Gahr, Brooklyn, NY. © ADAGP, Paris and DACS, London 1998.

49. Claes Oldenburg: *The Street*, installation at the Reuben Gallery, New York, 1961. Courtesy of the artist (PaceWildenstein, New York)/photo Charles Rappaport.

50. George Segal: *The Diner*, 1964–6. Plaster, wood, chrome, formica, masonite and fluorescent lamps. 238.1 × 366.4 × 243.8 cm. Walker Art Center, Minneapolis, Gift of the T. B. Walker Foundation, 1966. © DACS, London/VAGA, New York 1998.

51. Claes Oldenburg: *Bedroom Ensemble*, 1963. Wood, vinyl, artificial fur, cloth and paper. 300 × 650 × 525 cm. National Gallery of Canada, Ottawa. Courtesy of the artist (PaceWildenstein, New York).

52. Edward Kienholz: *Portable War Memorial*, 1968. Mixed media. 189.2 × 464.8 × 330.2 cm. Museum Ludwig, Cologne/photo Rheinisches Bildarchiv. Courtesy the Estate of Edward Kienholz.

53. Mark di Suvero: *Ladder Piece*, 1961–2. Wood and steel. 189.2 × 464.8 × 330.2 cm. Museum of Modern Art, New York. Gift of Philip Johnson/photo © 1997 Museum of Modern Art, New York.

54. Anthony Caro: *Early One Morning*, 1962. Steel and aluminium. 289.6 × 619.8 × 335.3 cm. Tate Gallery, London. Courtesy of the artist.

55. David Annesley: *Swing Low*, 1964. Painted steel. 128.3 × 175.9 × 36.8 cm. Tate Gallery, London. Courtesy of the artist.

56. William Tucker: *Series A (Number 1)*, 1968–9. Fibreglass. 55.2 × 231.1 × 186.1 cm. Tate

Gallery, London. Courtesy of the artist (McKee Gallery, New York).

57. Phillip King: *Rosebud*, 1962. Fibreglass on wood. 148.5 × 167 × 158.7 cm. Museum of Modern Art, New York. Susan Morse Hilles Fund/photo © 1997 Museum of Modern Art, New York. Courtesy the artist.

58. David Smith: *Cubi XXVII*, 1965. Stainless steel. 282.9 × 222.9 × 86.4 cm. Solomon R. Guggenheim Museum, New York/photo Robert E. Mates © The Solomon R. Guggenheim Foundation, New York. © DACS, London/VAGA, New York 1998.

59. Donald Judd: *Untitled*, 1969. Anodized aluminium and blue plexiglass. Five units, each 120.6 × 151.7 × 151.7 cm. The Saint Louis Art Museum. © Donald Judd/VAGA, New York/DACS, London 1998.

60. Dan Flavin: *'Monument' for V. Tatlin*, 1966. White fluorescent light tubes. 305.4 × 58.4 × 8.9 cm. Tate Gallery, London. © ARS, New York and DACS, London 1998.

61. Sol LeWitt: *1 2 3*, 1978. Baked enamel on aluminium. 457.2 × 914.4 × 457.2 cm. Photo courtesy the artist. © ARS, New York and DACS, London 1998.

62. James Turrell: *Afrum Proto*, 1966. Quartz halogen light projection as installed at Whitney Museum of American Art, New York. Collection of Michael Jeanne Klein. Photo John Cliett, courtesy the artist.

63. Marcel Duchamp: *Bottlerack*, reconstruction, 1964. Original, 1914. Galvanized iron. 55.8 × 34.8 cm. Moderna Museet Stockholm/photo Statens Konstmuseer. © ADAGP, Paris and DACS, London 1998.

64. Robert Morris: *Two Columns*, 1961. Painted aluminium. 243.8 × 61 × 61 cm. Courtesy Leo Castelli Gallery, New York/photo Bruce C. Jones. © ARS, New York and DACS, London 1998.

65. Carl Andre: *Equivalent VIII*, 1966. Firebricks. 12.7 × 68.6 × 229.2 cm. Tate Gallery, London. © DACS, London/VAGA New York 1998.

66. Robert Morris: *I-Box*, 1962. Painted plywood with sculpmetal, and photograph of the artist inside. 45.6 × 30.6 × 3.4 cm. © Robert Morris Archive, Solomon R. Guggenheim Museum, New York/photo courtesy Leo Castelli Gallery. © ARS, New York and DACS, London 1998.

67. Robert Morris: *Continuous Project Altered Daily*, Castelli Warehouse, New York, 1969. Mixed materials. © Robert Morris Archive, Solomon R. Guggenheim Museum, New York/photo courtesy Leo Castelli Gallery. © ARS, New York and DACS, London 1998.

68. Richard Serra: *Splashing*, Castelli

Warehouse, New York, 1968. Lead. 45.7 × 792.7 cm. Photo courtesy Leo Castelli Gallery, New York. © ARS, New York and DACS, London 1998.

69. Eva Hesse: *Untitled*, 1970. Fibreglass over wire mesh, latex over cloth and wire. 230.5 × 374.7 × 107.9 cm. Des Moines Art Center, Iowa. Purchased with funds from the Coffin Fine Arts Trust. Nathan Emory Coffin Collection (1988.6)/photo Ray Andrews. Estate of Eva Hesse (Robert Miller Gallery, New York).

70. Joseph Beuys: *Fat Chair*, 1963. Wooden chair and fat. H. 90 cm. Hessisches Landesmuseum, Darmstadt. © DACS London 1998.

71. Joseph Beuys: *Tramstop*, as installed at the Venice Biennale, 1976. Iron. Measurements vary with arrangement. Barrel with head is 376 × 45 × 29 cm. Photo Caroline Tisdall, London. © DACS London 1998.

72. Michelangelo Pistoletto: *Golden Venus of Rags*, 1967–71. Concrete with mica and rags. 180 × 230 × 100 cm. Courtesy the artist and Lia Rumma Gallery, Naples.

73. Luciano Fabro, *Feet*, 1968–72. Installation at Venice Biennale, 1972. Marble and silk. H. 130 cm approx. Courtesy the artist/photo Ugo Mulas.

74. Giovanni Anselmo: *Untitled (Structure that Eats Salad)*, 1968. Granite and copper thread, lettuce and sawdust. 65 × 30 × 30 cm. Courtesy the artist and the Sonnabend Collection, New York.

75. Mario Merz: *Ingot*, 1968. Brushwood, steel and beeswax. 262 × 313 × 114 cm. Courtesy the artist and Anthony d'Offay Gallery, London.

76. Jannis Kounellis: *Untitled*, 1967. Mixed materials. Measurements vary with arrangement. Each planted metal bin 40 × 200 × 100 cm. Halle für Neue Kunst, Schaffhausen/photo John Riddy, courtesy the Arts Council of England and the artist (Marian Goodman Gallery, New York).

77. Barry Flanagan, *Four Casb 2' 67, Ring 1 1' 67, Rope (gr 2sp 60) 6' 67*, 1967. Sand, sacking, rope, linoleum. Max. H. 183 cm. Tate Gallery, London. Courtesy the artist.

78. Panamarenko: *Crocodiles*, 1967. Sand, plastic foil, cardboard, plastic, tiles, cellophane. 25 × 230 × 110 cm. Museum van Hedendaagse Kunst, Ghent/photo Dirk Pauwels. Courtesy the artist.

79. Bruce Nauman: *Neon Templates of the Left Half of My Body Taken at Ten-Inch Intervals*, 1966. Neon tubing on clear glass tubing suspension frame. 177.8 × 22.9 × 15.2 cm. Philip Johnson Collection/photo courtesy Leo Castelli Gallery, New York. © ARS, New York and DACS, London 1998.

80. Bruce Nauman: *Green Light Corridor*, 1970. Wallboard and green fluorescent light fixtures. 304 × 1219 × 30.5 cm. Solomon R. Guggenheim Museum, New York. Panza Collection, Gift, 1992/photo Prudence Chung Associates Ltd. © The Solomon R. Guggenheim Foundation, New York. © ARS, New York and DACS, London 1998.

81. Gilbert & George: *The Singing Sculpture*, 1970. Courtesy the artists and Anthony d'Offay Gallery, London.

82. Vito Acconci: *Seedbed*. Performance/Installation at the Sonnabend Gallery, New York 15–29 January 1972, nine days, eight hours a day, over three-week period. Loudspeaker system, wood ramp. 76.2 × 670.6 × 914.4 cm. Photos courtesy the artist and Barbara Gladstone Gallery, New York.

83. Rebecca Horn: *Measure Box*, 1970. Iron and aluminium. 194.5 × 90 cm. Staatsgalerie, Stuttgart. © DACS 1998.

84. John Latham: *Art & Culture*, 1966–9. Leather case, with book, letters, photostats etc., labelled bottles with powders and liquids. 7.9 × 28.2 × 25.3 cm. Museum of Modern Art, New York. Blanchette Rockefeller Fund/photo © 1997 Museum of Modern Art, New York. Courtesy the artist (Lisson Gallery, London).

85. Walter de Maria: *New York Earth Room*, 1977. Surface 335 m²; depth, 56 cm; 127,300 kg of earth, peat, and bark. Courtesy the artist copyright © 1977, Dia Center for the Arts, New York/photo John Cliett.

86. Walter de Maria, *Olympic Mountain Project*, 1970. Depth, 120 m (60 m above, and 60 m below ground). Courtesy the artist, copyright © 1970 Walter de Maria/photo E. Glesman.

87. Michael Heizer: *Displaced/Replaced Mass*, 1969. Three granite rocks. Weight, 30.5, 73.2, and 43.7 tonnes. Photos courtesy the artist.

88. Michael Heizer: *Double Negative*, 1969. Mormon Mesa, Overton, Nevada. 243.9 tonnes displacement in ryholite and sandstone. 457.2 × 15.2 × 9.1 m. Museum of Contemporary Art, Los Angeles/photo courtesy the artist.

89. Robert Smithson: *Spiral Jetty*, 1969–70. Great Salt Lake, Utah. Mud, salt crystals, rocks. L. of spiral 457.2 m; W. of spiral 4.6 m. Estate of Robert Smithson/John Weber Gallery, New York/photo Gianfranco Gorgoni (Sygma).

90. Robert Smithson: *Six Stops on a Section*, 1968. Six painted steel bins with gravel, sandstone, sand, stones, slate, plus maps. Each

bin, 20.3 × 60.9 × 20.3 cm. Museum Moderner
Kunst Stiftung Ludwig, Vienna. Estate of
Robert Smithson/photo John Weber Gallery,
New York.

 ng: *Stone Line*, 1980. 183 × 1067
tional Gallery of Modern Art,
rtesy the artist (Anthony d'
ondon).

.. Ulrich Rückriem: *Double Piece*, 1982.
Stone. 146 × 55 × 55 and 21.5 × 242 × 110 cm. Tate
Gallery, London. Courtesy the artist
(Heinrich Ehrhardt, Frankfurt-am-Main).
93. David Nash: *Flying Frame*, 1980. Wood.
216 × 343 × 120 cm. Tate Gallery, London ©
David Nash, 1998. All rights reserved DACS.
94. Andy Goldsworthy, *Leaf Works*,
photographed in 1989. Various sizes. Courtesy
the artist.
95. Ian Hamilton Finlay (with John Andrew):
Nuclear Sail, 1974. Slate. H. 105 cm. Courtesy
the artist/photo David Paterson.
96. Alice Aycock: *Studies for a Town*, 1977.
Wood. 304 × 350 × 369 cm. Museum of
Modern Art, New York. Gift of the Louis and
Bessie Adler Foundation, Inc., Seymour M.
Klein, President/photo © 1997 Museum of
Modern Art, New York. Courtesy the artist
(John Weber Gallery, New York).
97. Mary Miss: *Perimeter/Pavilions/Decoys*,
1977–8, Nassau County Museum, Roslyn
Harbor, Long Island, NY. Wood. Tallest
tower, H. 548.6 cm; pit opening, 487.7 × 487.7
cm. Photos courtesy the artist.
98. Per Kirkeby: *Untitled*, 1982. Brick. 624 ×
586 × 326 cm. Courtesy the artist and Galerie
Michael Werner, Cologne.
99. Siah Armajani: *Reading Garden No. 3*,
State University of New York at Purchase,
1980–1. Wood and corrugated plastic. 853 ×
304.8 × 2286 cm. Courtesy the artist.
100. Dan Graham: *Two Adjacent Pavilions*,
1978–81. Glass, steel, and two-way mirrors.
Each 251 × 186 × 186 cm. Kröller-Müller
Museum, Otterlo, The Netherlands. Courtesy
the artist (Marian Goodman Gallery, New
York).
101. Gordon Matta Clark, *Office Baroque*, 1977.
Wood fragment and cibachrome photograph.
40 × 150 × 230 and 76.2 × 50.8 cm. The Gordon
Matta Clark Trust, Weston, CT.
102. Joel Shapiro: exhibition installation at
Paula Cooper Gallery, New York, 1975.
Smallest object 3.6 cm. Courtesy the artist/
photo Geoffrey Clements.
103. Daniel Buren: *Up and Down, In and Out,
Step by Step. A Sculpture*. Art Institute of
Chicago, 1977. Coloured paper. Photo Rusty
Culp, Shaker Heights, OH. © ADAGP, Paris
and DACS, London 1998.

104. Michael Asher: Installation at 73rd
American Art Exhibition, 1979. Art Institute
of Chicago/photo J. Kobylecky, © 1997 Art
Institute of Chicago. All Rights Reserved.
Courtesy the artist.
105. Marcel Broodthaers: *Décor: A Conquest by
Marcel Broodthaers*, 1975. Various materials.
Photos courtesy Maria Gilissen, Brussels. ©
Estate of Marcel Broodthaers.
106. Lothar Baumgarten: *Terra Incognita*,
1969–84. Installation: wood, porcelain, light
bulbs, electric cable and machete. Tate
Gallery, London. © DACS 1998.
107. Hans Haacke: *Condensation Cube*, 1963–5.
Acrylic, water, 30.5 × 30.5 × 30.5 cm. Photo
courtesy the artist and John Weber Gallery,
New York. © DACS 1998.
108. Hans Haacke, *Isolation Box, Grenada*,
1984. Wood with stencilled lettering, hinges,
and padlock. 244 × 244 × 244 cm. Photo
courtesy the artist and John Weber Gallery,
New York. © DACS 1998.
109. Richard Serra, *Tilted Arc*, Federal Plaza,
New York, 1981. Cor-ten steel, 365.8 × 3657.6
cm. Photo courtesy Leo Castelli Gallery, New
York.
110. Jochen and Esther Gerz: *Harburg
Monument against Fascism*, 1986. Graphite
over aluminium, size variable. Kulturbehörde,
Freie und Hansestadt Hamburg/photo
Wolfgang Neeb. © DACS 1998.
111. Hans Haacke: *Und Ihr habt doch gesiegt
(And you were victorious after all)*, Graz, 1988.
Photo Landesmuseum Joanneum, Graz.
Courtesy the artist and John Weber Gallery,
New York. © DACS 1998.
112. Chris Burden: *The Other Vietnam
Memorial*, 1991. Steel and etched copper. 394 ×
286 cm. Museum of Modern Art, New
York/photo © 1997 Museum of Modern Art,
New York. Courtesy the artist.
113. Christian Boltanski: *Reserve Canada*, 1988.
Clothes and lights. 170 × 211 cm. Courtesy
Marian Goodman Gallery, New York.
114. Ilya Kabakov: *The Red Wagon*, 1989.
Various materials. Courtesy the artist (Barbara
Gladstone Gallery, New York) © ADAGP,
Paris and DACS, London 1998 /photo Nic
Tenwigenhorn, Düsseldorf © DACS 1998.
115. Magdalena Jetelova: *Untitled*, 1991. Oak,
750 × 390 × 500 and 110 × 520 × 500 cm.
Courtesy the artist and the Henry Moore
Sculpture Trust/photo Werner J. Hannappel,
Essen.
116. Tony Cragg: *New Stones, Newton's Tones*,
1978. 366 × 244 cm. Arts Council Collection,
South Bank Centre. Courtesy the artist
(Lisson Gallery, London).
117. Bill Woodrow, *Blue Monkey*, 1984. Couch,

scooter, car bonnet and metal box. 405 × 100 × 300 cm. Courtesy Cordiant plc, London and the artist (Lisson Gallery, London).

118. Anish Kapoor: *As if to Celebrate, I Discovered a Mountain Blooming with Red Flowers*, 1981. Wood, cement and pigment, 101 × 241.5 × 217.4 cm. Arts Council Collection South Bank Centre, London. Courtesy the artist and Lisson Gallery, London.

119. Richard Deacon: *The Eye Has It*, 1984. Stainless and galvanized steel, brass, cloth and wood, 80 × 344 × 170 cm. Arts Council Collection, South Bank Centre, London. Courtesy the artist and Lisson Gallery, London.

120. Julian Opie: *Imagine You Are Driving, Sculpture 2*, 1993. Concrete, 25 × 420 × 430 cm. Photo John Riddy, London, courtesy the artist and Lisson Gallery, London.

121. Rachel Whiteread: *Ghost*, 1990. Plaster on steel framework, 269 × 317 × 355.5 cm. The Saatchi Collection, London. Courtesy the artist (Anthony d' Offay Gallery, London).

122. Thomas Schütte, *Eis*, Documenta, Kassel, 1987. Courtesy the artist. © DACS 1998.

123. Reinhard Mucha, *Das Figur-Grund Problem in der Architektur des Barock (Für Dich allein bleibt nur das Grab). (The Figure-Ground Problem in the Architecture of the Baroque (For you alone will be only the grave))*, 1985. Various materials. Courtesy the artist and Galerie Max Hetzler, Cologne.

124. Katharina Fritsch: *Madonna of Lourdes* at Münster Sculpture Project, 1987. Resin and paint. 169.5 × 34.3 × 40 cm. Courtesy the artist and Matthew Marks Gallery, New York. © DACS 1998.

125. Jeff Koons: *Two Ball 50/50 Tank*, 1985. Glass, iron, water and two basket balls. 159.4 × 93.3 × 33.7 cm. Courtesy the artist and Sonnabend Collection, New York.

126. Haim Steinbach: *basics # 1/3*, 1986. Plastic laminated wood shelf; stuffed leather bear; stuffed polyester bears. 76 × 135 × 32 cm. Courtesy the artist/photo David Lubarsky.

127. Ashley Bickerton: *Biofragment No. 2*, 1990. Various materials. 294 × 213.6 × 113.8 cm. Tate Gallery, London. Courtesy the artist and ꞏ ꞏꞏꞏꞏbend Gallery, New York.

ꞏꞏꞏ ꞏꞏꞏ ꞏꞏum: *Fifty Perfect Vehicles*, ꞏid-cast hydrocal. ꞏan Abbemuseum, ꞏꞏrtist (Lisson Gallery, Lꞏ

129. David Ham ꞏ ꞏ *Sculpture*, 1986. Eꞏ ꞏꞏ ꞏꞏꞏeaves, wheels. Each piece, ꞏꞏ ꞏ Courtesy the artist anꞏ ꞏꞏꞏꞏery, New York/photo Dawouꞏ

130. Antony Gormley: *Home*, ꞏ ꞏ ꞏꞏ, terracotta, plaster, fibreglass. 65 × 22ꞏ ꞏꞏ ꞏꞏꞏm. Courtesy the artist and White Cube, Lꞏ ꞏꞏ ꞏ/ photo Jay Jopling.

131. Stephan Balkenhol: *Man with Black Trousers*, 1987. Painted beech wood. 229.5 × 92 × 88.2 cm. Hirshhorn Museum and Sculpture Garden, Smithsonian Institution, Washington DC. Museum purchase from De Weer Art Gallery 2 October 1989/photo Riccardo Blanc. Courtesy the artist (Barbara Gladstone Gallery, New York).

132. Juan Muñoz: *Wasteland*, 1986. Installation at the Galleria Marga Paz, Madrid. Mixed media (ceramic tile floor). 35 × 35 m. Collection of Contemporary Art Fundació 'la Caixa', Barcelona. © DACS 1998.

133. Robert Gober: *Untitled*. Installation at Galerie Nationale du Jeu de Paume, Paris, 1991. Wood, wax, leather, human hair, against a silkscreened background. 38.7 × 42 × 114.3 cm. Courtesy the artist.

134. Kiki Smith: *Man*, 1988. Ink on gampi paper. 122 × 96.5 × 17.8 cm. Courtesy the artist and PaceWildenstein, New York.

The publisher and author apologize for any errors or omissions in the above list. If contacted they will be pleased to rectify these at the earliest opportunity.

Bibliographic Essay

Publications on sculpture since 1945 are different from those in earlier periods. The majority of the artists considered are still alive, and the historical perspective on the work of even the earlier sculptors is short. Museum and library archives contain papers of living artists, but much of the material listed here comes from exhibition catalogues and exhibition reviews. Exhibition catalogues, which have become a leading form of art-book publishing during the period, are now the single most important source of published information about many living artists. These catalogues have generally been prepared with the co-operation of artists, and their dealers and friendly critics play a large part in them. Publications are a part of living artists' career structures and should not be regarded by their readers as neutral sources. The public interest in contemporary art has stimulated demand for artists to give interviews and offer explanations. Up to 1960 Modernism's sense of the self-sufficiency of a work of art led artists to resist statements, and published interviews were not common. The artist's role was within the studio; making art was a unique practice for which there was no equivalent in words, and an artist writing for publication was felt to risk loss of creative power. With Minimalism and Conceptual Art the emphasis began to shift from the self-sufficient sculpture to its external context, and artists began to see their work in terms of discourse. Their own role might no longer simply be as creative artists within the closed environment of the studio, but as active participants in the re-situating of art among the other practices and institutions of modern life. With the ending in the 1960s of the sense that an artist is compromised by being anything other than an art-maker in the narrowest sense, there was no reason why artists should not rationalize their own practices through the written word. But it is difficult to make a clear dividing line between the artist as critic (which implies two different,

if related, practices, making and writing), and art writing, which is an extension of art practice itself. Donald Judd's criticism in the early 1960s might be an example of the first—though it impacts on the second—and Robert Smithson's almost ten years later an example of the second. If that is so, writing is implicated in the collapse of sculptural boundaries that occurred around 1967. Indeed, some of the artists considered here (such as Dan Graham and Daniel Buren), who have been particularly effective as writers, are the ones whom it is also most difficult simply to designate sculptors—or, indeed, to categorize under any heading at all. Foregrounding in this bibliography the writings of sculptors (Donald Judd, Robert Morris, Sol LeWitt, Robert Smithson, Dan Graham, Daniel Buren, Michael Asher) does not imply that artists are better equipped to reveal meaning than critics or historians, only that they have recognized as the province of the artist discourses that could be interestingly reflected upon by means other than making objects.

The artists listed above are mainly Americans whose practice as writers started in the 1960s. This is a historically specific issue, a part of the art revolution of the 1960s. The issue of criticality has a history in American art writing that goes back to the 1930s, to Alfred Barr and subsequently Clement Greenberg. But, earlier, to be critical meant to be critical within the practice of art rather than of art's external context. Nonetheless, there is a long tradition of American art writing that is concerned with criticism as clarifying and exposing the mechanisms whether of a particular art practice or of the way art takes its place in the wider world. If, in terms of artists' writings, the expression of this was mainly confined to the 1960s and 1970s, the beginning of the 1980s saw a new critical forum represented in such key publications as Hal Foster (ed.), *The Anti-Aesthetic: Essays in Post-Modern Culture* (Seattle, 1983); Brian Wallis

(ed.), *Art after Modernism: Rethinking Representation* (Cambridge, Mass., 1984); and Rosalind Krauss, *The Originality of the Avant-Garde and Other Modernist Myths* (Cambridge, Mass., 1984). Different authors defined the Post-Modern in their own ways, but all agreed that reality was coded rather than transparent and that experience of it is conditional—we do not live as isolated individuals in a vacuum. For artists, that 'vacuum' had been the studio, or the 'studio to art gallery' system which many had been moving away from since the 1960s. Some artists had already seen that the market and the museum were parts of structures of power and authority which, from being conditioning factors in their lives, became the subject of their art.

There is no list of 'general' works here. This is partly because no single author's work covers the whole fifty years, but more because it seems better to include a publication more than once than to de-historicize it by making a super-category outside the individual chapter headings. The only exception is the very useful collection of documents *Art in Theory 1900–1990: An Anthology of Changing Ideas*, by Charles Harrison and Paul Wood (eds), (Oxford, 1992). Publications have been chosen for the value of the writing, and compilations of pictures and *catalogues raisonnés* have not been included for their own sake.

Chapter 1. European Sculpture after 1945

Modern sculpture
The first history of modern sculpture was Carola Giedion-Welcker's *Contemporary Sculpture: An Evolution in Volume and Space* (Stuttgart and London, 1937, revised English edition with a new introduction, 1956), which provides a very useful overview of a well-informed writer's views as they changed over twenty years. A. C. Ritchie's *Sculpture of the Twentieth Century* (New York, Museum of Modern Art, 1952) followed the museum's early established practice of books published to accompany exhibitions. Towards the end of the 1950s the buoyancy of sculptural production and the increasing audience for modern art led to expansion in art publishing. Michel Seuphor's *Sculpture of this Century* (Neuchâtel and London, 1959) and Eduard Trier's *Form and Space: The Sculpture of the Twentieth Century* (Berlin, 1960, London, 1961) were the first attempts to organize post-war sculpture by type. Robert Maillard's *Dictionary of Modern Sculpture* (London, 1962) and Herbert Read's *Modern Sculpture: A*

Concise History (London, 1964) end this series of books linking post-war to pre-war developments. The growing popularity of sculpture is reflected in the Dutch art historian A. M. Hammacher's editing in the late 1950s the paperback 'Modern Sculptors' series (Amsterdam and London, 1958–61) which consisted of books on Arp, Chadwick, Despiau, Gonzalez, Hepworth, Laurens, Lehmbruck, Lipchitz, Marini, Martini, Moore, Picasso, Richier, and Zadkine. Books on Brancusi and Giacometti were planned but not produced. However, only Richier and Chadwick were post-war reputations. A more expensive series of books on sculpture was produced at the same time by Editions du Griffon, Neuchâtel, including a useful work on Hepworth, intro. J. P. Hodin (1961).

Moore and Hepworth
The extensive literature on Henry Moore centres on the catalogue of his work, the first volume of which, *Henry Moore: Sculpture and Drawings. Vol. 1 1921–1948*, was published in 1944. Herbert Read's introduction placed Moore in a world art context, and was reprinted in Read's *The Philosophy of Modern Art* (London, 1952). Moore was also prominent (as were Gabo and Hepworth) in Read's most important work on sculpture, *The Art of Sculpture* (London, 1956), based on the 1954 A. W. Mellon lectures at the National Gallery of Art, Washington. Moore's own writings were edited for publication by Philip James as *Henry Moore on Sculpture* (London and New York, 1966, revised 1971), and Alan Wilkinson's research on Moore's drawings for an exhibition at the British Museum (1977) is valuable for the study of his sculpture. Richard Cork's essay in the catalogue of the Royal Academy's 1988 exhibition, 'An Art of the Open Air', summarized Moore's outdoor commissions. *Barbara Hepworth: Carvings and Drawings*, intro. Herbert Read (London, 1952) is useful for the most substantial collection of the artist's own writing. The recent catalogue by Penelope Curtis and Alan Wilkinson for the Hepworth exhibition at the Tate Gallery, Liverpool (1994) contains much new information. Curtis's essay 'The Artist in Postwar Britain' is important for patronage.

Post-war French sculpture
Post-war French sculpture is extensively described by Sarah Wilson in 'Paris Post War: In Search of the Absolute', in Frances Morris's invaluable *Paris Post War: Art and Existentialism 1945–1955*, Tate Gallery, 1993.

Aftermath: France, New Images of Man, (London, Barbican Art Gallery 1982) contains useful articles by Germain Viatte and Henry-Claude Cousseau. Germain Viatte's *Paris 1937–Paris 1957* (Paris, Centre Georges Pompidou, 1981) is an encyclopaedia of information with short contributions in French by many scholars. Picasso's sculpture was the subject of an essay by his lifelong friend Daniel-Henry Kahnweiler (English translation London, 1949). The catalogue of the landmark exhibition of Picasso's sculpture at the Tate Gallery, London 1967 (also shown in New York and Paris) was written by Picasso's friend and biographer Roland Penrose. Oddly, though, for an artist who had been a world figure for so long, Picasso's later sculpture was ordered and published only recently by Elizabeth Cowling and John Golding in *Picasso: Sculptor/Painter* (London, Tate Gallery, 1994.) The scholarly standard for writing on Giacometti was set by Reinhold Hohl whose book (Lausanne and London, 1972) includes numerous early reviews of his work and other documents that would otherwise be hard to find. Hohl's work is complemented by David Sylvester's excellent *Looking at Giacometti* (London, 1994, but incorporating earlier material). There has been considerable expansion of interest recently in the sculpture of post-war Paris, with exhibitions of Fautrier at the Musée National Fernand Léger at Biot, 1996 (catalogue: Paris, Réunion des musées nationaux), and of Richier (Vence, Fondation Maeght, 1996). There are several monographs on Marino Marini, of which the most up-to-date is by Sam Hunter (New York, 1993).

Non-figurative sculpture
Debates around non-figurative sculpture in the 1950s have largely focused on Gabo. The most up-to-date publication is *Naum Gabo: Sixty Years of Constructivism* by Steven Nash and Jan Merkert (Dallas Museum of Fine Art and Munich, Prestel, 1985) Gabo's views of twentieth-century sculpture are found in several publications including the anthology of writings on non-figuration, *Circle*, of which he was one editor (London, 1937). Read's introduction to the Museum of Modern Art's Naum Gabo and Antoine Pevsner joint exhibition, 1948, and his collaboration with the architect Leslie Martin on *Naum Gabo: Constructions, Sculptures, Drawings, Engravings* (London, 1957) represent contemporary views of Constructivism. The American sculptor George Rickey's later

Constructivism: Origins and Evolution (London, 1967) is an ambitious and encompassing attempt to link contemporary non-figurative sculpture to the pre-war tradition, but it should be read in conjunction with Camilla Gray's review (*Studio International*, March 1968), which started a revision of the history of Constructivism. See, more recently, Benjamin H. D. Buchloh's 'Cold War Constructivism' in Serge Guilbaut, *Reconstructing Modernism* (Cambridge, Mass., 1990), and the same author's 'Construire (l'histoire de) la sculpture' in *Qu'est-ce la sculpture moderne?* (Paris, Centre Georges Pompidou, 1986) There is a history of the relation of sculpture with architecture in the later 1950s waiting to be written. Starting points would be: *Aujourd'hui*, special issue on art and architecture, (May-June 1966) and *Architettura*, no 5 (1966). Both include commentaries on Mathias Goeritz in Mexico and the work of the Dutch artist Constant. Goeritz is the subject of an article by G. Nesbit in *Arts and Architecture* (May 1958). Jack Burnham's *Beyond Modern Sculpture: The Effects of Science and Technology on the Sculpture of this Century* (London, 1968) makes a detailed argument for a progressive sculptural development through the century from vitalism to the rule of science. It appeared at a time when the scientific model for material progress was breaking down and had very mixed reviews. It can usefully be read in conjunction with the (contrary) reviews by Albert Elsen and Walter Darby Bannard in *Artforum* (May 1969). The fullest exposition of kinetic art is the *Origins and Development of Kinetic Art* (London, 1968) by Frank Popper: it is divided on a strictly technical basis (how the sculptures work) which can be limiting. Lawrence Alloway wrote an introduction to the reprint of *Zero*, by Otto Piene and Heinz Mack (eds.), ([1958–61], new edition, Cambridge, Mass., 1974). Peter Selz's *Art in a Turbulent Era* (Ann Arbor, 1985) is a useful retrospect on the period of kinetics and light art in which the author was involved as a curator. Guido Ballo's *Lucio Fontana* (New York, 1971) is a good introduction to this undervalued artist.

Chapter 2. 'The New Sculpture'
Post-war British sculpture
Post-war British sculpture is well covered, especially in relation to Paolozzi and Turnbull, in David Mellor's 'Existentialism and Post War British Art', in *Paris Post War: Art and Existentialism 1945–1955*. Frank Whitford's

catalogue for the Tate Gallery's 1974 exhibition is a good summary of Paolozzi's work, while Richard Morphet's catalogue for the Turnbull exhibition at the Tate Gallery (1973) is admirably detailed. For the 'geometry of fear' sculptors the best analysis is 'Sculpture in the 1940s and 1950s: the Form and the Language' by John Glaves Smith in Sandy Nairne and Nicholas Serota (eds), *British Sculpture in the Twentieth Century* (Whitechapel Art Gallery, 1981). Lawrence Alloway's useful 'Britain's New Iron Age', *Art News* (June-August 1953), was the first to relate British developments to an American audience. Chadwick is the subject of a monograph by Dennis Farr (Oxford, 1990), while Butler's work has been studied by Richard Calvocoressi for the Butler exhibition at the Tate Gallery (1983), and in relation to the Unknown Political Prisoner competition Robert Burstow's 'Butler's Competition Project for a Monument to the Unknown Political Prisoner' in *Art History* (December 1989), is indispensable. Richard Calvocoressi's 'Public Sculpture in the 1950s' in the 1981 Whitechapel catalogue is very informative.

American sculpture in the 1940s and 1950s

For the study of American sculpture in the 1940s and 1950s the writings of Clement Greenberg are indispensable. The publication of Greenberg's *Collected Essays and Criticism*, by John O'Brian (ed.), (Chicago, 1986–93, 4 vols) was a major publishing event, and the reviews and articles on sculpture in the first two volumes (to 1956) are worth reading sequentially to follow Greenberg's perception of the new American sculpture against his reviews of older European sculptors. These books are a major source for an understanding of David Smith. Among contemporary publications *The Tiger's Eye* (15 June 1948) is interesting for 'The Ides of Art: 14 Sculptors Write', but contemporary comment is relatively sparse. Retrospective views of the period start with a sculpture special issue of *Art in America* (winter 1956–7). In terms of contemporary literature, Peter Selz's *New Images of Man* (New York, Museum of Modern Art, 1959)—covering painting as well as sculpture—closed this period of the history of the human figure in European and American art. Among later reviews of the period Rosalind Krauss's analysis of sculpture by type in 'Magicians' Games: Decades of Transformation, 1930–1950', in 'Two Hundred Years of American Sculpture', Whitney

Museum of American Art, New York, 1976 is important. Revival of interest in post-war sculpture in America and Europe was signalled by a special issue of *Art Journal*, winter 1994, by Mona Hadler and Joan Marter (eds). Among monographs Rosalind Krauss's *Terminal Iron Works: The Sculpture of David Smith* (Cambridge, Mass., 1971) is exceptional, testing Smith's sculpture against particular ideas. Deborah Wye's *Louise Bourgeois* (New York, Museum of Modern Art, 1982) is an appropriate tribute to an astonishing artist. Frederick Kiesler is best approached through the catalogue edited by Lisa Phillips for the exhibition at the Whitney Museum of American Art, 1989.

Chapter 3. Sculpture and the Everyday
The 1960s

Udo Kultermann's *The New Sculpture* (Tübingen and London, 1968) is a useful survey of the 1960s as a decade. It was the first book to concentrate on a single post-war decade, and is even-handed in covering developments in different countries at a time when American leadership was being very heavily promoted. Pierre Restany's manifesto of *Nouveau Réalisme* (1960) is translated in *Art and Theory*. William Seitz's *The Art of Assemblage*, the catalogue of a exhibition connecting Dada and Surrealism with the new movement (New York, Museum of Modern Art, 1961), a key contemporary document, is still useful, and Pontus Hulten's *The Machine as Seen at the End of the Mechanical Age* (New York, Museum of Modern Art, 1969) is useful for Tinguely, Rauschenberg, and others. Anne Seymour's *Beuys, Klein, Rothko: Transformation and Prophecy* (London, Anthony d'Offay Gallery, 1987), looks at different artists in terms of shared spiritual goals. Yves Klein's work is well covered by the catalogues of two international touring exhibitions, by Thomas McEvilley (Rice University Art Gallery, Houston, 1982) and Sidra Stich (London, Hayward Gallery, 1995). Germano Celant's *Piero Manzoni 1933–1963* (Musée d'Art Moderne de la Ville de Paris, 1991) is the best recent survey of his work. Jan van der Marck wrote the catalogue for an exhibition of Arman at La Jolla Museum of Contemporary Art, California, 1974, and Pierre Restany contributed to the Arman retrospective at the Museum of Fine Arts, Houston, 1992. Pontus Hulten's *Jean Tinguely, 'Meta'*, (London, 1976) is the fullest analysis of Tinguely's work. Most of the best publications on Christo are attached to individual projects.

Marina Vaizey's short monograph (London, 1990) is a summary of his work.

American sculpture in the 1960s
While critical writing on sculpture from 1945 to 1960 reflects the primacy of Europe, the explosion of creative energy in the USA around 1960 has been matched in writing. Barbara Haskell's *Blam! The Explosion of Pop, Minimalism and Performance 1958–1964* (New York, 1984) is a good starting-point. Allan Kaprow's *Essays on the Blurring of Art and Life*, by Jeff Kelley (ed.) (Berkeley, 1993) reprints key texts by the pivotal artist of Happenings, while RoseLee Goldberg's *Performance Art from Futurism to the Present* (London, 1979) provides a useful context for a number of artists whose work crossed boundaries between the arts. Jasper Johns's sculpture is most fully discussed by Fred Orton in *Jasper Johns: The Sculptures*, accompanying an exhibition at the Henry Moore Centre for the Study of Sculpture, Leeds, 1996, while important earlier commentaries are by Alan Solomon in the catalogue of the Johns exhibition at the Jewish Museum, New York, 1963, and Leo Steinberg's 'Jasper Johns: The First Seven Years of his Art', first published in 1962 and reprinted in *Other Criteria* (Oxford, 1972). Max Kozloff's two short works on Johns are also useful. Alan Solomon's introduction to *Robert Rauschenberg* (New York, Jewish Museum, 1963) is worth taking the trouble to find, Leo Steinberg's title essay in *Other Criteria* is indispensable, while Lawrence Alloway's introduction and catalogue for *Robert Rauschenberg* (Washington, Smithsonian Institution, 1976) is a good introduction to Rauschenberg's work. There is an interesting section on Rauschenberg, relevant to his sculpture, in Douglas Crimp's *On the Museum's Ruins* (Cambridge, Mass., 1993).

Warhol, Oldenburg, Kienholz
Nothing has been written specifically on Warhol's three-dimensional work. Useful articles are in *The Work of Andy Warhol*, Dia Art Foundation, Discussions on Contemporary Art No. 3, Gary Garrels (ed.) (Seattle, 1989), and the catalogue of the Museum of Modern Art's *Andy Warhol* exhibition, Kynaston McShine (ed.) (New York, 1989). Barbara Rose's *Claes Oldenburg* (New York, Museum of Modern Art, 1970), is the best introductory text, while *Claes Oldenburg: An Anthology* by Germano Celant and others, (New York, Guggenheim

Museum, 1995) contains much useful material. For Edward Kienholz, see Walter Hopps and others, *Edward Kienholz: A Retrospective* (New York, Whitney Museum of American Art, 1996). For George Segal, see Jan van der Marck's monograph (revised edn, New York, 1979).

Chapter 4. Modernism and Minimalism
Anthony Caro
The early 1960s marked the ascendancy of Clement Greenberg, but the third and fourth volumes of his *Collected Essays and Criticism* (Chicago, 1993) should ideally be read alongside *Art and Culture* (Boston, 1961), the anthology of his writings that was available and very widely read at the time. A focus of the writing of Greenberg and his younger colleague Michael Fried was the English sculptor Anthony Caro. Richard Whelan's *Anthony Caro* (Harmondsworth, 1974) contains reprints of articles by Greenberg (1965) and Fried (1968 and 1970), as well as an interview with Phyllis Tuchman (1972). Michael Fried's important first article on Caro, the catalogue introduction for Caro's exhibition at the Whitechapel Art Gallery in 1963, was reprinted in *Art International* (September 1963). William Rubin wrote the introduction to the catalogue of Caro's retrospective at the Museum of Modern Art, 1975, and, arising from the exhibition, Rosalind Krauss wrote 'How paradigmatic is Anthony Caro?' (*Art in America*, September–October 1975). Michael Fried's defence of his aesthetic, 'Art and Objecthood', appeared in *Artforum* in June 1967, and reappeared in Gregory Battcock's *Minimal Art: A Critical Anthology* (New York, 1968; new edn 1995 with an introduction by Anne Wagner). Battcock's book also included important articles by Barbara Rose, Bruce Glaser, and others. The twentieth anniversary of the appearance of Fried's article was the occasion of a round-table discussion with Michael Fried, Benjamin H. D. Buchloh, and Rosalind Krauss, published as 'Theories of Art after Minimalism and Pop', in Hal Foster (ed.), *Dia Art Foundation Discussions in Contemporary Art, No 1* (Seattle, 1987).

Minimalism
Rosalind Krauss's *Passages in Modern Sculpture* (New York and London, 1977) is, at one level, a history of European sculpture from Rodin to c.1970; but it is concerned specifically with the re-location of meaning in sculpture from the core to the surface. This is a character (almost

a precept) of Minimalism, and Krauss's book can be regarded—summarily put—as Modernism seen through Minimalist eyes. In several cases Minimalist artists were also important writers on art. Donald Judd's *Complete Writings 1959–1975* (Halifax, Nova Scotia, 1975) consists mainly of short reviews but includes the pivotal essay 1965 'Specific Objects'. Robert Morris's collected writings *Continuous Project Altered Daily* (New York, 1993) is one of the most enlivening art books of the post-war period. The writings of Sol LeWitt are key to an understanding of Minimalism's relationship to Conceptual Art and have been collected by A. Zeri in English and Italian editions (Rome, 1995). 'Paragraphs on Conceptual Art' (1967) and 'Sentences on Conceptual Art' (1969) are included in *Art in Theory*, while further writings appear (and all up to that point are listed) in Alicia Legg (ed.), *Sol LeWitt* (New York, Museum of Modern Art, 1978), with contributions by several scholars.

Other monographs on Minimalist artists with significant critical contributions include Brydon Smith (ed.), *Dan Flavin* (Ottawa, National Gallery of Canada, 1969), and Barbara Haskell, *Donald Judd* (New York, Whitney Museum of American Art, 1988). Robert Morris's exhibition at the Corcoran gallery, Washington DC, was prefaced by Annette Michelson's important early essay 'Robert Morris an Aesthetics of Trangression'. The catalogue of his show at the Tate Gallery (1971) was written by Michael Compton and David Sylvester. A major publication published by the Guggenheim Museum in 1994, *Robert Morris: The Mind/Body Problem*, contained articles by Rosalind Krauss and others. A significant contribution setting Minimalism in its wider context is Hal Foster's 'The Crux of Minimalism' in *Individuals 1945–1986* (Los Angeles Museum of Contemporary Art, 1986), reprinted in Foster, *The Return of the Real* (Cambridge, Mass., 1996). Much of the best American criticism in the late 1960s appeared in *Artforum*, and sculpture was prominent (an impressive sculpture number appeared in June 1967).

Britain's new generation
Apart from Caro's, British sculpture of the period has been less fully reviewed than American. Charles Harrison's 'Sculpture's Recent Past' in Terry Neff (ed.), *A Quiet Revolution: British Sculpture since 1965* (New York and London, 1987) is the best overview, and the same author's 'Suppression of the Beholder: Sculpture and the Late Sixties' in *Starlit Waters, British Sculpture: An International Art 1968–1988* (Liverpool, Tate Gallery, 1988) is useful for the period as a whole. Tim Hilton's *Phillip King* (London, 1992) is the best introduction. King's own writings are extensively published in *Phillip King*, intro. David Thompson (Otterlo, Kröller-Müller Museum, 1974). William Tucker's writings on earlier twentieth-century sculpture, *The Language of Sculpture* (London, 1974) reflect interestingly on contemporary attitudes to sculpture, but the book does not include Tucker's reflection on the present, 'An Essay on Sculpture' (*Studio International*, January 1969). *Studio International* published the best English art criticism of the time, particularly the reviews of Charles Harrison. A series of essays on the English 'new generation' sculptors by Anne Seymour, Richard Morphet, and Michael Compton appeared in *The Alistair McAlpine Gift* (Tate Gallery, 1971). For a foreign view of British sculpture of this period, see Françoise Cohen, 'English and American Art in the Sixties and Seventies: Sculpture is still Possible', in *Britannica: Trente ans de sculpture* (Le Havre, Musée des Beaux Arts, 1988).

Chapter 5. 'Anti-Form'
The collapse of boundaries
Rosalind Krauss's *Passages in Modern Sculpture* is as fundamental reading for this chapter as for chapter 4. One of its themes is the reinstatement of temporality in late-1960s sculpture, and the author draws attention to the possible reading of the word 'passage' in the book's title in terms both of the implication of time within sculpture of the period and of actual passages in the work of Nauman. Krauss's 'Sculpture in the Expanded Field' (1979), reprinted in *The Originality of the Avant-Garde and other Modernist Myths* (Cambridge, Mass., 1984) is a basic text for this chapter, which is about the collapse of boundaries and non-traditional materials. Yve-Alain Bois and Rosalind Krauss, *L'informe: Mode d'emploi* (*Formless: A User's Guide*) (Paris, Centre Georges Pompidou, 1996) was a key exhibition drawing on work from Surrealism onwards. It was divided into four sections: horizontality, which is particularly relevant to chapters 5 and 6; pulse (involving art that registers the passing of time); base materialism, drawing on earlier artists here, such as Dubuffet and Fontana, but relevant to many artists in chapters 5 and 6; and entropy, referring to increasing disorder,

relevant, again, to chapters 5 and 6. The exhibition was about crossing boundaries, and was not arranged chronologically, by medium or country, and its importance is therefore difficult to convey in a book that follows a broadly chronological pattern.

America at the end of the 1960s
The Robert Morris bibliography (see chapter 4) remains central. On Eva Hesse the best introduction is Lucy Lippard's monograph (New York, 1976), expanded on and modified by the essays in Helen A. Cooper (ed.), *Eva Hesse: A Retrospective* (Yale University Art Gallery, 1992). A critical look at the Hesse literature, its involvement with biography and the impact of Hesse's early death is taken by Anne Wagner in 'Another Hesse', *October* (summer 1994). Bruce Nauman's work is the subject of two major publications, Coosje van Bruggen's *Bruce Nauman* (New York, 1988) and Neal Benezra and Kathy Halbreich (eds), *Bruce Nauman* (Minneapolis, Walker Art Center, 1994). A particularly rich bibliography surrounds the work of Richard Serra. The Museum of Modern Art's *Richard Serra/Sculpture*, by Laura Rosenstock (ed.) (New York, 1986), with contributions by Rosalind Krauss and Douglas Crimp, is the best starting-point. Crimp's essay, 'Richard Serra Redefining Site-Specificity' is reprinted in his *On the Museum's Ruins* (Cambridge, Mass., 1993). Ernst-Gerhard Güse's *Richard Serra* (New York, 1988) has contributions by Yve-Alain Bois, Douglas Crimp, and Armin Zweite. Richard Serra's *Writings: Interviews* (Chicago, 1994) concern siting and installation of Serra's sculpture, his films, and recent sculptural history. *The Destruction of Tilted Arc: Documents* (Cambridge, Mass., 1991), by Clara Weyergraf Serra and Martha Buskirk (eds), intro. by Richard Serra, is a politically charged narrative concerning the sculptor's use of public space.

Body and performance
For Performance Art RoseLee Goldberg's book (see chapter 3) remains relevant. For Gilbert & George the writing of Carter Ratcliff is useful: 'Gilbert & George and Modern Life' in *Gilbert & George 1968–80* (Eindhoven, Van Abbemuseum, 1980), and 'Gilbert & George: The Fabric of their World', in *Gilbert & George: The Complete Pictures 1971–1985* (London, 1986). Kate Linker's *Vito Acconci* (New York, 1994) gives a full account for the first time of this interesting and varied artist. The Guggenheim Museum's book on Rebecca Horn, with various contributors, was prepared for an international touring exhibition (New York, 1993) and covers very fully her work in performance, sculpture, installation, and film-making.

Beuys and *Arte Povera*
The clearest and most sympathetic account of Beuys's work in English is by Caroline Tisdall for the exhibition at the Guggenheim Museum (New York and London, 1979). *Energy Plan for the Western Man: Jospeh Beuys in America*, Carin Kuoni, compiler, includes writings by, and interviews with, the artist. It contains much that is useful, including Beuys's first interview in America, with Willoughby Sharp, reprinted from *Artforum*. Biographical information can be got from Heiner Stachelhaus's book (New York, 1991). The Beuys literature divides fairly clearly into 'for' and 'against'. The anti-Beuys publications start, after the 1979 exhibition, with Benjamin H. B. Buchloh's 'Beuys: The Twilight of the Idol', *Artforum* (January 1980), and three articles in *October* (summer 1988): Eric Michaud, 'The End of Art according to Beuys', Thierry de Duve, 'Jospeh Beuys or the Last of the Proletarians', and Stefan Germer, 'Haacke, Broodthaers, Beuys'. The history of *Arte Povera* has been dominated by the writing of its champion and protagonist Germano Celant, who launched the movement with 'Arte Povera: Notes for a Guerilla War', *Flash Art* (November–December 1967) (in Italian, but translated into English in *Flash Art: Two Decades of History: XXI Years*, by Giancarlo Politi and Helena Kontova (eds) (Cambridge, Mass., 1990)). This was followed by a book: Germano Celant, *Arte Povera: Conceptual, Actual or Impossible Art?* (Milan and London, 1969). Celant's later writings around *Arte Povera* include *Precronistoria 1966–69* (Florence, 1976), a useful blow-by-blow diary, in Italian, of international art events, comparable with Lucy Lippard's slightly earlier *Six Years: The Dematerialisation of the Art Object* (New York, 1973). Celant's *Arte Povera: Histories and Protagonists* (Milan, 1985) contains translations into English. Celant's sculptor friend Piero Gilardi acted as the international emissary of the movement, and introduced *Arte Povera* (and other comparable English and German art) to America in 'Primary Energy and the "Microemotive Artists" ', *Arts* (September–October 1968). There are a number of monographs on individual *Arte Povera* artists written in, or translated into, English: Germano Celant,

Pistoletto (New York, 1989); Gloria Moure (ed.), *Jannis Kounellis*, with various contributions (Barcelona, 1990); Thomas McEvilley, 'Mute Prophecies: The Art of Jannis Kounellis,' in Mary Jane Jacob (ed.), *Jannis Kounellis* (Chicago, Museum of Contemporary Art, 1986); various authors, *Luciano Fabro* (San Francisco Museum of Art, 1992); Germano Celant, *Mario Merz* (New York, Guggenheim Museum, 1989). For the English sculptor Barry Flanagan the catalogue, with contributions by Tim Hilton and Michael Compton, of the exhibition of his work at the 1982 Venice Biennale and subsequently shown at the Whitechapel Art Gallery, London, is a good starting-point.

Chapter 6. Natural Materials

Earth Art

Gilles A. Tiberghien's *Land Art* (London, 1995) is by far the most comprehensive work on the subject and essential reading. Many of the artists are referred to in John Beardsley's summary account *Earthworks and Beyond Contemporary Art in the Landscape* (New York, 1984). *Art in the Land: A Critical Anthology of Environmental Art*, by Alan Sonfist (ed.) (New York, 1983), gathers a large number of varied contributions on site-specific art, extending well beyond what is referred to here. Lucy Lippard's *Overlay: Contemporary Art and the Art of Prehistory* (New York, 1983) reviews 1970s art's concern with the past and its physical traces on landscape. For Robert Smithson the key work is Nancy Holt (ed.), *The Writings of Robert Smithson* (New York, 1979. A new edition of Smithson's writings was edited by Jack Flam, New York, 1996). Smithson's learned, sometimes ironical and often disjointed, writings are, as much as Robert Morris's *Continuous Project Altered Daily*, a key to the understanding of sculpture's changing identity. More than a book about his own art and his contemporaries' sculpture, it is a part of Smithson's artistic output parallel with his sculpture. The first edition was the subject of a major review by Craig Owens, 'Earthwords', *October* (fall 1979), reprinted in Owens, *Beyond Recognition: Representation, Power, and Culture* (Berkeley, 1992). Owens used the review as the starting-point for his seminal articles 'The Allegorical Impulse: Towards a Theory of Postmodernism', *October* (spring and summer 1980), which were quickly reprinted in Brian Wallis (ed.), *Art after Modernism: Rethinking Representation* (Boston and New York, 1984). The first major collection of essays on Smithson, and

catalogue of his work, was *Robert Smithson Sculpture*, by Robert Hobbs (ed.), with contributions by Lucy Lippard, Lawrence Alloway, and John Coplans (Cornell, 1981). Subsequent publications include Eugenie Tsai, *Robert Smithson Unearthed* (New York, 1991), which is important for the study of his drawings. In Rosalind Krauss's 'Echelle/ monumentalité. Modernisme/ postmodernisme. La ruse de Brancusi', in Margit Rowell (ed.), *Qu'est-ce que la sculpture moderne?* (Paris, Centre Georges Pompidou, 1986), Smithson's photographic essay and commentary 'A Tour of the Monuments of Passaic' are interestingly compared with Brancusi's work at Tirgu-Jiu, in terms of the notion of the relation of site, commemorative function, the blurring of boundaries between architecture and sculpture, and sculpture as horizontal rather than vertical structure. Other publications of Rosalind Krauss that are relevant here are 'Sculpture in the Expanded Field', 1979, reprinted in *The Originality of the Avant-Garde and Other Modernist Myths* (Cambridge, Mass., 1994), and *L'informe: Mode d'emploi* (1996, with Yve-Alain Bois), see above, chapter 5.

Sculpture and landscape

Michael Compton's 'Some Notes on the Work of Richard Long' written to accompany Long's work at the Venice Biennale, 1976, is a good introduction. *Richard Long in Conversation* (with Martina Giezen) (Noordwijk, Holland, two parts, 1985 and 1986) is useful, and two books on Long's work are Rudi Fuchs, *Richard Long* (New York and London, 1986) and Anne Seymour, *Richard Long, Walking in Circles* (London, 1991). The work of Alice Aycock and Mary Miss is known through articles, including: Nancy Rosen, 'A Sense of Place: Five American Artists', *Studio International* (March–April 1977); Kate Linker, 'An Anti-Architectural Analogue', *Flash Art* (January 1980); and Lucy Lippard, 'Complexes: Architectural Sculpture in Nature', *Art in America* (January–February 1979). Exhibition catalogues that gather together themes of these and other contemporary American artists include *Dwellings*, intro. Lucy Lippard (Institute of Contemporary Art, University of Pennsylvania, 1978); and *Connections Bridges/Ladders/Ramps/Staircases/Tunnels*, intro. Janet Kardon, at the same venue, 1983. For Siah Armajani, Julie Brown's essay for the catalogue of the exhibition at the Hudson River Museum, Yonkers, New York, 1981, and

Jean-Christoph Amman's text for the exhibition at the Kunsthalle Basel and the Stedlijk Museum, Amsterdam, 1987, make good introductions. Other useful publications on sculptors working in different landscape contexts are: *Hand to Earth: Andy Goldsworthy Sculpture 1976–90*, with various contributions (Leeds, 1990); Julian Andrews, *The Sculpture of David Nash* (London, 1996); Yves Abrioux, with notes and commentaries by Stephen Bann, *Ian Hamilton Finlay: A Visual Primer*, (London, 1985); and Lars Morell, 'Per Kirkeby's Brick Sculptures', in *Per Kirkeby, Malerie/Paintings: Skulptur/Sculptures. . . . 1964–1990* (Stockholm, Moderne Museet, 1990).

Chapter 7. Public Spaces
Sculpture and the museum

Here, as with chapter 4, artists have made a major contribution as writers and critics. The section 'Architecture: Art, Design, Urbanism' in Dan Graham's *Rock my Religion: Writings and Art projects, 1965–1990*, by Brian Wallis (ed.) (Cambridge, Mass., 1993) is important. For Gordon Matta Clark the exhibition catalogue for IVAM, Valencia, has interesting articles by Marianne Brouwer and Judith Kirshner in translation. Donald Wall, 'Gordon Matta Clark's Building Dissections', *Arts* (March 1976), and Thomas Crow, 'Site-Specific Art, the Strong and the Weak', in *Modern Art in the Common Culture* (Yale, 1996) are both useful. A key text for the discussion of 'criticality' in 1970s American and Euopean art is Benjamin H. B. Buchloh, 'Formalism and Historicity—Changing Concepts in American and European Art since 1945', in *Europe in the Seventies: Aspects of Recent Art* (Art Institute of Chicago, 1977). This substantial essay looks back over the 1960s and is interesting also for its views on Klein, Manzoni, and more recent artists. For the function and ideology of the museum the key text is Douglas Crimp, *On the Museum's Ruins* (Cambridge, Mass., 1993). Daniel Buren's writings on the context of art making and exhibiting are fundamental. Some of the most important in English are: 'Beware', *Studio International* (March 1970), followed by commentary by Michel Claura; 'Standpoints', *Studio International* (April 1971); 'The Function of the Museum', *Artforum* (September, 1973); and 'The Function of an Exhibition', *Studio International* (December 1973). These are searching analyses of the role of the artist's institutional framework and a key

to understanding the significance attributed to physical context by certain artists at the time. A complementary critical text is Benjamin H. D. Buchloh, 'The Museum and the Monument', in *Daniel Buren: Les Couleurs: Sculptures. Les Formes: Peintures* (Halifax, Nova Scotia, 1981). On Michael Asher there is no substitute for the artist's own publication, in collaboration with Benjamin H. D. Buchloh, *Michael Asher Writings 1973–1983 on Works 1969–1979* (Halifax, Nova Scotia, and Los Angeles, 1983). The comments in the text of chapter 7 here draw on Anne Rorimer, 'Michael Asher Recent Work', *Artforum* (April 1980). The best introduction to the complex art of Marcel Broodthaers is Michael Compton, one of several contributors to *Marcel Broodthaers* (Minneapolis and New York, 1989). Broodthaers is the subject of Douglas Crimp's essay, 'This is not a Museum of Art', in *On the Museum's Ruins*. *Broodthaers: Writings, Interviews, Photographs*, by Benjamin H. D. Buchloh (ed.), with various contributions was a special issue of *October* (fall 1987). The fullest discussion of Baumgarten appears in *America* (New York, Guggenheim Museum, 1993), with a number of interesting contributions; Craig Owens's 'Improper Names' appears in *America* and *Beyond Recognition*. Denys Zacharopoulos, 'The World and its Traditions, or the Tradition of the World', *Artforum* (October 1985), is also useful.

Hans Haacke
The best starting point for Hans Haacke is *Hans Haacke: Unfinished Business* (New York and Cambridge, Mass., 1986), with excellent contributions (including Leo Steinberg, Rosalyn Deutsche, and Fredric Jameson). His own writing and giving interviews have been for Haacke essential parts of communicating his polemical messages, and collected texts by Haacke are available as *Hans Haacke: Volume 1* (Oxford, Museum of Modern Art, 1978) and *Hans Haacke: Volume II: Works 1978–1983* (London, Tate Gallery, 1984). Yve-Alain Bois, Douglas Crimp, and Rosalind Krauss, 'A Conversation with Haacke' was published in *October* (fall 1984), and reprinted in *October: The First Decade, 1976–1986* (Cambridge, Mass., 1987). Material for chapter 7 here has also been drawn from Hans Haacke, 'Contribution to Points of Reference 38/88', and Werner Fenz, 'The Monument is Invisible, the Sign Visible', both in *October* (spring 1989).

Sculpture in public places

On sculpture in public places, Kate Linker's 'Public Sculpture: The Pursuit of the Pleasurable', *Artforum* (March 1981), introduced much new information in relation to developments in America. A more sceptical analysis of public sculpture by Rosalyn Deutsche is 'Public Art and its Uses', *October* (winter 1988). Public art, memorials, and monuments are discussed in the pivotal publication *Art and the Public Sphere*, by W. J. T. Mitchell (ed.) (Chicago, 1990), which includes Michael North, 'The Public as Sculpture', Mitchell, 'The Violence of Public Art: *Do the Right Thing*', and James Young, 'The Counter-Monument: Memory against itself in Germany Today'. Harriet Senie and Sally Webster, *Critical Issues in Public Art: Content, Context and Controversy* (New York, 1992), grew from a special issue of *Art Journal* (winter 1989), by the same editors on the same theme, in which Mathias Winzen's 'The Need for Public Representation and the Burden of the German Past' was an important contribution. Lieven van den Abeele's 'The Monument in Twentieth Century Sculpture: Historical, Political and Social Aspects' in *Monumenta*, 19th Biennale, Open Air Sculpture Museum, Middelheim (Antwerp, 1987), is a very useful survey.

Boltanski and Kabakov

Lynn Gumpert, *Christian Boltanski* (Paris and London, 1992) is an excellent short book making use of interviews. Further articles and interviews, by Didier Semin, Georgia Marsh, and others, appear in *Parkett*, 22 (1989). The most comprehensive work on Kabakov is Jean-Hubert Martin, Boris Groys, and others, *Ilya Kabakov: Installations 1983–1995* (Paris, Centre Georges Pompidou, 1995). Articles on Kabakov by various authors appear in *Parkett*, 34 (1992). 'Dislocations', an exhibition organized by Robert Storr (New York, Museum of Modern Art, 1991) was a group of installations by artists including Kabakov and, among others who are discussed here, Louise Bourgeois, Chris Burden, David Hammons, and Bruce Nauman.

Chapter 8. Objects and Figures

British sculpture

Several of the earliest interesting reviews of the new British sculpture of the early 1980s were written by Michael Newman for: *British Sculpture Now* (Kunstmuseum, Lucerne, 1982); *Figures and Objects: Recent Developments in British Sculpture* (Southampton, John Hansard Gallery, 1983); and 'Between Discourse and Desire: Recent British Sculpture', *Flash Art* (January 1984). Lynne Cooke has written several useful accounts: 'Reconsidering the "New Sculpture" ', *Artscribe* (August 1982); 'Between Image and Object: The New British Sculpture', in *A Quiet Revolution: British Sculpture since 1965* by Terry Neff (ed.); and 'British Sculpture in the Eighties: Questioning Cultural Myths, Confirming Artistic Conventions', in *Britannica: Trente ans de sculpture* (Le Havre, Musée des Beaux Arts, 1988). Works on individual artists include *Richard Deacon*, with contributions by Pier Luigi Tazzi, Jon Thompson, and Peter Schjeldahl (London, 1995); Charles Harrison, 'Empathy and Irony. Richard Deacon's Sculpture' (in the catalogue of Deacon's exhibition at the Kunstmuseum, Lucerne, 1988); *Tony Cragg*, with an introduction by Lynne Cook (London, Arts Council, 1987); *Tony Cragg: Sculpture 1975–1990*, with contributions from various authors (Newport Harbor Museum, 1990); David Elliott, intro. *Bill Woodrow: Beaver, Bomb and Fossil* (Oxford, Museum of Modern Art, 1983); Germano Celant, *Anish Kapoor* (London, 1996); *Julian Opie*, with contributions from various authors (London, Hayward Gallery, 1994); Rachel Whiteread in conversation with Iwona Blazwick (Eindhoven, Van Abbemuseum, 1992); Rachel Whiteread, *House*, by James Lingwood (ed.), with contributions from various authors (London, Phaidon, 1995); and various authors, *Rachel Whiteread: Shedding Life* (Liverpool, Tate Gallery, 1995).

American 'commodity sculpture'

Discussion of American 'commodity sculpture' has centred on the issue of the artist's attitude to consumerism and the market: criticism versus complicity. For a negative view of commodity sculpture, see Hal Foster, 'Signs Taken for Wonders', *Art in America* (1986) (mainly about painting but relevant to sculpture); 'The Future of an Illusion', in *Endgame. Reference and Simulation in Recent Painting and Sculpture* (Boston, Institute of Contemporary Art, 1986) and, especially, *The Return of the Real* (Cambridge, Mass., 1996). For a somewhat different view see David Joselit, 'Modern Leisure', also in *Endgame*, and the same author's 'Investigating the Ordinary', *Art in America* (May 1988). Similar ground is covered in Lynne Cooke, 'Object Lessons', *Artscribe* (September–October 1987). In relation to different artists

the exhibition 'A Forest of Signs', curated by Mary Jane Jacobs and Ann Goldstein (Museum of Contemporary Art, Los Angeles, 1990), touched on similar issues. Jacobs's catalogue essay 'Art in the Age of Reagan' is useful, as is the review by Brooks Adams in the 'New Art International' issue of *Art and Design*, 1990. Dan Cameron first introduced this art to Europe in the exhibition *Art and its Double: A New York Perspective* (Barcelona, Fundacio Caixa de Pensiones, 1986). Paul Schimmel's *Objectives: The New Sculpture* (Newport Harbor Museum, 1990) included a wide range of American and European artists using the ready-made object in different ways, and had a substantial catalogue by Dan Cameron and others. A round-table discussion between the artists involved, moderated by Peter Nagy, was published as 'From Criticism to Complicity', *Flash Art* (summer 1986). Gudrun Inboden's essay 'Ecstasy and Banality' in *Jeff Koons* (Amsterdam, Stedelijk Museum, 1992) has been used here. The most useful publication on Allan McCollum is the catalogue of the exhibition at the Serpentine Gallery, London, and elsewhere, with contributions by Anne Rorimer, Lynne Cooke, and Selma Klein Essink.

European sculpture

For German and other European art: Iwona Blazwick, James Lingwood, and Andrea Schlieker, *Possible Worlds: Sculpture from Europe* (London, ICA and the Serpentine Gallery, 1990), included several artists discussed here. A major publication with contributions by Gudrun Inbogen, Paul Virilio, Ludger Gerdes, and Catherine David accompanied Mucha's exhibition at the Centre Georges Pompidou, Paris, 1986. The major publication on Thomas Schütte (with English translations) is *Sieben Felder*, with contributions by Ulrich Loock and others (Berne, Kunsthalle, and elsewhere, 1989).

A number of publications deal with the relationship of sculpture to building and architecture: 'Models', *Flash Art* (March 1985), and 'Room as Medium', *Flash Art* (December 1986–January 1987), both by Stephan Schmidt-Wulffen; the catalogue of 'Like Nothing Else in Tennessee' (London, Serpentine Gallery, 1992), intro. Bartomeu Mari, is useful in the same context; and Carolyn Christov-Bakargiev's 'Something Nowhere', *Flash Art* (May–June 1988), touches on some of the same problems. Short articles and interviews on Juan Muñoz by Lynne Cooke, Alexandre Melo, James Lingwood, and Gavin Bryars appeared in *Parkett*, 43 (1995).

The human figure

For the human figure: *Antony Gormley*, with contributions by various authors (London, 1987), and *Antony Gormley* (Liverpool, Tate Gallery, 1993) are useful. Neal Benezra's *Stephan Balkenhol: Sculpture and Drawings* (Washington, Hirshhorn Museum, and Stuttgart, Cantz, 1995) is the best source of information on this sculptor. On Robert Gober, Joan Simon and Catherine David write in the catalogue of his exhibition at the Museo Nacional Center de Arte Reina Sofia, Madrid, 1991, and Richard Flood and Lynne Cooke in *Robert Gober* (Liverpool, Tate Gallery, 1993). In *David Hammons. Rousing the Rubble* (Cambridge, Mass., 1991), Tom Finkeplearl's 'The Ideology of Dirt' is most useful. Short articles on Hammons appear in *Parkett*, 31 (1992). For Kiki Smith, good sources are Susan Tallman, 'Kiki Smith: Anatomy Lessons', *Art in America* (April 1992), and Linda Shearer and Claudia Gould, *Kiki Smith* (Williamstown, Williams College Museum of Art, 1992). Abjection is excellently discussed by several authors in *Abject Art: Repulsion and Desire in American Art* (New York, Whitney Museum of American Art, 1993).

	1945		1950		1955

Art

- 1946 Henry Moore exhibition, Museum of Modern Art (MOMA), New York
- 1948 First open-air sculpture exhibition, Battersea Park, London
 Henry Moore wins Sculpture Prize at Venice Biennale
 – N m Gabo–Antoine Pevsner exhib tion, MOMA, New York

- 1949 Start of Sonsbeek sculpture exhibitions at Arnhem, Holland
 – Yevgeny Vuchetich and Yakov Bepolsky, Memorial to the Fallen Soviet Heroes, East Berlin, completed

- 1950 Start of Sculpture Biennales at Middelheim Sculpture Park, Antwerp
- 1953 Unknown Political Prisoner competition judged
 – Ossip Zadkine's The Destroyed City unveiled in Rotterdam
 – Henry Moore sculptures for Time-Life Building, London, completed

- 1954 Sculptures by Henri Laurens, Hans Arp, and Antoine Pevsner for the University of Caracas, Venezuela
 – Robert Rauschenberg starts Combine paintings

- 1955 First Documenta exhibition at Kassel, West Germany
 – Denise René, 'Le Mouvement' exhibition, Paris
- 1956 Lynn Chadwick wins Sculpture Prize at Venice Biennale
 – Herbert Read, The Art of Sculpture

Cultural

- 1945 Jean-Paul Sartre, The Age of Reason
 – Albert Camus, The Plague
 – Roberto Rossellini, Rome Open City
- 1946 First Cannes Film Festival
- 1947 André Breton and Marcel Duchamp organize International Surrealist Exhibition, Paris

- 1948 Norman Mailer, The Naked and the Dead
 – Vittorio de Sica, Bicycle Thieves
- 1949 Simone de Beauvoir, The Second Sex
 – Carol Reed, The Third Man

- 1950 First regular colour television in USA
 – Philip Johnson, Glass House, New Canaan, Connecticut, completed
- 1951 Festival of Britain
 – Mies van der Rohe, Farnsworth House, Plano, Illinois, completed

- 1953 Buckminster Fuller, Geodesic Dome shown at MOMA, New York
 – Le Corbusier, Unité d'Habitation, Marseilles, completed
 – Samuel Beckett, Waiting for Godot
- 1954 John Cage, 4'33" concert in silence
 – Le Corbusier, Chapel of Notre Dame du Haut at Ronchamp, France, completed

- 1955 Rebel without a Cause, with James Dean. Dean killed in a car accident the same year
- 1956 Elvis Presley records reached maximum sales
 – Walter Gropius, redesign of Illinois Institute of Technology completed
 – John Osborne, Look Back in Anger
 – My Fair Lady opened on Broadway

Current Affairs

- 1945 End of the Second World War
 – Bretton Woods Act. International Monetary Fund and the World Bank founded
- 1946 Foundation of UNESCO
 – Winston Churchill coined phrase 'Iron Curtain'

- 1947 Marshall Plan for American aid to Europe
 – Truman doctrine of American economic support against communism

- 1948 General Agreement on Tariffs and Trade
- 1949 Germany re-established as an independent nation state
 – Foundation of NATO

- 1950 Korean War started
- 1952 Formation of European Coal and Steel Community (not including UK)

- 1955 Launch of British commercial television
 – Germany joins NATO. Formation of Warsaw Pact
- 1956 Khruschev's beginning of de-stalinization in USSR
 – Hungarian revolt crushed by USSR
 – Anglo-French invasion of the Suez Canal

● 1957 Naum Gabo, De Bijenkorf project, Amsterdam, completed – Mathias Goeritz, *The Square of the Five Towers*, Mexico City, completed

● 1958 Zero Group founded by Heinz Mack, Otto Piene, and Gunter Uecker in Düsseldorf – Jasper Johns highly successful show at Leo Castelli gallery, New York ● 1959 Documenta 2, Kassel 'Art after 1945', with large sculpture section – Sidney Janis's de Kooning exhibition sold out on first day

– 'New Images of Man' exhibition, MOMA, New York – Donald Judd becomes an art critic for *Arts*, New York – Allan Kaprow organizes *18 Happenings in 6 Parts* at the Reuben Gallery, New York – Anthony Caro, first visit to USA

● 1960 Jim Dine, *The House*, and Claes Oldenburg, *The Street*, at Judson Memorial Church – *Nouveau Réaliste* group founded, Paris – Arman installs *Le Plein* at Iris Clert's gallery, Paris – Yves Klein's 'Leap into the Void', Paris – Jean Tinguely's *Homage to New York*, MOMA, New York

● 1961 Robert Rauschenberg and Jasper Johns in Paris – Oldenburg, *The Store*, 107 E 2nd Street, New York – The Art of Assemblage' exhibition, MOMA, New York – John Cage, *Silence* – Clement Greenberg, *Art and Culture*

– Joseph Beuys Professor of Monumental Sculpture at Düsseldorf Academy of Arts ● 1962 'Six Painters and the Object', Guggenheim Museum, New York – 'New Realists' (French and American artists) at Sidney Janis gallery, New York

● 1957 Alain Robbe-Grillet, *Jealousy* – Ingmar Bergman, *The Seventh Seal* – *West Side Story* opened on Broadway – Roland Barthes, *Mythogies* – Citroën DS 19 car launched – Jack Kerouac, *On the Road*

● 1958 Samuel Beckett, *Endgame* – Vladimir Nabokov, *Lolita* – Lawrence Alloway, 'The Arts and the Mass Media' – Mies van der Rohe, Seagram Building, New York, completed

● 1959 Jean-Luc Godard, *A bout de souffle* – Alec Issigonis designed the Mini car – Michelangelo Antonioni, *L'Avventura* – Frank Lloyd Wright, Solomon Guggenheim Museum, New York, completed

● 1960 Daniel Bell, *The End of Ideology* – Publication of D. H. Lawrence, *Lady Chatterley's Lover* (1928), after obscenity trial ● 1961 *Beyond the Fringe*, satirical review, Edinburgh and London – François Truffaut, *Jules et Jim* – Günter Grass *The Tin Drum*

● 1961 Alain Resnais, *Last Year at Marienbad* ● 1962 Maurice Merleau-Ponty, *The Phenomenology of Perception* (1945 translated into English) – *Sunday Times*, London, the first newspaper colour supplement – New Wing of Museum of Modern Art designed by Philip Johnson, opened

– Beatles signed with EMI and release 'Love Me Do' – Start of satirical magazine *Private Eye*, London

● 1957 Soviet Sputnik 1 world's first space satellite – Prime Minister Harold Macmillan 'you have never had it so good' – Treaty of Rome

● 1958 Establishment of the European Economic Community (now European Union) – First parking meters in London – Campaign for Nuclear Disarmament founded, UK. First Aldermaston march – De Gaulle returns as French president

● 1959 USA Explorer 6 spacecraft took first pictures of Earth from Space – Full convertibility of currencies under the Bretton Woods system

● 1960 J.F. Kennedy becomes US president ● 1961 Yuri Gagarin first man in space – Erection of the Berlin Wall

● 1962 USA naval blockade of Cuba to stop deployment of Soviet missiles – Rachel Carson, *Silent Spring* – Conclusion of the Algerian War

● 1963 Kennedy assassination, seen on TV – Civil Rights march on Washington – British application to join Common Market vetoed by De Gaulle

1965

Art

– Fluxus movement started by George Maciunas in Wiesbaden, then New York
– Yves Klein installed *Le Vide* at Iris Clert's gallery, Paris
– David Smith worked at Voltri, Italy
– Andy Warhol's first one-man show at Ferus Gallery, Los Angeles

– Suicide of Marilyn Monroe, followed by Warhol silkscreens
● 1963 Andy Warhol's 'Race Riot' series
● 1964 Robert Rauschenberg wins main prize at Venice Biennale
– Susan Sontag, 'Notes on Camp'
– Herbert Marcuse, *One Dimensional Man*

● 1965 'New Generation' sculpture exhibition at Whitechapel Art Gallery, London
– Robert Morris and Carolee Schneeman, dance piece, *Site*
– Donald Judd, 'Specific Objects'

● 1966 Julio le Parc wins main prize at Venice Biennale. High point of kinetic art
– 'Primary Structures' exhibition, Jewish Museum, New York
– 'Eccentric Abstractions' exhibition, Fischbach Gallery, New York
– Robert Smithson's first visits to New Jersey quarries

● 1967 First Earth Art projects
– Marshall McLuhan, *The Medium is the Message*
– Sol LeWitt, 'Paragraphs on Conceptual Art'
– Germano Celant founded *Arte Povera*, Genoa
– 'Picasso Sculpture' exhibition, Paris, New York, London

Cultural

● 1963 Robin Day designs first polypropylene chair for Hille, London
– Beatles reach top of the charts
– Rolling Stones' first record 'Come On'
– Marcel Duchamp retrospective at Pasadena

● 1964 Terence Conran, first Habitat store, London, opened
– Biba Boutique opens, London
– Saul Bellow, *Herzog*
– Beatles first movie, *A Hard Day's Night*

● 1965 Harold Pinter, *The Homecoming*

● 1966 Chagall decorates the Metropolitan Opera, New York

● 1967 Michelangelo Antonioni, *Blow-Up*
– Beatles, *Sergeant Pepper's Lonely Hearts Club Band* album

Current Affairs

● 1964 Increasing US involvement in Vietnam. First US pilot shot down

● 1966 Chinese Cultural Revolution

● 1967 150,000 Americans march against the Vietnam war
– Homosexuality legalized in UK
– First heart transplant

● 1968 'Dada, Surrealism and their Heritage', exhibition, MOMA, New York
– Walter de Maria, first Earth Room, Munich
– Mario Merz, first igloos
– Daniel Buren posts striped posters in Paris during student protests
– National Gallery Berlin (20th-century Art)

designed by Mies van der Rohe, opened
– Paris students deface statuary in Tuileries Gardens with red paint
– Earthworks exhibition at Dwan Gallery, New York
– Minimal Art exhibition, Gemeente-Museum, The Hague
– Art of the Real' exhibition, New York and London

● 1969 '9 at Leo Castelli' exhibition, New York
– 'When Attitudes Become Form' exhibition, Berne, Krefeld, London
– 'Anti-Illusion: Procedures, Materials' exhibition, New York
– Gilbert & George first performed *The Living Sculpture*

– First issue of *Art–Language*
– Artists protest at MOMA, New York, and foundation of Artworkers Coalition

● 1971 Part of Robert Morris exhibition at Tate Gallery, London, regarded as physically dangerous and closed
– Hans Haacke exhibition at the Guggenheim Museum, New York closed on account of contents

● 1972 'The New Art' exhibition, Hayward Gallery, London
– Joseph Beuys dismissed from professorship at Düsseldorf
● 1974 'Coyote', Beuys's first action in New York
– First exhibition of Nazi art, Kunstverein, Frankfurt

● 1968 Jean Baudrillard, *The System of Objects*
– Stanley Kubrick, *2001: A Space Odyssey*

● 1969 Dennis Hopper and Peter Fonda, *Easy Rider*
– 400,000 attend Woodstock Festival

● 1971 Stanley Kubrick, *A Clockwork Orange*
● 1972 Pruitt–Igoe estate, St Louis, Minoru Yamaski (architect) 1952, demolished.
– Robert Venturi, *Learning from Las Vegas*
– Tim Rice and Andrew Lloyd Webber, *Jesus Christ Superstar*

– Louis Kahn, Kimbell Art Museum, Fort Worth completed
● 1973 Thomas Pynchon, *Gravity's Rainbow*

● 1968 Student riots in Paris, Germany, Italy, and Britain
– USSR invasion of Czechoslovakia
– Assassination of Black rights activist Martin Luther King

● 1969 Neil Armstrong first man on the moon
– Start of IRA violence in Ulster
– First flight by supersonic airliner, Concorde

● 1970 Boeing 747 aeroplane brought into service
● 1972 Watergate break-in
● 1973 Britain joins the Common Market
– US withdrawal from Vietnam
– Eugene F. Schumacher, *Small is Beautiful*
– Floating currencies end Bretton Woods

system of fixed exchange rates
– OPEC oil crisis. Crude oil price rises 400% in 2 years
● 1974 Miners' Strike in UK
– Start of period of high inflation in Europe
– Nixon first US president to resign

	1975	1980		1985

Art

● 1975 Anthony Caro exhibition at MOMA, New York
● 1976 Carl Andre's *Equivalent* [___ ate Bricks] row
– *October* magazine started
● 1977 'Pictures' exhibition, Artists Space Gallery, New York

● 1978 'Bad Painting' exhibition, New York
● 1979 Joseph Beuys retrospective at the Guggenheim Museum, New York

● 1980 Anselm Keifer and Georg Baselitz cause stir at Venice Biennale
● 1981 'Westkunst' exhibition, Cologne
– 'A New Spirit in Painting' exhibition, London and Berlin
● 1982 'Zeitgest' exhibition, Berlin
– 'Englische Plastik Heute' exhibition, Lucerne
● 1983 'The New Art' exhibition, Tate Gallery, London

● 1984 'Von hier aus', exhibition, Düsseldorf
– Primitivism in 20th-century Art' exhibition, MOMA, New York

● 1985 Saatchi Gallery, London, opened
– 'Kunst in der Bundesrepublik Deutschland, 1945–1985', exhibition, Berlin

Cultural

● 1976 Denys Lasdun, National Theatre, London, completed
● 1977 Robert Venturi, *Complexity and Contradiction in Architecture*
– Charles Jencks, *The Language of Post-Modern Architecture*
– Sex Pistols concerts banned from British television

– Centre Pompidou, Paris, architects Piano and Rogers, opened
– Woody Allen, *Annie Hall*
● 1978 Francis Ford Coppola's *Apocalypse Now*
● 1979 Jean-François Lyotard, *The Postmodern Condition*
– Charles Moore Piazza d'Italia, New Orleans, completed

● 1980 Edgar Reisz, *Heimat* television series begins (to 1984)
● 1981 Memphis design studio started by Ettore Sottsass, Italy
– Salman Rushdie, *Midnight's Children*
● 1982 Hans Hollein, Städtisches Museum Abteiberg, Mönchen-gladbach, completed

● 1983 Jean Baudrillard, *Simulations*
● 1984 Milan Kundera, *The Unbearable Lightness of Being*
– James Stirling and Michael Wilford, Neue Staatsgalerie, Stuttgart, completed

● 1985 John Boorman's Brazilian rainforest film, *Emerald Forest*
– Norman Foster, Hong Kong and Shanghai Bank, Hong Kong, completed

Current Affairs

● 1977 Apple computer launched in USA
● 1978 Red Brigades murder former Italian prime minister Aldo Moro

● 1979 Second oil price crisis
– Margaret Thatcher becomes first woman prime minister in UK

● 1980 Personal computers and fax machines become commonplace
– World Health Organization (WHO) declares world free of smallpox
● 1981 Space Shuttle *Columbia* makes the first shuttle mission
– Ronald Reagan elected President of USA

● 1982 British war against Argentina in Falkland Islands
– Compact disc produced
● 1983 Greens win seats in German Bundestag
● 1984 Miners' strike in Britain
– CD ROM introduced as data storage device

● 1985 WHO declares AIDS an epidemic
– Gorbachev elected president in USSR
● 1986 Nuclear accident at Chernobyl
– Privatization of industries begins in UK
– Single European Act paves way for tighter European union. UK signs

● 1986 'Damaged Goods. Desire and the Economy of the Object', exhibition, New York
– Ludwig Museum, Cologne, opened
– Museum of Contemporary Art, Los Angeles, opened
– 'Endgame' exhibition, Boston
● 1987 Münster Sculpture project

● 1989 'Magiciens de la Terre' exhibition, Paris
– 'A Forest of Signs. Art in the Crisis of Representation' exhibition, Los Angeles
– Removal of Richard Serra's *Tilted Arc*, New York

● 1990 'High and Low. Modern Art and Popular Culture' exhibition, New York
● 1991 Museum of Contemporary Art, Frankfurt, opened
– 'Metropolis' exhibition, Berlin
– 'Dislocations' exhibition, New York

● 1993 'Abject Art' exhibition, New York
● 1994 'Bad Girls/Bad Girls West' exhibition, New York and Los Angeles

● 1995 Turner Prize won by Damien Hirst

● 1986 Richard Rogers, Lloyds Building, London, completed
● 1988 Salman Rushdie, *Satanic Verses*
– Stephen Hawking, *A Brief History of Time*

● 1989 Bernard Tschumi, pavilions in Parc de la Villette, Paris, completed
– Quinlan Terry, Riverside Development, Richmond Surrey, completed

● 1990 A S Byatt, *Possession*
● 1992 Steven Spielberg, *Jurassic Park*

● 1994 Quentin Tarantino, *Pulp Fiction*

● 1995 Rem Koolhaas, congress and exhibition hall, Lille, completed
● 1996 Daniel Libeskind, Jewish Museum, Berlin, completed

● 1997 J.Paul Getty Center, Los Angeles, completed

● 1987 Heysel stadium disaster, Brussels. 41 die because of British football hooliganism
– British stockmarket collapse
● c.1988 Worldwide interconnection of computer networks through Internet

● 1989 German Neo-Nazis represented in European parliament
– Massacre of protesters in Tiananmen Square, Beijing
– Demolition of Berlin Wall

● 1990 Reunification of Germany
● 1991 Gulf War
– Start of civil war in Yugoslavia
– Collapse of Communist regime USSR
● 1992 Euro-Disney theme park, Paris, opened
● 1993 Promotion of the Internet
– Bill Clinton elected President of USA

● 1994 End of White rule in South Africa, and Nelson Mandela elected President
– Channel Tunnel link between UK and France opened

● 1995 Bosnia peace accord signed in Dayton, Ohio

● 1997 Deng Xiaoping, China's chairman of Military Affairs Committee and effective leader, dies
– Tony Blair's Labour government wins landslide victory in UK general election

Index

The Oxford History of Art is an important new series of books that explore art within its social and cultural context using the most up-to-date scholarship. They are superbly illustrated and written by leading art historians in their field.

'Oxford University Press has succeeded in reinventing the survey ... I think they'll be wonderful for students and they'll also appeal greatly to members of the public ... these authors are extremely sensitive to works of art. The books are very very lavishly illustrated, and the illustrations are terribly carefully juxtaposed.'
Professor Marcia Pointon, Manchester University speaking on *Kaleidoscope*, BBC Radio 4.

'Fully and often surprisingly illustrated, carefully annotated and captioned, each combines a historical overview with a nicely opinionated individual approach.'
Independent on Sunday

'[A] highly collectable series ... beautifully illustrated ... written by the best new generation of authors, whose lively texts offer clear syntheses of current knowledge and new thinking.'
Christies International Magazine

'The new series of art histories launched by the Oxford University Press ... tries to balance innovatory intellectual pizzazz with solid informativeness and lucidity of presentation. On the latter points all five introductory volumes score extremely well. The design is beautifully clear, the text jargon-free, and never less than readable.'
The Guardian

'These five books succeed admirably in combining academic strength with wider popular appeal. Very well designed, with an attractive, clear layout and carefully-chosen illustrations, the books are accessible, informative and authoritative.'
The Good Book Guide

'A welcome introduction to art history for the twenty-first century. The series promises to offer the best of the past and the future, mixing older and younger authors, and balancing traditional and innovative topics.'
Professor Robert Rosenblum, New York University

Oxford
History of
Art

The Photograph
Graham Clarke

How do we *read* a photograph?

In a series of brilliant discussions of major themes and genres, Graham Clarke gives a clear and incisive account of the photograph's historical development and elucidates the insights of the most interesting critics on the subject. At the heart of the book is his innovative examination of the main subject areas — landscape, the city, portraiture, the body, and documentary reportage — and his detailed analysis of exemplary images in terms of the cultural and ideological contexts.

'Graham Clarke's survey, *The Photograph*, argues elegantly while it informs.'
The Guardian

'entrancing . . . There was hardly an image new to me, hardly an image he did not make new to me, reading its complicity . . . with the most sensitive and perceptive eye.'
Sister Wendy Becket, *The Observer*

'Carefully selected images work with the text to illustrate the theme: how the photograph is 'read'. Read this book and you will never look at a photograph in the same way again.'
House & Garden

Twentieth-Century Design

Jonathan M. Woodham

The most famous designs of the twentieth century are not those in museums, but in the marketplace. The Coca-Cola bottle and the McDonald's logo are known all over the world, and these tell us more about our culture than a narrowly-defined canon of classics.

Professor Woodham takes a fresh look at the wider issues of design and industrial culture throughout Europe, Scandinavia, North America, and the Far East. In the history which emerges design is clearly seen for what it is: the powerful and complex expression of aesthetic, social, economic, political, and technological forces.

'a showcase for the virtues of the new series . . . deftly organized, extremely cool-headed account . . . his range of reference and eye for detail are superb'
The Guardian

'[F]or a good general introduction to the subject you could not go very far wrong Yet another example of the impressive new Oxford History of Art series.'
The Bookseller

Oxford History of Art

Titles in the Oxford History of Art series are up-to-date, fully-illustrated introductions to a wide variety of subjects written by leading experts in their field. They will appear regularly, building into an interlocking and comprehensive series.

Western Art

Archaic and Classical Greek Art
Robin Osborne
Hellenistic and Early Roman Art
John Henderson & Mary Beard
Imperial Roman and Christian Triumph
Jaś Elsner
Early Medieval Art
Lawrence Nees
Late Medieval Art
Veronica Sekules
Art and Society in Italy 1350–1500
Evelyn Welch
Art and Society in Early Modern Europe 1500–1750
Nigel Llewellyn
Art in Europe 1700–1830
Matthew Craske
Nineteenth-Century Art
Modern Art: Capitalism and Representation 1851–1929
Richard Brettell
Art in the West 1920–1949
Modernism and its Discontents: Art in Western Europe & the USA since 1945
David Hopkins

Western Architecture

Greek Architecture
David Small
Roman Architecture
Janet Delaine
Early Medieval Architecture
Roger Stalley
Late Medieval Architecture
Francis Woodman
European Architecture 1400–1600
Christy Anderson
European Architecture 1600–1750
Hilary Ballon
European Architecture 1750–1890
Barry Bergdoll
Modern Architecture 1890–1965
Alan Colquhoun
Contemporary Architecture
Anthony Vidler
Architecture in the United States
Dell Upton

World Art

Ancient Aegean Art
Donald Preziosi & Louise Hitchcock
Classical African Art
Contemporary African Art
African-American Art
Sharon Patton
Nineteenth-Century American Art
Barbara Groseclose

Twentieth-Century American Art
Erika Doss
Australian Art
Andrew Sayers
Byzantine Art
Robin Cormack
Art in China
Craig Clunas
East European Art
Jeremy Harvard
Ancient Egyptian Art
Marianne Eaton-Krauss
Indian Art
Partha Mitter
Islamic Art
Irene Bierman
The Arts in Japanese Society
Karen Brock
Melanesian Art
Michael O'Hanlon
Latin American Art
Mesoamerican Art
Cecelia Klein
Native North American Art
Janet Berlo & Ruth Phillips
Polynesian and Micronesian Art
Adrienne Kaeppler
South-East Asian Art
John Guy

Western Design

Twentieth-Century Design
Jonathan M. Woodham
Design in the United States
Jeffrey Meikle

Western Sculpture

Sculpture 1900–1945
Penelope Curtis
Sculpture Since 1945
Andrew Causey

Photography

The Photograph
Graham Clarke

Special Volumes

Art and Film
Art and Landscape
Malcolm Andrews
Art and the New Technology
Art and Science
Art and Sexuality
The Art of Art History: A Critical Anthology
Donald Preziosi (ed.)
Portraiture
Women in Art